Raphael
and France

The Pennsylvania State University Press
University Park, Pennsylvania

Raphael and France

The Artist as Paradigm and Symbol

Martin Rosenberg

Library of Congress Cataloging-in-Publication Data

Rosenberg, Martin, 1951–
 Raphael and France : the artist as paradigm and symbol / Martin
Rosenberg.

 p. cm.
 Includes bibliographical references and index.
 ISBN 0-271-01300-1
 1. Classicism in art—France. 2. Raphael, 1483–1520—Influence.
3. Art, Modern—France. I. Title.
N7432.5.C6R67 1995
709'.44'0903—dc20 93-30505
 CIP

Published by The Pennsylvania State University Press,
University Park, PA 16802-1003

It is the policy of The Pennsylvania State University Press to use acid-free
paper for the first printing of all clothbound books. Publications on
uncoated stock satisfy the minimum requirements of American National
Standard for Information Sciences—Permanence of Paper for Printed
Library Materials, ANSI Z39.48–1984.

To
Ellen, Matthew,
and Valerie

CONTENTS

LIST OF ILLUSTRATIONS

All works are by Raphael and assistants unless otherwise noted.

ACKNOWLEDGMENTS

During the period of time this book reached fruition, I incurred many debts to both institutions and individuals. The book is an outgrowth of my doctoral dissertation, written at the University of Pennsylvania under Professor John McCoubrey. I thank him for his invaluable guidance and support over the years. Research in France was supported by a Penfield Scholarship from the University of Pennsylvania, and initial writing was completed under a Mellon Fellowship at Carleton College.

I have also benefited from the support and interest of many colleagues. I wish to express my appreciation to Robert Rosenblum, Francis Haskell, and Donald Kuspit for their interest in my work. I have also benefited immeasurably from the support of friends and colleagues, including Lauren Soth, Linda Hults, Mary Lewis, Mark Thistlethwaite, Beth Schneider, James Czarnecki, Lenore Kuo, Frances Thurber, and Joanne Sowell. Readings of the manuscript by Bernard Barryte and Michael Paul Driskel were extremely helpful.

I also wish to express my appreciation to the staffs of the British Library, the Warburg Institute, and the Cabinet des Estampes of the Bibliothèque Nationale, Paris, where much of the research for the book was done.

A Faculty Development Leave from the University of Nebraska at Omaha allowed me to complete the final revisions. I owe a deep debt of gratitude to Philip Winsor, senior editor, at Penn State Press, for his steadfast support. I also wish to thank Betty Waterhouse for her meticulous editing, Amy Struthers for editing the French translations, Mary Gallagher for her assistance with indexing, and Cherene Holland for guiding the book to press.

Finally, words cannot adequately express how much the moral support of all my family has meant to me. I wish to dedicate this book to Ellen, Matthew, and Valerie, and to my mother, Marian Rosenberg. May you share fully in this achievement, for without all you have given me, it would not have been possible.

INTRODUCTION

For more than two centuries, Raphael had a greater impact on the French classical tradition than any other foreign artist, yet no comprehensive study of his place in French art theory, criticism, and practice has been made. So there is an intrinsic interest in examining the ways in which Raphael shaped French art. An artist's influence on subsequent generations is usually considered rather narrowly in terms of borrowed compositions or motifs or direct emulation of the master's style. Certainly Raphael was copied and emulated more than any other master from the sixteenth through the nineteenth centuries, yet Raphael's authority in shaping French art theory and practice transcended these instances of direct influence.

In addition to inheriting the products of Raphael's hands, what we might call the "visible" Raphael, the French also inherited a "mythical" Raphael. This fictionalized version of Raphael's art and life was largely the creation of Vasari. By the founding of the Academy, Poussin and his contemporaries had already demonstrated how to turn the character of Raphael's works more in the direction of French taste. The early theorists in and around the Academy equated the works of Raphael and Poussin as the best examples of the classical ideal they favored, an elevated aesthetic conception based on perfecting nature. They further strengthened the authority of this *beau idéal* by identifying it with reason, the most highly valued philosophical quality of the late seventeenth century.[1]

At the same time, French artists and theorists adapted the "mythical" Raphael inherited from Vasari, and co-opted the authority of this picture of the Renaissance master's life to support their own aesthetic, social, and political values. In terms of practice, Raphael's art provided the French with a paradigm embodying the *beau idéal,* which fit their taste for a rationalized, classicizing approach to art. By following the course of "Raphaelism" in France, we can trace the evolution of these classical values, which form a central thread in French art and theory from the seventeenth through the nineteenth centuries. Raphael's authority, however, transcended aesthetics.

Both the "visible" and "mythical" Raphael could be placed in the service of Academicians' social and political aims, which were closely intertwined. Academicians aimed to establish a clear distance between their pursuits and those of menial craftsmen, thereby increasing their social status and obtaining and solidifying the exclusive protection of the king. Within two decades of the Academy's founding, they managed to turn an Italianate taste among a small group of history painters into a theoretically justified and officially sanctioned *grand goût,* defined and promulgated through an official institution—the French Academy—with the direct support and under the direct control of the monarchy. Both the art and images of Raphael played a central role in this transformation.

In the late seventeenth century, the professional and social aspirations of French artists converged with the political requirements of an increasingly centralized state under Louis XIV. The classical approach to art, as embodied in the works of Raphael and Poussin, was based on clarity, unity, and the subordination of all parts to an overriding idea. This elevated style and rhetorical approach, as adapted by Charles Le Brun's Academy, could fill the political requirements of absolute monarchy, as was amply demonstrated in works commissioned for Versailles.[2] Louis XIV could take the position of authority in French art that the pope and the Church had occupied in the art of the Italian Renaissance. As one concrete example of the institution of a political role for the Academy, we can point to the revision of its statutes, which took place in 1665. A specific article required students to submit annually drawings of "a general subject on the heroic actions of the King."[3] Through such measures, the artistic and political roles of the Academy became inextricably intertwined.

The symbolic images of Raphael, adapted from Vasari, played a central role in the formation of French academic theory. Although the purpose of theoretical discourse in the Academy was ostensibly the artistic one of establishing a common aesthetic, these discussions also served a social, and ultimately, a political purpose. They established around the rather down-to-earth daily business of making art a higher activity of intellectual discourse imbued with the proper air of gentlemen involved in an elevated pursuit in the service of the king, the *honnêtes hommes* the artists aspired to be.[4] The elevated conception of both the artist and his art conveyed by the images of Raphael, which the French adopted, provided ideal support for the Academicians' aspirations and pretensions.

Theorists in and around the Academy transformed Vasari's picture into that of a "French Raphael." By making Raphael a cornerstone of their theory and practice, in effect, by aspiring to *be* Raphael, French Academicians made the Italian artist part of their tradition. At the same time, they made Raphael's name synonymous with the highest levels of artistic achievement and the most elevated conception of the artist and his works. By emulating the artistic conception embodied in Raphael's life and works, they, in effect, enhanced their own status. These efforts gave the works and life of Raphael a virtually absolute authority for the French.

Both the art and images of Raphael thus played a central role in establishing the Academy's privileged position under Louis XIV, by providing the Academy with both a coherent artistic model and a conceptual framework on which to erect its edifice of academic doctrine. The production of theory was one of the essential activities by which the Academy differentiated itself from its chief rival, the Guild, in order to claim the exclusive protection of the king.[5] The Academy's construction of a "French Raphael" placed the most elevated conception possible of the artistic enterprise in the service of academic ideals and aims, while Raphael's works provided direct models for practice in the service of the king. Both elements were essential in establishing the French Academy as the central institution in French art.

The "French Raphael" was constructed out of a series of symbolic images adapted from Vasari, including the "*modern Apelles,*" the *exemplary history painter,* the *model academic,* and the *ideal courtier.* These symbolic images, which shaped the French responses to Raphael's works, were an integral part of French academic theory, just as Raphael's works were exemplary for French artists from Poussin to Le Brun. Defined and codified in

the seventeenth century, they were used to justify French academic ideals and practices, as well as the prestige and patronage the Academy hoped to claim. Not surprisingly, these images recur constantly in the literature on art. In effect, the name of Raphael was made a signifier of absolute artistic value, and the Italian artist was claimed by the French as one of their own.

Since Raphael's supremacy in the artistic hierarchy was associated with a definite classical aesthetic, one that subordinated sensual aspects to what were seen as the intellectual values of art, changes in the French view of Raphael can indicate shifts in underlying artistic values. By placing the views of Raphael in the broader context of the development of French art theory and practice, we gain insight into the evolution of the classical ideal between the seventeenth and nineteenth centuries. We discover that the aesthetic shifts from classical to Rococo to neoclassical styles were not so all-embracing or abrupt as is generally accepted. By tracing the evolution of Raphael's image in relation to artistic practice and to the historical situation, we find that Raphael was equally important as a symbol and a paradigm.

In the last two decades, studies of eighteenth-century French art have proceeded in either of two major directions: One of these is expansive, aimed at broadening the range of art deemed worthy of study by viewing this work more in terms of the values of the time in which it was produced. Beginning with such studies as R. Rosenblum's seminal *Transformations in Late Eighteenth-Century Art* and such exhibitions as *French Painting 1774–1830* and *The Age of Louis XV*,[6] scholars have focused on hitherto ignored aspects of the art of the period, such as history and religious painting, to give us a more comprehensive view of the eighteenth century than that inherited from the Goncourts. Other studies, such as the recent exhibition *The Loves of the Gods,* curated by Colin Bailey, have examined seemingly familiar aspects of this with a new depth and inclusiveness. The resulting view goes beyond Watteau, Chardin, Boucher, and Fragonard. Other recent examples of this more inclusive approach to the period include the exhibition *La Grande Manière,* mounted by Donald Rosenthal, and Phillip Conisbee's *Painting in Eighteenth-Century France.*[7] There have also been important synthetic studies of the art in its historical, cultural, and political contexts by Honour, Boime, Crow, and others.[8]

The second direction in study of the period has tended to be more theoretical in focus, ahistorical, and perhaps somewhat reductivist. Such works as Norman Bryson's *Word and Image* and Michael Fried's *Absorption and Theatricality* have contributed significant new perspectives but both tend to focus only on those works that fit their theoretical formulations, derived primarily from structuralism and semiotics. Although both authors have made us aware of new dimensions of the works they discuss, they have tended to subordinate the visual dimension of works to the linguistic dimension, and to remove the works from their historical contexts. Yet some recent works, such as Mary Sheriff's book *Fragonard,* demonstrate that it is possible to make one's scholarship both theoretically informed and historically grounded.[9]

The present study is an attempt to enlarge our view of the development of artistic theory and practice in France by tracing the continuity and evolution of a particular set of artistic values within their aesthetic and cultural contexts. By focusing on the Academy as the central institution in French art, by relating theory to practice, and by placing aesthetic developments in historical context, the study contributes to a more balanced and compre-

hensive view of French art from the late seventeenth to the early nineteenth century. In this book, I do not attempt to give a comprehensive account of French art and theory over a period of more than a century and a half. Rather, I focus on tracing the establishment, continuity, and evolution of the French classical tradition, for the classical ideal was never entirely abandoned in France, even at the height of the Rococo. In addition to providing protection and patronage for its members, the French Academy attempted to define and to promote a clear artistic doctrine. Although the terms in which art theory was couched were derived from rhetoric,[10] the artistic rules the academicians codified and that shaped their works were derived from the works of the most generally accepted exemplary past masters, including Raphael, Poussin, Titian, and Correggio. Unlike their amateur contemporaries, artists were always faced with the fundamental task of giving their ideas visual form. Yet practice even within the Academy was never narrowly proscribed by theory. Artists' works were always more diverse than the *préceptes positifs* derived in academic discourse might suggest.

In many studies of French painting of this period, major artistic developments have been painted with a rather broad brush: The shadow of Poussin and the domination of the Crown over the Academy of Le Brun supposedly led to the monotonous uniformity of the French classical style. The classicists' hegemony was challenged and overcome by Roger de Piles and the *Rubénistes,* leading to the triumph of sensuality and the Rococo. Around the middle of the eighteenth century, an anti-Rococo reaction set in, and, largely through the agency of the king's ministers, a new, more severe, and elevated approach to painting led to neoclassicism. Although, in the broadest terms, there is some truth in this picture, it is both too simplistic and too categorical. Crow, for example, has demonstrated that the "public" became an increasingly key element in the equation.[11] Bryson, in *Word and Image,* proposes an alternative semiotic history of the art of this period. Although Bryson introduces a new perspective, he still reinforces the traditional view that the only significant aspects of French art in the period are the works of its most "original" artists. Certainly, rebellion and disruption were key aspects in the development of French art, but continuity and transformation played a more significant role overall. The classical ideal, in the broadest sense, forms a continuous element in French art from the late seventeenth to the nineteenth centuries. Raphaelism, in both its concrete and symbolic forms, was one of the major vehicles of the continuity and transformation of that ideal.

From the foundation of the Academy, the artists, who had little taste for or practice in theorizing, felt that amateurs, such as Fréart de Chambray, Roger de Piles, and the Comte de Caylus, could make significant contributions to the theoretical discourse. Inclusion of these influential individuals could also serve a useful political function and lend legitimacy to the Academy's claims for art's exalted intellectual status. The treatises of certain foreigners, including Vasari, Richardson, Winckelmann, and others, also had an impact on French art theory and criticism. Sources for defining the French view of Raphael include theoretical treatises by French and foreign artists and amateurs, the Academy's lectures and correspondence (particularly that between the *surintendant des bâtiments* and the directors of the French Academy in Rome), exhibition catalogs, Salon criticism, guidebooks, and handbooks for amateurs and other types of documents. In evaluating all these works, I have tried to keep in mind the perspective and biases of each author, as well as the author's level of knowledge of Raphael's work.

Since Raphael is a central, all-pervasive presence in French artistic literature, defining his role in theory and criticism is relatively straightforward. His direct impact on French artistic practice is equally pervasive, yet more difficult to define, as is the relationship between theory and practice in its historical and cultural context. There are several reasons for this: A French work can draw on Raphael at a variety of different levels; it can echo Raphael's compositions, can emulate his forms, use his narrative devices, copy specific details, or any combination of these. Defining Raphael's influence precisely is also complicated by his central role in the French classical tradition. Thus, we may, for example, see a work by David that is based on Raphael filtered through the intermediary of Poussin. With the pervasive eclecticism of the French, Raphael may be only one among a variety of sources for a given work. Despite these difficulties, however, it is generally possible to trace Raphael's direct influence on French art in the broadest sense, including his central position in academic pedagogy, in relation to the French understanding of attributes symbolized by the artist. At times, as in the late seventeenth century, the stream of Raphael criticism seems to parallel and even to shape artists' responses to Raphael's works, and Raphael's roles in theory and practice seem mutually reinforcing. At other times, as in the first half of the eighteenth century, Raphael's symbolic influence seems relatively independent of prevailing taste, which shifts away from the classicizing ideal that dominated the seventeenth-century Academy. Wherever possible, this study traces the interrelationships among theory, criticism, and practice, within the changing historical and cultural context.

But why was Raphael so central to French academic theory and practice? It cannot be assumed that artists modeled their works on Raphael solely because he was a varied, readily available model. We must ask if the quoting or emulation of Raphael signified something beyond the specifics of a particular borrowing. Did a relationship to Raphael convey an instantly recognizable imprimatur of legitimacy onto an artist's work? Tradition, as Norman Bryson has recently pointed out, can be a force to be struggled against, as much as a source from which to draw.[12] Yet, tradition can also play a very important positive role, in providing stability and continuity, and a filiation with values that transcend the moment and the individual. This positive role is more likely when a tradition is based on a paradigm embodying what are viewed as essential artistic qualities, but capable of adaptation to changing tastes and values. Raphael provided this "bedrock" of the French classical tradition. One must examine the degree to which French artists defined themselves in relation to both the works and image of Raphael. To a large degree, the theoretically assumed perfection of Raphael, as much as the usefulness of his works, created the value the French ascribed to Raphael. Raphael's works provided the French with a central classical paradigm they viewed as universal, yet not constraining.

Since in addition to being a teaching body, the Academy was an arm of the king's power, it seems appropriate to view its values in historical and political terms as well as aesthetic ones. Certainly, Raphael's art and image lent prestige and authority to the Academy while providing a model for the type of didactic works required by the king and his ministers. By identifying themselves with Raphael, the "Prince of Painters," the members of the Academy helped secure and justify their elevated status among the artists of France. In the eighteenth century, as political power became diffused, those outside the court could use the prestige of Raphael to their own ends. This implicit political dimension to Raphael's

importance was given explicit form under Napoleon, who used the works by Raphael brought to Paris as a symbol of his hegemony over Europe.

One must also consider the sources of French ideas, since the elevated view of Raphael among French artists and amateurs was not their creation. The French contribution to art theory in general and Raphael criticism in particular was more in terms of codification and creative adaptation than originality. By the second half of the seventeenth century, Italian theorists, including Vasari, Dolce, Lomazzo, and others had established Raphael's eminence.[13] In addition, most of the artists who had formed the French classical style, Poussin, Le Brun, Le Sueur, and others had been influenced by Raphael. In exalting Raphael and placing him at the center of their pedagogy, the Academy was only codifying widely accepted theory and practice. Even the eclecticism on which academic theory was based was inherited from Italians such as Lomazzo. At least in their theoretical discourse, French Academicians argued that each aspect of painting could be codified and perfected independently by following the proper model. Raphael was the greatest modern painter because, in André Félibien's words: "If some have excelled in one aspect of painting, they have only known the others to a limited degree, and one could say that Raphael was admirable in all areas."[14]

Like all judgments of Raphael after the sixteenth century, Félibien's is based on that of Giorgio Vasari, whose *Lives* created the conceptual framework within which the French viewed the Italian master. Vasari's praise of Raphael's catholic excellence could be shaped, by selective emphasis, to support French artistic, social, and even political values. Very little of what the French had to say about Raphael was either original or critical in the strictest sense. How the French used these well-established ideas about Raphael, and how their preconceptions shaped their responses to his art are the questions of greatest interest. Vasari's "parable" not only channeled French artists' aesthetic responses to Raphael's work; it also legitimized the Academy's eclecticism and placed a high value on identification with the Renaissance master.

Although Raphael was clearly exemplary for the French, no systematic study of his role in the development of French art theory, criticism, and practice has been made. Eugene Müntz's extensive bibliography (1883) of Raphael criticism from the sixteenth through the nineteenth century provides a starting point. Anthony Blunt and Vincenzo Golzio have published brief, limited studies of selected Raphael critics, but neither acknowledges the complexity of the French view of Raphael, nor places his ideas in the context of the evolution of art theory.[15] For the general outline of that evolution, this study draws on Fontaine's seminal but sketchy *Doctrines d'art en France*.[16] Since my original examination of these ideas,[17] a major exhibition *Raphael et l'art français* examined Raphael's direct impact on French art.[18] This book attempts to synthesize the more theoretical perspective of my original study with the exhibition's focus on Raphael's direct impact. Where appropriate, I have acknowledged and incorporated some of the wealth of information and examples from that exhibition, enriching my study without modifying my original thesis.

A major fault of both my original study and the French exhibition is that they focus on only one aspect of Raphael's influence while treating others as peripheral. Wherever possible, I have tried to redress this defect by interrelating questions of Raphael's place in theory, criticism, and practice, as I have come to feel that many of the most interesting questions relate to the interaction of these various aspects of Raphael's influence. Such

questions include: To what degree and in what ways did symbolic images of Raphael shape French responses to his work? What was the relationship between theory and practice at various periods? Why was the copying of Raphael deemed essential to academic pedagogy? Was it for the direct benefit of the master's example, or was it as much for the symbolic value of identifying with the paradigm of Renaissance classicism? What was the nature of Raphael's authority within the French artistic tradition? Another limitation of both previous studies is that they treat artistic issues as if they occur in a vacuum. This study attempts, at least to a limited degree, to place artistic and aesthetic issues in the complex social, cultural, and political contexts in which they developed. Our understanding of the politicization of aesthetic issues in this period has been greatly enhanced by Thomas Crow's *Painters and Public Life in Eighteenth-Century Paris*.

From the perspective of the Academy, the study divides logically into four chronological sections. The first traces Raphael's establishment in academic theory and practice as the modern classical ideal. In the treatises of Félibien, Fréart de Chambray, and the *conférences* of Le Brun and others, a "French Raphael" was created. A clear view of Raphael emerged that both shaped and was shaped by the direct responses of Poussin, Le Brun, Le Sueur, and other French artists to his works. The Academy *conférences* devoted to Raphael and the establishment of a comprehensive project beginning with the foundation of the French Academy in Rome in 1661, for students to copy his works to decorate the king's residences, placed Raphael at the center of academic pedagogy. The elevated conception of the artistic enterprise exemplified by Raphael, which the French adopted, also played a fundamental role in the political struggle by the Academy to distinguish itself from the guild and to gain control over artistic training. Raphael's roles in theory and practice, as well as in the politics of artistic institutions were all mutually reinforcing.

Roger de Piles, a pivotal and highly original theorist who supported a more sensual aesthetic in opposition to the intellectualized classicism of the Academy, opposed the view that Raphael's admitted strengths rendered him the perfect academic model. Yet, rather than abandoning Raphael, de Piles redefined him by suggesting that he had been moving at the end of his career toward a synthesis of naturalism and the classical ideal. Since Raphael had not achieved this synthesis, de Piles was quick to point out that one had to look to Rubens and the Venetians to master color. Part One ends with a careful consideration of the views of de Piles, whose redefinition of the artist allowed the Raphaelesque ideal to survive the rise of Rubenism and the Rococo.

Part Two considers the extent to which the Raphaelesque ideal survived in the more eclectic, naturalistic climate of the first half of the eighteenth century. This ideal, although overshadowed by the Rococo, was sustained by amateurs with classical tastes, such as Richardson and Mariette; in the pedagogy of the Academy, particularly in Rome; and in the works of certain older history painters, such as Jean Restout, Antoine Coypel, and Sébastien II Le Clerc. Although Raphael's influence during this period is more evident in theory and pedagogy than in broader artistic practice, his continuing importance in the French academic tradition provided a bridge between seventeenth-century classicism and the neoclassical revival. One can raise the question as to why Raphael remained so central to theoretical discourse at a time when most artists' taste had shifted away from the classical ideal of Raphael and Poussin.

Part Three, covering the time from 1749 to 1792, traces Raphael's central importance for

the revival of history painting, the anti-Rococo reaction, and the rise of neoclassicism. With the attempt to reestablish the authority of the Academy after the eclipse of its power in the first half of the century, the symbolic images of Raphael codified in the seventeenth century are revived and are used to justify a return to a more elevated conception of painting. Among the artists who participated in the revival of history painting are those, such as Noël Hallé and Carle Van Loo, who had copied Raphael as students in the Rome Academy. One can ask what the theoretical revival of Raphael had to do with the rise of neoclassicism and a more serious, didactic approach to painting. From mid-century on, the view of Raphael is once again affected by French and foreign amateurs, including La Font de Saint-Yenne, Diderot, the Comte de Caylus, Winckelmann, Mengs, and others. Although Winckelmann and Mengs fueled the fires of neoclassicism in France, they perceived a far greater gulf than the French did between the perfections of antiquity and those of Raphael. With the neoclassical revival, we can trace a profound respect for Raphael in David, inherited from his teacher Vien, which he clearly transmitted to his own pupils Ingres, Gros, Girodet, and others.

Part Four, covering the period from 1793 to 1830, discusses Raphael's crucial role within the Musée Napoléon. In Napoleon's "trophy of conquest," well-established images of Raphael were given their most concrete manifestations as ideas about the artist were translated from the parochial realm of academic art theory into the public arena of international politics. Raphael's works, particularly the *Transfiguration,* generated more critical comment than any other modern works in the museum, and Raphael's life even became the subject of contemporary paintings.[19] Part Four ends with a consideration of the effects of some dimensions of the rise of Romanticism to Raphael's position in the artistic hierarchy. To make the range of theoretical and critical positions available at this time concrete, the ideas and works of Delécluze and Ingres are opposed to those of Delacroix and Stendhal. Of course, the responses of both Ingres and Delacroix to Raphael were much more complex and ambivalent than their opposing positions in nineteenth-century art history would imply. Historical factors also affected Raphaelism in France. As Michael Driskell has shown, the Catholic revival around 1830 had a profound impact on the French views of Raphael.[20]

This study defines and amply demonstrates the power and persistence of the Raphaelesque ideal in France for more than two centuries. The direct impact of Raphael's works waned somewhat when the French moved away from the seventeenth-century classical ideal. One key to Raphael's sustained importance is the adaptability of his life and works to various interpretations. Just as artists and amateurs could transform their views of Raphael to fit changing tastes, they could continue to nourish themselves on Raphael's art and to borrow his prestige, even if their style or ideas bore little resemblance to his. Equally important for Raphael's enduring influence were what were perceived as his unsurpassed skills in invention, design, and expression, which the French never ceased to regard as cornerstones of great painting. For them, Raphael was truly "le plus grand peintre du monde."

Part One

Raphael in French Classical Theory and Practice (1660–1700)

The Creation of a French Raphael

From 1518, when Pope Leo X commissioned the *Holy Family* (Fig. 1) as a gift to the French court from Leo's nephew, and as Francis I began to collect other works attributed to Raphael, the French interest in the Italian Renaissance master was firmly established. Although Raphael's impact on French artists, including Vouet and Poussin, was apparent by the 1630s, Raphael came to occupy a central position in French art theory and practice only after the establishment of the French Academy of Painting in 1648.[1] At first, the Academy was little more than a loose coalition of a dozen history painters who wished to escape the restrictions of the guilds. In 1661, however, the desire of Louis XIV and his minister Colbert that culture become an emanation and reflection of centralized state power led to the direct control and patronage of the Academy by the Crown. In return for this protection, the Academy of Painting would train artists in the officially sanctioned "grand goût" and would provide appropriate works to decorate the king's residences. To justify their hegemony over artistic training and virtual monopoly on state commissions, the Academicians not only had to demonstrate their utility to the state; they also had to differentiate themselves clearly from the members of

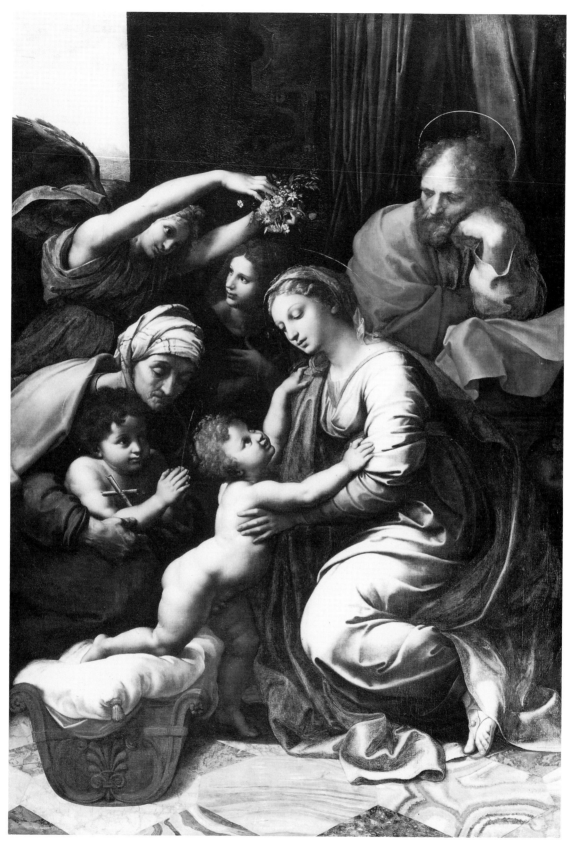

Fig. 1. *Holy Family of Francis I,* 1518, Louvre, Paris

the Maîtrise, the guild.[2] The creation of a theoretical base for the Academy's approach to painting became central to the Academicians' bid for enhanced status.

Norman Bryson has recently asserted that French history painting in this period was little more than a "discursive" formulation predicated solely on serving the needs of the Crown. In Bryson's conception, Le Brun is little more than a bureaucrat whose primary function is to ensure uniformity.[3] This simplistic formula ignores both the historical development and aesthetic dimensions of French classicism. The classical style, derived from the example of antiquity and Raphael, was already evident in the art of Poussin and other French artists prior to the founding of the Academy. The clear rhetorical style they developed was based on what was seen as a reasoned approach to art and an allegiance to a higher idealism. The emphases on clarity of expression and subordination of details to a central idea did make the style an appropriate vehicle for conveying clear statements about royal power, such as those which Le Brun painted for Versailles. The classical style, however, was well established before the Academy came under direct royal protection. To reduce French classicism to nothing more than a rhetorical formulation is to ignore the other kinds of values the work embodied and to make a too-simplistic equation between art and politics. A recent study by Martin Weyl, for example, has stressed the role of the social concept of *honnêteté* in the formation of the Academy, as artists—who were viewed as little more than artisans—attempted to achieve the status of gentlemen.[4] The French Academicians believed that the artist's ideas must be given the proper form, embodying the correct choice from nature, which constituted the *beau idéal*. One learned to make this choice by following the ancients, Raphael and Poussin.

The formation of the Academy and the development of academic theory was predicated on the notion that painting was a "discipline" governed by rules that could be defined and taught. These rules were derived from the works of the most exemplary past masters, including Titian, Correggio, Michelangelo, and above all, Raphael and Poussin, whose art perfectly fit the classicizing predilections of the French. The political requirement that the Academy differentiate itself clearly from the guild gave a privileged position to theoretical discourse in that body and allowed for the impact of amateurs as well as artists. As with the very concept of the Academy, the contribution of enlightened amateurs in learned discourse on the arts was part of the heritage of Italian humanism adopted by the French. These amateurs tended to be men of influence, as well as lovers of art so their support could lend prestige to academic discourse. They were also men of letters, so they were much better equipped than many academicians to carry on learned discourse, and their contributions broadened the intellectual range of art theory into the realm of the liberal arts.

Raphael's position at the pinnacle of artistic achievement was already well established in France by his prominence in the king's collection and his influence on the generation of French artists who founded the Academy. For example, by interpreting Poussin as the "French Raphael," French art theorists in and around the Academy heightened Poussin's prestige and strengthened his pedigree as the father of the French classical tradition. Blunt is at most partly correct in asserting that the French saw Poussin as the "French Raphael" because they interpreted Raphael as the "Italian Poussin," an artist whose work conformed with reason.[5] Raphael's work provided a rich, varied classical paradigm which fit prevailing French tastes; and, above all, his art and life could be interpreted to provide support

for French classicism and the pedagogical approach on which the Academy was based, and his prestige could be used to strengthen the Academy's political position.

The view of Raphael that the French developed in the 1660s and 1670s coalesced from several sources: direct knowledge of Raphael's works, through engravings and copies, as well as through originals; the responses of leading French artists, including Poussin, Le Sueur, and Le Brun, to Raphael's works as reflected in their own; and Italian biographical and critical ideas, particularly as expressed in Vasari's 1568 edition of the *Lives*.[6] The interaction of these sources needs to be examined in more detail. In addition, the theoretical discourse about painting was framed in terms drawn from classical literary theory, particularly as defined in Aristotle and Horace, and elaborated by Italian theorists from Alberti to Lomazzo. As Raphael's works could be fruitfully viewed from this rhetorical perspective, and also could be seen to embody the *beau idéal* so desirable to the French, they could view Raphael and Poussin as paradigms for their approach to classicism.[7]

In comparison to the limited remains of antiquity, particularly of painting, all of Raphael's works certainly seem to have been available to the French in some form. Yet French artists' ability to obtain a comprehensive, in-depth knowledge of Raphael's oeuvre was complicated by a number of factors. Among the large number of works attributed to Raphael in the Royal Collection and in that of the duc d'Orléans, several, including some of the most prominent, are now considered to have been executed by his assistants. For example, the execution of the *Holy Family* (Fig. 1), one of the most emulated works in the collection, is now attributed to Giulio Romano.[8] Other works in the collection reveal even less of the direct imprint of Raphael's artistic imagination. Another problem was presented by the immobility of many of Raphael's most important works. Without a trip to Rome, artists and amateurs could not study the Vatican frescoes, the tapestries of the *Acts of the Apostles*, the *Galatea*, and other key works firsthand. Raphael's cartoons for the Vatican tapestries were even less accessible in England and so were known in France primarily through engravings. Although a sojourn in Rome became an obligatory part of a young artist's training, particularly after the founding of the French Academy in Rome, study of Raphael's works there was, of necessity, limited, often consisting of copying parts of whole compositions in the Stanze. At various times, Raphael's works were not even accessible to pensionnaires.[9]

With access to many of Raphael's works limited by physical factors, copies and engravings after Raphael became one of the most important sources for artists' direct knowledge of his oeuvre.[10] Of course, neither copies nor engravings were exact transcriptions; they already embodied an interpretation of the original, shaped by the artist's preconceptions and values, which tended to emphasize certain aspects and to minimize others. By emphasizing the characteristics of Raphael's *disegno*, engravings after the master contributed to the French notion of Raphael's mastery of this aspect of art. These engravings also fit well with French academic eclecticism by providing a readily available corpus of whole compositions and even collections of exemplary details from Raphael's works. In innumerable instances, we can trace the origin of motifs and even whole compositions by French artists back to an engraving of Raphael's work.[11]

Poussin, the "French Raphael," was certainly the most important French artist before the Academy's foundation who had been influenced by Raphael. Viewing Poussin's art from the perspective of the 1660s, French academicians could see Raphael's art as a corrective

that drew Poussin away from an excessive dependence on the Venetians toward the true path of idealized classical beauty. In such works as his second series of *Seven Sacraments* (1644–48), so obviously inspired by Raphael's cartoons, Poussin transposed Raphael's graceful, elegant compositions into a more grave, austere key.[12] In addition to emulating Raphael's classicizing method based on antiquity, Poussin found congenial what the French viewed as Raphael's rhetorical approach to composition, pose, and gesture.

Despite Poussin's close affinity to Raphael and his many works that bear traces of Raphael's influence, there is no evidence that Poussin ever copied Raphael directly in any finished work. In fact, even among Poussin's drawings, there are very few that directly copy Raphael's works. Even the works that are most clearly filtered through Raphael's example, such as the *Baptism* from both his first and his second group of the *Seven Sacraments,* reveal a strong element of independent invention. In the first of his versions of the *Baptism,* which was the last of the series of the Seven Sacraments done for Cassiano dal Pozzo, Poussin clearly models his conception on the corresponding scene from the Vatican Loggia (Figs. 2 and 3), in terms of the composition as a whole, as well as a number of specific poses and gestures. In drawings for the *Baptism* from the second series of *Seven Sacraments,* which were done for Fréart de Chantelou, brother of Fréart de Chambray, Poussin departs more emphatically from Raphael's model (Fig. 4)[13] Despite the fact that Poussin was not a member of the Academy, his spirit pervaded the body from the time of its founding, and much French academic discourse was framed with Poussin in mind. By claiming Raphael as their own, the Academicians were able to construct their aesthetic on the bedrock of classicism, through Poussin, to Raphael, to the ancients, in the hope of creating their own version of the *beau idéal.*

Although various artists responded to different aspects of Raphael's works, these exemplary aspects influenced all French artists of the generation that founded the Academy, including Le Brun, Le Sueur, Mignard, the Boullogne brothers, and others.[14] Raphael's grand rhetorical style, in which all parts are clearly subordinated to an overriding idea, clearly fit the artistic spirit and the nature of commissions under Louis XIV; whereas, his inherent grace and idealization, on which all critics remarked, and which were seen as a reflection of his personality, appealed to another side of French taste and social values.

In effect, Raphael's art provided a solid foundation and a secure armature for the development of a variety of French classical styles. Perhaps Raphael's style was open to more individualistic interpretations than was that of Michelangelo or Rubens because it seemed to be based on the balance of a number of elements—design, expression, naturalism, idealism—rather than on the dominance of one, whether it be anatomy or color. This balance was interpreted by the French to demonstrate the role of reason in Raphael's art, a dimension on which the French placed the highest value. Without copying Raphael directly, French artists with a variety of different styles could find inspiration and support in his works. Prior to the Academy's foundation, Simon Vouet and Poussin had already shifted French history painting in an Italianate direction. Poussin, for example, in his *Parnassus* (1631–33, Prado, Madrid), which clearly owes a debt to Raphael's version of the same subject (Fig. 5) a painting he had copied, pushes Raphael's concept in a more austere direction. Le Sueur, whose Muses for the Hôtel Lambert (Fig. 6) are clearly inspired by the same work, enhances the grace and lyricism of Raphael's figures. In other contexts, Le Brun, for example, in such works as his *Battles of Alexander,* could be inspired by

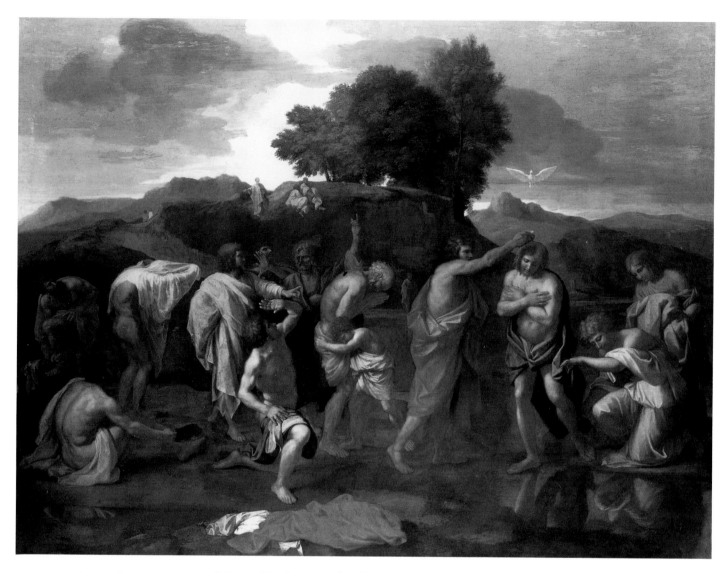

Fig. 2. Poussin, *Baptism of Christ*, 1641–42, National Gallery of Art, Samuel H. Kress Collection, Washington, D.C.

Raphael's rhetorical clarity and expressive power. The extraordinarily varied oeuvre of Raphael, ranging from his powerful religious scenes, to his sensual mythologies, to his graceful Madonnas, provided a fertile field to nourish French artists' imaginations.

Vasari's *Life*

Although French artists had responded to Raphael since the sixteenth century,[15] he only takes on a clear image in French art theory in the latter half of the seventeenth century. As

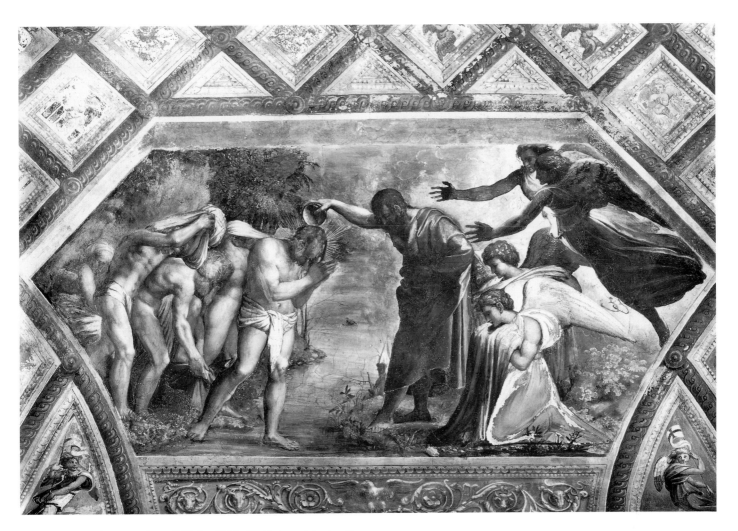

Fig. 3. *Baptism of Christ,* 1516–19, Vatican Loggias, Rome

with their academic method, the French adapted their exalted view of Raphael from the Italians, particularly Vasari. His picture of Raphael's talents and limitations, as described in his 1568 edition of the *Vite,* became canonical.[16]

In many ways, the "mythical Raphael," created by Vasari, had as much impact on the French as the direct products of Raphael's hand. Although Vasari's image of Raphael is clearly constructed as a foil to that of Michelangelo, his overall view of Raphael is laudatory. After all, he did see Raphael as an epitome in the most highly developed period of modern painting, an outstanding end-product of a long evolution. Vasari praised Raphael as an artist so outstandingly gifted that he was like a "mortal god."[17] Yet to develop his talents fully, Raphael required inspiration from a variety of both ancient and contemporary artists. Vasari divided Raphael's career into three periods based on the predominant influence on his style. After diligently studying the battle cartoons of Leonardo and Michel-

Fig. 4. Poussin, studies for *Baptism,* drawings, c. 1645, Louvre, Cabinet des Dessins, Paris

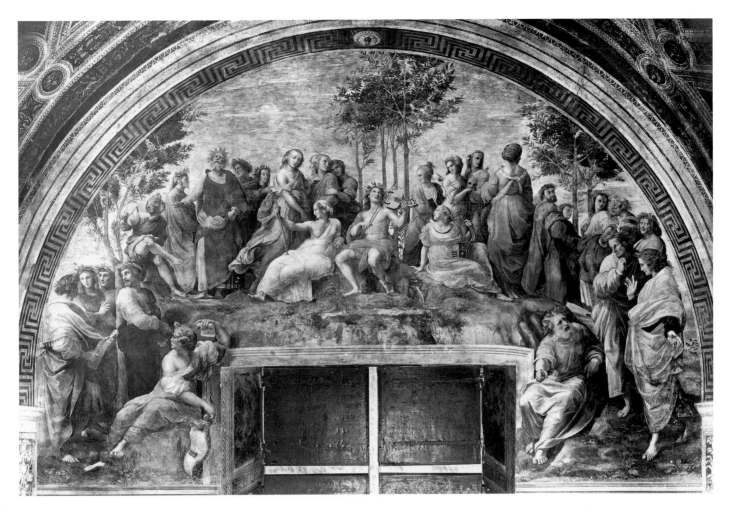

Fig. 5. *Parnassus,* 1510–11, Vatican, Rome

angelo and works by Fra Bartolommeo, Raphael abandoned the limited conception and
dry manner of his first master Perugino. Although he surpassed Leonardo with his sweet-
ness and natural facility, he never achieved the sublimity of Leonardo's basic conceptions
or the grandeur of his art. He also realized that he could never compete with Michelan-
gelo in depicting the nude. Instead of emulating Michelangelo's style, he reflected that
there was more to painting than simply representing the nude human form:

> That one can enumerate among the perfect painters those who express historical
> inventions well and with facility, and who show fine judgement in their fancies; and
> that he who, in the composition of scenes, can make them neither confused with
> too much detail, nor poor with too little, but distributed with beautiful invention
> and order, may also be called an able and judicious craftsman. To this, as Rafaello
> was well aware, may be added the enriching of those scenes with a bizarre variety
> of perspectives, buildings, and landscapes, the method of clothing figures grace-
> fully, the making them fade away sometimes in the shadows, and sometimes come

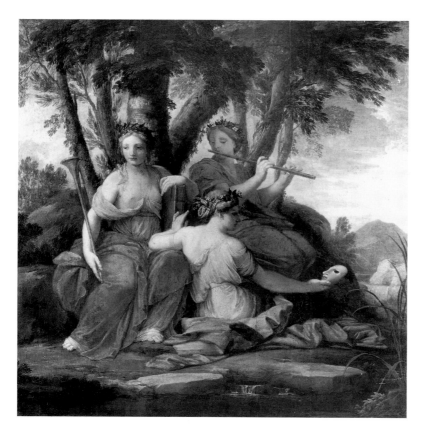

Fig. 6. Le Sueur, *Muses* (Clio, Euterpe, and Thalia), 1652, Louvre, Paris

forward into the light, the imparting of life and beauty to the heads of women, children, young men and old, and giving them movement and boldness, according to necessity. . . . Pondering over these things, I say, Rafaello resolved, since he could not approach Michelangelo in that branch of art to which he had set his hand, to seek to equal, and perchance to surpass him, in these others; and he devoted himself, therefore, not to imitating that master, but to the attainment of a catholic excellence in the other fields of art that have been described.[18]

Vasari clearly intended to show that, since Raphael was not the equal of the genius Michelangelo, he did what he could to compensate. Yet, the passage also defines Raphael's art as a virtual encyclopedia for history painters. During the second period of his career, Raphael painted the *Dispute of the Holy Sacrament,* which Vasari praised for its verisimilitude of color, perspective, and modeling, its decorum and expression. By this time, Raphael had made a name for himself in Rome, developing a smooth and graceful style that everyone admired. He had studied the numerous remains of antiquity available in the city. Yet his figures still lacked the "indefinable grandeur and majesty that he now started to give them."[19]

According to Vasari, Raphael's source for aggrandizing his style was Michelangelo's unfinished Sistine Ceiling, which Bramante revealed to him in Michelangelo's absence. Raphael, according to Vasari, was so astounded by what he saw that he immediately

repainted his Prophet Isaiah in San Agostino. What he saw of Michelangelo's work enabled him to give his style more majesty and grandeur so that the picture was vastly improved.[20]

Raphael's fame continued to grow, but he lost some of his fine reputation by striving to give his works more variety and grandeur in Michelangelo's manner, instead of following his natural inclinations. At every opportunity, Vasari makes clear that Raphael could not compete with the sublime Michelangelo. He also left too much work to assistants. Regretting these mistakes, he resolved to paint the *Transfiguration* without any assistance, "wherein are all those qualities which, as has already been described, are looked for and required in a good picture." In Raphael lore, the *Transfiguration* would be viewed as Raphael's greatest masterpiece.[21]

Taking a page from Castiglione's *Courtier,* Vasari described Raphael as having the grace and even disposition of a perfect gentleman, making him loved as well as admired. He lived more like a prince than a painter; yet Vasari saw clear limitations in his art, in comparison to that of Michelangelo. His works betrayed diligence and accuracy, not grandeur and majesty; grace and decorum, but not sublimity. He excelled at painting his scenes as if they were written stories and embellishing them with interesting natural details. He chose a "middle course, both in drawing and colouring; and mingling with that method certain others selected from the best work of other masters, out of many manners he made one, which was looked upon afterwards as his own, and which was and always will be vastly esteemed by all craftsmen."[22]

With this eclectic image, Vasari made Raphael the ideal model of Academy procedure. He even suggested that Raphael "enriched the art of painting with that complete perfection which was shown in ancient times by the figures of Apelles and Zeuxis."[23] For the seventeenth-century Academicians, the work of Raphael, the modern Apelles, could serve in place of ancient painting's lost masterpieces.

Regardless of whether or not Vasari's picture was true to the historical Raphael, the French found much in this artistic parable as they adopted and codified various aspects of Vasari's image of Raphael for their own purposes: what Raphael lacked in sublimity, he compensated for with a catholic excellence in conveying all that was necessary in a scene, so Vasari and later the French saw Raphael as the "model history painter," the master of invention, expression and propriety who could impart life and beauty to everything he painted. The French judged Raphael's "middle course" more in accord with reason, than the *terribilità* of Michelangelo, and thus, more in accord with their own taste. Vasari stressed that Raphael constantly strove to improve his style by borrowing from many antique and modern sources. By focusing on his eclecticism and study, rather than genius in achieving his ends, Vasari created a picture of Raphael as an exemplary "academic." Vasari stated, in passing, that Raphael approached the perfection of the ancients; the French, much more concerned than Vasari with allegiance to antiquity, would see him as the bridge between Poussin and the ancients. Finally, Raphael's biographer stressed his grace and gentlemanly ways, establishing him as the "perfect Courtier," an irresistible view of the artistic profession for French painters who were seeking to raise their social status. These images of Raphael recur in various combinations in all subsequent writings on the artist. Although Vasari clearly intended his picture to stress Raphael's inferiority to Michelangelo, the French manipulated his ideas to establish Raphael, who more closely fit their predilections, as the supreme modern painter. Since these symbolic images of Raphael

derived from Vasari could be used to justify academic ideals and procedures and the prestige which the Academy hoped to claim for its profession, these images became commonplaces of academic discourse. Views of Raphael were never simply a matter of aesthetics.

French Artists and Amateurs

In the 1660s and 1670s, amateurs' treatises and Academicians' *conférences* established Raphael's central position in French classical theory through the symbolic images discussed above. These works provided both a body of theory on which to base academic practice, and a justification for the social and intellectual pretensions of the Academy. The perspectives and degrees of knowledge these artists and amateurs had about Raphael ranged widely. Fréart de Chambray, an amateur who, although a friend of Poussin's, knew little of the techniques of painting, approached Raphael's art in a very abstract and theoretical fashion, seeing the Italian master's work through the perspective of the extensive Poussin collection his brother owned.[24] Abraham Bosse, an engraver and professor of perspective, was particularly concerned with precision and correctness in art. André Félibien, amateur, friend of Poussin, and secretary of the Academy, focused on the development of Raphael's art and its relationship to the art of antiquity. Dufresnoy, an artist and the composer of the very influential *De Arte Graphica,* had copied Raphael while in Rome.[25] Le Brun, who devoted the first academic *conférence* to Raphael's *Saint Michael,* had copied many of Raphael's works while in Rome in the 1640s, and Raphael had continued to inspire him throughout his career.[26] Mignard and Philippe de Champagne, who also delivered *conférences* on Raphael's work, had also copied the Italian master in Rome.[27] Each artist and amateur contributed a portion of what became the canonical view of Raphael in France. Each of these artists and amateurs found exemplified in Raphael's work what he considered most essential to great art and, in turn, contributed to what became the standard view of Raphael in France.

Although the individuals who defined the French view of Raphael varied in taste and degree of eclecticism, all were classicist in orientation, viewing antiquity as the model for ideal beauty, and Raphael and Poussin as the moderns who most successfully emulated that model. Fréart and Félibien had also been friends with Poussin, so the promotion of the artist viewed as the father of French classicism was one of their strongest motivations. Fréart and Bosse, following the rationalist spirit of the age, both embraced the notion that art was governed by certain indispensable principles exemplified in Raphael's works, although Bosse disputed some of Fréart's specific observations.[28] Fréart was also much more dogmatic in subordinating what they viewed as the sensual delights of color to the intellectualized pleasures of invention and design.

Roland Fréart de Chambray, Poussin's friend and cousin of Sublet de Noyers, *surintendant des bâtiments,* was an early, enthusiastic advocate of classicism who epitomized the literary approach to the visual arts. His 1651 translation of Leonardo's *Treatise on Painting* provided an important theoretical text for Academicians. In his *Idée de la perfection de la peinture,*[29] Fréart utilized the aspects of art that Franciscus Junius culled from

descriptions of painting in ancient literature to analyze a series of engravings after Raphael.[30] Fréart seems to have two principal aims: to define the immutable rules governing classical art and to demonstrate that Raphael's art is superior to Michelangelo's because it embodies those principles. His treatise reveals little knowledge of or sensitivity to the visual qualities of Raphael's art, implying the the engravings have all the essential qualities of the originals.

Fréart stresses the identity between the art of Raphael and antiquity and establishes Raphael as the classical paradigm. In writing the treatise, he hoped to

> give a general idea of perfection in painting, following the maxims of the ancient masters, and to provide a visual demonstration of these through the example of some of the characteristic works of Raphael, in order to open the eyes of many painters of our time, who already have the disposition to become excellent in their profession,who need no more than this to be reminded of what is fundamental for perfection in art. (*Idée,* 116–17)

Just as Winckelman would later claim that the only way to attain greatness was to emulate the ancients, Fréart implies that for contemporary artists to excel, they must emulate Raphael. Although he viciously attacked Vasari for "the ineptitude and baseness of the reasonings of this grand sayer of nothing" and hoped to rescue Raphael from this "dangerous friend" (100, 105),[31] Fréart viewed the essence of Raphael's art as had Vasari: as painted stories embellished with pleasing details from nature. Viewing painting in terms drawn from classical rhetoric, he felt Raphael's works particularly exemplified *decorum,* which he viewed as the cardinal principle governing design and expression. In his extremely limited view, proportion, color, and perspective were deemed merely mechanical aspects of the art. In fact, he criticized those who pursued brilliance and richness in colorism, ease of brushwork, and other "fanciful beauties that one never sees in the works of the great ancient painters" (62–63). Since these were aspects that many found deficient in Raphael's art, Fréart's treatise tended to minimize their importance.

For Fréart, perspective was one of the most fundamental aspects of art because it was based on mathematical principles, and was thus in conformity with reason. In his discussion of perspective in the engravings, Fréart demonstrates how preconceptions about Raphael could determine how his works were viewed. Fréart reasons that since proper perspective is essential to great art, and Raphael is a great artist, his work must exemplify proper perspective. Discussing an engraving after Raphael of the *Judgment of Paris* (Fig. 7), he incorrectly concludes that it has a single vanishing point, a mistake pointed out by Bosse in his own treatise.[32] This type of discrepancy between absolute rules supposedly derived from past masterpieces, and the works that did not always embody those rules, is often found in Raphael criticism. The presumption of his perfection often predetermined the critical responses to his works.

Although Fréart's treatise was important in the history of French Raphael criticism, it had severe limitations. The tone of many of his comments suggested an emotional diatribe against all nonclassical art, rather than a reasoned advocacy based on clearly defined principles. His bias came out most strongly in his violent condemnation, following Dolce, of Michelangelo's painting, particularly the *Last Judgment.*[33] For Fréart, Raphael was the

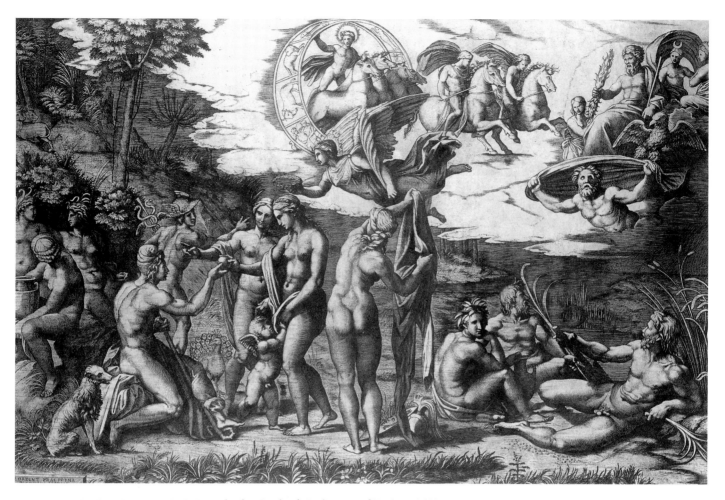

Fig. 7. Marcantonio Raimondi after Raphael, *Judgment of Paris,* c. 1512, engraving

"good angel," and Michelangelo was the "bad angel of painting" (65–66), the antithesis of all Raphael's fine qualities (preface). Raphael's work exemplified grace, beauty and decorum; Michelangelo's revealed a rustic coarseness and exaggerated anatomy and flaunted proper standards of decency.

To Fréart, among artists after Raphael, only Domenichino, who was the greatest of the Carraccis' pupils, and Poussin, "a great eagle in his profession" (122) merited praise. Although he never compared Poussin directly to Raphael, Fréart called Poussin "the most accomplished and most perfect painter among the moderns" and thus introduced the notion that Poussin had been the "French Raphael" (122). After all, Fréart's brother had commissioned Poussin to paint the *Ecstasy of Saint Paul* as a pendant to the *Vision of Ezekiel* (see Fig. 21), a work in his collection that he believed to be by Raphael.[34] Not surprisingly, he posited some of Poussin's most clearly Raphaelesque works, the *Seven Sacraments,* as a paradigm of Poussin's style. Like Raphael, Poussin was praised for his novel inventions, noble ideas, judicious observation of costume, and the force of his

expression. These were the same qualities that distinguished the greatest artists of antiquity, "among whom," Fréart believed, "he would have held the first rank" (123).

Although Abraham Bosse strongly disputed Fréart's notion that perspective was a simple matter, he agreed with Fréart's belief that art be governed by rules, and he felt that Raphael exemplified what was most essential in art. *Le Peintre converti aux précises et universelles règles* (The painter converted to precise and universal rules), published in 1667, by Abraham Bosse, engraver, honorary Academician, and professor of perspective, focused on the geometrical and mathematical parts of painting. Defining what he regarded as ironclad rules of geometry and perspective, Bosse also revealed attitudes of interest concerning Raphael. Although his views of the essentials of painting differed sharply from Fréart's, they both praised Poussin as "the Raphael of our time."[35] Bosse found that the rules that Poussin had observed so well, conformed to those he had elaborated. He also agreed that ancient art was the best model, but would admit a larger group of artists to the modern Pantheon: Great painters included Leonardo, Mantegna, Michelangelo, "the excellent Raphael," his pupil Giulio Romano, Giorgione, Titian, Correggio, the Carracci, Domenichino, and others.

Despite their virtues, however, the moderns had not attained the perfections of the Greeks. Unlike Fréart, Bosse appreciated a greater diversity of artistic approaches (*Peintre*, 18–19). Although he appreciated virtues ignored by Fréart, he concluded that the painter with all the gifts is Poussin, praising him for his correctness, good taste, and powerful expression (19).

Ancient sculpture was admirable for its diversity of beautiful proportions, types, and attitudes. Most moderns failed to preserve this beautiful diversity by depending too completely on models from their own countries. In many works by Rubens, everything appeared "to have been made and shaped in Flanders" (Bosse, *Peintre*, 30). At this stage in the evolution of French art theory, Rubens's taste was seen as parochial rather than universal, in contrast to that of Raphael and Poussin. Except for Raphael, Giulio Romano and a few others, many artists had made similar mistakes. Bosse also stressed the importance of *costume* and saw Raphael as the perfect example. Although Bosse appreciated the colorists' virtues, he implied that those associated with Raphael and Poussin had a deeper, longer-lasting effect. He admitted that the works of the Venetians and other excellent colorists made an immediate impression on the viewer. This was not so much the case with Raphael's works, yet

> they insinuate themselves gently into the spirit, such that the more one sees them, the more one is satisfied to constantly discover new beauties. For these others, it is totally the opposite, for setting aside color and the manner of painting, one finds different mistakes and errors relating as much to history as to custom or the rules of perspective.[36]

Less extreme and limited than Fréart, Bosse also implied a hierarchy among the parts of painting. Raphael's and Poussin's virtues, associated with invention, proportion, perspective, expression, and decorum were more basic and essential than the sensual beauties of the colorists. Seductive color and paint handling could not excuse errors in decorum and

design, a stand not surprising for an engraver. The painterly virtues could strike the eye, but the works of Raphael and Poussin provided lasting stimulation for the spirit. This conclusion would be reversed by Roger de Piles. The lack of immediate sensual appeal of Raphael's work, a virtue in Bosse's eyes, would be seen by de Piles as Raphael's major fault.

André Félibien, was another crucial figure in the formation of French art doctrine. In his *Entretiens sur les vies et sur les ouvrages des plus excellens peintres anciens et modernes* (Discussions of the lives and works of the most excellent ancient and modern painters) published in parts between 1666 and 1688, Félibien detailed the progress of painting from ancient to modern times.[37] The material included biography, discussion of aesthetic principles, and references to specific works. His attitude toward Raphael seemed unequivocal: "This celebrated man, who surpassed all who preceded him, had no equal among those who followed" (*Entretiens,* vol. 1, part 2, 291). His treatise helped to establish several of the central symbolic images of Raphael. Far less dogmatic about the rules of art than Fréart or Bosse, Félibien agreed with Dufresnoy that the "rules" were what could be derived from the works of accepted exemplary past masters. Rules can help define greatness; they cannot confine it.[38] Not only did Félibien differ philosophically from Fréart and Bosse, he also differed in his level of direct experience of Raphael's works. Unlike Fréart, for example, Félibien had been in Rome from 1647 to 1649, and had seen Raphael's major works there.[39]

Like Dufresnoy he admitted that other artists, such as Michelangelo, excelled in particular parts of painting but

> Raphael elevated himself so much above everyone else by the force of his genius, that even though color is not treated with as exquisite a beauty in his works as in those of Titian, and even if he did not have as charming a technique as Correggio, overall, there are so many other exemplary aspects of his works, that regardless of what others have done better, one must admit that no one is comparable to him. For if some have excelled in one aspect of painting, they were mediocre in others, and one could say that Raphael was admirable in all areas.[40]

Although Félibien highly regarded the virtues associated with color and paint handling, these were not sufficient for a supreme painter. Yet, by acknowledging Raphael's weaknesses, Félibien also opened the door for the attack on the system of values that established Raphael's position at the pinnacle of the academic hierarchy. According to Félibien, Raphael knew how to make the perfect choices from nature. In all key aspects of history painting, he provided the model (*Entretiens,* 294).

Primarily this picture of Raphael's catholic excellence in all parts of painting was an elaboration of Vasari's views, but Félibien drew different conclusions, seeing Raphael, not Michelangelo, as the leading modern artist. Answering Vasari, Félibien agreed that Raphael might not have drawn the nude so sagely as Michelangelo, but his style of drawing was better and more pure. Michelangelo, despite the grandeur and severity of his design, was surpassed by Raphael, who expressed all things with "sweetness and marvelous grace" (*Entretiens,* 293). Félibien even disputed that Michelangelo had been more knowledgeable than Raphael in anatomy. Discussing the old man in the *Fire in the Borgo,* which we see here in a drawing by Bourchardon after Raphael's fresco (Fig. 8), Félibien asserted that the anatomy was so correct and forceful, that this single figure was evidence of Raphael's

Fig. 8. Bouchardon, drawing after Raphael of detail from the *Fire in the Borgo,* c. 1725, Louvre, Cabinet des Dessins, Paris

mastery of this aspect of painting. Vasari and others would not admit that Raphael drew with as much force as Michelangelo, but Félibien felt that Raphael's subtlety was more admirable (*Entretiens,* 314).

Félibien even turned Raphael's dependence on the Sistine Ceiling from a weakness into a strength. Michelangelo worked for many years; Raphael, however, was able to assimilate and even to surpass Michelangelo's perfections after only briefly seeing his work (*Entretiens,* 302). Félibien's technique is to transform all the weaknesses Vasari found in Raphael into new proofs of his supremacy.

Raphael also learned from the best remains of antiquity

> to rise above all visible things, to contemplate the most perfect ideas on which he based his works. Also one sees traits similar to those of the ancient Greeks, since they all drew on the same sources, and used as examples these rare masterpieces of art, in which nature is represented with a beauty and perfection such as has only been seen by these great men. (*Entretiens,* 332)

Although Vasari mentioned Raphael's study of and debt to the ancients, Félibien, in supporting the classical bias of his period, introduced a new emphasis. He, like Bellori,

stressed that the perfection of Raphael and the ancients was based on correcting nature's imperfections and raising its imitation to a state of ideal beauty. The works of Raphael and the ancients became the artist's guide to "la belle nature."

Félibien, echoing Vasari, stressed that Raphael had learned from a variety of sources: Fra Bartolommeo, Leonardo, Michelangelo, and the ancients. He thus strengthened the view of Raphael as a successful follower of the academic procedure, a sublime eclectic who achieved individuality He also singled out the *Transfiguration* for particular praise for its invention and expression, suggesting that "there are such extraordinary figures in this work, that knowledgeable people feel that this is Raphael's greatest work" (*Entretiens,* 328).

Félibien, deriving many of his ideas on Raphael from Vasari, did not contribute to a more profound understanding of Raphael's work, but he stressed three images of the artist that would recur in much subsequent criticism: Raphael as the perfect history painter; Raphael as the reborn ancient, the modern Apelles, who represented ideal nature; and Raphael as the model Academic, who incorporated ideas from everyone into his personal, superior style. Although Félibien revealed his appreciation of colorism in his fifth *Entretien,* published in 1679, in his view Titian could never challenge Raphael for first rank among painters. Of all modern painters, only Poussin was such a challenger. In fact, Félibien's discussion of Poussin formed the culmination of his *Entretiens* (Pace, 63ff.).

Among this early group of theorists, the most eclectic was the painter and poet Charles-Alphonse Dufresnoy, who spent more than twenty years in Italy studying the best masters. With another former pupil of Vouet, Mignard, he had been commissioned to copy the works in the Farnese Palace. They had also intensely studied the works of Raphael and the remains of antiquity. After almost twenty years in Rome, Dufresnoy went to Venice in 1653 and traveled through Lombardy before returning to Paris in 1656.

De Arte Graphica (published in three editions between 1668 and 1700), Dufresnoy's collection of poetic aphorisms on painting modeled on Horace's *Ars Poetica,* helped to shape academic doctrine.[41] By collecting accepted principles of invention, design, color, and the other parts of painting derived from the best Italian masters, Dufresnoy provided an ideal framework for the systematic approach to painting desired by the artists of the Academy. As a painter, unlike Fréart, Félibien, or Bosse, he considered practical aspects of composition and execution, rather than abstract notions of beauty or propriety. Dufresnoy also felt that color was as essential to painting as design. By stating his ideas in poetic terms, he allowed for some notion of the *je ne sais quoi* of art.

Treating each part of painting separately, he created a flexible group of principles that could be arranged and selected to support a variety of aesthetic ideas and preferences. This flexibility is already evident in Roger de Piles's 1668 translation of the poem from Latin to French with his appended notes, which constitute an interpretation rather than a simple translation and explanation of Dufresnoy's ideas.[42]

Although only two of the poem's more than five hundred lines were devoted specifically to Raphael, many of Dufresnoy's general principles, particularly concerning invention, design, and expression, could have been derived from his works. Figures should be drawn with graceful, correct outlines to convey their ideas and emotions with lively and appropriate expressions. A work should be composed of a few major parts admirably constrasted in form and color, but the overall effect should be a harmonious unity

(Dufresnoy, 59). Although Raphael was not mentioned in the sections on invention, expression, composition, and design, subsequent writers who accepted Dufresnoy's principles saw them embodied in the *Saint Michael,* the Vatican frescoes, the cartoons of the *Acts of the Apostles,* and other works by Raphael.

Dufresnoy suggested the basis for a broadened eclecticism by suggesting models for color and overall harmony, as well as for invention and design. In addition to mastering the principles of ancient Greek sculpture, the artist should learn from a variety of sources. Like Lomazzo, Dufresnoy attributed primacy in the different aspects of painting to a number of different artists. Raphael excelled in invention, "the highest part of painting," and his works revealed a unique grace (lines 520–21). Michelangelo was exemplary in design, Correggio for chiaroscuro and the delicacy of colors, and Titian for unity and harmony of color and disposition (lines 522–23, 529–36). Dufresnoy would, perhaps, have agreed with Lomazzo that the perfect painting would have Adam drawn by Michelangelo on the proportions of Raphael and colored by Titian, with an Eve drawn by Raphael and colored by Correggio. Annibale Carracci was the perfect academic model because he took perfections from all of his great predecessors to form his own unique style.[43]

Dufresnoy, although essentially a classicist, had a catholic appreciation for many aspects and schools of painting: Roman, Venetian, and Bolognese. He also argued that studying nature was as important as studying past masterpieces. His eclectic classicism, which was developed and transformed by Roger de Piles, was an early example of what would become the dominant taste in France. In this view of painting, Raphael was only one of many models worthy of emulation.

Roger de Piles's translation of and commentary on *De Arte Graphica,* published in French in 1668, helped to establish him as a leading theorist and popularizer of artistic ideas. His commentary, four times as long as the poem, modified and amended Dufresnoy's ideas. De Piles attempted to change aphorisms into rules, to raise the prestige of painting and to widen its audience to include amateurs like himself, as well as professional artists, and to stress, more than Dufresnoy, the coloristic aspects of painting. (Lipking, *Ordering,* 38–65).

De Piles's *Remarques* on the poem were followed in the 1668 edition by Dufresnoy's *Sentimens* on the best painters of the last two ages, purportedly a transcription by de Piles of a manuscript of Dufresnoy's hand,[44] although, at the very least, de Piles had added sections on Rubens and Van Dyck. Dufresnoy agreed with Fréart in believing Raphael superior to Michelangelo. Michelangelo's attitudes were not always beautiful or pleasing. His taste in design was not the finest, nor were his outlines the most elegant. His drapery folds were neither graceful, nor noble. His compositions were sometimes fantastic and extravagant, and he took liberties with perspective. His coloring was not very truthful or pleasant, and he did not know the artifices of chiaroscuro, although his knowledge of anatomy and thus, his accuracy of design was greater than that of any other painter, giving his figures an air of grandeur and severity.[45]

De Piles added to Dufresnoy's *Sentimens* an appreciation of "the lively, free, noble and universal genius" of Rubens, whose manner was "so solid, so ready, and so knowing that it may seem that his rare accomplished genius was sent from Heaven to instruct mankind in the art of painting."[46] Although his love of Rubens was already evident in this early work, there is nothing here to suggest that de Piles's appreciation of Rubens necessarily implied

a denigration of Raphael's gifts or the antique model. His eclecticism allowed an appreciation of both artists. Although his preference for the sensual qualities of Rubens was already clear, at this point, he did not find appreciation of both Raphael and Rubens irreconcilable. However, as early as 1668, de Piles had already driven a wedge into the solid assumption of Raphael's supremacy and prepared the way for an attack on Poussin.

Fréart de Chambray, Bosse, Félibien, Dufresnoy, and de Piles, despite their different orientations to painting, established Raphael as the prime example of proper design, invention, and expression. Félibien also emphasized his eclecticism, making Raphael a model of academic procedure. Their creation of doctrine was anything but an objective search for first principles of painting. Instead, they derived their ideas from artists they admired, then used those artists' works to support their principles of painting. Artists were judged in relation to each other on the basis of an assumed hierarchy of values given to different kinds of painting, not by a careful critique of individual works. Despite their limitations, their writings established Raphael as a solid foundation of the French classical tradition.

Not surprisingly, most of their judgments were generalities. In Raphael's case, these amateurs took aspects of Vasari's picture as examples of general laws. After all, when they published their treatises, their firsthand exposure to Raphael's art was limited to works in the king's collection. They could only recall his greatest works, such as the Vatican frescoes, from memory or engravings. Their preconceptions, rather than critical judgments of specific works, primarily determined Raphael's place in their pantheon of modern artists, particularly since their aims were primarily theoretical rather than critical. Yet the symbolic images of Raphael they defined, formed the lenses through which his works would be viewed from that time on. They hoped that by following his tastes and methods, French artists could reach his level of perfection in painting. These early theorists differed in the significance they gave to Raphael's admitted weakness in colorism. Fréart and Bosse ignored it; Félibien subordinated it to his perfection of design. All three viewed him as the model history painter. Dufresnoy and de Piles differed sharply from the others in that they believed that his weak colorism rendered Raphael's paintings inadequate as self-sufficient models for artists. Félibien's position was developed in the Academy lectures on Raphael's paintings in the king's collection. These important lectures purported to transform abstract theorizing into principles of instruction based on past artists' great masterpieces, yet abstract theory never entirely proscribed practice. The degree to which Le Brun and the Academy imposed absolute uniformity of style has been greatly exaggerated.

The Academy in Paris and Rome: Theory and Practice

The Academy *Conférences*

The Academy *conférences,* established at the insistence of Colbert and held regularly beginning in 1667, played a seminal role in the formation of French art theory and criticism.[1] Although these lectures have often been seen as proof of the pedantry and despotism of Le Brun's Academy, they played a positive role in forming a consensus around French classical values. These lectures also had a social dimension in serving the higher intellectual pretensions of the Academicians, and a political dimension in serving the desires of the Crown. As the first systematic attempt in France to use past masterpieces to teach the principles of painting, they consisted of a discourse on one of the works in the king's collection followed by open discussions. Their ostensible purpose was to derive and to illustrate the correct principles governing each aspect of painting and to crystallize these rules into *préceptes positifs* by which students could be guided.[2] In many cases, they seemed to change Dufresnoy's aphorisms into absolute rules. Although these *conférences* were more than an intellectual exercise, they did not narrowly constrain artistic practice, as is apparent from the diversity of styles among Academicians. Artists clearly did not always follow the rules they defined. Yet,

in discussing past masterpieces, they revealed attitudes of interest about Raphael and the underlying values that supported their judgments of his works. The *conférences* extolled the virtues of works in the king's collection and gave the Academy an aura of intellectual sophistication. There is ample evidence, however, that the Academicians were far more interested in making art than in discussing it, as is apparent from the desultory interest in these lectures often shown by the Academicians.[3]

In 1637, Franciscus Junius had illustrated the difficulty of basing rules solely on literary descriptions of lost paintings by the ancients.[4] Students, artists, and amateurs needed to *see* the principles of painting properly applied in finished works. Moreover, these academic exercises seemed an appropriate way of stressing that the Academy was not a mere confederation of craftsmen but, like its sister body the Académie française, was a group of intellectuals engaged in the higher pursuits of one of the liberal arts. By 1667, Raphael and Poussin were already established as modern embodiments of classical principles. Not surprisingly, their works, along with Titian's for illustrating colorism, were the basis for most of the early *conférences.*[5] Raphael's *Saint Michael,* considered a paradigm of composition, design, and expression, was the subject of the first regularly scheduled *conférence,* held on 7 May 1667 (lecture published in Jouin, 1–11). On one level, these lectures attempted to rationalize and systematize what had formerly been simply a matter of studio practice. As a work clearly acknowledged as one of the masterpieces of the king's collection, it was also an appropriate choice politically. The clear implication of the *conférences* was that they showed the path for French artists in the service of the king to achieve masterpieces like those under discussion.

By 1667, Raphael's excellence had already been identified with the parts of painting based on design: drawing, composition, invention, and expression by Fréart, Bosse, Dufresnoy, Félibien, and others. In part, they inherited this characterization of Raphael from Italian theorists, including Vasari, Dolce, Lomazzo, and others.[6] Dolce praised Raphael for invention, propriety, draftsmanship, diversity, and grace, and likened him to the ancients. He even praised his color as surpassing all who had preceded him. Lomazzo praised Raphael for similar qualities and made Raphael one of the seven governors of his temple of painting, identifying him with the qualities of gentleness, beauty, and grace. He also praised him for his truth, invention, and decorum. In his treatise on painting published in 1587, G. B. Armenini attempted to delineate a system of rules to guide the practice of painting, and used Raphael often as a prime example.[7] As is evident from the choice of works discussed in the Academy lectures, Raphael and Poussin were logical examples for the balance of Academicians, who conceived design as the fundamental basis of painting, the aspect associated with art's intellectual and spiritual dimensions.

As with so much pretended criticism in this period, the Academicians' procedure was entirely circular. They began with the assumption that they were discussing a masterpiece by a great artist. They then attempted to define that greatness by showing that the work followed the proper principles of painting that had been derived from such works in the first place. Most of the comments were general praise with almost no critical examination. The usual conclusion, confirming prevailing values, was that everything in the work was as it should be.

Recently, Norman Bryson has focused on what he sees as the overwhelmingly discursive nature of both painting and the theory developed around it in Le Brun's Academy. Bryson

and Puttfarken have argued that these *conférences* were little more than discussions of subject matter and the propriety with which it was rendered. Although they are correct in noting that the terms of the discourse are generally derived from classical rhetoric, and that the discursive dimensions of these works were important, they seem to deny any aesthetic dimension to the *conférences* and to create a false dichotomy between what Bryson terms the "discursive and figural aspects" of the works under discussion.[8] The *conférences* devoted to Raphael do not support this division. In addition, Bryson and Puttfarken ignore the role of these discussions in holding up visual paradigms of different aspects of painting for artists and students to follow. These choices were based on a clear set of values. As has often been noted, what makes French art theory particularly interesting is that it was shaped by artists and amateurs in close contact with the studio. It is never purely a matter of abstract theorizing.

Discussing Raphael's *Saint Michael* (Fig. 9), Le Brun praised the composition and expression for correctness, propriety, beauty, and force. Le Brun suggested that through the beauty of his design, Raphael, the modern Apelles, showed himself the proper heir of the ancients (quoted in Jouin, *Conférences,* 3). Raphael admirably contrasted the forms of the angel and the demon. He represented the angel with youthful beauty (which Félibien, the recorder of the proceedings, notes is appropriate in this context), while also conveying a sense of divine power like that of the *Apollo Belvedere.* The gist of the remarks by Le Brun, who adopts Vasari's characterization of the perfect history painter, was that Raphael had neglected nothing to convey his subject in a correct, appropriate, and beautiful manner.

One of the most interesting aspects of the discussion concerns what at first seems a relatively insignificant detail, yet it reveals the degree to which biases and preconceptions could channel the critical response to Raphael's work. One member suggested that Raphael had been anatomically incorrect in drawing the angel's right arm. He was obviously noting the lack of foreshortening in the right arm, which contributes to the "mannerist" aspect of the work. After a close examination of the work, the company disagreed with him. One remarked that some painters exaggerate aspects of their works, such as their contours, their expressions, or their color, but in the best work subtlety in relating one part of the work to another is evident, and Raphael's works exemplify this quality. The recorder of the lecture concludes that the initial criticism of Raphael gave way to an even greater admiration (quoted in Jouin, 6).

This interchange clearly reveals why Raphael appealed to the seventeenth-century Academicians more than Michelangelo did: Raphael's art found the mean between lack of expression and exaggeration, the balance that should represent the artistic ideal. As Martin Weyl has suggested, this desire to achieve a *juste milieu* had a social, as well as an aesthetic dimension, through its association with the ideal of *honnêteté* (158ff.). The passage also explicitly denigrates what de Piles will argue is crucial to every great work of art: an immediate impact on the viewer. Thus, criticism of Raphael is transformed into proof of his perfection. It is interesting to note that although Le Brun negated this criticism of Raphael's anatomical correctness in his theoretical pronouncements, in several drawings inspired by the *Saint Michael* (Fig. 10), Le Brun "corrected" the right arm. Le Brun reversed Vasari's idea that Raphael was inferior to Michelangelo in the sublimity of his art by suggesting that Raphael's *juste milieu* represented a superior artistic style. Echoing Félibien, Le Brun asserted that many painters had concentrated on one aspect of painting

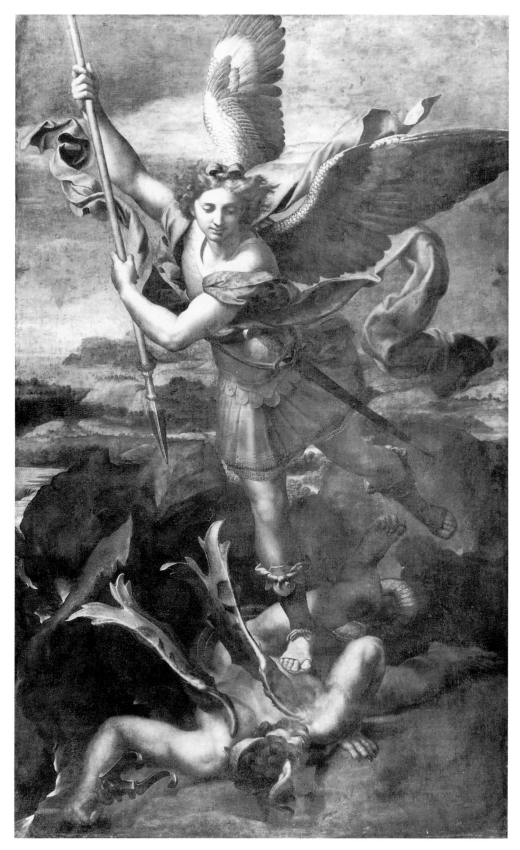

Fig. 9. *Saint Michael,* c. 1518, Louvre, Paris

Fig. 10. Le Brun, Académie, drawing after *Saint Michael,* c. 1672, Louvre, Cabinet des Dessins, Paris

to the exclusion of others, but Raphael was too knowledgeable to make these mistakes (quoted in Jouin, 8). This passage implicitly condemns such artists as Titian for, from the French view, he neglected correct design in favor of an emphasis on color, and Michelangelo, who focused on anatomy, but neglected other aspects of painting.

Le Brun's discussion of color and chiaroscuro was so brief that it seemed an afterthought, amounting to little more than a statement that Raphael's use of color in the work was appropriate. However, color was certainly not deemed inessential or insignificant by the members of the Academy. They devoted entire lectures to this part of painting, particularly with reference to Titian. In Raphael's paintings, color and chiaroscuro, which were considered merely material aspects of painting, were considered subordinate to design, invention, and expression. The sensual aspects were considered neither the most exemplary, nor the most important aspects of his art, as it was generally acknowledged that other painters had surpassed him in colorism. Color was only considered necessary for the simple imitation of nature, not an essential aspect of expression.

The second lecture on a Raphael painting was on the *Holy Family,* by Nicolas Mignard on 3 September 1667.[9] Mignard had also copied Raphael's works including the *Saint Michael* and had been influenced by him. In fact, Mignard had paid a direct tribute to Raphael in his work *Saint Luke Painting the Virgin.* The Virgin is in an attitude taken from a Raphael madonna.[10] Like Le Brun, Mignard underlined artistic values in Raphael's work that were evident in his own. One might expect Mignard, a much richer colorist than Le Brun, to criticize Raphael's colorism. Although he emphasized the importance of color and chiaroscuro, he still subordinated them to maintaining a strong sense of relief (see Jouin, 28–31).

In effect, Mignard finds a way of defending Raphael from what is clearly evident in the work and that might be seen in a negative light: the hard, schematic quality of the modeling. Once again, the assumed perfection of the artist determines how the work is viewed. If the physical evidence conflicts with the preconception, it must be reinterpreted, negated, or ignored. Discussing Raphael's drawing in this work, Mignard made his value system quite clear. Echoing a response to Le Brun's lecture, he found Raphael's art a *juste milieu.* From him one could learn to draw correctly, without exaggerating modeling so that the figures seem dry and disagreeable. Although some have accused Raphael of these faults,

> It would be more correct to say that he found the mean between excessive softness and excessive muscularity, the first manner of which is practiced in Lombardy, and the second in Florence. In leaving behind the dry manner he had learned from Perugino, he took care not to go to the other extreme, in abandoning correctness to focus solely on color, and an excessively delicate approach to painting, which often serves only to cover up errors in design. (Quoted in Jouin, 34)

This passage is a tacit condemnation agreeing with Bosse, of those who exaggerate design, such as Michelangelo, and those who neglect it to pursue a beautiful effect, such as the Venetians and Correggio. Raphael maintained correctness while making the *beau choix* from nature.

Mignard's defense of Raphael against charges of dryness suggests that his failings in colorism were already a matter of discussion. This conclusion is bolstered by one of the criticisms raised in the ensuing discussion. One Academician objected that Raphael had not painted color reflections as Titian had, and that Raphael should not be excused for this failing in naturalistic representation (quoted in Jouin, 32). Contradicting this view, Mignard argued, in effect, that following nature too slavishly, which meant departing too far from the classical ideal, could destroy the force of the work. One had to be selective. Mignard also argued that Raphael and Titian had different aims and so were not directly comparable: Titian's sole aim was to make his works beautiful through color, not to represent objects as they are. Raphael, on the other hand, only wished to represent nature in its most perfect aspects, in order to give figures grandeur and majesty (quoted in Jouin, 32–33). Raphael thus made the correct choices to paint *la belle nature.*

Mignard, who had a richer appreciation of color than Le Brun, revealed in his painting as well as his criticism, even made specific the relative positions of Raphael and Titian in the artistic hierarchy. Titian's great art had been to use color and chiaroscuro to satisfy the eye, but Raphael had ideas that were "more noble, elevated and more in conformity with

reason." He suggested that there is so much to admire in the work, that it should be the object of study by all painters (quoted in Jouin, 35–36).

Many of the virtues found in Raphael's paintings were also found in Poussin's. In a lecture of 5 November 1667, on Poussin's *Israelites Collecting Manna,*[11] Le Brun clarified the widely acknowledged connection between Raphael and the "French Raphael" from his perspective in stressing that the two artists' works had guided his own development (quoted in Jouin, 48–49). Le Brun argued, however, that Raphael's work had altered with time, whereas Poussin's work had not. Certainly, a strong element of French chauvinism shaped Le Brun's appraisal of Poussin as the most universally talented artist of all, who combined all the talents of the Italians in a single painter: the drawing of Raphael, the color of Titian, and Veronese's facility with the brush.

All of the above factors contributed to the greater number of *conférences* devoted to Poussin than to Raphael. Believing that Poussin's works embodied all of Raphael's perfections, and finding his works available and accessible in greater number than Raphael's, they turned to Poussin for examples. Although the *Saint Michael* and the *Holy Family* were considered the greatest masterpieces, Raphael's major commissions, such as the Vatican frescoes or the cartoons for the *Acts of the Apostles,* were only accessible abroad or through engravings.

Although Poussin's virtues were closely identified with Raphael's, they were not considered identical. Poussin was open to a criticism that did not apply to Raphael. In a discourse on Poussin's *Rebecca,* Philippe de Champagne introduced a theme that would be amplified by de Piles. He criticized Poussin for copying certain figures too slavishly from antique sources, leading to a kind of sterility (quoted in Jouin, 91). Le Brun countered that Poussin had not copied but had reached the same conclusion independently. According to Le Brun, since both Poussin and the artists of antiquity followed "nature" and "truth" as their guides, inevitably, they would produce similar figures (quoted in Jouin, 91). This argument, that antique models, and their modern parallels in the works of Raphael and Poussin showed the way to make the correct choices from nature to achieve a "true" representation was one of the most powerful in the classicists' arsenal.

The third *conférence* on a Raphael painting was on the small *Holy Family* (Fig. 11), much of the execution of which is now attributed to Giulio Romano and other members of Raphael's atelier.[12] The *conférence* was delivered on 2 March 1669 by Philippe de Champagne. He began by praising the quality of light in the work, which preserved relief, but also created an overall harmonious tone that agreeably united the figures. Foreshadowing the aesthetic shift in the Academy, Champagne believed a painting should reveal an agreeable harmony that could please the eye as music pleases the ear (in Fontaine, *Conférences inédites,* 90–96). This was uncharacteristic praise for an aspect of Raphael's art usually judged weak. Champagne emphasized, above all, that Raphael excelled in the spiritual side of painting (92–93).

The series of discourses of Henri Testelin, a painter and secretary of the Academy, beginning in 1675, dealt with every aspect of painting. These summaries of accepted principles derived from past masterpieces led to the *préceptes positifs,* published in table form in 1681. These *préceptes* show the Academy at its most dogmatic, but the principles were neither universally accepted, nor did they entirely proscribe practice.[13]

Testelin stressed that the artist must combine a study of nature with that of past masterpieces (quoted in Jouin, 142–43). Study of nature provides knowledge of the true nature of

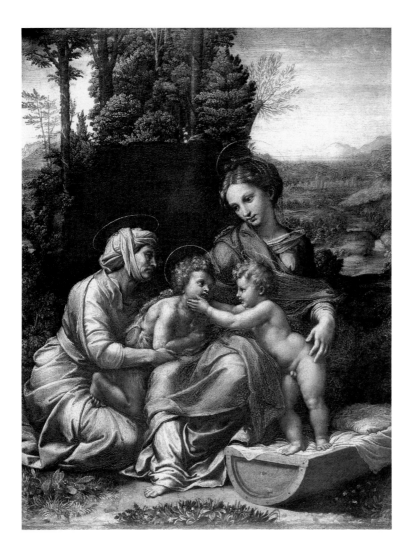

Fig. 11. *Holy Family,* c. 1518–19, Louvre, Paris

things; study of past masterpieces provides a guide to what is expressive and appropriate in rendering a particular idea or effect. This importance of propriety even extended to the type of contour a particular figure was given. In using the *Saint Michael* as an example, Testelin introduced an idea that reminds one of Winckelmann: Although the angel's action "suggests the desire to strike a great blow, it is without giving any trace of emotion, appearing with a perfect tranquility, so that it is very similar to the ancient figure of Apollo."[14]

In conjunction with the amateurs' treatises published in the 1660s and 1670s, the Academy *conférences* firmly enshrined Raphael as the model history painter. Raphael may not have been born French, but in a very real sense, by the end of the 1670s, he had been adopted and transformed into a cornerstone of the French classical tradition. In addition, the masters who established that tradition, Le Brun, Mignard, Le Sueur, and their great predecessor Poussin had all been strongly influenced by Raphael. Although Raphael's cartoons were only available in France through engravings, French artists could see hangings of the resulting tapestries of the Acts of the Apostles. Le Sueur's *Preaching of Saint Paul at Ephesus* (1649; Fig. 12), clearly inspired by Raphael's cartoons, and as

Fig. 12. Le Sueur, *Preaching of Saint Paul at Ephesus,* 1649, Paris, Notre-Dame

Raphaelesque a work as any done in the seventeenth century, could be seen at Notre-Dame de Paris.[15] The work clearly echoes Raphael in composition, figure type, use of rhetorical gesture and other aspects as well, and seems particularly close to the cartoon of the *Death of Ananias* (Fig. 13).

Students could see the fruits of Le Brun's study of the *Sal del Constantino* in the Vatican in his magisterial cycle of the life of Alexander, including such scenes as the *Crossing of the Granicus* (Fig. 14), which, in its overall conception and composition, as well as in many details, was clearly inspired by Raphael's *Battle of Constantine* (Fig. 15).[16] In both of these cases, Raphael's work provides not only the conceptual framework, but also the model for realizing these scenes. In Holy Families by Poussin, Mignard, and others there were constant echoes of Raphael's works.[17] Of course, as Norman Bryson has suggested, influence can also have a pernicious effect. The power of tradition, particularly as established by an artistic personality as strong and varied as Raphael, could pose a real threat to later artists' independence and originality—albeit Poussin never copies Raphael directly and clearly puts his own stamp on any ideas which he takes from the Renaissance master.[18]

Fig. 13. Cartoon, *Death of Ananias,* c. 1515–16, Victoria and Albert Museum, London

Nonetheless, I believe Bryson overstates his case, neglecting the positive dimensions of tradition. Certainly, too slavish copying of any model could lead to sterility, a fate traditionally ascribed to all art labeled "academic." Richard Shiff has suggested a more useful definition of "academic art":

> The path from immediate truths to original nature, leads through the conventions and styles of art. . . . Original truths might be revealed only through an identification with those for whom such original or "true" reality was congruent with (personal) artistic style; this was certainly the case with the Greeks, and also, according to many, with Raphael. To attain the vision of the Greeks or of Raphael, one would appropriate their manner of representation.[19]

This is the true meaning of the "academic tradition," and we can see why Raphael and Poussin were central to it for the French. In general, French artists found they could draw on Raphael while still finding room for individual expression. The Academicians thus placed themselves within Raphael's protective aura, without being too shackled by his example.

Academy Practice

Raphael's favored position, as suggested by the Academy *conférences,* was bolstered by academic practice. In Paris, the Academy students could know most of Raphael's masterpieces only through engravings. The founding of the French Academy in Rome in 1661, served to make Raphael's most important works—the Vatican frescoes, the Loggia scenes, and those in the Farnesina—accessible to a select group of students who won the Grand Prix.[20] In one sense, establishing the Roman Academy simply formalized a practice that had been common among French artists since Vouet and Poussin. Nevertheless, the study of art in Rome became subject to the same kinds of bureaucratic direction as the parent Academy. The artistic purpose of the Academy at Rome was clearly stressed in a letter of 1664, written on behalf of Colbert, asking Charles Errard to serve as director of the new Academy after Poussin had refused. The letter stresses the importance of an opportunity for young artists to acquire their taste from the great works of ancient and modern masters. Since students, who generally did not come from the wealthy classes, could not afford such study on their own, the king should subsidize it.[21] To facilitate the learning process, these pupils should be under the guidance of a master, who would serve as a guide to the beauties of antiquity and the Old Masters they would copy (*Correspondance,* 1:25). This director could also ensure quality control in works produced to decorate the king's residences.

Study in Rome was clearly regarded as an extension of the Academy regimen of life-drawing classes combined with theoretical discussions of exemplary masterpieces. Having been trained to recognize artistic correctness and beauty and given the necessary practical skills, the student should become capable of replicating those beauties in his copy of an acknowledged masterpiece. Copying could provide a far deeper and more profound

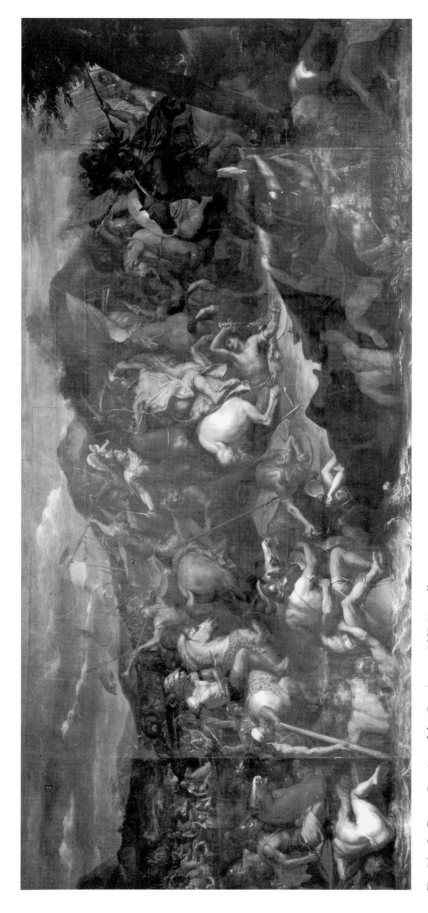

Fig. 14. Le Brun, *Crossing of the Granicus*, c. 1665, Versailles

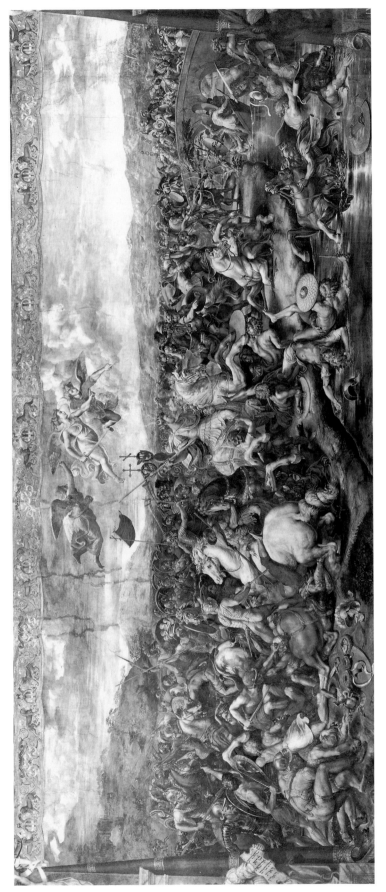

Fig. 15. *Battle of Constantine*, c. 1520–24, Vatican, Rome

understanding than could mere discussion, a comprehension based on practice as well as theory. The production of copies also served a political purpose. With the vast building program instituted by Louis XIV in the 1660s, which included the renovation of Versailles, a need arose for huge quantities of decorative material. Copies after antique sculptures and modern paintings suited this need perfectly, providing a return on the king's investment in the French Academy at Rome and a justification for his exclusive patronage of Academicians.

Soon after assuming the post of director, Errard was instructed to have the students in Rome make full-size copies of Raphael's Vatican frescoes and other works to serve as models for tapestries to be executed at the Gobelins. A letter from the duke de Chaulnes to Colbert of 11 February 1670, which described the advantages of the undertaking shows that the project was well under way by that time. He stressed that the effort would provide the king with copies of Rome's most beautiful tapestries, that these could ornament the king's residences, and, finally, that making these works served an educational function for the painters.[22]

The primary considerations were clearly not pedagogical. Unable to transport the originals to France, Louis XIV and Colbert set up a system to provide the best possible copies. One might also argue that such decorations could serve a political function as well, linking Paris to Rome, and the Catholic French king to one of the greatest periods of the papacy, the era of Leo X. It was so much the better that this enterprise also served instructional ends. That the Vatican frescoes, tapestries and other works by Raphael were chosen for this mammoth undertaking also indicated the high esteem in which he was held. Raphael's Vatican tapestries seem a particularly appropriate initial choice for copying, since the cartoons on which they were based were the property of the king of England. They also provided a model for the type of didactic painting required by the Crown. Of course, many French artists had copied Raphael prior to the foundation of the Roman Academy, including Dufresnoy, Mignard, Poussin, Le Brun, and later, Charles de la Fosse. Even Le Sueur, who did not go to Rome, based works on Raphael's Roman oeuvre, which he knew through engravings; for example, in 1645, Le Sueur did a series of designs after Raphael's Vatican Loggia to serve as models for a suite of tapestries for Jacques Le Coigneux, a key member of the parlement of Paris.[23] The Academy project, however, was the first large-scale, coordinated effort to copy Raphael's major works, particularly the Vatican tapestries and frescoes. The correspondence between the *surintendant des bâtiments* and the director of the French Academy at Rome was filled with references to this project. Artists who copied Raphael's works included Louis de Boullogne, Grand Prix winner in 1673; Pierre Monier, the first grand-prize winner; DuVernoy, Canonville, Desforest, Bocquet, Sarabat, and others.

It is difficult to say how much direct effect copying Raphael had in shaping these artists' styles. Much of the work of these artists' immediate predecessors, such as Poussin, Le Brun, and Le Sueur, was already Raphaelistic. Copying Raphael in Rome may simply have confirmed existing predilections, helping to maintain the existing classical tradition. For example, the Boullogne brothers obviously felt the impact of Raphael's works, as is evident by the copy of a detail of the *Fire in the Borgo* by Bon (Fig. 16), which is clearly a precise copy of approximately two-thirds of the original composition (Fig. 17). At any rate, a drawing such as Louis de Boullogne's *Christ and the Centurian* (Fig. 18) is clearly

Fig. 16. Bon Boullogne, copy of *Fire in the Borgo* after Raphael, Louvre, Paris

Raphaelesque in figure type, composition, and other aspects of expression,[24] as we can see by comparing it to Raphael's cartoon of *Christ Giving the Keys to Peter* (Fig. 19). Pierre Monier, Prix-de-Rome winner and Raphael copyist, who gave a series of lectures on design in the Academy, expressed great admiration for the artist in his treatise of 1698.[25]

Pierre Monier, the first winner of the Prix de Rome, made three copies after Raphael's tapestries representing the mysteries of religion (*Correspondance,* 1:6). Louis de Boullogne, who won the prize in 1673, made full-sized copies of the *School of Athens* and the *Dispute of the Holy Sacrament* (*Correspondance,* 1:67). Canonville copied the *Attila* in 1683 (*Correspondance,* 1:120). Desforest was paid for colors for his copy of the *Disputà* in 1683 (*Correspondance,* 1:123). The inventory made at the French Academy in Rome on 6 December 1684 listed several Raphael copies: a full-size copy of the *Disputà* by DuVernoy, a small copy of the same work by Bocquet, and five plates engraved by Thomassin, each with a figure from one of Raphael's frescoes—two from the *Disputà,* two from the *Parnassus,* and one from the *Fire in the Borgo* (*Correspondance,* 1:134).

In addition to these and other copies, a letter from La Teulière, director of the French

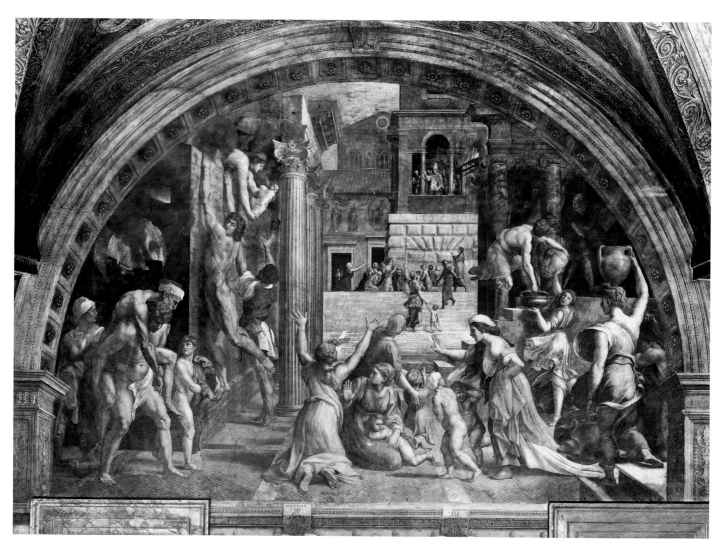

Fig. 17. *Fire in the Borgo,* c. 1514, Vatican, Rome

Academy at Rome (1684–99), to the marquis de Louvois, *surintendent des bâtiments* (1683–91), confirmed Raphael's importance in the academic curriculum. He suggested that the study of Raphael's works had greatly improved Sarabat's design (*Correspondance,* I, 208). Exposure to Raphael's greatest works was considered essential for learning proper design.

Copying Raphael's works, particularly the Vatican frescoes, seems to have occupied the students' time from the foundation of the Rome Academy through the 1680s. In all, by 1691, ten tapestries had been made, including the *Fire in the Borgo, Mass at Bolsena, Heliodorus, Vision of Constantine* (three pieces), *Attila,* and the *Parnassus.*[26] These copies could often take five or six years to complete because the students' other studies only allowed one day a week for copying and then only when weather permitted (*Corres-*

Fig. 18. Louis de Boullogne,
Christ and the Centurian,
Louvre, Cabinet des Dessins,
Paris

pondance, I, 230). The conduct of the Rome Academy in general, and, in particular, this immense copying enterprise seemed to have continued unaltered and unabated through the period of ferment in the Paris Academy that included the battle between the partisans of color and design: the Poussinists against the Rubenists.

The Conflict in the Academy: Color versus Design

Although the precise chronological and ideological limits of the color-versus-design conflict are still a matter of debate, some of the major events, issues, and protagonists have been identified by Bernard Teyssèdre and others.[27] The dispute was of fundamental importance in Raphael criticism because it challenged the assumption that art was primar-

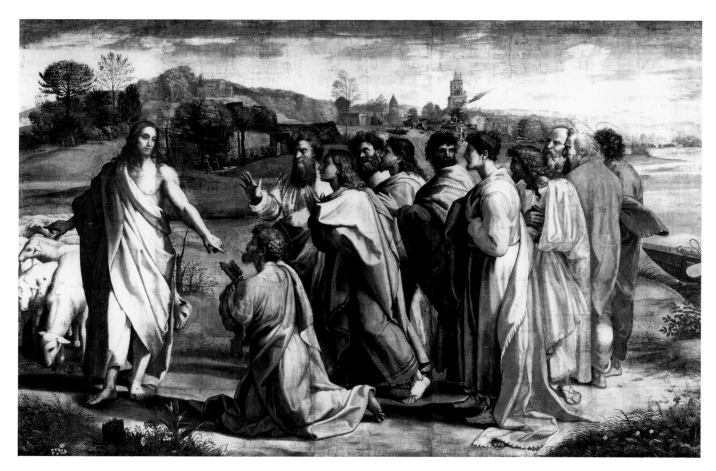

Fig. 19. Cartoon, *Christ Giving the Keys to Peter,* c. 1515–16, Victoria and Albert Museum, London

ily an intellectual activity that owed its significance to the aspects related to drawing: composition, invention, design and expression. Since these were the areas in which Raphael had been judged to excel, in the eyes of most of the Academicians his strengths far outweighed his weak colorism, making him the greatest modern painter. If, as Blanchard, de Piles, and others maintained, art appealed primarily to the eye through the effects of color and light, then Raphael's failings could not be dismissed so lightly. More than a difference of taste was involved. The advocates of color challenged the theoretical assumptions that had justified the presumed preeminence and superiority of the ancients, Raphael and Poussin over the Venetians, Rubens and Correggio.

The conflict did not mean that de Piles and the Rubenists disparaged antiquity and Raphael or regarded their example as unnecessary, but rather that in their view of painting, the qualities missing from these works, particularly the lack of immediate visual impact, rendered them incapable of serving as self-sufficient artistic models. The beauties of color and light could not be subordinated to those of line because these former aspects were what defined the essential nature of painting.

The most public and obvious phase of the dispute occurred in four Academy lectures in 1671–72, by Philippe de Champagne, Gabriel Blanchard, Jean-Baptiste Champagne (Philippe's nephew), and Le Brun. Since the details of the conflict have been elucidated in great detail in other studies,[28] I shall only touch on the points that directly affected the view of Raphael.

In his lecture on color of 7 November 1671, Gabriel Blanchard went further than simply stressing the equality of color and design. He asserted that color was the most necessary and fundamental aspect of painting; indeed, it was what distinguished painting from other arts. According to Blanchard, "a painter is only a painter because he employs colors which can seduce the eyes and imitate nature" (quoted in Teyssèdre, *Roger de Piles,* 170).

From Blanchard's more naturalistic perspective, there could be no truthful image of nature without color. He also argued that if painting's end was to please, then it should appeal to the largest number of people. Only the most learned could appreciate design, but anyone could appreciate beauty and harmony of color. Moreover, the ancients had held Zeuxis in as high a regard for his color, as Apelles for his design (quoted in Teyssèdre, *Roger de Piles,* 173). Blanchard ultimately argued that one could not neglect color and achieve perfection in painting, since both design and color were essential for the perfect imitation of nature. Students must be taught to handle the brush, as well as the pencil. Along with the works of the ancients, Raphael and Poussin, one had to render justice to the paintings of the Venetians and Rubens, which he called the "miracles of art" (quoted in Teyssèdre, *Roger de Piles,* 173). Blanchard directly challenged the notion that Raphael and the ancients were all-sufficient models, laying the groundwork for the broader eclecticism that would dominate the early eighteenth-century Academy.

After various polemical sorties, on 9 January 1672 Le Brun gave his verdict in this dispute in a lecture entitled "Sentiments on the discourse on color by M. Blanchard." He refuted each of Blanchard's assertions in turn: First, color was not so essential to painting as design. There could be no color without some object to carry it, but design could exist without color. One did not diminish the merit of painting by diminishing that of color because "[i]t is the design which dominates it and which constitutes all the brilliance and all the glory." Moreover, the ancients did not hold color in so high a regard as design. Color satisfied the eye, but design satisfied the spirit. Since paintings should please both, color had its part in the perfection of a work, but it was not the essence (quoted in Teyssèdre, *Roger de Piles,* 178).

Although Le Brun seemed to have closed the case in the Academy on the side of design, the issues raised were far from resolved.[29] In general, the range of aesthetics in the Academy was always far more diverse than the theoretical discourse suggests. These issues were kept alive by that advocate of colorism, Roger de Piles, beginning with his translation and emendation of Dufresnoy's *De Arte Graphica.* He published a series of pamphlets, treatises, and lectures that espoused the importance of color and the perfection of Rubens's paintings. Since de Piles's views helped shape not only the artistic ideas and preferences of the Academy, but also of all those amateurs that followed him, his views on Raphael should be examined in some detail.

Just as de Piles was about to take up the offensive in earnest against accepted academic theory and practice, however, Bellori was reinforcing those ideas with his writings.

Giovanni Bellori and Poussin's Ideas on Art

In 1664, Bellori, the Roman classicist and close friend of Poussin, gave a lecture at the Roman Academy of Saint Luke entitled "L'idea del pittore, dello scultore e dell'architetto scelta dalle bellezze naturali superiore alla Natura" (The idea of the painter, sculptor, and architect, superior to nature by selection from natural beauties).[30] In this essay, Bellori fashioned a combination of Neoplatonic and Aristotelian ideas into a system of artistic idealization.[31] According to Bellori, "the noble Painters and Sculptors, imitating that first maker, also form in their minds an example of superior beauty, and in beholding it they emend nature with faultless color or line."[32] This idea

> [c]onstitutes the perfection of natural beauty and unites the truth with the verisimilitude of what appears to the eye, always aspiring to the best and the most marvelous, thereby not emulating but making itself superior to nature, revealing to us its elegant and perfect works, which nature does not usually show us as perfect in every part.[33]

Bellori stressed that this idea was not a total abstraction, but rather was based on selection of the most perfect parts from various bodies in nature. He quoted as an example, the story of Zeuxis, as related in Pliny, who had formed his image of Helen from the five most beautiful virgins he could find.[34] He suggested that Raphael had also based his conceptions on an ideal, quoting Raphael's letter to Castiglione concerning the *Galatea:* "In order to paint a beauty I would have to see several beauties, but since there is a scarcity of beautiful women, I use a certain idea that comes to my mind."[35]

Moving from the abstract to the practical realm, Bellori gave an academic classical prescription: "It remains to be said that since the sculptors of Antiquity used the marvelous Idea, as we have indicated, a study of the most perfect antique Sculptures is therefore necessary to guide us to the emended beauties of nature and with the same purpose direct our eyes to contemplate the other outstanding masters."[36]

The *Idea* was published in 1672 as the preface to Bellori's *Le Vite de pittori, scultori, et architetti moderni*[37] (Lives of modern painters, sculptors, and architects), which included lives of the Carracci, Caravaggio, Rubens, Poussin, and others. The *Vite* was dedicated to Colbert, and the ideas expressed by Bellori paralleled those of France's developing classicism. As Barasch has noted, Bellori's ideas clearly reflected the values of his friend Poussin.[38] Although the *Vite* was never translated into French, at least some of the Academicians and amateurs knew them, particularly those who spent some time in Rome. Abbé Nicaise attempted to have Bellori's works sent to France, and Félibien and de Piles were certainly familiar with them. Bellori's ties to France were strengthened when, in 1676, the Accademia di San Luca, of which he was rector, was amalgamated with the French Academy in Rome. In 1689, Bellori was also made an honorary member of the Académie royale in Paris, being named both as *peintre* and *conseiller-amateur.*[39]

Bellori expressed his admiration for Raphael in the first lines of the first *vita,* that of Annibale Carracci:

Painting is now greatly admired and seems as though descended from heaven, when the divine Raphael by his supreme drawing has raised its beauty to the summit of art, restoring to it all the graces of its ancient majesty and enriching it by the attributes that had once rendered it glorious among the Greeks and Romans.[40]

Bellori, writing from the perspective of the Baroque period, warned that such a level of perfection had been short-lived. Artists had abandoned the study of nature and corrupted art with mannerism, drawing on custom rather than imagination. Not until Annibale Carracci was the perfection of painting revived. Bellori also introduced the notion that the Carracci had attained their perfection eclectically, repeating words supposedly written to him by Annibale's favorite pupil Albani:

Nor can it be said that they [Annibale and Agostino] learned style from the works of Correggio alone, since they went to Venice and finally to Rome: Rather it might be said that also from Titian and ultimately from Raphael and Michelangelo jointly they attained a style in which all the most precious masters shared. . . . But Lodovico, who remained alone in Bologna, does not seem in the judgements of experts to have equalled Annibale, who was far ahead and in advance of him in observations from, in addition to the works of Raphael, the most beautiful antique statues.[41]

The *Vite* would have been particularly noteworthy to the French because it contained the first extensive life of Poussin with some of his ideas on art appended.[42] Bellori stressed Poussin's debt to Raphael. Early in his career Poussin had begun to copy engravings after Raphael and Giulio Romano.

He imitated them with great vigor and great diligence so that he impressed on his mind their design and forms, no less than their movements and inventions and the other admirable aspects of these masters. For this reason, in his fashion of interpreting the story, in expression, he appears to be a pupil of the school of Raphael, from whom he certainly drank the milk and by whom he was brought to the life of art. (Caillier, *Vie,* 17)

Bellori pointed out that Poussin had modeled many works on Raphael's example, such as his scenes of the Old Testament executed for the royal chambers. He concluded that Poussin's manner was strongly based on the study of antiquity and Raphael, which he had begun in his youth (Caillier, *Vie,* 18).

In other *vite* Bellori showed that Raphael's art had been Poussin's standard of excellence. In Annibale's *Life* he quoted Poussin in praise of the Farnese frescoes, suggesting that these works were the "most beautiful compositions" after those of Raphael.[43] In the *Life* of Domenichino, Bellori again quoted Poussin concerning the *Communion of Saint Jerome,* praising it and Raphael's *Transfiguration* as two of the most celebrated paintings of all.[44]

Poussin's dozen aphorisms on painting[45] could be interpreted as reinforcing accepted academic practice. In his poetic, ambiguous statements, he stressed the importance of

following good masters in order to see painting's principles properly applied. Poussin also suggested that novelty lay not solely in introducing a new subject, but also in a new disposition and expression of an old subject.[46] Poussin emphasized expression and art's dependence on nature, but believed that one could improve on nature.[47] Concerning the use of color and line, he could be seen to echo the Academy's stand on behalf of moderation: Color and line should be used in such a way that neither dominates the other.[48]

Bellori continued to promote knowledge and appreciation of Raphael's art with his *Descrizioni delle Imagini Dipinte da Rafaelle d'Urbino,* published in 1695, which contained detailed descriptions of the Stanze della Segnatura, Heliodorus, Constantine, and the frescoes in the Farnesina.[49] Abbé Nicaise obtained a copy from Bellori's heirs and translated it into French.[50] Bellori's descriptions were followed by a series of essays on Raphael's art. After attacking the notion suggested by Vasari that Raphael's perfection depended on Michelangelo, Bellori likened Raphael to Apelles in genius, excellence, and grace.[51] De Piles certainly knew the *Descrizioni:* In his *Abrégé* he sided with Vasari against Bellori, agreeing that Michelangelo had influenced Raphael.[52]

Roger de Piles and the Partisans of Color and Design

Roger de Piles, artist, amateur, collector, diplomat, theorist and critic, is rightly seen as a pivotal figure in French seventeenth-century art theory and aesthetics. He played a central role in promoting ideas first raised in the famous 1671 quarrel in the French Academy between the partisans of color and those of design. Through numerous treatises published between his 1668 translation of Dufresnoy's *De Arte Graphica* and his death in 1709, de Piles attacked and helped overturn the French Academy's narrow view of painting, which subordinated the sensuous delights and immediate impact of color to the more intellectual virtues of design.[1] He also succeeded in placing Rubens firmly in the French pantheon of great past masters. Although the ultimate triumph of de Piles and Rubenism marked a profound shift in the aesthetic of the Academy, it did not mark the complete abandonment of Raphael and the classicizing ideal. De Piles never entirely rejected Raphael's art. Rather, he redefined the role of Raphael as that of an artist moving toward a new artistic ideal that embraced equally the beauties of color and design. Since, in his view of painting, colorism was primary, de Piles viewed Raphael's acknowledged inadequacy in this area as a fundamental weakness.

De Piles's early knowledge of Raphael's works would have been limited to the works in the king's and other private collections occasionally open for public scrutiny.[2] He would have only been familiar with Raphael's frescoes, cartoons, and other major works through engravings or copies. In 1673, de Piles began a fourteen-month stay in Rome, during which he stayed at the Farnese Palace and must have frequented the French Academy in Rome under Noël Coypel. He would have had ample opportunity to study the Vatican frescoes the young pensionnaires were copying at the time, the Vatican tapestries, the frescoes in the Farnesina, and other works (Teyssèdre, *Roger de Piles,* 217). This experience, no doubt, strengthened his admiration of Raphael and also gave him a more precise sense of what he viewed as Raphael's limitations. For example, de Piles notes in his *Abrégé* (Paris, 1699) that Raphael's sense of chiaroscuro improves in his later works, such as the Vatican tapestries and the *Transfiguration* (178).

As a consequence of seventeenth-century thought, de Piles's aesthetic views were deeply imbued with the classical idealism embraced by the French Academy under Charles Le Brun. Yet the sensuous color, immediate impact, and naturalistic vigor of the paintings of Rubens and the Venetians excited de Piles far more than the placid beauties of the art of Raphael and Poussin. As recent studies, such as those by Puttfarken (*Roger de Piles,* esp. chap. 5) have demonstrated, de Piles was determined to create a theory of painting freed from the fetters of literary theory, which accounted for the specifically visual character of painting. At first, de Piles attempted to modify academic theory to fit his critical aims by proving that color was as central to painting as design. In his later treatises, as his principal aim shifted from a general defense of color to promotion of the superiority of color and a pointed advocacy of the art of Rubens, the tensions between de Piles's theoretical conceptions and his critical responses became more acute. De Piles admired Rubens's painting most for its originality, vitality, and naturalism, all aspects difficult to reconcile with the idealizing classicism of Le Brun and his followers. In effect, Roger de Piles attempted to bridge two different aesthetic eras in France: the period before about 1680, which was dominated by the art of Raphael and Poussin; and the late seventeenth and early eighteenth century, which embraced the sensuous naturalism and immediate visual impact found in the works of the Venetians and Rubens, and culminated in the full development of the French Rococo style.[3]

De Piles has been viewed both too broadly as a fiery radical bent on destroying all established classical values, and too narrowly as simply a critic whose ideas reflect the taste of his time.[4] Neither designation adequately describes the particular mixture of radicalism and eclecticism that formed his theory. In recent works, Thomas Puttfarken, Jacqueline Lichtenstein, and Norman Bryson have stressed de Piles's role in liberating the theory of painting from the dominance of literary theory that had pervaded the early Academy. Although we can certainly agree that this was a major focus of de Piles's theoretical writings, we must ask to what degree, and at what level of subtlety, his ideas affected the doctrine of the Academy. Many aspects of de Piles's art theory were quite original and even radical. By viewing de Piles's ideas from a purely theoretical perspective, however, as if they existed in isolation from the historical and institutional contexts in and for which they were produced, Bryson and Puttfarken distort his role in relation to the development of French art and theory, particularly, in the Academy.

Although an amateur, de Piles exerted a great influence on the transformation of academic theory at the end of the seventeenth century. As a connoisseur, he was willing to form his own opinions, exhibiting an independence of taste rare for the French. After he was officially designated by the Academy as an *associé libre* in 1699, at the behest of his friend the new *surintendant* Hardouin-Mansart, ideas that de Piles had championed in his treatises were delivered directly to the Academicians in a series of lectures; nonetheless his ideas were already well known and much discussed.[5] To a degree, de Piles was justifying an aesthetic shift that was already taking place, as the regime of Mignard and La Fosse superseded that of Le Brun. Although de Piles was clearly successful in broadening the aesthetic of the Academy, his specific ideas redefining painting in specifically visual terms do not seem to have come to dominate academic theory. Perhaps de Piles helped prepare the way for a Watteau, Boucher, or Fragonard,[6] but he did not extirpate the classical ideal. We must ask what elements of that ideal survive in de Piles's theory and what form they take.

The amateur Roger de Piles did not instigate the quarrel between the partisans of color and those of design, but he became its public standard-bearer on behalf of colorism. Through a series of treatises beginning with his 1668 translation of and commentary on Dufresnoy's *De Arte Graphica,* he argued that color was not only as essential as design, but that color was the essential difference between painting and the other arts.[7] To balance the Academy's intellectualized view of painting based on antiquity, de Piles promoted a sensual ideal based on nature. To counter the dominant notion that what mattered in painting was conveying the message clearly and appropriately, de Piles stressed the visual impact and independent nature of painting—which, he felt, depended primarily on color. He championed Rubens, against the Academicians, who claimed that Rubens did not make the proper choices among nature's beauties; his naturalism overwhelmed his idealism.[8]

Although the partisans of design acknowledged that verisimilitude in painting demanded correct color, they viewed its sensual delights as a siren song that lured artists away from correctness and propriety. Academicians acknowledged that the works of Raphael, a weak colorist, did not capture the viewer's attention immediately; they only revealed their beauties with long and thoughtful scrutiny. De Piles strongly opposed this view. In numerous treatises, beginning with the *Dialogue sur le coloris* published in 1673, he asserted that good painting had to have immediate visual impact created through the effective use of color and light. De Piles argued that Raphael's failing in this area should not be excused, even though he moved in the proper direction at the end of his life (*Conversations,* 79).

De Piles challenged the Academy's ideal without rejecting it completely. De Piles's "Balance des Peintres," that curious, much-discussed table appended to his 1708 *Cours de peinture par principes* provides the clearest evidence that he did not totally denigrate Raphael.[9] The "Balance" has always presented difficulties for those who would brand de Piles a total radical who entirely rejected the tenets and values of the seventeenth-century Academy. Although according to de Piles, we should be cautious in seeing these judgments as some absolute theoretical statement, they are still worth considering, particularly since they represent his mature judgments. Rating artists according to their relative merits

in the primary aspects of painting, he judged Raphael equal in overall merit to Rubens, his favorite. Out of a possible twenty, the marks were:

	Composition	Design	Color	Expression	Total
Raphael	17	18	12	18	65
Rubens	18	13	17	17	65

It seems paradoxical that Raphael, with his weak colorism, the aspect that de Piles considered most essential in painting, should be rated the equal of Rubens, the master colorist. Rubens's low rating in design seems equally anomalous coming from that artist's foremost advocate. Recently, Norman Bryson has argued that the overall aim of the "Balance" was simply to weaken the importance of expression (*Word and Image,* 58–60). Alternatively, one might argue that de Piles is simply asserting that color is as essential to expression as design, since Rubens, despite his weakness in design, is almost Raphael's equal in expression.

Roger de Piles's writings thus shared two distinct aims: the promotion of a coherent aesthetic based more fundamentally on color than design (which, as Thomas Puttfarken has recently argued, acknowledged the specifically visual character of painting), and the establishment of Rubens as one of the most exemplary masters for the French.[10] At the beginning of his career in such works as the *Dialogue* and at the end in his *Cours* (1708), the second aim was held in check by the first.[11] In the middle of his career, particularly in treatises such as the *Dissertation,* connected with the duc de Richelieu's Rubens collection, de Piles's overwhelming desire to promote Rubens seems to have driven him to modify his theory.[12] To put it another way, de Piles placed his theory in support of his taste. He attempted to prove that Rubens, not Raphael, had been the supreme master, excelling not only in colorism, but in design as well. Granted, de Piles acknowledged that the study of painting should begin with design, particularly that of antiquity and of Raphael. For this reason students should study in Rome, but should not be taught that all perfections were contained in antique sculpture or the Vatican frescoes:

> Until then one paid attention only to that which is concerned with invention and drawing, and although Raphael invented very ingeniously, or designed with correctness and accomplished elegance, that he expressed the passions of the soul with a force and an infinite grace, that he treated subjects with all possible nobility and propriety, and no painter could rival him in the great number of aspects he possessed, it is nevertheless true that he had not penetrated enough into colorism to be able to render objects in a truthful and lively manner, nor to give the idea of perfect imitation.[13]

When de Piles sings Raphael's praises, he seems merely to utter stock phrases from Vasari, Félibien, and Bellori. When he shifts his focus to Raphael's limitations, he speaks as a connoisseur and theorist who found something essential lacking: the sensual qualities that gave a work its initial impact and were essential for its total effect. For example, in the *Abrégé,* de Piles criticizes Raphael for taking such care with drawing that his execution is a bit dry. He seems to have Rubens in mind when he describes Raphael's colorism: "His

local colors are neither brilliant, nor striking; they are neither truthful enough, nor intense enough. He never clearly understood chiaroscuro, although he seems, in his last works to have attempted to master it, as one sees in his Tapestries for the Acts of the Apostles and in his *Transfiguration*" (178).[14] This last comment is significant because it reveals that, unlike most French critics, de Piles actually studied Raphael's works and was the first to notice that Raphael's chiaroscuro and colorism was richer in his later works.

De Piles also challenged the Academy's deference to Poussin. Although Poussin had copied the art of Titian early in his career, de Piles maintained that he never understood the Venetian's color. Later, Poussin's slavish attachment to antiquity increasingly barred him from a true knowledge of color. By following antique sculpture too closely, Poussin imbued his work with a coldness inappropriate to painting. Thus Poussin was unable to master color and antique beauty simultaneously (*Dialogue,* 50–51).

Raphael had been superior to Poussin in several regards. His art revealed a grace that de Piles found conspicuously lacking in Poussin's. Although the notion of Raphael's "grace" was taken from Vasari, de Piles uses the term with a French inflection. Unlike Poussin, Raphael had only used antiquity as a guide to *la belle nature,* that is, nature corrected according to an ideal. One suspects that, in part, de Piles was finding a theoretical justification for his critical preference for the art of Raphael over that of Poussin; yet the distinction between copying antiquity and using it as a guide to improve nature was an important one for de Piles, since he later used that distinction to support his advocacy of Rubens. As de Piles maintained, antiquity was certainly an antidote to bad taste, but if it were followed too slavishly, without being leavened by the living beauties of nature, it could be a bad influence.[15] De Piles also defended Raphael against Poussin's supposed disparaging re-mark when the latter stated that "compared to the ancients, Raphael was an ass, but to the Moderns, he was an eagle."[16] De Piles suggested that the expression was too strong. He says only that Raphael had been as much below the ancients as the Moderns were below him (*Abrégé,* 24).

As his career progressed and as he increasingly abandoned the simple beauties of nature, Poussin adopted a more idealizing style based on classical antiquity. De Piles believed that in contrast to Poussin, Raphael had been moving at the end of his career toward a synthesis of nature and the antique ideal, beginning to master color without diluting his other perfections. In his *Dialogue,* de Piles made this idea clear through his interlocutor Pamphilus. Asked whether he would rather be Raphael or Titian, Pamphilus answered that he would rather be Raphael, although he believes that Titian was "a greater painter . . . [but] Raphael had other talents, and that all these together please you more than the colorism of Titian" (33–34). This is little more than a restatement of Félibien's ideas, but de Piles added a highly original twist: "Raphael, with all the advantages that he had, made so much progress in colorism, that if he had not died prematurely—he would have possessed this part in its highest perfection. Thus I am convinced [said Pamphilus], that if I were Raphael, that in a little more time, I would be Titian" (34).[17] In placing color on an superior footing to design, de Piles did not abandon Raphael's art as a model. Rather he redefined him as an artist who had mastered the perfection of antique design and, with increasing naturalism, was moving toward a mastery of color. Already Apelles, in time, he would be Zeuxis as well.

Since Raphael's career had been cut short before he could achieve the desired perfect

synthesis, one had to turn to other artists, particularly Rubens, for exemplary color, harmony, and the immediate impact de Piles deemed so essential. Yet not even the Flemish master was perfect in de Piles's eyes: "There is no perfect painting. If the design is not that one ought to esteem the most in the engravings of Rubens, there are enough other aspects which render them noteworthy" (*Dialogue,* 27). Ironically, this is the same argument often heard in relation to Raphael's color. In his earlier treatises de Piles took this fairly evenhanded approach in evaluating the works of various artists. His second *Conversation* (1677) and his *Dissertation* (1681) are more strident (see *Conversations,* 224). Although a cause-and-effect relationship is difficult to prove, it is worth noting that at this time de Piles advised the duc de Richelieu to replace his lost Poussins and Carraccis with Rubens. He even wrote the catalog of the collection to which he appended his *Dissertation.*[18] Perhaps de Piles felt a greater need to justify his taste than at other times in his career.

To French eyes, of course, Rubens did not appear to follow the antique ideal sufficiently. In his *Conversations,* rather than denying Rubens's faults in design, de Piles argued that they shoud be excused, since Rubens's prolific nature and rapid execution did not always allow him to concentrate on correct design. Moreover, if Rubens did not directly emulate antique models, he followed the ancients' method in drawing his ideas from nature. He knew nature so well "that with a bold, but wise and knowledgeable exaggeration of this character he rendered painting more lively and natural, than so to say, nature itself."[19] Academicians had criticized Titian for being naturalistic rather than following the antique ideal in design, as they had criticized Michelangelo for exaggerating that ideal beyond the limits of propriety.[20] By turning similar "faults" in Rubens's art into virtues and justifying his "exaggerated" color, design, and chiaroscuro, de Piles attacked the Academy aesthetic of restraint.

In his *Dissertation,* de Piles shifted from indirect to direct attack. He even invented new aesthetic categories to prove Rubens's superiority. For instance, in order to argue that Rubens was supreme in design, de Piles argued that the Flemish master surpassed Raphael in *esprit du contour,* the quality that gives a figure life.[21] He boldly defined painting as the perfect imitation of visual objects, the essence of which was "to deceive the view, and its fitness to instruct strongly and to stir the emotions,"[22] a definition obviously conceived with Rubens in mind. De Piles asserted that in these respects Raphael and the Roman school had been mediocre at best (*Dissertation,* 33–36). To declare that Raphael's color had been weak was commonplace; to suggest that Raphael failed in the essence of painting was to reverse radically the accepted academic position.

At this point in his career, the passion de Piles felt for Rubens's works in his role as critic overwhelmed his desire to create a viable, comprehensive theory of art. Although he certainly succeeded in making a Rubenist alternative acceptable, his belief that Rubens had been the greatest master of all time was never generally embraced in France. Rather, the liberal eclecticism expounded in his late works set the tone for French art theory and practice in the first half of the eighteenth century, as the dominant aesthetic shifted toward greater sensuality and naturalism.[23]

De Piles's eclectic approach embraced all aspects of the teaching, creation, and appreciation of art. He argued that students must study the works of great masters of color as well as those of design. Artists should emulate only the strengths of a given past master rather

than slavishly copying any single model, and connoisseurs should not allow their prejudices to blind them to the virtues of any school. Rather, they should appreciate all the good points in any work of art. As one of the first French connoisseurs to appreciate the art of Rembrandt, de Piles clearly displayed the critical openness he professed.[24]

In 1699, Roger de Piles was officially recognized by the Academy as a *conseiller honoraire.* Until his death in 1709, he exerted direct influence on that body through his lectures and treatises. No longer an outsider writing for like-minded amateurs and collectors, de Piles was now the official theoretician of the Academy. His ideas were summed up in his *Cours de peinture par principes* of 1708, consisting of twelve parts, nine of which were delivered as Academy lectures. One of these was specifically devoted to praising Raphael's *School of Athens* as exemplary;[25] it was to this treatise that de Piles appended his famous "Balance."

The key to de Piles's theory as expressed in the *Cours* is his concept of truth. As Puttfarken has shown, this was a reinterpretation of an idea found in Bellori. In painting, de Piles believed that "truth" was of three types: the *vrai simple,* the *vrai idéal,* and the *vrai composé* or *parfait.* The *vrai simple* consists of the vivid, yet simple and faithful imitation of nature and the model. The *vrai idéal* relies on "a choice of diverse perfections which are never found in one model, but which can be drawn from several, generally from antique works" (*Cours,* 30–32). Like Zeuxis, the modern artist should synthesize the best aspects of different models to achieve a higher perfection. This "truth" included the abundance of ideas, richness of conceptions, propriety of attitudes, elegance of contours, and choice of beautiful expressions. These were the virtues the Academy held dear. Yet Roger de Piles qualified this ideal. His "truth" included only "that which can be done without altering the first truth, to render it more piquant and more appropriate."[26] In effect, de Piles accepted the importance of ideal beauty, but subordinated it to the faithful imitation of nature, reversing the traditional academic hierarchy.

De Piles's ideal, the greatest truth, was the *vrai composé* or *parfait,* which harmoniously combined the other truths. This truth resulted from "the perfect imitation of *la belle Nature*" (*Cours,* 34), which had never been fully achieved in the history of art. Giorgione, Titian, and the other Venetians possessed only the *vrai simple.* Leonardo, Raphael, Poussin, and others of the Roman school established their reputations through the *vrai idéal.* In effect, de Piles established a new set of criteria for judging artistic excellence, equally dependent on fidelity to nature and the ideal: "As perfect truth is a composite of simple truth and ideal truth, one could say that painters are skillful according to the degree to which they possess the parts of the first and second truths, and according to the happy facility which they have acquired in making a good synthesis" (*Cours,* 35–36).

Raphael was outstanding because "adding to the beauties of ideal truth, he possessed a considerable part of the simple truth, and thus more closely approached perfect truth than anyone else of his nationality" (*Cours,* 35). It is significant that de Piles limits the comparison of Raphael and the resulting supremacy solely in relation to other Italians, not to Rubens. According to de Piles, Raphael rendered truth more regular and expressive, yet always retained the truth and singular character of his model. He was not perfect, however, since "without the knowledge of chiaroscuro and all that is dependent on colorism, the other aspects of painting lose much of their merit, even at the point of perfection to which Raphael carried them" (*Cours,* 13–15).

Among all painters, Rubens had indicated the most clear, facile way to the mastery of color. De Piles saw his art as the logical extension of the Venetian school: "Titian evoked through legitimate distance more truth and precision in his local color, having left to Rubens the talent for grand compositions and the artifice to make us comprehend to the greatest extent the harmony of his whole composition." (*Cours,* 360). De Piles loved Rubens's ability to aggrandize nature, since he felt that "Nature is insufficient by itself, and whoever devotes himself simply to copying it as it is, without artifices will always have somewhat poor and limited taste" (*Cours,* 346).

Although they began from opposite directions, Raphael and Rubens came closer than anyone else to de Piles's perfect balance between nature and the ideal. De Piles believed, at least in theoretical terms, that by combining the virtues of Raphael's art (*le vrai idéal*) with those of Rubens's (*le vrai simple*), one could attain perfection. Nonetheless, for de Piles, Rubens's virtues were ultimately far more substantive than Raphael's and more basic to the essentials of great painting.

In summary, we find that Roger de Piles was neither simply a product of his time, nor a total radical bent on destroying the artistic ideal which the Academy had embraced since its founding. Rather, he sought to modify that ideal to embrace the sensuous delights of color, which he regarded as even more essential to the immediate impact and overall effect than the intellectual beauties of design, and to focus on the specific elements that make painting unique. By placing de Piles's views of Raphael's art in the overall context of his theory, we better understand his eclectic redefinition of classicism, replacing Le Brun's *grand goût* with a more sensuous ideal.[27] Although his ideas may have helped prepare the way for a Watteau, a Boucher, and a Fragonard, as Bryson has asserted;[28] they also allowed the continuation of the classical ideal in a modified form. By seeing how de Piles's views were modified by his more strident advocacy of Rubens, we comprehend better the nature of the internal conflict in his theory. We have seen how he attempted to resolve that conflict by modifying the accepted view of Raphael's art to support a more naturalistic aesthetic based on a more purely visual conception of painting. In the process, he clearly distinguished Raphael from Poussin. In doing this, he helped lay the foundation for the aesthetic that would dominate French art in the first part of the eighteenth century. In this way, de Piles helped shift the primary goal of painters from instructing to pleasing.

Part Two

Raphael in French Eclecticism
(1700–1743)

BY 1676, UNDER COLBERT, Charles Le Brun had consolidated his power and influence as chancellor of the Academy, director of the Gobelins, and *premier peintre* to the king under the protection of Colbert. De Piles's *Conversations,* introduced at this time, were widely attacked by many Academicians who embraced Raphael and Poussin as the supreme modern artists.[1]

In 1699, Hardouin-Mansart was *surintendant.* Charles de la Fosse, an ardent Rubenist, was *premier peintre,* and Roger de Piles, admitted to the Academy as a *conseiller honoraire,* gave a series of *conférences* on various aspects of painting, and was generally recognized as a major painting theorist. To make de Piles's acceptance within the Academy possible, the intellectual and aesthetic climate of the Academy had to change. Raphael and antiquity were not abandoned, but their example became only one of many that could be followed. This section will trace Raphael's place in the broadened eclecticism and aesthetic shifts in France in the first half of the eighteenth century.

Many political and economic, as well as artistic and intellectual forces altered and shaped the Academy in the last two decades of the seventeenth century.[2] The deaths of Colbert and Le Brun, the penury of the state treasury, and finally the death of Louis XIV all weakened centralized control over the Academy, as patronage became more decentralized, and the nature of work required by patrons shifted from the grand machine to the cabinet pictures and more modest schemes of interior decoration. From extolling the exploits of the king, painters became increasingly involved in providing objects of delectation for private residences.[3] This shift in patronage was accompanied by a gradual growth in the belief that painting's sensual aspects were as important as its intellectual content. The battle of the partisans of color and design was a matter of taste and doctrine. Certainly, de Piles's promotion of color and Rubens affected the ideas of artists and amateurs. De Piles's ideas were given impetus and substance by extraordinary collections of Rubens's art in France, such as the Medici Cycle in the Luxembourg and the duc de Richelieu's collection.[4]

By the 1680s, a new generation of artists, who did not accept the orthodox dogmatism of Le Brun's Academy, became Academicians. Charles de la Fosse, Antoine Coypel, the Corneilles, Jean-François de Troy, François Lemoyne, and others tended to be much more open than their predecessors to the sensual aspects of painting and Rubens's example.[5] They shared a broadened eclecticism that valued color and design as equally essential to painting. De Piles was assimilated by the Academicians because in general, his views on color had become theirs. Ideas about Raphael now circulated in a broader context. In addition, with the weakening of the Crown and the death of Louis XIV, the Academy was no longer the center of French art theory and practice. Instead, a major center of both artistic and political power formed in the circle around the banker Crozat.

To define Raphael's place in the new, broader eclecticism of the first half of the eighteenth century, I shall examine the views of artists, such as Antoine Coypel and the directors of the Roman Academy, and amateurs, including Mariette, Abbé Dubos, Dézallier d'Argenville, and the Richardsons.

Raphael and the Academy (1699–1746)

Antoine Coypel

The broadened eclectic spirit that transformed academic aesthetics in the early eighteenth century is epitomized in the theory and practice of Antoine Coypel (1661–1722).[1] Beginning his studies as a child prodigy under his father Noël's tutelage in Rome, he spent virtually his entire life in the Academy. Three years in Rome followed by a year in northern Italy formed his taste in the eclectic mold that embraced the Bolognese, Correggio, and the Venetians, as well as the Romans. His influence and prestige in the Academy were enhanced by his position as *premier peintre* under the Regency and also to Louis XV after his ascension to the throne in 1715. In 1716, he became *recteur* of the Academy. He was also a member of the influential group of artists and amateurs that formed around the wealthy financier and collector Pierre Crozat in the early eighteenth century. Coypel received many major commissions, including the decoration of the Palais Royale for the duc d'Orléans in 1707, and the ceiling of the Versailles chapel in 1708.

Antoine Coypel expressed his artistic ideas in his *Epistre à mon fils* (Letter to my son), a poem read to the Academy in 1708. Following the model of de Piles's commentary on Dufresnoy's poem, Coypel

elaborated at length on his concepts in a series of many lectures delivered to the Academy between 1712 and 1720 and published in 1721.[2] By placing traditional ideas in the context of a broadened eclecticism and an artistic system that acknowledged antiquity and nature as equally important guides, he established the dominant aesthetic for the next twenty-five years. Coypel's were virtually the only original ideas expressed in Academy *conférences* between the death of de Piles and 1745. The Academy leader's position gave his works an authority perhaps akin to that which Reynolds's *Discourses* would have later in the century.[3]

At first glance, *Epistre à mon fils* could have been a product of the 1670s. The artistic models Coypel suggested for his son can for the most part, be found in Dufresnoy: Correggio, Titian, Annibale, Giulio, and above all, Raphael. He devoted 25 of 186 lines to this great master, but made no mention of Poussin or Rubens. Coypel believed that one should learn from all the diverse beauties of the past, but should be mindful to avoid each artist's errors.

Although Coypel admired Annibale Carracci, who combined the beauty and truth of Correggio with the majesty and grandeur of Michelangelo, Coypel did not feel that Annibale had ever attained the sublime beauties of Raphael, in whom one

> [d]iscovers at the same time the rarest treasures: justice of contours, proportions of the body, the elegant design of antique sculpture, joined with the naive effects furnished by nature; a pure and wise choice of simple pleasures; an elevated taste in drapery. . . . A genius at once sublime and profound. . . . Wise without being cold, and simple without baseness. Grand without appearing excessive, always full of nobility, profound without being obscure and pleasing without excess. Reason there appears master of art.[4]

In the first portion of his verses on Raphael, Coypel followed tradition in praising him for the simple beauty of his design. Coypel also echoed de Piles, suggesting that this beauty derived from antiquity joined to the "effets naïfs" of nature. This new emphasis on nature was the basis for eighteenth-century French aesthetics. Rather than abandoning Raphael when a reborn Apelles was no longer sufficient, De Piles and then Coypel transformed him to serve the new aesthetic. Yet Coypel also retained much of the traditional image of Raphael. He saw Raphael's art as the ideal example of profound sublimity expressed with simple clarity and vividness.

In many ways, the *Epistre* has a retrospective tone celebrating an exclusive aesthetic that had already passed, one to which Coypel himself no longer adhered. Coypel expounded a broader eclecticism in his commentary on the poem. Raphael was a model, but only one among many. Traditionally, Raphael's perfections had been associated with his idealizing qualities; Coypel, following de Piles, shifts the emphasis to Raphael's naturalism:

> Here the expressions of natural beauty offer us a faithful representation of the subject. Movements of the soul are painted in a learned manner, One sees strength unified with harmony. Under his hand, everything takes on a divine character. By touching charms of simple truths, he always elevates himself to sublime beauties. (lines 105–12)

The young artist should be guided by Raphael to rectify, enrich, and ennoble his ideas, but one should be aware that, even if one follows him, one cannot equal him (233, lines 115–16).

Although Coypel quoted reason as his guide and Raphael as his ideal, his tastes were closer to de Piles's than to Le Brun's. One should "Imitate nature and know how to make a choice; Work to bring together the grand and the amiable, the tender, the naive, the strong and the pleasing; Know how to stir the spirit by fooling the eyes. Be lively, correct and always harmonious" (233, lines 150–56).

Color is important because it can charm the eye the way music delights the ear, but one must not depart from reason or truth (233, lines 159–64). In a passage that could serve as an indictment of much of academic classicism following Le Brun, Coypel concluded:

> I hate a cold painter, with his extreme blindness, who, servile and without force, is satisfied with himself. My eyes are repulsed by a cold precision. I prefer faults and great beauties. But do not go after some false brilliance simply to please yourself; Stick to the true, the solid, the beautiful, so that, above all, reason guides your brush. (233, lines 169–76)

Coypel's ideal, in which the artist would be guided equally by nature and reason, followed de Piles's concept of the *vrai parfait*. This delicate balance was far easier to describe in theory than to follow in practice. He seems to call for a retention of the *grand goût*, but with a softer, gentler, more naturalistic quality, a combination Coypel attempted to achieve in such works as his *Finding of Moses* (1704; Allen Art Museum, Oberlin College).[5]

In a series of Academy lectures between 1712 and 1720, Coypel expounded on the ideas he had already expressed in poetic form. Following traditional academic methods, Coypel suggested that one could perfect one's art on the models of past masterpieces, guided constantly by nature and reason. The young artist should understand how past masters achieved their effects, not copy them slavishly. For example, one should note how Raphael had rendered nature's beauties in such a way that they were raised to sublimity by their simplicity. Although one should imitate the choice and freshness of his expressions, gestures, and attitudes, one should not follow him when he indulges in too violent and affected contrasts.[6] Coypel was thinking of the *Fire in the Borgo* or something similar. Coypel also introduces the novel notion that Raphael owes his sublimity to simplicity, a notion that presages Winckelmann's idea of *edle Einfalt* (noble simplicity).

In accordance with de Piles, Coypel spoke out against those whose prejudices blinded them to diverse kinds of beauty. Placing the last thirty years' conflicts in perspective, he suggested that at one time only Poussin was in favor. Albani, Rubens, Van Dyck, and the Bassani had all been proscribed. Then, despite Poussin's admirable qualities, Rubens supplanted Poussin. Rembrandt was the only model that one tried to imitate. Coypel noted that the praise that one gives to the master one favors is always at the expense of less favored masters. It would make more sense to appreciate the beauties in all artists' works (*Discours,* in Jouin, 247). A student should imitate Guido Reni's grace and nobility; Rubens's chiaroscuro and overall harmony, and his color, when it is not too extreme; Poussin's elegant design, his propriety, and the nobility of his expressions, which particu-

larly appeal to knowledgeable viewers (253). Coypel defined the aesthetic of his time with these statements of eclecticism and individual tastes. (One recalls that at this time Watteau was made an Academician in the new category of *peintre champêtre* [rustic painter]).

Coypel thus sees no contradiction in a rich appreciation of both Poussin and Rubens. He would have a student choose from the riches of the past like a guest at a banquet, according to taste, but always aiming for the *juste milieu* (261). For Coypel, different models should serve for different kinds of subjects. Correggio should be the model for portraying gracious objects and sweet passions. Grave, ceremonial subjects require a strong composition with subtle contrasts; for these, Raphael should be the model (284).

In design, Coypel distinguished between *grand goût* and simple correctness. Dürer, Cranach, and others were correct without being grand; Correggio was grand without being correct. The models were Leonardo, Michelangelo, Raphael, and the Carracci. For Coypel, grand taste in design was insufficient for a great work; grace, the most amorphous of virtues, was of surpassing importance: "The rarest works, the most correct ones, even the most knowledgeable and profound ones, without a doubt, can be appreciated; but they won't always have the advantage of pleasing, if they are devoid of that divine charm one calls grace" (285–86).

Grace should be evident in all aspects of painting: composition, figures, expression, design, color, and execution, but it is not absolute. One's ideas of grace vary with one's inclinations, experience and country, but Coypel perceived a hierarchy, with Raphael at the top: "It seems that he wished to give a soul to the admirable statues of the ancient Greeks, which are and always will be the model of the most perfect beauty" (287–88).[7] Indeed, Coypel's artistic creed could be summarized with two lines from his *Epistre:* "The elegant design of antique sculpture, joined to the naive effects of nature." "Le dessin élégant de l'antique sculpture, Joint aux effets naïfs qui fornit la nature" (302).

Of course, Vasari had emphasized Raphael's grace, but Coypel gives the concept a decidedly eighteenth-century inflection. Commenting on Titian's color, Coypel recalled the battle of color versus design (294–95). One group's standard was Rubens; the other's was Poussin. To Coypel, who had been quite young at the height of the cabal, the argument made no sense. He could not understand why one would want to attack one aspect of painting to increase the value of another and, to be sure, the examples of *many* of their predecessors weighed heavily on Coypel's artistic generation.[8] In advocating eclecticism, he proposed a series of ideal models for each aspect of painting: Titian, Giorgione, and Correggio for color; Poussin, Raphael, Domenichino, and the antique for correct design; the Carracci, Michelangelo, and Correggio for *grand goût* in design; Correggio, Parmigianino, Guido, and Raphael for grace; and Rubens, Van Dyck, and Rembrandt for chiaroscuro and the total effect. Coypel suggested that, in almost any aspect of painting, if an artist wished to achieve renown, he should not depart too greatly from the examples of the great artists who had preceded him (*Discours,* in Jouin, 303). Perhaps it is not surprising that bold originality was not a distinguishing characteristic of this artistic generation.

With such an extensive pantheon of acceptable models, the diversity of styles and subjects was wide. Coypel's *Adam and Eve Rebuked by God* (1704; Museo de Arte de Ponce, Puerto Rico; Fig. 20) exemplifies this broad eclecticism. Although the composition is based on Domenichino and Rubens's Medici cycle, the figure of God the Father recalls

Fig. 20. Antoine Coypel, *Adam and Eve Rebuked by God,* 1704, Museo de Arte de Ponce, Puerto Rico

Raphael's *Vision of Ezekiel* (Fig. 21), and his handling of form recalls Correggio or the Bolognese.[9] Coypel not only preached eclecticism, he practiced it.

Raphael and the French Academy in Rome, 1690–1740

Although there was a clear shift of style and taste in the Academy around the beginning of the eighteenth century, as is evident in such works as Charles de la Fosse's *Bacchus and Ariadne* (1699) or Louis de Boullogne's *Diana Resting* (1707; Musée des Beaux-Arts, Tours),[10] the effects of that shift were not immediately felt in the Academy in Rome. Of course, one of the primary raisons d'être of that Academy had been providing access to some of Raphael's most exemplary works, and that emphasis did not change. Except for

Fig. 21. *Vision of Ezekiel,* c. 1517, Louvre, Paris

the period 1705–26, when Raphael's works were not accessible, they were studied assiduously and copied continuously from 1690 through the 1740s.[11]

Of course, French artists who came to Rome were not working in a vacuum. They would have been exposed to the strong classicizing current in Roman painting, exemplified by Maratti and his followers, among others. The Accademia di San Luca's role in maintaining the *grand goût* must also be considered.[12]

Although by 1691, eight of Raphael's Vatican frescoes had been copied, Mignard, who had been influenced by Raphael, suggested to the director La Teulière, that others could be copied, including the *Coronation of Charlemagne* and the *Oath of Leo III,* works particularly significant to the French. The *Coronation of Charlemagne by Leo III* was believed to represent the coronation of Francis I by Leo X. The other scene represented Leo III swearing an oath before Charlemagne. Both scenes obviously dealt with French

power in relation to Rome, and thus had a political as well as artistic significance.[13] One student Bocquet was also making preparatory drawings for engravings of the Farnesina (*Correspondance,* 1:207–8). With the shift of taste toward sensuous naturalism, this seems particularly appropriate.

In a letter of 26 January 1694, La Teulière stressed the exemplary qualities of Raphael. In discussing the exemplary qualities of Raphael's works for the development of young students, he called the Raphael rooms in the Vatican a "school without equal" (*Correspondance,* 1:447). Such a sentiment so clearly based on the image of Raphael as the "model history painter," could have been spoken by Le Brun. La Teulière continued to assign students to copy Raphael's works. Between 1694 and 1696, Favannes copied the *Galatea, Assembly of the Gods* in the Farnesina and the *Attila.* Beginning in 1696, La Teulière suggested that students copy in the Loggias.

Students also continued to copy the Vatican frescoes. In a letter of 17 March 1699, to the new *surintendant* Mansart, La Teulière recounted that Favannes was making a copy of the *Mass at Bolsena,* which, the director remarked, was one of Raphael's best-colored works. He also noted that, after making some copies in the Loggias, St. Yves had just finished the *Heliodorus* (*Correspondance,* 1:452–53).

Houasse, La Teulière's successor as director, continued the copying of Raphael's works, despite the penury of the state treasury. In a letter to Mansart of 26 July 1701, Houasse confirmed that he was doing everything possible to ensure that the copies were faithful to the originals (*Correspondance,* 3:80). The copies, including the *Fire in the Borgo,* the *Parnassus* and the *Attila* were made by St. Ives, Cornical, and Du Lin (*Correspondance,* 3:89).

With the directorate of Poerson (1704–25), the French Academy in Rome reached its lowest point. Louis sent him to Rome as a consolation, although Mansart had a low opinion of him as a painter.[14] The indifference of Mansart combined with the general lack of funds almost destroyed the Roman Academy. Louis XIV's defeats created a climate of ill-will in Rome in which the Vatican and other palaces were closed to students. Several times during the period no Grand-Prix winner was sent to Rome for lack of funds or a quality candidate. In 1705, the last pensionnaire left the Academy, so the director was left with no money and no students.

Poerson described the situation in Rome in a letter of 9 December 1704 to a Mr. Marignier. He stressed that copies made in the Farnesina fourteen years ago were in very bad shape. He had had to unroll them and place them in a gallery so that they could be seen; since the Vatican was closed to students, the copies might help to substitute for seeing Raphael's originals.[15]

Although the Vatican had been closed for several years, Poerson managed to obtain permission from the duke of Parma for the students to work in the Palazzo Farnese and Chigi (*Correspondance,* 3:173). One suspects that the director's concerns were primarily political, in justifying the continued existence of the Roman Academy by providing copies for the king's residences.

The situation in the Rome Academy was so disheartening that Poerson actually suggested abolishing it in 1707 (Pevsner, 104), and it was only kept from closing by the marquis d'Antin, Mansart's successor. The correspondence of Poerson, which told more

about Roman society than the labors of students, suggested an unprecedented, laissez-faire attitude on the part of the director.

From 1710 to the end of Poerson's directorate there was no mention of copying Raphael, which had been such a central part of the curriculum until then. This was from lack of opportunity, not indifference, since Raphael's works were still regarded as important examples. In 1724, Wleughels, a painter strongly influenced by Venetian naturalism, who was sent to Rome as co-director of the Academy, suggested renting the Farnesina to serve as the new home of the Academy (*Correspondance,* 7:48). Poerson supported the move in a letter to d'Antin of 26 September 1724 (*Correspondance,* 7:62), but ultimately the Chigi Palace was rented to someone else, and the Academy was moved to the Palais Mancini.[16]

Under the co-directorate of Wleughels and Poerson, there was an increasing eclecticism and a new concentration on nature, reflecting directions of the parent body. These attitudes were reflected in Poerson's summary of the pupils' activities in a letter to d'Antin of 7 November 1724: In addition to having students copy works by the Carracci and Domenichino, they were also being sent to sketch the remains of antiquity at Tivoli and Frascati (*Correspondance,* 7:84).

The Directorate of Wleughels (1725–1737)

After the lackluster directorate of Poerson, Wleughels was a dynamic leader who worked tirelessly on behalf of his pupils Although a friend of Watteau's, whose own paintings owed much to Veronese and something to Rubens,[17] Wleughels had a true appreciation of many different artists. His curriculum upheld traditional concerns, including the copying of Raphael's works, and opened his students' eyes to new possibilities. Through his personal connections he was able to obtain access for students to notable collections throughout Italy, as well as regaining access to the Vatican after a hiatus of more than twenty years. Despite his love of Venetian painting, Wleughels obviously felt that copying Raphael was an indispensable part of his students' education.

A letter to d'Antin of 8 November 1724, clearly expressed Wleughels's eclectic approach. In addition to his students' studying Poussin, Titian, the Carracci, and others, he planned to take them sketching to Tivoli, suggesting that the extraordinary natural and man-made elements would stimulate students' imagination and help inspire them to compose their works in new ways (*Correspondance,* 7:86). This practice of taking his students landscape sketching was radically new and in keeping with the new emphasis in the Academy on following nature more directly.

His encouragement of innovation in no way reduced Wleughels's esteem for traditional models, particularly Raphael. Indeed, Wleughels expressed the importance of studying Raphael in a letter to d'Antin of 4 October 1726:

> Everyone, except the architects, is drawing in the Vatican after Raphael and, this is
> what one must do to become facile, and if, for a century, painting has seemed to

decline from the perfection it had achieved, it is because one does not take enough trouble to become knowledgeable; one is content with what nature has given one, that one embellishes by practice, producing works which are passable and graceful, but, in truth, could never appear with the ancients, because they are neither as studied, nor as filled with erudition (*Correspondance,* 7:86)

This concentration on Raphael continued throughout Wleughels's directorate as he pointed out in a letter of 12 May 1729. He stressed that students were working in the Vatican, which was "the best study they could make, particularly for those who had the taste to understand the beauties of Raphael's works" (*Correspondance,* 8:26). Raphael's works were still regarded as essential to a young artist's training.

In addition to concentrating on Raphael, Wleughels had students copy a wide range of other models: the Carracci, Titian, Veronese, Domenichino, Guido, Pietro da Cortona and others (Hercenberg, 17–18). He also altered the orientation of copying from exact imitation to a selection of what was beautiful in each work. Wleughels would have agreed with de Piles that one did not copy an artist's faults (Hercenberg, 19–20).

With his belief in the importance of a wide variety of artistic models, Wleughels did not limit his efforts to Rome. In a letter to d'Antin of 13 February 1727, he suggested other places where students could profitably study: Florence, Bologna, Parma, Modena, and Venice. He stated in a letter of 1 July 1734 that he would have the pupils copy Raphael's works in the churches, which had never been copied, and by December 1734, a student had copied Raphael's *Prophet Isaiah* in the church of Sant'Agostino (*Correspondance,* 9:273).

The duc d'Antin was succeeded by Orry, the former finance minister, in 1736. In a revealing letter to Wleughels of August 1737, Orry set out a series of rules and procedures by which he desired the Academy to be run. It appears that the political desire to justify the expense of the Roman Academy, rather than artistic concerns were of primary importance to the *surintendant;* yet, Orry emphasized that one of the first objects of study for students should be Raphael's works. Less advanced students could copy parts of works; others could copy entire works (*Correspondance,* 9:316ff.). Studies after parts of works could be kept by students, but complete copies became the property of the king. Orry also sketched an ambitious project: to provide new copies of Raphael's works, to replace the copies that had been used as models for Gobelins tapestries (*Correspondance,* 9:316).

When the students copied, the director should instruct and correct them. They should apply themselves equally to their studies after antiquity and the model. Expressing a sentiment that could equally well have come from Poussin or Le Brun, Orry stated that "the study of antiquity had to form the basis for the mastery of painting and sculpture (*Correspondance,* 9:317). He suggested that the casts around the Academy be used for study, as well as decoration.

Wleughels immediately assigned Raphael copies to Blanchet, Frontier, and Duflos (*Correspondance,* 9:317ff.). His innovative, energetic teaching was in sharp contrast to the laissez-faire intellectual and artistic attitude of the parent Academy. During the reign of Louis XV, who had far less interest than his predecessor in artistic matters, the Academy in Rome became the dynamic body, in contrast to the stasis in Paris.

Directorate of De Troy

J. P. De Troy served as director of the French Academy in Rome from 1738 to 1751, a period of change in the parent body in Paris.[18] On De Troy's succession of Wleughels, Orry emphasized to him the importance of copying Raphael in the Vatican, urging him to make certain that the copies be as faithful as possible (*Correspondance, 9:377*). De Troy's letter of 12 August 1740, to Orry stated that students, including Favrai, Hallé, Duflos, Blanchet, and Van Loo were copying the *Fire in the Borgo, Heliodorus, School of Athens,* and the *Battle of Constantine.* Van Loo also wished to copy the *Mass at Bolsena* (*Correspondance, 9:431–32*).

As each new pupil arrived and was found capable, De Troy assigned him a copy in the Vatican. His memo on Academy activities dated 23 March 1746 stated that Le Lorrain and Challes were copying the *Parnassus,* and *Attila.* De Troy hoped shortly to give new arrivals Tersonnier and Vien, Vatican assignments (*Correspondance,* 10:105). By April 1749, Blanchet had copied the *Battle of Constantine;* Le Lorrain had finished the *Parnassus,* and Challes had completed the *Attila.* Tersonnier was beginning a copy of the *Disputà* and De Troy hoped to put Barbault to work in the Vatican as soon as he was capable (*Correspondance,* 10:173, 183, 198).

This copying enterprise went on until 1757. By this time ten copies had been delivered to the Gobelins to serve as tapestry models: *Attila, Battle of Constantine, Disputà, Parnassus, Apparition of the Cross to Constantine, Mass at Bolsena, School of Athens, Fire in the Borgo,* and the *Heliodorus* (*Correspondance,* 11:275). This enterprise had occupied the pensionnaires for twenty years, throughout what is generally termed the height of the Rococo.

We have seen that, except for a part of Poerson's directorate, copying Raphael's works was emphasized in the Roman Academy. In the 1670s and 1680s, Raphael had been one of a series of congruent examples, including Poussin, Le Brun, and the Carracci, presented as models for students. As a change in taste in the 1690s and thereafter was signaled by the ascendency of colorism, Rubens, the Rococo, and a broadened eclecticism, Raphael might no longer be such an obvious example. Yet La Teulière, Wleughels, and De Troy, under Orry's direction, made his works a focus of the curriculum.

In theoretical and pedagogical terms this emphasis on Raphael in the Rome Academy continued a major aspect of the aesthetics of the seventeenth-century Academy. In political terms, copying continued to provide a major justification for the existence of the Roman Academy. The authority of Raphael transcended matters of taste. But one would also like to know whether exposure to some of Raphael's greatest works and the practice of copying Raphael shaped the styles of the artists involved. Did the study of Raphael provide continuity in both practice and theory, or were his principles considered a hollow echo of the Grand Siècle, which an artist could ignore once he ceased to be a student? Had the act of copying Raphael taken on such symbolic importance in justifying the necessity of study in Rome, that copying him was essentially independent of prevailing artistic taste?

To put the question in slightly broader terms, To what degree did Raphael's works continue to exert a direct influence on French art? There can be no doubt that as taste shifted, the Rococo flowered; Raphael's overall impact lessened, yet never disappeared completely. As the dominant taste shifted toward sensuous naturalism, most of the major

painters of the first half of the eighteenth century, such as De Troy, De la Fosse, Lemoyne, Watteau, and later Boucher certainly owed more to Rubens than to Raphael.[19] Yet, Raphael's images were such paradigms that even Watteau occasionally turned to the Renaissance master for inspiration as in his *Judgment of Paris* (c. 1728; Paris, Musée du Louvre), in which the pose of the principal figure is based on Raimondi's engraving of the same subject.[20] Among the history painters whose careers continued through this period were artists such as Antoine and Noël-Nicolas Coypel and Jean Restout, whose works still revealed Raphael's inspiration, although they might translate his ideas into a slightly different aesthetic key.[21] Often in this period, Raphael's inspiration is filtered through seventeenth-century intermediaries, such as Poussin or Le Brun. For example, Raphael's paintings in the Farnesina, such as the *Wedding of Cupid and Psyche* (see Fig. 28), could serve as inspiration to painters of erotic mythologies, just as Raphael's images of the Holy Family had inspired so many French artists in the late seventeenth century. For example, Noël-Nicolas Coypel's *Rape of Europa* (1726–27; Philadelphia Museum of Art) can be traced back through Poussin's *Triumph of Venus* (c. 1635; Philadelphia Museum of Art) to Raphael's *Galatea.*[22]

In addition, in the eclectic atmosphere of the early eighteenth century, an artist might paint a Raphaelesque composition with Rubenesque handling, particularly when the subject called for the *grand goût.* A good example of this kind of translation is evident in Lemoyne's *Blinding of Elymas,* one of the final *Mays* done for Saint-Germain-des-Prés, in 1719. Such religious commissions provided a continuing outlet for works that combined the *beau idéal* with a more sensuous approach. Although Lemoyne was definitely a Rubenesque artist, he had copied Raphael's *Saint Michael* in 1710, had copied a dozen of Bouchardon's drawings after Raphael's works in the Farnesina, and clearly took many elements of his *Elymas* from Raphael.[23]

In fact, it was Bouchardon, the most classicizing of early eighteenth-century sculptors,[24] who most assiduously copied Raphael. Winning the Prix de Rome in 1722, just at the time when Wleughels was renewing the focus on Raphael in the Rome Academy, Bouchardon remained in the city for nine years, making extensive copies of details from Raphael's frescoes.[25] These studies formed the basis for his mature style. His drawing of the head of Galatea (Fig. 22) is typical in its emphatically sculptural modeling, hard contour, and linear purity, as if he were searching for the essence of Raphael's idealism.

As our view of the first half of the eighteenth century was broadened beyond that of the Goncourts to include history and religious painting as well as *fêtes galantes,* we have come to realize that the *grand goût* was not so totally supplanted by the *petite manière* of Watteau and Boucher as has sometimes been assumed. For artists who worked in the grand tradition, such as Antoine and Charles-Antoine Coypel, Jean Restout, Sebastien II Le Clerc, and others, Raphael's works were more than a hollow echo of an outdated tradition.[26] For example, the large *Ecce Homo,* done by Charles-Antoine Coypel, for the Congregation of the Oratoire in Paris (1729) would be unimaginable without the inspiration of Raphael's large figural compositions such as the *Disputà* (Fig. 23).[27] Although Jean Restout clearly reveals in his works that he is Jouvenet's pupil, some of his drawings are strikingly Raphaelesque. For example, in his drawing for the *Presentation of the Virgin in the Temple* (1740; Fig. 24),[28] the setting, composition, figure types, and gestures all recall Raphael's frescoes, such as the *Disputà.*

Sebastien II Le Clerc, a pupil of Bon Boullogne, also recalled Raphael and Poussin in

Fig. 22. Bouchardon, drawing after Raphael's *Galatea,* c. 1725, Louvre, Cabinet des Dessins, Paris

such works as the *Death of Saphire* (1718; Saint-Germain-des-Prés). Sebastien Le Clerc clearly absorbed some of Raphael's lessons by copying him. In drapery style, dramatic focus, and composition of figures in an architectural setting, his *Death of Saphire* recalls Raphael's cartoons, particularly *Saint Paul Preaching* and the *Death of Ananias.*[29] The apostle's hand gesture resembles one in the *Healing of the Lame Man.* Henri de Favanne's *Coriolanus* of 1725 followed Poussin as much as Raphael, but is so far removed from the Rococo as to seem neoclassical "avant la lettre."[30] Favanne's sense of dramatic focus and the rhythmic, but frieze-like composition recall cartoons such as the *Sacrifice at Lystra.* The man on one knee with an extended arm is found in both works.

 With so much emphasis on the expressive power of all parts of Raphael's figures, even to the point of engraving exemplary hands, feet, and heads, as well as individual figures (see Fig. 34),[31] it is not surprising that motifs from Raphael's works appeared in eighteenth-century history paintings. Raphael's sense of dramatic narrative and the statuesque grandeur of his figures provided unsurpassed examples for history painters. Many of the artists who copied Raphael in the Rome Academy during the first half of the century,

Fig. 23. *Disputà,* 1509, Vatican, Rome

such as Carle Van Loo, Collin de Vermont, Noël Hallé, and Blanchet, thus played a role in the revival of history painting that took place in the second half of the eighteenth century. In a sense, one could argue that Raphael, whose prominence was maintained by amateurs in Paris and artists in the French Academy in Rome, acted as a bridge between late seventeenth-century classicism and the neoclassical revival.

Fig. 24. Jean Restout, *Presentation of the Virgin,* drawing, 1735, Musée des Beaux-Arts, Rouen

Amateurs' Contributions (1700–1747)

As we have seen, amateurs played an important role in forming French art theory from Fréart and de Piles, through a long line of collectors, connoisseurs, and men of letters. Their works could have a broad influence, since they were aimed at the interested layman as well as the artists. In the late seventeenth century, the consolidation of the French artistic enterprise within the Academy provided the obvious focus for amateurs' efforts. With the decline of the Academy and the rise of bourgeois collectors such as Crozat, amateurs aimed their treatises at a still select, but growing audience. In the first half of the eighteenth century, many amateurs, such as Richardson and Abbé Dubos, acted to conserve classical doctrine, after its strictures had been abandoned by many artists. Others, such as the marquis d'Argens and Dézallier d'Argenville shared the new vogue for nature and modernity. For most of them, Raphael remained a prime example who could not be ignored.

The Works of Jonathan Richardson

Perhaps Jonathan Richardson saw himself as the English de Piles.[1] Like de Piles he was a theorist, connoisseur, painter, and collector, addressing his works to interested laymen and artists. His works included the *Theory of Painting* (1715), *Essay on the Art of Criticism* (1719), *Science of the Connoisseur* (1719), and *An Account of some of the Statues, Bas-reliefs, Drawings and Pictures in Italy* (1722), a critical catalog, written with his son's assistance, of works by artists of all schools and periods.[2] This treatise could serve as a guidebook for the Grand Tour or a list of resources for the artist. It differed from most of the treatises by French amateurs in that it was based on detailed scrutiny of the actual works. In it, Richardson attempted to use the principles of criticism and connoisseurship espoused in his theoretical works to judge past masterpieces.

Richardson, borrowing freely from Vasari, Fréart, Dufresnoy, Félibien, Bellori, de Piles, and others,[3] presented few original ideas in his *Theory of Painting*. Instead, he sought to create a clear system of understanding, appreciating, and evaluating works of art. An orthodox classicist, Richardson, like Bellori, believed that antiquity and Raphael provided the best models for the selection and improvement of nature to reach the ideal (*Works,* 72). He thus reinforced the ideals of the seventeenth-century Academy at a time when that aesthetic had been transformed in France.

For Richardson, painting was an important liberal art capable of showing great men in exemplary actions, improving on nature, pleasing and instructing the viewer, heightening one's own perceptions and helping us visualize what we read, and raising the level of our ideas and sentiments. He felt Raphael's work, particularly his cartoons, fulfilled all these functions (*Works,* 6–9). More familiar with the cartoons, which were in England, than with Raphael's other works, Richardson considered them Raphael's greatest masterpieces. Like Fréart, Richardson used Raphael consistently as the example of his general principles of painting. According to his system of values, a nobly executed subject based on the ideal selection from nature produced perfection in painting (*Works,* 72).

Richardson reserved his highest praise for "grace and greatness," qualities he deemed essential to great painting. These virtues were evident in Raphael's cartoons, such as the *Miraculous Draught of the Fishes* (Fig. 25) and the *Sacrifice at Lystra* (Fig. 26):

> When a man enters into that awful gallery at Hampton Court, he finds himself amongst a sort of people superior to what he has ever seen and very probably to what those really were. Indeed this is the principal excellence of those wonderful pictures, as it must be allowed to be that part of Painting, which is preferable to all others. What a grace and majesty is seen in the great apostle of the gentiles, what a dignity is in the other apostles wherever they appear, how infinitely and divinely great, and genteel is the Christ. (*Works,* 74)

He even suggested that Raphael had surpassed antiquity: "Rafaelle was the modern Apelles, not however without a prodigious degree of greatness. His style is not perfectly antique, but seems to be the effect of a fine genius accomplished by study in that excellent school; it is not antique, but (may I dare to say it) it is better, and that by choice and judgement" (*Works,* 86). For Richardson, the sublime was the highest level of perfection:

Fig. 25. Cartoon, *Miraculous Draught of the Fishes,* c. 1515–16, Victoria and Albert Museum, London

"Certainly it is that to possess a thousand good qualities moderately, will but secure one from blame, without giving any great pleasure, whereas the sublime wherever it is found, though in company with a thousand imperfections, transports and captivates the soul; the mind is filled and satisfied" (*Works,* 96). For this reason a painter must not only avoid faults, do reasonably well, and try to please, he must surprise. Directly contradicting de Piles, Richardson asserted that Raphael did this more than any other artist (*Works,* 96–97).

In *Connoisseurship,* Richardson called for an unbiased appraisal following a Cartesian system based on reason. Since no work is perfect, one should appreciate its good qualities, but also recognize its faults (*Works,* 109).

Richardson believed that one could judge a work's quality by the extent to which the artist followed the rules, but he also acknowledged another quality: to what degree a

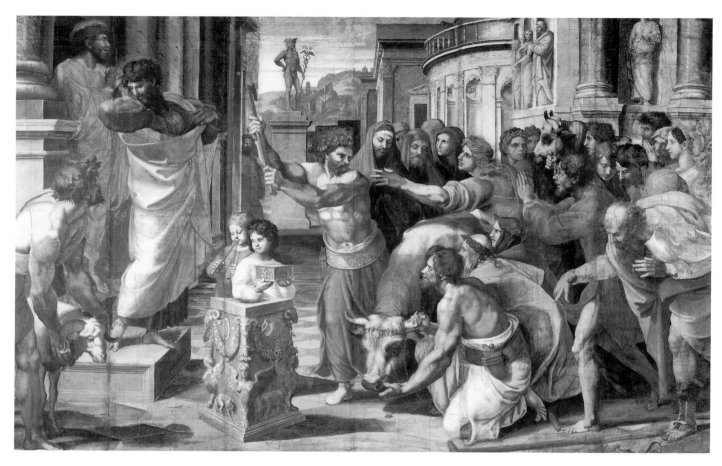

Fig. 26. Cartoon, *Sacrifice at Lystra*, Victoria and Albert Museum, London

picture served the ends for which it was intended. He spoke as a man of the eighteenth century when he saw these ends as pleasure and improvement, but he clearly saw the latter as superior: "Painting is a fine piece of workmanship; it is a beautiful ornament, and as such gives us pleasure, but over and above this, we Painters are upon the level with writers, as being poets, historians, philosophers, and divines; we entertain, and instruct equally with them" (*Works,* 117–18). In his emphasis on painting's didactic role, Richardson foreshadowed the views of Diderot and other Enlightenment philosophers.

Richardson established a hierarchy of the parts of painting based on the extent to which they both pleased and instructed. They ranked from lowest to highest as follows: paint handling, drawing after pure nature, coloring, composition, expression, invention and grace, and greatness (*Works,* 120). With the exception of his views on the "French school," his appraisal of the relative merits of various schools agreed with Félibien. The French would not have agreed with his assessment of Rubens: "Rubens himself lived, and died a Fleming, though he would fain have been an Italian; but his imitators have caricatured his manner, that is they have been more Rubens in his defects, than he himself was, but without his excellencies" (*Works,* 205).

In his *Traité de la peinture et de la sculpture,* published in 1722 and translated into French in 1728, Richardson continued to devote his critical attentions to Raphael, focusing on specific drawings, panel paintings, and frescoes. Richardson's son had seen all of these works firsthand, in private collections and public places. The treatise analyzed most of Raphael's important works. Although Raphael was a major example of proper painting for the Richardsons, they still attempted to criticize his works without bias or preconceptions. Like the French, Richardson used Raphael's reputation for its symbolic value. If even Raphael had imperfections, one must certainly expect them in less divine artists and judge each person objectively, on his merits (preface, n.p.).

For virtually the first time, Richardson actually viewed closely at firsthand and criticized specific works, transcending the limitations of what had become critical clichés. He discussed a number of works that had not appeared in the French artistic literature. One of these was the *Madonna della Sedia,* which Richardson discussed at some length (see Fig. 63). Although he praised the beauty of the attitudes of the Virgin and Christ, he did not feel that Christ was so sublime as in some of Raphael's other works. He also praised the color and chiaroscuro (*Traité,* 122). This was uncommon praise for Raphael. Although the work was well drawn, there was something awkward about one of the Virgin's hands and the forward foot of Christ.

Richardson praised Raphael as a great portraitist, not confining his remarks to history painting. Discussing the portrait of *Leo X with Two Cardinals* (Fig. 27), he stated, that except perhaps, for Van Dyck's works, this portrait was one of the finest. He particularly praised the work for the dignity and nobility of the subjects, qualities characteristic of all Raphael's works (*Traité,* 128).

Richardson's ideal portrait would combine the virtues of Raphael, Guido, and Van Dyck. Discussing scenes from the Farnesina (Fig. 28), Richardson showed far more knowledge of the work and discernment than most of his predecessors. He pointed out that except for two or three figures, Raphael's role was limited to designing. In addition, the restoration by Maratti and others had been so extensive that the frescoes no longer represented the original in most places. Although there are beautiful parts, single figures, etc., the quality was very uneven, and the overall compositions of the large scenes lacked harmony (*Traité,* 190).

Although Bouchardon, who had copied the work, had found it a model of the *beau idéal,* Richardson also criticized the *Galatea* (Fig. 29):

> She does not correspond to the idea that I had formed of her. The face of Galatea is neither beautiful, nor perfectly drawn. . . . It stands out so strongly from the background, it appears to be mounted like a piece of Marquetry, but no doubt, this is partially caused by color changes. The color of the complexion, which is an ugly, dark red, is unpleasant.[4]

These criticisms would be echoed by Mengs later in the century. Criticism of the *Galatea* indirectly criticized Raphael's ideal, since in the famous letter to Castiglione, Raphael used this work to exemplify how he based his image on a certain idea of beauty rather than a single model.

Instead of simply establishing a priori painting principles and then finding these in

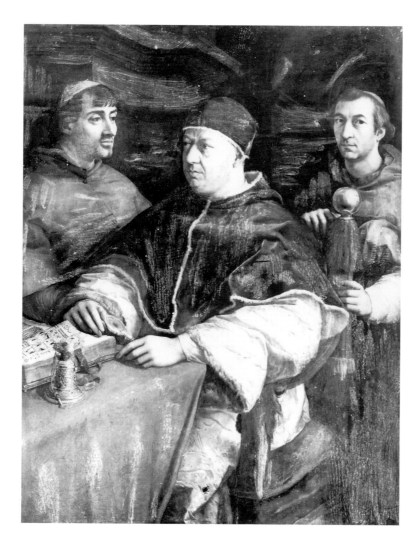

Fig. 27. *Leo X with Two Cardinals,* c. 1518, Florence, Uffizi

Raphael's works or sticking to vague generalities as most earlier critics had done, the Richardsons, father and son, attempted to take a fresh look for themselves, yet the well-established images of Raphael shaped their criticism as well. Comparing Raphael and Correggio, Richardson showed that he did not completely eschew contemporary sensibilities: Raphael was great and sublime with a kind of grace that resembled the best of antiquity, but no one surpassed Correggio in natural grace (*Traité,* 293).

Richardson was much more aware than his predecessors of the nuances of Raphael's style. Although every writer from Vasari on had acknowledged three periods of Raphael's development, Richardson was the first to make individual differences between works a basis for criticism. He was sensitive to works at different stages of Raphael's career, of works designed by, but not executed by the master and of restorations. In many ways he was the first true critic to draw his conclusions directly from the works.

Like all his predecessors, Richardson discussed the Vatican frescoes at great length; Unlike them, however, he did not believe that the Stanze contained Raphael's greatest

Fig. 28. *Wedding of Cupid and Psyche,* Farnesina, Rome

works. Although he noted praiseworthy parts, he believed that the cartoons at Hampton Court provided a much better example of Raphael's prowess.[5] Discussing the individual scenes, he agreed with Bellori, in opposition to Vasari, Félibien, de Piles, and others that the *Disputà* was executed before the *School of Athens,* seeing a real advance in conception and technique from one to the other. The *Disputà*'s sublime subject presented a great opportunity, one that Raphael did not realize completely. Richardson believed that if the work had been done more in the manner of the Cartoons, it would have been better executed (*Traité,* 338). The work still achieved its ends by exciting piety and devotion, by its lively, noble representations and strong expressions, but only to a degree (*Traité,* 349).

Although the *School of Athens* had a less sublime subject, Raphael created a powerful realization of reasoning man. No artist since the ancients had so richly expressed man's dignity, wisdom, and character (*Traité,* 350). Richardson found Raphael's *Allegory of Poetry* less successful, criticizing Raphael for not sufficiently distinguishing the character of

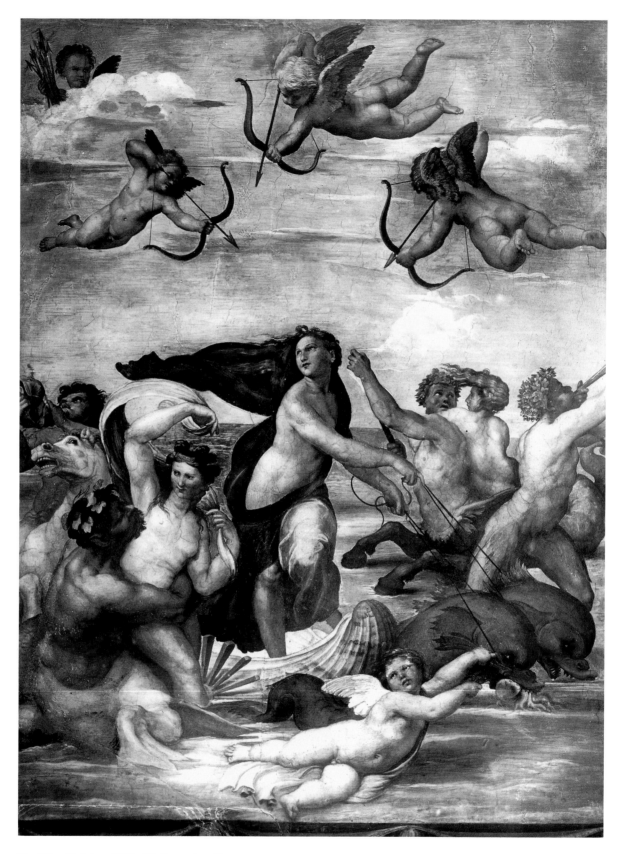

Fig. 29. *Galatea,* 1511–12, Farnesina, Rome

the figures in the *Parnassus* from those in other scenes, suggesting that the figures were not pleasing enough to match the poetic subject (*Traité*, 363, 367). Even Apollo, who should be noble and majestic, seems ordinary. This was rare criticism of Raphael's sense of propriety.

Richardson accepted the qualities of execution and style that others had found admirable in the Vatican frescoes, even praising some aspects of Raphael's color and chiaroscuro, but he criticized Raphael's invention, his way of visualizing the scenes (*Traité*, 380). He suggested that although individual figures were represented excellently, the compositions as a whole did not work to represent poetry or philosophy (*Traité*, 381).

In many ways Richardson found the Stanza d'Eliodoro more successful than the Stanza della Segnatura. He praised the powerful expression of the *Heliodorus*, finding the focal group particularly well conceived (*Traité*, 385). Richardson quoted Abbe Dubos's praise of color and expression in the *Mass at Bolsena*. Elaborating on Vasari's description, Richardson praised the lighting in *Saint Peter Freed from Prison*, calling it "the most beautiful nocturne in the world" (*Traité*, 395). After discussing the Stanza dell'Incendio, Richardson pointed out that most of the room of Constantinian frescoes had been executed by Raphael's pupils. Richardson felt that the *Holy Family of Francis I* and the *Transfiguration* (Fig. 30) were the only works other than the cartoons that adequately revealed Raphael's highest talents. As oil paintings they had certain advantages over the frescoes in finish and force of presentation, but these were not the qualities for which Raphael was renowned (*Traité*, 441–42).

The cartoons were superior to the Vatican frescoes for a variety of reasons: The medium was preferable to fresco; the subject was more in keeping with Raphael's character. The form of the frescoes detracted from them. The cartoons were made entirely by the master and at a more advanced stage of his career. The composition and expression of the cartoons are far superior, and the subject is more significant and elevated. He concluded that the only reason the cartoons were less famous than the frescoes was their location in England instead of Rome (*Traité*, 444ff.).

Richardson did believe that the *Transfiguration* was Raphael's greatest single work. He found the use of chiaroscuro to highlight the central action particularly admirable. He even made allowances for changes that had occurred with time, suggesting that some of the subtlety of chiaroscuro, which would have unified the work more fully, had no doubt been lost (*Traité*, 611–12). Although Richardson criticized Raphael for violating the biblical story and the Aristotelian unities of time and place, suggesting that each part could make a separate picture, he still believed that it was a magnificent work. In praising the work, he tied it closely to the central mythic images of Raphael:

> Is this not the the principal, single work that he ever gave to the world, and which, perhaps, has ever been made? The subject is one of the most magnificent which could occupy the human imagination. . . . It is the most perfect genre of painting; Certainly, it is much superior to any of the Ancients' works; It is in oil, very-finished, and by the greatest master of all time. . . . It is his last work, executed at the height of his powers; and it is all by his hand. (*Traité*, 612)

Richardson's *Treatise* and other works must have enjoyed wide popularity, since they were almost immediately translated into French. They also quickly drew fire for the

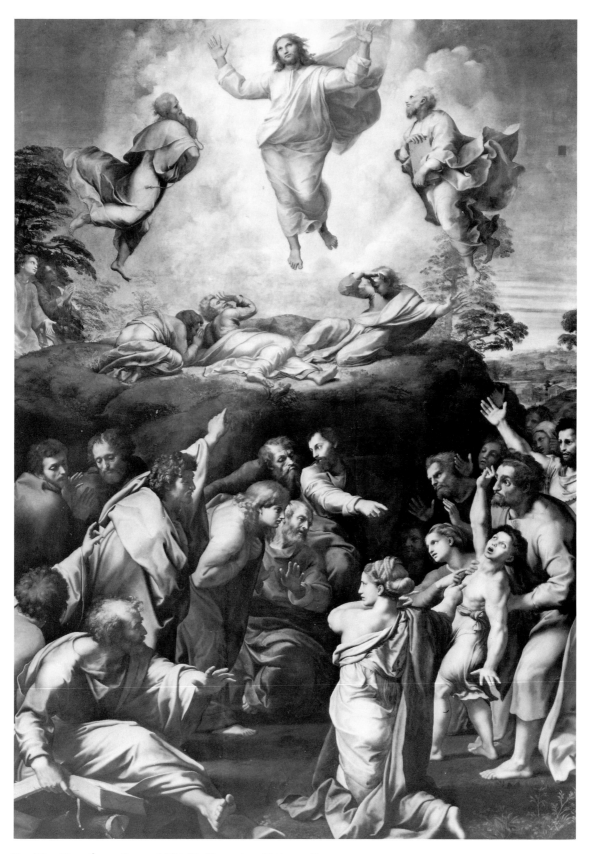

Fig. 30. *Transfiguration,* c. 1517–20, Pinocoteca Vaticana, Rome

opinions expressed about Raphael's works. In the preface to his translation of Dolce's *Aretino* (1735), Wleughels attacked the Richardsons' judgments (Hercenberg, 189–92). This is not surprising, since Wleughels obviously held the Vatican frescoes, which Richardson had criticized, as among the finest examples of the painter's art. The attention given to Raphael by Richardson is paralleled in the writings of French travelers to Italy, such as the comte de Caylus, président de Brosses, and Cochin.

Richardson's theoretical ideas on Raphael added some new nuances to the established French images of the artist. He reaffirmed the view of Raphael as the modern Apelles, with the novel twist that Raphael had surpassed the ancients in certain ways. He also reinforced the notion that Raphael's works were models for history painters, arguing that the cartoons represented the epitome of Raphael's art, a view strongly challenged in France despite the inspiration the cartoons provided to so many French artists. He also pointed out nuances of the Vatican frescos and other works on which French theorists had not commented. Richardson introduced the novel idea that Raphael had achieved his sublimity by means of simplicity, a notion that seems to have influenced Winckelmann.[6] Perhaps his most significant contribution was in terms of his examination of specific works with an unprecedented specificity and acuity. We find many of his specific judgments either echoed or challenged by later French theorists and critics.

French Amateurs' Contributions: The Crozat Circle

One could argue, as has Thomas Crow, that the center for the development of French art theory in the early eighteenth century was no longer the Academy. So many of the important artists and amateurs of the period gathered in the circle created by the great collector Crozat, that his gatherings constituted a kind of "shadow academy." Crozat acquired political influence and amassed his own great collection by directing negotiations for the duc d'Orléans, the regent, in acquiring the great collections of the Odascalchi family, which they had indirectly inherited from Queen Christina of Sweden.[7] Crozat's collection, which contained thousands of drawings and many paintings, contained numerous works by Raphael, which were catalogued by Crozat's friend Mariette, the son of the leading print dealer in Paris and the greatest connoisseur of his time.[8] Even before these works arrived in Paris, the duc d'Orléans suggested making the public aware of them through the publication of a corpus of reproductive prints. This project evolved into a much more elaborate publication, indeed, a history of Italian art, that became known as the *Recueil Crozat*. The works of Raphael were considered the most important in the collection, literally defining it as a collection of the highest quality.[9] Thus the bourgeois collector Crozat demonstrated that Raphael's prestige was not the exclusive property of the Academy.

Among the artists who congregated at Crozat's were Charles de La Fosse; Antoine Coypel, the major theoretical voice of the Academy in the early eighteenth century; Nicolas Wleughels, who played such an instrumental role as director of the French Academy in Rome; Rosalba Carriera, the great pastel portraitest; and Watteau. The list of amateurs and critics who congregated there was equally luminous: P. J. Mariette, a great connoisseur and

collector in his own right; Jean de Julienne, patron of Watteau; the Abbé Dubos, who wrote the most important aesthetic text of the period; the comte de Caylus and Louis Petite de Bachaumont, who assumed influential positions as amateurs and critics around mid-century.[10] Although Roger de Piles died in 1709, his masterwork the *Cours de Peinture,* was produced under a pension from Crozat, all his works were in Crozat's library, and his ideas were well known and much discussed by the members of that circle. In addition to serving as a forcing ground for the birth of the Rococo, the Crozat circle also provided a site for the maintenance of the *beau idéal.*

In the early eighteenth century, the collection of the duc d'Orléans in the Palais Royale, much of which was acquired through the assistance of Crozat, was more accessible to the public than the Royal Collections in the Louvre (Crow, *Painters,* 41). This collection contained more than fifteen works attributed to Raphael and, along with Crozat's own collection and the writings of many of the Crozat circle, would have been a factor in maintaining taste for the *grand goût* in the first half of the eighteenth century.[11] Now that we have established the general artistic climate, we can consider the specific ideas of French amateurs.

Abbé Dubos's *Réflexions*

Judging by its number of editions, Abbé Dubos's *Réflexions critiques sur la poésie et sur la peinture* was one of the most widely read treatises of the eighteenth century.[12] It was even included in the Academy library.[13] Preceding Diderot, Dubos felt that the great force of the arts was their ability to move the spectator's emotions. Concentrating on the conceptual aspects of poetry and painting, Dubos believed Raphael's works exemplified the expressive power tempered with propriety, which he saw as the sine qua non of the painter's art. In this, he extended a view of one of Raphael's major virtues already well established in France. Looking at painting with literary values, like Fréart de Chambray, he saw Raphael as the storyteller par excellence whose realizations of themes were appropriate to his elevated conceptions. Describing the *Attila,* he stated that it was not the illusion itself that gave us pleasure, but its power to move our emotions. Rejecting de Piles's notion that the impact of a work derived from its direct visual impact,[14] Dubos asserted that the impact came from the work's *vraisemblance,* which enabled the viewer to experience much the same emotional response that one would have in viewing the actual event depicted.[15]

Although Dubos concentrated on the expressive force of Raphael's works, he discussed their sensuous qualities as well. After conventional praise of Raphael's invention in the *Mass at Bolsena,* Dubos praised his colorism:

> The color of this work, which is why we are speaking of it, is very much superior to the color in other works by the master. Even Titian had not painted flesh better, such that one sees the softness of a body composed of liquids and solids. The drapery looks like the beautiful materials of linen and silk which the tailor uses. If Raphael had made many works with such true and rich color, he would be considered one of the greatest colorists. (*Réflexions,* 1:48–49)

Not constrained by the Academy's dichotomy between Raphael and Titian, Dubos could appreciate to a greater extent Raphael's colorism in one of his richest works. Yet, unlike de Piles and like the members of the seventeenth-century Academy, Dubos regarded Raphael's color solely in terms of verisimilitude, rather than as a key expressive element.

For Dubos, as for Antoine Coypel, the question of the respective merits of color and design was pointless. One could legitimately ask what Le Brun's rank was among the designers or Titian's among the colorists, but it was pointless to ask whether Le Brun was preferable to Titian. All men judged according to their particular inclinations and prejudices. Like de Piles, Dubos was interested in the effect of a work, rather than in the absolute standard of quality so he saw all value judgments as subjective and relative. According to him, the greatest painter is the one whose works give the greatest pleasure (*Réflexions,* 1:470). With his literary taste and sensibilities, Dubos preferred Raphael. Like Diderot, Dubos liked Raphael's works because their powerful realizations of great themes affected him. Raphael's oeuvre truly embodied *ut pictura poesis.*[16] Yet, he would not deny different tastes.

P. J. Mariette

P. J. Mariette, a royal administrator who was a collector, connoisseur, a close friend of the great collector Crozat, and an influential amateur with close ties to the Academy, helped to perpetuate the taste for the grand manner of Raphael, Michelangelo, and Annibale through the first half of the eighteenth century. Unlike earlier French critics of Raphael, Mariette, the son of a connoisseur and dealer in engravings, was a true connoisseur, with a broad knowledge of Raphael's works, particularly of drawings and engravings after his designs. In 1717, Mariette had written the catalog for the extensive collection of engravings his father had sold to Prince Eugene of Savoy. In 1719, he traveled to Italy where, through his connections, he met many collectors and other amateurs, such as Monsignore Bottari, with whom he corresponded a great deal on artistic matters after returning to France.[17] In 1735, Mariette began a catalog of engravings in the Royal Collection. At this time, he also frequented the Crozat circle. In 1740, Mariette was given the task of cataloging Crozat's collection of 19,000 drawings, including many by Raphael.[18]

His ideas on art and artists are found in his *Notes manuscrites,* written between about 1740 and 1770, a portion of which were published posthumously as his *Abécédario.*[19] Although he was friendly with Watteau, he could appreciate Boucher's facility and Fragonard's free invention. He was displeased with the virtuosities of such Rococo masters as Meissonier, whose works departed from the rules of "beautiful and noble simplicity" (Bacou, 8)

Like his contemporaries, Mariette was not averse to everything other than classical art. He admired Rubens and Rembrandt, and was enchanted by Boucher's facility. By and large, however, Mariette favored artists who had attempted to adapt the *grand goût* of the seventeenth century to the new sensibilities of the eighteenth: Antoine Coypel and Lemoyne. He was also enthusiastic about a new generation led by his friend Bouchardon who, he felt, recovered a sense of grandeur and noble simplicity in modeling his art on

antiquity and the great Italian masters. For Mariette, as for de Piles, Antoine Coypel, and so many others, Raphael, although greater than most, was still only one among many favored artists (Bacou, 8).

Mariette was certainly aware that his taste for the *grand goût* was not universally shared: "They make fun of the amateurs who, like me, prefer the works of the Italian masters to those of the Low Countries. Those works are so in vogue that one tears them out of one's hands, and showers one with gold and silver in order to have them. This fashion has by no means prevented me from following my taste" (Bacou, 8). Mariette's sentiments echo de Piles's (with whose works he was obviously familiar) in stressing that Raphael only lacked a mastery of color to bring his painting to perfection.[20]

Appended to Mariette's general comments on the artist in the *Abécédario* was an annotated catalog of more than one hundred drawings and engravings by and after Raphael from the Cabinet Crozat, one of the most extensive collections of the period. His annotations took the form of critiques of specific works.[21] Although his general view of Raphael was clearly based on Vasari's ideas as modified by seventeenth-century French artists and amateurs, and further transformed by de Piles, his judgments were refined through detailed scrutiny of Raphael's works. His ideas about specific drawings or engravings were constantly refined, as can be seen in his manuscript notes, in which passages are crossed out, modified, and amended. He was particularly careful to distinguish between engravings done during Raphael's lifetime by Marc-Antonio and others, and those done later.[22]

Among the works he described was a drawing for the *Massacre of the Innocents* showing a soldier with a sword and a woman by his side. Mariette praised Raphael's facility and expressive power at length, suggesting that in such studies, one could best appreciate Raphael's genius. Even though the heads of the soldier and the woman are only formed with four strokes, one can already clearly read the passions: the fear of the woman and the fury of the soldier. Mariette asserts that the emotions are conveyed with such sensitivity, that no one could fail to be moved (*Abécédario*, 4:273). Here Mariette adopted Abbé Dubos's chief criterion for excellence, but with a connoisseur's appreciation for the visual means of achieving the desired expressive end.

Mariette revealed the height of his admiration for Raphael in his praise of the sublime qualities of an engraving after the *School of Athens* (*Abécédario*, 4:332). In praising an engraving by Raimondi after Raphael of *Alexander Depositing the Books of Homer,* he spoke of the artist as the modern Apelles, in terms which would recommend him as an example for neoclassicists. He pointed out that in this particular work, Raphael had imitated antique bas-reliefs, of which he had made a careful study (*Abécédario*, 4:331–32). Further, in discussing a series of engravings of *Christ and his Disciples* by Sylvestre de Ravenna after Raphael, Mariette supports Raphael's role as the model history painter, suggesting that his works had been used so much by painters, that it was difficult to find prints in good condition (Wildenstein, ed., *Notes manuscrits,* 1:98).

Mariette's taste for the Italian *grand goût* can be contrasted with that of the marquis d'Argens, the leading apologist for the French school, whose views represented a particular extreme, rather than a norm. In his *Réflexions critiques sur les différentes ecoles de peinture* of 1752,[23] the marquis attempted to prove that French painters had equalled or surpassed all of their predecessors, including Raphael. He also argued that study at

Rome, the fountainhead of classicism, was unnecessary, since one could study design from plaster casts of antique works. As for color, nothing surpassed the Medici cycle by Rubens (21).

Attacking Raphael, Argens quoted and exaggerated de Piles's criticisms, suggesting that Raphael had neglected color, landscape, and chiaroscuro. Even if his contours were a bit harsh, he still had a large number of excellent qualities (*Réflexions critiques,* 40–41). He went on to give Raphael the conventional praise for design and expression, particularly in the Vatican frescoes, but implied that knowing these works through engravings was good enough.

Much of the marquis d'Argens's passage on Raphael is devoted to a comparison with Le Sueur; indeed, he argued that Le Sueur, who had never visited Rome, equalled and even surpassed Raphael. Considering what Le Sueur's art owed to Raphael, this claim seems all the more chauvinistic. He compared an engraving after each of the same subject, the *Parnassus:*

> Viewing these engravings could prove, not only that Le Sueur understood landscape better than Raphael, but that he composed in a more gallant and picturesque manner than the Roman painter. At the very least, one can be assured that the Frenchman has demonstrated that he has as extensive and fecund an imagination as the Italian. (*Réflexions critiques,* 47)

According to the marquis, the essence of painting was perfect imitation, which is equally dependent on design and color. Since Raphael and his contemporaries had an imperfect mastery of color, a notion of the essence of painting based solely on their works would be imperfect (*Réflexions critiques,* 29). Marquis d'Argens differed with de Piles in stressing the French rather than the Flemish school, but he also rejected the idea that the Italians, particularly Raphael, provided a necessary and self-sufficient artistic model.

Dézallier d'Argenville

Perhaps the attitudes of most men of the first half of the eighteenth century were best summarized by Dézallier d'Argenville in his *Abrégé de la vie des plus fameux peintres* (1745).[24] Although an ardent *Rubéniste,* he had great admiration for Raphael:

> He knew how to unite the nobility, elegance, and correctness of antiquity with the truth of nature: rich in his inventions and in his compositions, he brought together noble attitudes, fine and powerful expressions, admirable draperies . . . what delicacy of thought! what grandeur of idea. . . . Ultimately, all these perfections taken together render him, without contradiction and without taking anything away from Michelangelo, the greatest painter until this day. (1:10–11)

Echoing de Piles, Dézallier d'Argenville believed that Raphael was approaching a richer comprehension of nature's beauties in his last works. Discussing the *Transfiguration,* he

suggested having mastered the beauties of antiquity, Raphael could have gone on to acquire color as fine as that of Titian, and technique as elegant as that of Correggio (*Abrégé,* 1:11). He could appreciate Raphael's beautiful inventions and elevated thoughts, but he saw additional virtues in contemporary works: "A light and supple touch, svelte and elegant figures, natural attitudes, and ample, flowing drapery."[25]

Although he still believed that history was the most elevated genre, d'Argenville no longer embraced the absolute hierarchy that had predetermined the value of a painting based on its subject. History might be the highest, most instructive form of painting, but a painter, such as a master of still life, who could imitate nature perfectly, was as perfect in his genre, as Raphael was in his (*Abrége,* 1:xviii). Could he have been thinking of Chardin?

Although these amateurs varied in their level of knowledge and in their orientations—from the connoisseurs, such as Mariette and the Richardsons, to men of letters, such as the Abbé Dubos—all helped to preserve Raphael's prominence in the more eclectic atmosphere of the first half of the eighteenth century. They also revealed the powerful impact that Roger de Piles had in transforming the prevailing view of Raphael. Even the marquis d'Argens, who ardently believed in the superiority of French painting, maintained the classical ideal and chose Raphael as the example against which he had to prove his point.

Part Three

*Raphael in the Neoclassical Revival
(1747–1793)*

THE YEAR 1747 was not an entirely arbitrary choice for Jean Locquin to begin his study of the revival of history painting in France.[1] The date marks the beginning of the marquis de Tournehem's term as *surintendant;* Tournehem, along with his successors, instituted measures to promote history painting. Regular Salon criticism also began in this year, including a call for more serious subjects, particularly antique ones, by La Font de Saint-Yenne and others. The notion that painting should instruct, not simply delight, was in accord with the general tenor of Enlightenment thinking. The Ecole des élèves protégés was established to upgrade the quality of students sent to Rome.[2] After many years of stagnation in the Academy, regular *conférences* were reinstituted with their former prominence. Regular Salon exhibitions were also instituted. As Locquin and others have argued, these changes were part of the effort by the *surintendants* to force changes in the Academy's values and practices from above and to restore the Academy to the relationship it had had with the state in the late seventeenth century.

Yet, if we see these years as an absolute break with the all-pervasive Rococo, we distort the history of French painting in general and the importance of Raphael in particular. As we have seen, the *grand goût,* although transformed, did not entirely die out in the first half of the eighteenth century. In his recent study *Painters and Public Life in Eighteenth-Century Paris,* Thomas Crow has placed the developments discussed above in the political context of the rise of Madame de Pompadour and her family to positions of prominence within the French court. Although Raphael had a place in these efforts, the rise of a public sphere for art and the shifts in taste that had occurred in the early eighteenth century had changed the terms of the equation. Norman Bryson has described these changes as a return to a discursive mode in French painting, minimizing the role of style or other aesthetic values, and Michael Fried has explained them in terms of the shift from an absorptive to a theatrical conception of painting.[3] There are a variety of meaningful perspectives on these developments. My purpose is not to give an absolute explanation of the readily perceived changes in French theory and painting, but to trace the role of Raphael in them.

As we have seen, the classical ideal represented by Raphael was never abandoned, particularly in theory, although it was no longer preeminent. The taste of the patrons of Boucher, including the king and Madame de Pompadour, and Boucher's contemporaries lay in other directions. Yet, Antoine Coypel, the directors of the Rome Academy, and amateurs of the Crozat circle had kept the Raphaelesque ideal and the *grand goût* alive.

The period 1747–93 saw history painting and the classical ideal returned to preeminence, but not without a struggle. This neoclassical revival, which was one key aspect of a shift back to what was seen as a more serious and elevated conception of painting, certainly affected the view of Raphael's art. French neoclassicism was shaped by foreign theorists, such as Winckelmann, Mengs, Algarotti, and Reynolds, who evaluated Raphael based on a growing taste for and knowledge of antiquity. To measure the impact of their ideas, we must define Raphael's position in France prior to 1760. We can then differentiate between foreign and French views of Raphael. Finally, we can attempt to understand how the assimilation of foreign artists' and amateurs' views affected Raphael's prominence in France during the neoclassical period.

Artistic Ferment Around Mid-Century

Raphael in Mid-Eighteenth-Century *Conférences*

In the first half of the eighteenth century, most *conférences* had been devoted to memoirs of former Academicians or rereading of earlier lectures. The reestablishment of regular *conférences*—at the instigation of the *surintendant,* Marigny—presenting theoretical material, manifested a renewed didactic spirit in academic instruction, an attempt to again define the essential aspects of art. Crow has convincingly argued that these attempts to reconstitute the authority of the Academy were in the service of the "dynastic ambitions" of the *surintendants* and were aided by amateurs, such as the comte de Caylus, who had been nurtured in the Crozat circle (*Painters,* 110– 18). These *conférences* provide a means of assessing artistic ideas at mid-century;[1] they are not significant for their originality, but rather for their resurrection of Raphael's well-established symbolic images at a crucial period in the foundation of neoclassicism. (It is worth noting that most of these conferences were given by history painters, who would tend to favor the *grand goût.*)

Justifying the academic system in a lecture entitled "Discourse on the Necessity of Receiving Advice," of 1 July 1747, Charles-Antoine Coypel,[2] whose work, as we have noted, revealed Raphael's influence,

referred to Raphael's example, suggesting that Raphael had aggrandized his style by studying Michelangelo's works, without abandoning the grace and simplicity that characterized his work (*Conférences académiques,* 1:66). When Coypel wished to justify academic eclecticism, he revived this image of Raphael as an eclectic.

In a *conférence* of 4 May 1748, entitled "Observations on the Advantages of Academic Lectures," Desportes[3] suggested that artists could only develop their talents by following accepted rules and principles and studying judiciously. As an example, Desportes compared the untutored genius Correggio with Raphael, the careful student of antiquity and other masters. Correggio produced sublimely imaginative works, but he would have been greater had he not detracted from the grace of his works with errors in design: "Raphael, who united both these perfections, and who, by the great number of aspects of painting in which he excelled, has acquired among modern painters the rank Apelles held among the ancients. Raphael, I say, had an imagination which was more elevated and extensive" (*Conférences académiques,* 1:162). It is curious that Desportes, a naturalistic painter of still lifes and hunting scenes, should extol Raphael as the modern Apelles in reviving the classical ideal. Yet Raphael exemplified the qualities essential for artistic success: a lively imagination combined with fine discernment and the patience necessary to perfect his art. Desportes suggested that Raphael was unlike fiery, impetuous spirits, who do not always reach their potential (*Conférences académiques,* 1:67).

This notion of a rather plodding, "academic" Raphael seems a far cry from our generally held image of the facile Renaissance master, but it certainly served the aims of reestablishing the role of the Academy and its approach to training artists. Emphasizing Raphael's patient study, the Academicians justified their own regimen for students and implied that Raphael's greatness and prestige could be achieved within the Academy.

Although Raphael's artistic development provided a perfect model for students, his art presented only one of many worthwhile examples. Since Roger de Piles, the Academy had freely accepted that there were different tastes, and that each artist had to follow his own inclinations to develop his talents. Massé, however, manifested the general desire of Academicians to return to solid principles in suggesting that one's tastes should not allow one to ignore the solid beauties of the antique and Raphael.

In a lecture entitled "On Pupils and their Studies," of 4 January 1749,[4] Massé used François Lemoyne as an example. Lemoyne's natural penchant rendered him less sensible to the "solid, sublime and serious beauties of Raphael and Michelangelo" than to the "amiable graces of Correggio, the clarity and freshness of execution of Guido, and above all to the types of beauty of Parmigianino and Pietro da Cortona" (*Conférences académiques,* 1:162). Even after Lemoyne was well established, he still attempted to improve. On seeing Bouchardon's studies after Raphael: "He was so touched by the loftiness, the variety of facial expressions, and the elegance of contours, that he copied all the drawings with the attention and submissiveness of a simple student."[5] Massé suggested that students should follow Lemoyne's example in studying these drawings after Raphael. By choosing one of the most prominent painters of recent times, who had died only ten years earlier, Massé seemed to assert that no artist, no matter how well established, should ignore the beauties of Raphael. Even if the story were apocryphal, Massé could use the prestige of Raphael to lend it credence and authority, in justifying the Academy's method of study.

Massé, speaking on 8 November 1749 on the necessity of knowing antiquity and anat-

omy well, seemed to return to the early Academy's neglected classicism. By not paying enough attention to nature, students reinforced false ideas and departed increasingly from truth. To avoid this departure from nature, a student must have the judgment to apply the rules derived from the works of antiquity to the model. It was not enough to have great enthusiasm; one needed to apply one's knowledge in a systematic fashion.[6] This is closer to the seventeenth-century Academy's concept of *la belle nature* than to the unbridled naturalism of the eighteenth century.

Massé's remarks implied a hierarchy of the different aspects of painting that was closer to Félibien than to de Piles. The ravishing beauties of painting are important. Color could exist with all its charms independently of correct design. The marvels of chiaroscuro and finish were admired in Flemish painters despite the baseness of their subjects, but none of these virtues excused the painter from knowing antiquity well (*Conférences académiques,* 1:208).

Massé stressed Raphael's neoclassicism, suggesting that from the works of antiquity, Raphael had acquired his perfect knowledge of anatomy and his refined taste (*Conférences académiques,* 1:210). Students could also benefit greatly by studying Raphael's works in the Vatican and elsewhere for the prodigious variety of types represented in such works as the *School of Athens* or the *Heliodorus,* representing many different stages of life, nations, and manners of action (*Conférences académiques,* 1:212).

Massé claimed that the Roman school was elevated above the others "by this majestic character which creates the sublime in painting, by the nobility of expression, as well as the purity and elegance of design; For this reason, it has attained a merited preeminence" (*Conférences académiques,* 1:213). Raphael, as chief of that school deserved the title of the "prince of painting."

The attitude during the first half of the eighteenth century toward artists such as Correggio and Rubens was that they should be seen as important artistic models because their vast talents excused their deficiencies, primarily in the "correctness" of their design. Massé suggested a shift in values; one must not ignore the faults of even celebrated artists:

> For if, despite the sublime talents of Correggio, of Rubens, of La Fosse, so revered in the three schools, one does not take care not to yield to the mistakes for which one reproaches them, what success can we promise our pupils, if they fall into the faults of these respectable men, without having their graces, enthusiasm, and great perfections?
>
> What care should they then take to acquire correctness which the knowledge of anatomy gives, and this masterful elegance in the beautiful antique, since that is what makes for the glory and triumph of the Roman School? (*Conférences académiques,* 1:217)

Nonetheless, Massé, with most of the Academy, believed that it was better to be a good genre painter than a mediocre history painter (*Conférences académiques,* 1:262). One could show that artists, by following the inclinations given them by nature "could produce Raphaels in all genres" (*Conférences académiques,* 1:293).

In a lecture of 1750, Galloche spelled out the importance of design and a program for its mastery.[7] One should begin by copying exactly drawings by Old Masters and works of

antiquity. Then students should be capable of drawing from the model, and from there can learn to imitate all nature, after learning how to correct it on the antique model (*Conférences académiques,* 1:313).

Galloche, a pupil of Louis de Boullogne, and the master of Lemoyne and Natoire, agreed with Massé that there were many genres in all of which excellence could be achieved, but history painting was the highest form of endeavor. In comparison to history painters, those who were content with the simple imitation of nature were like "the inhabitants of the valleys at the base of Parnassus, compared to those who, surmounting all difficulties rise to

Fig. 31. Louis Galloche, *Coriolanus,* 1747, Musée des Beaux-Arts, Orléans

Fig. 32. Cartoon, *Healing of the Lame Man,* c. 1515–16, Victoria and Albert Museum, London

the summit" (*Conférences académiques,* 1:315). Galloche clearly tried to maintain the *beau idéal* in such works as *Coriolanus* (Salon of 1747; Fig. 31), which recalls the rhetorical style and classical control of the cartoons, such as the *Healing of the Lame Man* (Fig. 32) and the works of Poussin, albeit clearly in an eighteenth-century vein.[8]

The most extensive paean of praise to Raphael in the series of *conférences* was given by Galloche in his "Remarks on the Great Masters." He resurrected the late seventeenth-century triumvirate of Raphael, Correggio, and Titian. His praise of Raphael's simplicity contradicts de Piles's notion of "savante exagération" as practiced by Rubens. Echoing Antoine Coypel, he suggests that in Raphael's works one finds the sublime simplicity that is so difficult to obtain and from which one often escapes by exaggeration (*Conférences académiques,* 1:337ff.; 2:8).

Praising Raphael for the variety of his compositions, attitudes, and expressions, Galloche asserted: "I do not hesitate to regard this great man as the most appropriate model to follow. . . . His refined spirit prescribes the invariable laws for simple beauty, which, in all he has made, is sublime. It is as in the beautiful antiques, purified reason" (*Conférences académiques,* 2:17). This was very different from the relativism of most statements of artistic value made in the first half of the eighteenth century.

This shift in the theoretical position of the Academy corresponded to the increasing desire on the part of the Bâtiments to make art a reflection of state policy once again as it had been in the late seventeenth century. There is an interesting divergence here between theory and practice. In comparison with French masters of the later seventeenth century, artists such as Galloche, Massé, and Lemoyne revealed relatively little of Raphael's influence on their works, yet they extolled Raphael's symbolic images in supporting a return to the *grand goût*. One could argue that these restored *conférences* and the orthodoxies expressed had as much to do with using the authority of Raphael to reassert the primacy of the Academy under state patronage as with a genuine aesthetic shift.

Comte de Caylus

The comte de Caylus, collector, antiquarian, engraver, critic, and theorist, was clearly Roger de Piles's successor in the influence he exerted in the Academy as *amateur honoraire*.[9] Like de Piles, he was an eclectic who appreciated works of antiquity, and past masters including Raphael, Rubens, and Watteau, and his contemporaries, such as Carle Van Loo and Oudry. He and de Piles were both instrumental in moving the Academy in a new direction; in Caylus's case, a greater emphasis on antiquity and expression. According to Hulst, Caylus was responsible for the rule of 29 March 1749, which required students to draw after the antique. In 1759, he founded the contest for a *prix de la tête d'expression* to promote what he considered one of the most essential aspects of painting.[10] He was a major ally of the *surintendants* in their efforts to harness the Academy to their consolidation of power.

Caylus presented his ideas in an extensive series of Academy lectures beginning in June 1747, and continuing until February 1759. The topics included "Reflections on Painting," "The Amateur," "On Harmony and Color," "On the Facility of the Tool," "Composition," "On Mannerism and the Means of Avoiding It," and "Parallel of Painting and Sculpture."[11]

Despite his eclecticism, Caylus recognized Raphael's authority, particularly in composition, invention, and expression. Caylus believed that composition was the poetic aspect of painting, the submission of the imagination to a particular object. The works of Homer and Raphael had become the rules of composition for painters and poets. Even if one could be a painter or poet without being a Raphael or a Homer, one should constantly present their works to those who wish to master their craft (*Vies*, 161–62).

To discuss general rules of composition and to show how to reach sublimity, Caylus described works by Raphael, including several of the *Acts of the Apostles*, as providing the best examples of propriety and poetry (*Vies*, 167). In keeping with this program, he praised the *Expulsion of Heliodorus* (Fig. 33) and *Christ Giving the Keys* at great length. Although much of his criticism was in terms of literary values, Caylus revealed a richer appreciation of the scene as a painting, not simply the illustration of a story. He praised the *Heliodorus*'s composition for its unity and the power of its expression:

> The middle of the composition is very open and allows a considerable pause. This is necessary in order to make understood the relationship that all the

Fig. 33. *Expulsion of Heliodorus,* c. 1511–12, Vatican, Rome

groups, with their different actions, have with Heliodorus. He is thrown down by an angel on horseback and menaced by two others. Anger, indignation and menace are expressed with as much truth as the nobility in these figures. One cannot help but admire the rapidity of their action, the intensity and variety of the three angels. Nature always provides the models, but the sublime and rational spirit knows how to add supernatural details which seem to emanate from the divine. (*Vies,* 168–69)

Despite the "force, wisdom, and grandeur" of Raphael's composition, Caylus criticized him for his error in *costume* in representing Julius II in the scene. Such a demand for the rigid observance of propriety recalled seventeenth-century critical standards (*Vies,* 169).

Caylus saw similar praiseworthy features in *Christ Giving the Keys to Peter* (see Fig. 19), which he had seen in London. He showed a real sensitivity to the subtleties of composition

and expression in specifically pictorial terms. Praising the figures of Christ and Saint John, he noted that

> [t]hese two figures do so perfectly what they ought to do, that they could not be differently posed. They produce the single, perceptible movement in the composition, and although the dominant figure is in the extreme foreground of the painting, it is so well spaced and so effectively linked to the large group, that the eye cannot fail to be attracted here, despite the large mass of the other ten apostles. (*Vies,* 170)

Caylus argued that the expressions of the "gentle passions" were the most difficult and sublime in painting. Antiquity did not provide adequate examples, so Caylus referred to Raphael. Referring to a drawing of the *Martyrdom of Saint Stephen* in Mariette's collection, he stated: "One distinguishes at one time confidence, submission, hope and resignation. The more one studies this drawing, the more one sees these different sentiments succeed each other, mutually banish each other, contesting with each other for the pleasure of occupying and satisfying us" (*Vies,* 179). Caylus found Raphael a paradigm of expression, the aspect of painting he deemed most essential. Like the seventeenth-century Academicians, he conceived expression solely in terms of elements of design. He also revealed eighteenth-century sensibilities in adopting Antoine Coypel's characterization of Raphael's art as a "delicate synthesis of antique beauty and living nature, providing, in effect, an incomparable teaching" (Locquin, 98).

Perhaps the clearest indication of Caylus's taste was in a letter he wrote to a young Lagrenée, who had just arrived in Rome to study (*Vies,* 211–14). Caylus instructed the young student to follow his own tastes. He should not be alarmed if at first he could not fully appreciate the wonders of Raphael:

> I would not dare avow how much, at times, I have questioned the beauties and sublimity of Raphael, and over how much time, I have only looked at him in terms of his faults. Don't force yourself; It will come one day, a flash of light which will enlighten you; then you will see, well. (212)

If Caylus did not create a novel aesthetic, he at least pointed in a new direction that coincided with and bolstered the revival of history painting in the Academy.

Caylus's efforts, however, were undercut with the rise to power of Charles-Nicolas Cochin, who assumed virtual control of artistic affairs in 1752 under the directorship of Marigny. With the rise of Cochin and the decline in the influence of Caylus this move toward a renewal of a Poussinist–Raphaelist aesthetic within the Academy lost much of its driving force.[12] In Cochin's *Examen critique* of works he had seen on his trip to Italy with Marigny, which he read in the Academy on 4 March 1752, he delivered a view of Raphael that echoed de Piles: Even though Raphael's works lacked initial impact, they were worthy of study, but that was in spite of their serious deficiencies:

> The studies of the celebrated Raphael's works are no less important even though they have few of the charms which seduce at the first viewing. Few great masses of

light and shade impede the total effect which gives the first pleasure, a color, often true, but feeble, does not present a charm which interests in relation to so many painters. A composition with beautiful figures, but often not very well tied together, leaving it inferior to some masters who could carry this aspect of painting so far.

Cochin mitigates this enumeration of Raphael's faults with a standard statement of his virtues:

> Nevertheless, if one studies the works of this great man with the attention which is due them, how much can you discover here to admire. What majesty! What a profound science of design! What nobility in the character of visages! What beautiful simplicity is in the attitudes of the figures, in the manner of the drapery! What refined and finished execution! (*Conférences académiques,* 2:69–70)

It is clear that Cochin did not favor a return to seventeenth-century classicism. In no sense did he regard Raphael as the prime model for reforming French painting. As Crow has suggested, by rejecting the values underpinning a serious, elevated approach to painting based on the classical aesthetic, Cochin, in effect, rejected the renewed basis for academic reform and the rejection of Rococo values.[13]

Raphael in Practice at Mid-Century

With the revived interest in promoting the antique and Raphael as exemplary, practical aids for students utilizing Raphael's works also appeared. These were not new. In 1606, Madame Chéron-le-Hay had presented a book to the Academy showing heads engraved after Raphael's works.[14] In 1710, Nicolas Dorigny published a series of engravings of heads from Raphael's cartoons (Fig. 34). In 1747, the pensionnaires of the Academy produced a volume entitled *Raphael de Sanctis, Urbines, primo elementa picturae, id est modus facilis delineandi omnes humani corporis partes.*[15] Such a volume was, perhaps, a logical extension of their theoretical studies, since most Prix-de-Rome winners were involved at this time with copying Raphael's Vatican frescoes for the king.

A similar manual was produced by Jombert in 1755, entitled *Méthode pour apprendre le dessin,*[16] illustrated with engravings of parts of the body after Raphael and other masters, the *Académies* of Cochin, and measured drawings after antique sculpture. Its purpose was to provide a better guide than had previously been available for teaching drawing. Jombert appeared to return to the grand manner of the seventeenth-century Academy in his prescriptions for students, suggesting that one should study the works of Michelangelo to master anatomy, those of Raphael for the nobility of contour and grace, and those of the Carracci for excellence of design (31).

Although Jombert made no mention of Rubens, his examples were not confined to the Italians; he suggested, for example, that Le Brun could be compared with the leading foreign painters for the nobility of his compositions and the vast extent of his imagination. Even though Le Sueur had never been to Italy, he possessed perfectly "the noble simplicity

Fig. 34. Nicolas Dorigny, engravings after Raphael's Cartoons, 1719

that one admires in Raphael" (31). Jombert was also emphatic on the necessity of studying antiquity—and the model for using antiquity as a guide to nature was Raphael (101). Jombert thus suggests a shift from the Rococo concept of nature (relying more directly on nature as a model) to the neoclassical one.

The Academy in Rome

After the lengthy enterprise of copying the Vatican frescoes for the king, Raphael was to a certain extent supplanted by Domenichino as the students' most-copied artist. Domenichino was believed to have many of Raphael's virtues, and most of his works had never been copied. Ménageot, an important young history painter and one of David's chief rivals,

expressed a common sentiment in a letter to d'Angiviller of 23 January 1788: "the only basis, the most certain route, in order not to lose one's way and to achieve sublimity in painting, is the study of antiquity, Raphael and Domenichino, because it is to study nature, and nature in its most beautiful choice."[17]

The Carracci, the Bolognese, particularly Guido, and others were also copied. Under d'Angiviller, however, there was an increasing emphasis on figure study. The new Academy rules he drafted required that students send to Paris five drawn and painted Académies each year, but only one Old Master copy during their four-year stay in Rome (*Correspondence,* 15:182–190).

Raphaelesque Paintings

With the long concentration on Raphael, particularly in the Rome Academy, one would expect some evidence of his direct influence on contemporary history painting. As we have noted, there is no sharp aesthetic shift around 1747. However, the incentives given to the *grand goût,* although not immediately effective, began to make the grand historical subject handled in a serious fashion more significant. This shift in emphasis increased the likelihood that artists would turn to Raphael as one of several classical paradigms.[18] Several works appearing in Salons between 1747 and 1760, seem to be modeled on Raphael, sometimes filtered through Poussin: Collin de Vermont's *Pyrrhus Imploring Glaucus* (Salon of 1747; Fig. 35)[19] echoes the *Judgment of Solomon* from the Vatican Loggias (Fig. 36) in composition, pose of the principal figure, drapery style, and sense of narrative. Boucher may have expressed a certain amount of disdain for Raphael,[20] but the figure of Joseph in his *Nativity* (Salon of 1750) recalls in type, drapery, and gesture the figure holding a book in the extreme left foreground of the *Disputà* (Fig. 23).

Copying Raphael under Wleughels seems to have left a lasting impression on Carle Van Loo.[21] His *Dispute of Saint Augustine* (Salon of 1753; Fig. 37) takes its composition and gestures from the cartoons, particularly *Saint Paul Preaching* (Fig. 38) and the *Blinding of Elymas* (Fig. 39). The statuesque solidity of the figure pointing to Saint Augustine recalls Saint Paul preaching, very directly.

An artist of an earlier generation and one of the key religious painters of the first half of the eighteenth century, Jean Restout[22] in his *Christ Washing the Feet* (Salon of 1755; see Locquin, fig. 40) recalls Raphael in its figure types and drapery style, albeit in a somewhat mannerist vein. The undulating composition and several poses and gestures echo Raphael's *Miraculous Draught of the Fishes.* Collin de Vermont and Restout were the last pupils of Jouvenet, a painter influenced by Raphael early in the eighteenth century (Schnapper, *Jouvenet,* 168).

Dumont le Romain's *Allegory of the Peace of Aix-la-Chapelle* (Salon of 1761, Musée Carnavalet, Paris; Fig. 40) recalls the grand rhetorical style of the cartoons,[23] albeit in a more Baroque vein. Amand's *Joseph Sold by his Brothers* (Salon of 1765, Musée des Beaux-Arts, Besançon) is clearly based on the same scene from the Vatican Loggia.[24] Of course, a key figure in the revival of classicism was Vien, who studied Raphael assiduously while in Rome. Yet, the works of these artists made one of the key difficulties with the academic

Fig. 35. Collin de Vermont, *Pyrrhus Imploring Glaucus,* 1747, Musée des Beaux-Arts, Besançon

approach painfully evident: to emulate great past masters was one thing; to equal them was another.

Public Exhibitions and Critics' Contributions

Beginning in 1699, a new stimulus to artistic discourse begins to appear in France: the public exhibition. One key element of such displays is that they placed works by contemporary artists in public view making possible a comparison with the achievements of past

Fig. 36. *Judgment of Solomon,* c. 1516–19, Vatican Loggias, Rome

masters. Regarding Raphael's works, such a comparison was made quite explicit. At the entrance to the very first "Salon" exhibition in 1699, were portraits of the king and dauphin, flanked by the entire suite of tapestries after Raphael depicting the Acts of the Apostles. Beyond these were the paintings by the artists of the Academy (Crow, *Painters,* 36–38). This comparison of contemporary artists' works with those of the Old Masters was also facilitated by the opening to the public, beginning in 1750, of the Luxembourg gallery, which contained works from the royal collection, including many by Raphael.[25] With the beginnings of regular Salon criticism in 1747, a new source of artistic ideas arose outside of, and often in opposition to, the Academy. In spite of their lack of artistic training, these individuals claimed the right of criticism as men of taste. Many of their critiques were general, strongly partisan, and of only the most ephemeral interest from the standpoint of art theory, although certainly of interest from the standpoint of politics.[26] For these critics, Raphael was primarily an indisputable standard of excellence against which the inadequacy of the academic system and the efforts of artists trained under it could be measured. We will consider two critics, La

Fig. 37. Carle Van Loo, *Dispute of Saint Augustine,* 1753, Notre Dame des Victoires, Paris

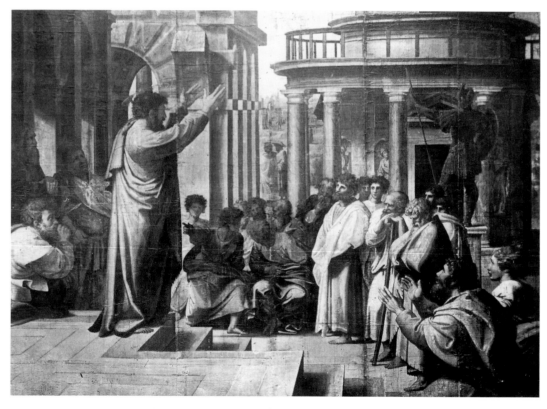

Fig. 38. Cartoon, *Saint Paul Preaching,* c. 1515–16, Victoria and Albert Museum, London

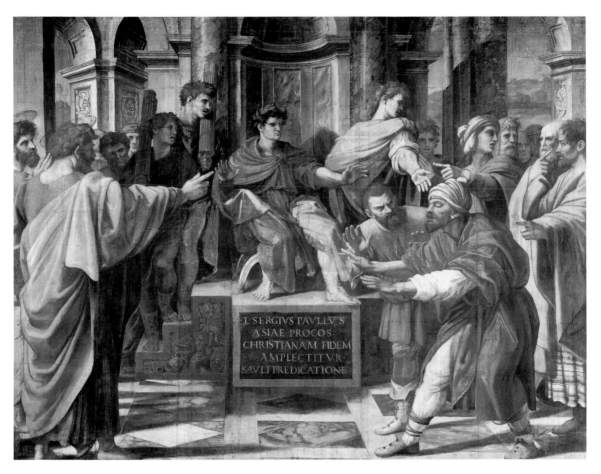

Fig. 39. Cartoon, *Blinding of Elymas,* c. 1515–16, Victoria and Albert Museum, London

Font de Saint-Yenne and Diderot, for the impact they had on artistic ideas. Although La Font de Saint-Yenne's ideas proved to be a harbinger of neoclassicism, they were not accepted very openly at the time they were introduced. As Thomas Crow has argued, La Font was writing from the viewpoint of the *Parlementaires* and attempting to use artistic doctrine as a political weapon against the Academy and its protectors in the government.[27]

La Font de Saint-Yenne's 1747 work *Réflexions sur quelques causes de l'état présent de la peinture en France* (Reflections on some causes of the present state of painting in France)[28] was one of the earlier examples of Salon criticism, but it also expressed a strong theoretical point of view. La Font called for a return to history painting, which spoke to the mind, decrying the vulgar taste of his contemporaries, whose favorite adornment was the mirror. One should follow the examples of great, past, history painters: Raphael, Domenichino, the Carracci, Giulio Romano, and Pietro da Cortona, but also Rubens, Poussin, Le Sueur, Le Brun, Coypel, and Lemoyne (*Réflexions,* 11). He saw French painting under Louis XIV as equal to Italian painting under Leo X. That period formed an apogee in French painting, the fruits of which had been abandoned, leading to decadence. La Font sounded the battle cry of the reformers who rejected the Rococo and helped shape the revival of history painting and neoclassicism. (*Réflexions,* 12–13).

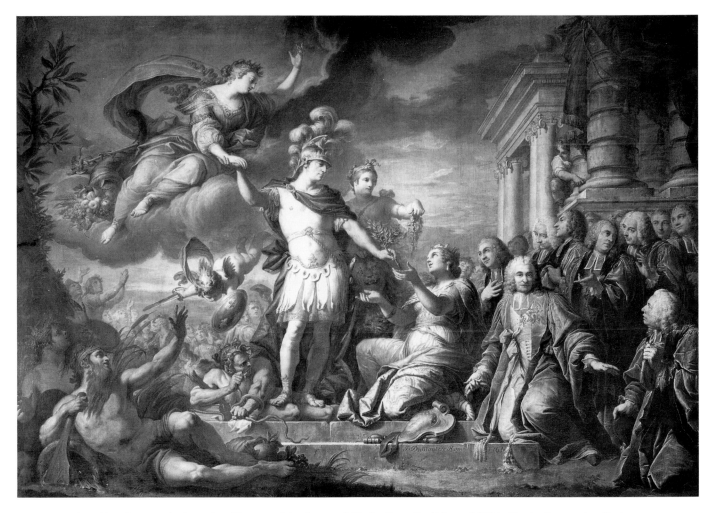

Fig. 40. Dumont le Romain, *Allegory of the Peace of Aix-la-Chapelle,* Salon of 1761, Musée Carnavalet, Paris

La Font compared contemporary artists with the great masters of the past and found them wanting in every respect. He vehemently criticized Boucher, Madame de Pompadour's favorite painter:

> One would like to see a stronger and more vigorous color in his fleshtones: more nobility and expression in his facial expressions, particularly in those of the Virgin, which might have some affinity in dignity and decency with those of Raphael, the Carracci, of Guido, of Carlo Marrata, of Le Brun, Poussin, Mignard, etc. which are all of a very noble character. (*Réflexions,* 75)

La Font's aesthetic criticisms are couched in moralizing terms, as if Boucher's artistic failings follow naturally from his decadence. Thus the critic attacks not only the taste, but also the morality of the current regime. He also criticized contemporary painters' lack of invention, reviving the idea of *ut pictura poesis* (*Réflexions,* 78). In both his broad eclecti-

cism and his appreciation of the sensual aspects of painting, however, he was very much in agreement with the contemporaries he criticized. His sentiments on the essential nature of excellent color could easily have come from Roger de Piles (*Réflexions,* 90–91).

The artist must, however, also be correct in design, La Font maintained. Criticizing Pierre for his drawing errors, La Font suggested Raphael as an example to follow: "The artist should be careful not to neglect such an essential aspect, and should bear in mind that Raphael was only elevated so high by the greatest severity in design, wherein he never allowed himself to neglect it, and that he preferred the perfection of this aspect to that of color" (*Réflexions,* 95–96). Once again, La Font's criticism shades over from the aesthetic to the moral realm, bringing in such terms as negligence. And Raphael indeed was one of La Font's potent weapons in stressing the gulf between the Academy's claims and the artists it produced.

Diderot

Denis Diderot, author, *philosophe,* Encyclopedist, and art critic was so multifaceted that he defies easy categorization.[29] His roles as Salon critic and art theorist are central to our concerns. Diderot distinguished himself from the large number of men of varying ability who posed as critics after 1747[30] by his understanding of the creative process as a writer and his philosophical perspective. His keen insights and ready wit set Diderot's writing apart from the mass of often anonymous diatribes that purported to criticize works exhibited at the Salons. Unlike most of his contemporary critics, Diderot had visited studios and had studied something of the craft of painting with artist friends, including Chardin, Falconet, and Lemoyne, and so could judge works from an artistic and aesthetic point of view, rather than a purely literary one. He also had extraordinarily rich and complex ideas about the nature of art, its experience, and its relationship to life.[31]

The most relevant works for Diderot's view of Raphael are the nine Salon reviews he wrote for Grimm's *Correspondance littéraire* between 1759 and 1781 (*Salons*), his *Essai sur la Peinture* of 1766, and his *Pensées detachées* on painting of 1776–80 (*Oeuvres esthétiques*). Although most of these works were only published posthumously in France, they exerted a great influence on nineteenth-century critics, including Delacroix and Baudelaire.[32] Diderot often invoked the shade of Raphael to elucidate general artistic principles and to criticize specific works.

Diderot, the brilliant man of letters, combined the range and fervor of a broad and enthusiastic connoisseur with the predilection for moral instruction of the Encyclopedist.[33] The interplay between his aesthetic appreciation, his insights into the creative process and his philosophical bent enlivened his Salon criticisms. His rapier wit demolished those who failed artistically or morally in his terms. His ideal of Raphael was one of many weapons in his critical arsenal. He constantly used the great examples of the past, such as Raphael, Rubens, Poussin, Le Sueur and Van Dyck to castigate contemporary artists for their shortcomings.[34]

I should briefly define Diderot's view of painting before considering his specific judgments. He expressed his ideas most systematically in his *Essai sur la Peinture* (1766)

published in Grimm's *Correspondance littéraire* and in the lengthy introduction to his *Salon of 1767* (*Salons,* 3:52ff.). By this time Diderot had reviewed five Salons. Diderot violently opposed traditional academic training in which a young artist spent most of his time copying other artists' works, believing that this practice led to mannerism, rather than true artistic creation.[35] He asserted that the artist must follow nature, but he used the term in a broader sense than had his predecessors or his contemporaries. He meant that a work of art had to reflect man's experience of the world, not by imitating its appearances, but by revealing the same kind of logical consistency and rapport among all parts, that same inner unity that he found in nature.[36] One could not create a great work of art simply by choosing an elevated subject. For Diderot, Chardin was a much greater artist than most of the history painters, such as Hallé or Boucher, because his art revealed this internal consistency (see *Oeuvres esthétiques,* 722ff.).

Diderot believed that by relating to man's understanding of the world and expanding it, based on his own experience and through imaginative use of his medium, the artist had a positive effect on society. For him, both the creation and understanding of works of art were intensely personal experiences. Criticism involved the dialogue between man, the organism, and the quasi-organism, the work of art. Diderot put this idea into practice by imaginatively re-creating a scene he was viewing in the Salon as he would have "painted it."[37]

Creation could not arise from copying. The artist did not create by keeping one eye on his naked model and the other on antique casts. Rather, he molded his material in conformity with his inner conception. The model was not external to the artist and his art, but grew and was perfected with it (Funt, 137–71). The great works of the past could be useful if one entered into their spirit without copying them slavishly. For instance, Diderot argued that an artist rarely excelled without visiting Italy, which provided the inspiration of great models, such as Raphael, Michelangelo, and other great masters from whom one could learn much (*Salons,* 3:238).

Diderot could equally admire Chardin and Raphael for producing works that were "naive" (*Oeuvres esthétiques,* 824–25). He meant by this that everything in their works was as one would expect it based on common experience, without a trace of mannerism.

Diderot shared the reviving interest in the example of antiquity of the period, but did not believe that one should imitate the ancients. As Fried has argued, Diderot had a very different conception of painting than had the seventeenth-century Academicians. He argued that no artist after ancient times had equaled their ideal of beauty. The ancients evolved their ideal slowly from nature; everyone that came after attempted to shortcut what Diderot believed was a necessary process, by copying the ancients' examples. Like Winckelmann, Diderot believed that the ideal of beauty had to be a direct product of the culture that produced it. He strongly criticized artists of all later ages: "Servile and nearly stupid imitators of those who preceded them, they study nature as perfect, rather than perfectable. They look not to approach the ideal model and the true line, but only to come as close as possible to a copy of those who have possessed them" (*Salons,* 3:61).

Not even Raphael escaped this scathing censure of the basis of academic classicism. Diderot repeated what Poussin reportedly said: that Raphael was "an eagle in comparison to the moderns, but an ass in comparison to the ancients" (*Salons,* 3:61). Although Diderot, like Winckelmann, placed Raphael below the ancients, he still saw him as praiseworthy and repeatedly used him as an example and object of comparison with contempo-

rary painters. Discussing the different aspects of painting in his *Essai*, he asserted that poor use of contrast was a major source of mannerism in painting, but contrast that arises from the action depicted, as in Raphael and Le Sueur, creates a sublime effect (*Oeuvres esthétiques,* 672). Diderot believed that artistic expression must arise from the experience of nature as in the works of Raphael and others (*Oeuvres esthétiques,* 703).

In discussing the works at the Salon, Diderot often used the name of Raphael rhetorically, to embody a standard of artistic excellence (*Salons,* 1:18). With his view of Raphael as a standard, Diderot saw a history painter such as Hallé as a second-rate talent. Commenting on a work of Hallé's in the Salon of 1763, Diderot jeered: "Hallé is always poor Hallé. This man is rash enough to choose great subjects, subjects which demand invention, characters, design and nobility, all qualities which he lacks. Mr. Hallé, where is this beautiful celestial quality which Raphael and Le Sueur knew how to give to their angels? Yours are three disguised thieves" (*Salons,* 1:207).

Diderot could also use Raphael as a standard for praise, rather than derision: Praising Deshay's *Marriage of the Virgin* in the Salon of 1763, he praised the Virgin for the qualities of nobility, grandeur, modesty, and natural drapery "in the true taste of Raphael" (*Salons,* 1:213). The qualities for which Diderot praised Raphael were not new, but Diderot had a unique and deeper understanding than had most of his predecessors or contemporaries of the significance of Raphael's virtues in painting. In all cases, however, Diderot was holding out principles he found in Raphael's art, not suggesting that other artists should copy him.

The great confrontation at the Salon of 1767 was between Vien's *Saint Denis Preaching* and Doyen's *Les Miracles des Ardens*.[38] Diderot devoted considerable space to the discussion of their relative merits and failings, using Raphael as a standard.

Discussing Vien's work, Diderot made a general statement about the difference between controlled expression and exaggeration:

> The expressions, such as they are, the passions, the movement diminishes in comparison to those whose characters are more exaggerated. And here is why some have accused Raphael of being cold, while he is truly sublime, while he is a man of genius, he proportions the expressions, the movement, the passions to the nature of what he has imagined and chosen. (*Salons,* 3:79)

The ideal is observed when the kind and stature of figures is engaged in the proper degree of emotion and motion to best convey the action. The degree of motion is inversely proportional to the grandeur of the figures.

Diderot found in Raphael's work his ideal inner consistency, without a trace of the mannerism that he saw as one of the most pernicious faults in so much contemporary painting, as well as in past masters, including Rubens (*Salons,* 3:337–39). Raphael had always been praised for his propriety, but Diderot saw the concept in broader terms than it had traditionally been defined. Diderot believed that one must be in consonance with nature, in what is expressed, and with the principles of art, in how it is expressed. Each character should express his type and state as fully as possible in all parts, so that as with Raphael, the figures seem as if they could not be represented more truthfully (*Salons,* 4:86).

Rather than being constricted by the clichés of Raphael criticism, Diderot characteristically rethought the nature of Raphael's greatness. To Diderot, Raphael was a great artist, not for successfully mimicking nature or antiquity, but for creating a coherent, artistic vision that was true and transcended truth at the same time.

Foreign Neoclassicists' Views of Raphael

From 1760 on, the French were exposed to the ideas of foreign neoclassicists, including Winckelmann, Mengs, Hagedorn, Algarotti, Webb, and Reynolds, all of whom were widely read in France. Although some of their principles echoed those well established in France, they concentrated more directly on promoting antiquity. They all believed Raphael was exemplary, but they generally attacked the notion widely accepted in France that the "modern Apelles" had equalled his ancient predecessors. As we have seen, the return to classical ideals, at least in theory, was already under way before the writings of Winckelmann and the others had any impact in France. Yet, although their ideas were certainly not universally accepted, they added impetus and theoretical justification to the movement and inflected its development.

Winckelmann

Johann Winckelmann, bibliophile, author, antiquarian, and theoretican, was one of the leading progenitors of neoclassicism.[1] He was

distinguished more by his zeal for Greek literature, art, and philosophy, than for his originality, as Goethe had remarked in his famous tribute: "By reading Winckelmann one does not learn anything, but one becomes somebody." His basic tenets are well known and require only a brief review.[2]

Winckelmann passionately believed in the moral and concomitant artistic superiority of the Greeks. Like Bellori and seventeenth-century French Academicians, he found his ideal, *la belle nature,* in Greek art. The ancients had possessed many advantages over the moderns in perceiving and representing ideal beauty. They were a healthy, humane, athletic people with temperate climate and laws; they valued beauty highly and displayed it constantly. By selecting individuals' most beautiful parts and recombining them according to an ideal, the Greeks raised representation above the imitation of nature to the sublime. Given the ancients' advantages, imitation of them was a clearer and shorter path to perfect beauty than imitation of nature. This is the neoclassical doctrine that Winckelmann expounded in his 1755 work *Gedanken über der Nachahmung der Griechischen Werke* and expanded in his *Geschichte der Kunst des Altertums* of 1764.[3]

Proposing imitation of the Greeks, Winckelmann distinguished between slavish copying (*Nachahmen*) and working in the same spirit and ideal (*Nachahmung*) (Hatfield, 10). Raphael demonstrated the proper kind of imitation in such works as the *Sistine Madonna,* which Winckelmann knew and admired in the Dresden Gallery. He stressed Raphael's debt to antiquity as the example that proved his rules for the pursuit of ideal beauty: "Thus Raphael formed his *Galatea,* as we learn by his letter to Count Balthazar Castiglione, where he says, 'Beauty being so seldom found among the fair, I avail myself of a certain ideal image.' This is how the Greeks formed their gods and heroes. But they also did their best to imitate nature."[4]

Winckelmann lauded Raphael's procedure, but in the *Geschichte* he would criticize Raphael's ideal. Winckelmann clearly subordinated naturalism to ideal design and elevated thought. De Piles had stated that Raphael intended, shortly before his death, to study nature more closely than antique works. Winckelmann saw this as a mistake: "He, perhaps, might have indulged more variety; enlarged his draperies, improved his colors, his light and shadow; but none of these improvements would have raised his pictures to that high esteem they deserve for that noble Contour and that sublimity of thoughts, which he acquired from the Ancients" (*Reflections,* 21). With this, Winckelmann revived the value system of the seventeenth-century French Academy, subordinating the sensual aspects of art to the more idealized ones and carrying that notion to an even greater extreme. In effect, he would reverse de Piles's assertion that Raphael had been moving in the proper direction in progressing toward a synthesis of nature and the ideal.

Throughout Winckelmann's comments, he is clearly only interested in Raphael to the extent that he can use the artist to support his basic contention of the superiority and indispensability of ancient art. According to Winckelmann, Raphael's art proved that one should imitate antiquity, rather than simple nature:

> Nothing would more decisively prove the advantages to be got by imitating the ancients, preferably to Nature, than an essay made with two youths of equal talents, by devoting the one to Antiquity and the other to Nature: this one would draw

nature as he finds her; if Italian, perhaps he might paint like Caravaggio; if Flemish and lucky, like Jacob Jordans; if French, like Stella; the other would draw her as she directs, and paint like Raphael. (*Reflections,* 22)

Winckelmann reserved his highest praise for Raphael's *Sistine Madonna* (Fig. 41), one of the few major works by Raphael with which he was directly familiar before moving to Rome; he said the work revealed noble simplicity and calm grandeur (edle Einfalt und stille Grosse), the highest qualities of ancient art, as exemplified by such works as the *Apollo Belvedere*.[5] In this work: "her face brightens with innocence, a form above the female size, and the calmness of her mien, make her appear as already beautiful, she has that silent awfulness which the ancients spread over their deities. How grand, how noble is her Contour" (*Reflections,* 38). Like countless critics before him, Winckelmann praised the propriety and poignance of Raphael's expression (*Reflections,* 39).

As with ancient sculpture, Winckelmann's appreciation was based on a direct emotional involvement with the work. Comparing the *Sistine Madonna* and *Transfiguration,* Winckelmann suggested that although the former's composition could not compare with that of the latter, the *Sistine Madonna*'s was completely by the master, whereas Giulio did much of the *Transfiguration* (*Reflections,* 183). This is a clear case of removing a work from the canon that does not fit one's preconceptions of the artist.

Echoing Bosse's assessment almost a century earlier of the beauties in Raphael, Winckelmann stated:

> Beauty pleases, but serious graces charm. . . . True charms owe their durability to reflection, and hidden graces allure our enquiries; reluctant and unsatisfied we leave a coy beauty, in continual admiration of some new-fancied charm; and such are the beauties of Raphael and the ancients; not agreeable trifling ones, but regular and full of graces. (*Reflections,* 184)

Winckelmann stressed that the viewer had to refine his taste on the ancients' works before he could properly appreciate Raphael: "You that approach his works, teach your eyes to be sensible of those beauties, refine your taste by the true antique, and then that solemn tranquility of the chief figures of his *Attila,* deemed insipid by the vulgar will appear to you equally significant and sublime" (*Reflections,* 35).

Although Winckelmann saw Raphael as kindred spirit to the ancients, he stressed Raphael's inferiority to them. Discussing beauty, he suggested:

> If ever an artist was endowed with beauty and deep innate feelings for it; if ever one was versed in the taste and spirit of the ancients, twas certainly Raphael; yet are his beauties inferior to the most beautiful nature. I know persons more beautiful than his unequalled Madonna in the Palazzo Pitti, in Florence or the Alcibiades in his Academy. (*Reflections,* 263)

Winckelmann concluded that "The Greek alone seems to have thrown forth beauty as a potter makes his pot" (*Reflections,* 264).

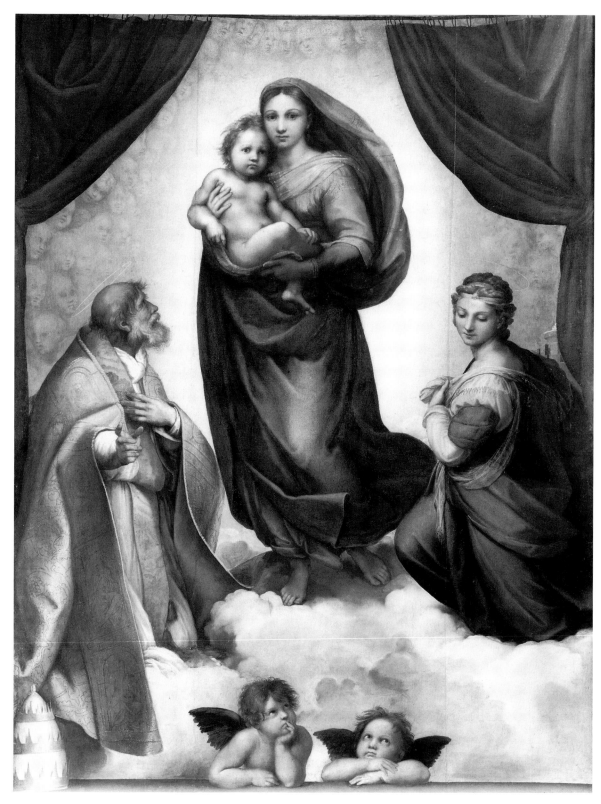

Fig. 41. *Sistine Madonna,* c. 1512, Dresden Gallery

Winckelmann's *Geschichte*

The purpose of Winckelmann's *Reflections* was to argue that one should use the ancients as a guide to *la belle nature*. Since Raphael pursued this method, Winckelmann referred to him constantly. The very different purpose of the *History of Ancient Art* was to trace art's development through periods and to argue the inevitable superiority of the Greeks based on environmental and cultural factors, over all who preceded or followed them. He made few references to Raphael, and of those, most pointed out his inferiority to the Greeks.

Departure from ancient models led to decadence. Revealing his distaste for the Baroque, Winckelmann suggested that most modern artists exaggerated expression:

> They confidently believed that art was capable of improvement by such principles. . . . For this reason, the successors of Raphael deserted him, and the simplicity of his manner, in which he imitated the Ancients, was termed a marble manner, that is, one on which repose resembles death. This corruption advanced with steady and gradual increase from the time of Michelangelo to that of Bernini.[6]

With a cyclical view of artistic development, Winckelmann proposed four periods of Greek art: the straight, the grand, the beautiful, and the imitative, corresponding to the age before Phidias; the period from Phidias to Praxiteles, Lysippus, and Apelles; the third to the school of these artists; and the fourth continuing until the downfall of art (*History,* vol. 3, book 8, chap. 3, 153).

Winckelmann perceived a similar developmental scheme in modern art, except he felt that art had fallen precipitously from its Renaissance heights. Speaking of design, he stated: "Until Michelangelo and Raphael, the style was dry and stiff; the highest point to which art attained, after its restoration was in these two men; after an interval in which bad taste prevailed, came the style of the imitators; this was the period of the Carracci and their school with its followers, and it extended unto Carlo Maratti" (*History,* vol. 3, book 8, chap. 3, 153–54). Winckelmann spoke primarily of design because he believed, along with the seventeenth-century Academicians, that it was the most essential aspect of art. Color could only assist beauty; it could not constitute it (*History,* vol. 2, book 4, chap. 2, 198). Winckelmann thus dismissed the major criticism of Raphael from de Piles on as being of little importance. He cited the famous paradigm of Zeuxis to prove that selection and harmonious combination of the most beautiful parts of the body from different figures produced ideal beauty, which was no metaphysical abstraction (*History,* vol. 2, book 4, chap. 2, 205). According to him, Raphael in painting his *Galatea* had made the mistake of regarding beauty as a mental abstraction, while ignoring the beauty in nature. He thus attacked the basis of Raphael's idealism as it had been set forth in Bellori's *Idea:*

> But the conception of the head of his Galatea is common; women of far greater beauty can be found everywhere. Moreover, the figure is so disposed that the breast, the most beautiful part of the naked female form, is completely covered by one arm, and the knee which is in view is much too cartilaginous for a person of youthful age. (*History,* vol. 2, book 4, chap. 2, 206)

Winckelmann's conception of beauty was based on a tranquil, harmonious unity. He believed that most modern artists had tried to introduce too much contrast into their works: Contrast, like antithesis in writing, ought to be easy and unaffected and not be regarded as an important or elevated point of knowledge, though modern artists valued it as a substitute for every excellence and an excuse for every fault. On this principle Chambray had justified Raphael, in his design of the *Massacre of the Innocents,* for having made his female figures stout and the murderers lean. Winckelmann condemned this departure from ideal beauty (*History,* vol. 2, book 5, chap. 6, 269). As Winckelmann stated in the *Gedanken:* "Let Raphael be imitated in his best manner, and when in his prime; those works want no apology" (*Reflections,* 173).

In a sense, Winckelmann's focus shifted somewhat from the *Gedanken* to the *Geschichte* as his experience of ancient art was enriched by his move to Rome. When the *Gedanken* was written, Winckelmann lived in Dresden where he was familiar with ancient literature and philosophy, and modern painting based on classical precedent, such as Raphael's *Sistine Madonna,* but he only knew a limited range of antique works.[7] Such works indicated to him the necessity of following the Greek model for ideal beauty. Since Raphael had followed this route more closely than any other modern, Winckelmann saw him as exemplary; nonetheless, because Raphael lacked the perfect society of ancient times that Winckelmann envisioned, he could only have an inferior sense of ideal beauty. When one looked for beautiful examples, rather than for a method of finding beauty, one should look directly to the ancients and not to Raphael. This shift of focus, extensively developed in the *Geschichte* and combined with Winckelmann's vastly increased knowledge of ancient art, explain why there are fewer than a dozen references to Raphael in the four lengthy volumes of the *History of Ancient Art,* many of which express Raphael's inferiority to the ancients.[8]

It is clearly acknowledged that Winckelmann had a profound effect on the appreciation of antiquity in France, but one cannot assume a similar effect on the view of Raphael.[9] Most of Winckelmann's notions of Raphael as an artist who had closely followed the ancients in pursuing beauty, were well established in the seventeenth-century Academy and maintained through the eighteenth century. He did argue the primacy of design over color, wiping out the major criticism of Raphael from de Piles onward, but his *Geschichte* was dedicated to promoting antiquity and scarcely mentioned Raphael. He attacked the equation of Raphael and antiquity, shifting his focus to specific ancient works as examples of all aspects of ideal beauty. According to Winckelmann, one should follow Raphael's procedure in seeking beauty, but only exceptionally imitate his works.

Anton Raphael Mengs

Anton Raphael Mengs, court painter to Augustus III in Dresden and Charles VII in Spain, *principe* of the Academy of Saint Luke, and one of the leading painters in Rome in the third quarter of the eighteenth century, was a major innovator and propagator of neoclassicism. His close friend Winckelmann praised him as the greatest painter of his time, the "German Raphael."[10] With such works as his *Parnassus* (1761) in the Villa Albani in Rome, he, like

his French contemporary Vien, established a new kind of painting. Their models were antiquity and great, modern classical masters, including Raphael.[11]

Mengs promoted a neoclassical aesthetic through his paintings and his writings, such as his *Gedanken über die Schonheit der Malerei* (1762). His theoretical works have generally been dismissed as a mere reflection of Winckelmann's ideas (Blunt, "Legend," 17), but this categorization ignores important differences in the background and aims of the two men. Generally, both men believed that the *beau idéal* was to be found only in antiquity, because ancient artists knew how to choose from nature. Mengs, however, was an artist, not simply an antiquarian. Winckelmann was primarily concerned with promoting knowledge and appreciation of antiquity through specific, beautiful examples and arguing the necessary superiority of Greek works over modern ones. Although Mengs generally agreed with Winckelmann's philosophical orientation and theory, he was a painter who wished to explain beauty and taste and to give examples for artists to imitate.[12]

Junius had shown the inadequacy of basing a painting treatise on lost ancient examples. Mengs instead revived the modern triumvirate of Raphael, Titian, and Correggio, the same group that had appeared in Félibien's *Entretiens* and Dufresnoy's *De Arte Graphica* (see Chapter 1). Mengs shared with them the belief that each, in his own genre of excellence, had surpassed all who followed him. Mengs also went beyond theoretical formulation to evaluate specific works by these artists. Of course, Mengs was able to study Raphael's great works in depth while in Rome. We see reflections of that study not only in Mengs's more specific criticism, but also in many of his paintings, such as his *Lamentation,* painted for King Charles III of Spain between 1765 and 1769, which may have been intended as a pendant to Raphael's *Christ Carrying the Cross,* and his copy of the *School of Athens* (Fig. 42), commissioned by Lord Percy for Northumberland House. Certainly, although his *Parnassus* (1761, Fig. 43) clearly reveals the influence of Winckelmann's ideas in its central figure based on the *Apollo Belvedere,* it is equally dependent on Raphael's *Parnassus* (see Fig. 5) for its overall conception and figure style.[13]

Mengs's ideas on Raphael were expressed in his treatise *Reflections on Beauty in Painting* and expanded in an unfinished work on Raphael, Correggio, Titian, and the ancients. Both were published in *The Works of Anton Raphael Mengs.* Three French editions within five years prove the popularity of this work.[14] Mengs agreed with Winckelmann that Raphael was the greatest of the moderns, but lacked the *beau idéal* of the ancients. He set up a hierarchy for each aspect of painting: the true, the pleasing, the significant or expressive, and finally, the beautiful. Raphael, who excelled in expression, composition and design, was the greatest master of the expressive level; Correggio's art was merely pleasing and Titian's merely true to nature (*Works,* 37). Mengs returned here to the seventeenth-century classicists' idea that color was only related to verisimilitude. Like Félibien, Mengs believed Raphael the superior artist because he excelled in the most important parts of painting, but he was beneath the ancients, since he lacked their sense of ideal beauty (*Works,* 37). Mengs combined this hierarchical approach with eclecticism.

According to Mengs, "Raphael was perfect in expression, but less so in color so one need only learn expression from him. . . . By the same method one should seek beauty and the causes of it in any great master' (*Works,* 42). Mengs considered each aspect of Raphael's art according to his hierarchy: His design was expressive, but not ideal; his chiaroscuro was imitative and his coloring was rough and ordinary. Discussing composi-

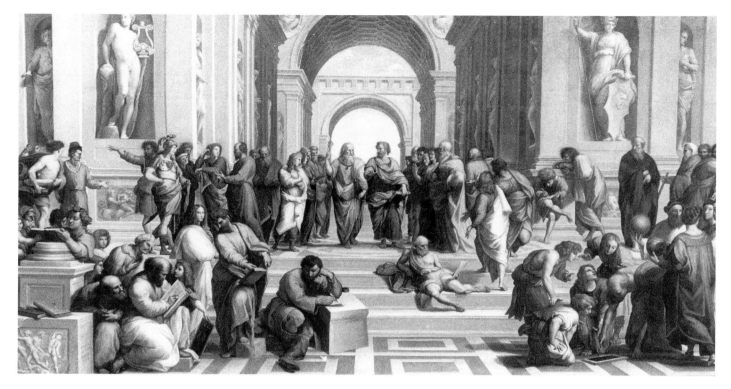

Fig. 42. Anton Raphael Mengs, full-sized copy of Raphael's *School of Athens,* 1755, Victoria and Albert Museum, London

tion, Mengs argued that the Greeks "hovered between heaven and earth; Raphael proceeded with sublimity and majesty on the earth alone" (*Works,* 63). Since Raphael always worked with a central idea, however, the essentials were always there. Everything in a work by Raphael was always integral and necessary. Here Mengs focused on the essence of Raphael's classicism.

Since Raphael was not dedicated to pleasing the viewer, his work was not harmonious. Mengs recalled Bosse in suggesting that Raphael does not please everyone immediately because his beauties are founded on reason and have to penetrate the imagination (*Works,* 46). By denying the importance of immediate impact of a work, Mengs rejected the aesthetic established by de Piles. He nonetheless agreed with de Piles's differentiation between Poussin and Raphael: Poussin had more of the ideal than Raphael, but Raphael was better able to combine the ideal with imitation of nature.[15]

In general, Mengs felt that Raphael had developed through his early commissions in the Vatican, but declined when he attempted to imitate Michelangelo, as in the *Fire in the Borgo.* This agreed with Vasari's appraisal. Differing with Winckelmann, Mengs believed that Raphael came out of his decline with the *Transfiguration:* "He is no longer the free and ardent painter of the Vatican frescoes; He chooses the true and beautiful, discovers a new degree of perfection, and opens the true road to the Art" (*Works,* 145). Mengs found the expression more noble and delicate, the chiaroscuro better, the differentiation of tone

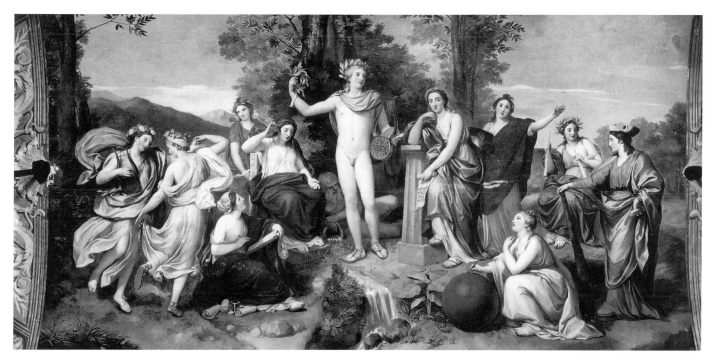

Fig. 43. Anton Raphael Mengs, *Parnassus,* 1761, Villa Albani, Rome

better understood, and the strokes more fine and admirable, since one does not find any lines or contours as in the earlier works (*Works,* 145f.).

Mengs dwelled on Raphael's virtues and faults at great length in his expanded treatise. Raphael's design was good, but not ideal like the ancients'. His male figures were excellent, but his female figures were not graceful, often having a trivial, vulgar, or harsh air.[16] Mengs realized that Raphael's antique examples had primarily been Roman relief, rather than the best Greek sculptures, so his figures were properly proportioned, but lacked much of the elegance and delicacy of the best Greek works, such as the *Apollo* or the *Gladiator* (*Works,* 146). Mengs concluded that Raphael was best when he could imitate an antique model. This weakness showed in his depiction of hands and children, for which few antique examples survive. As an example, Mengs criticized the common character of the child in the *Madonna della Sedia* (*Works,* 149). Raphael also made the mistake of copying Michelangelo, whose forms Mengs viewed as vulgar and overcharged, and who seldom showed muscles in repose. Michelangelo lacked Winckelmann's "edle Einfalt and stille Grosse" (noble simplicity and calm grandeur) (*Works,* 150).

Mengs argued that Raphael did not really know how to profit from the antique example. Concerning Raphael's forms, he stated that

> [h]e imitated the ancients only in practice or manner, not in beauty or perfection. He sought in nature the beautiful things he had discovered in ancients of the second order, and from them formed his taste. He was excellent in the natural

things he found in the ancients and what he didn't find there, he could not imagine. (*Works,* 150)

Here Mengs stressed one of the crucial differences between neoclassical and earlier classical theory: One should not simply work in the manner of the ancients, as Raphael did; one had to form one's taste directly on their best works. Like Winckelmann, Mengs felt that Raphael had not gone far enough in imitating the ancients.

Mengs criticized other aspects of Raphael's art. Raphael's chiaroscuro never transcended imitation and even contained frequent errors. His coloring improved under the influence of Fra Bartolommeo, as was evident in the Vatican frescoes. The confusion of color in the *School of Athens* was partially corrected in the *Heliodorus,* which was more forceful but lacked delicacy. In *Fire in the Borgo* he forgot color for design: "After that he neglected the parts which lead to perfection and took the easy road to fortune" (*Works,* 151), but recovered with the parts of the *Transfiguration* painted by him. The heads of the Apostles were beautifully colored. Mengs lamented that none of Raphael's oil paintings from his best period were entirely by him and concluded that his color was better in his frescoes than in his oils (*Works,* 157).

Composition was Raphael's greatest glory, in which he even surpassed the ancients (*Works,* 158). He used variety without contradiction, violent passions without affectations or baseness; he was able to understand and to express a variety of different circumstances. He emphasized expression, rather than mere effect. Mengs concluded that:

> Raphael changed and improved Nature in expression but left it as he found it in Beauty. His figures are always human. He even shows his creator with human imperfection. The Greeks were better than this. They also surpassed him in harmony. In the Ancients, one can know the character of the whole face from one part; this is not so in Raphael. His ideal figures are not perfect enough. (*Works,* 171–72)

Winckelmann and Mengs were certainly the most influential foreign theorists whose writings, translated into French, added fuel to the fire of neoclassicism in the last third of the century. There were others as well: Hagedorn, Algarotti, Webb, and Reynolds, who shared belief in antiquity as the guide to *la belle nature.* They revived and transformed French seventeenth-century classicism and Raphael's place within that system of values. Algarotti and Hagedorn combined classicism with an eclecticism and concern with painting's sensual aspects that recalled de Piles. They stressed his view that Raphael was moving toward a new kind of synthesis of the ideal and nature. Webb most slavishly exalted antiquity and came the closest to attacking Raphael for inadequacies. These men primarily fit Raphael into their preconceived set of values, rather than deriving their principles from his works. All contributed to the neoclassical revival.

Hagedorn, a close friend of Winckelmann and *directeur générale des beaux-arts* at Dresden,[17] was extraordinarily well read in art theory and criticism, drawing on the ideas of Armenini, Testelin, Félibien, de Piles, Dubos, Winckelmann, comte de Caylus, Perrault, Hogarth, and others. His ideas were published in his *Réflexions sur la peinture* (c. 1762; translated into French by M. Huber in 1775).[18]

Like Winckelmann and Mengs, Hagedorn believed that Raphael had followed the

proper route in emulating the ancients. He likened Raphael to Apelles in the "noble simplicity" of his work (*Réflexions,* 109). Mengs saw the *Galatea* as evidence of the insufficiency of Raphael's concept of ideal beauty formed apart from antiquity; Hagedorn saw it as moving beyond imitation of antiquity toward a synthesis of ideal and nature. Hagedorn revived de Piles's concept of the "perfect truth" as a combination of simple and ideal truth (*Réflexions,* 83–84). He also agreed with de Piles that Raphael had been moving toward this synthesis at the end of his career as he assimilated nature to the ideal, as he combined "the ancients' perfections with the graces of the Moderns."[19] In his own works, Raphael was already Apelles; he was now becoming Zeuxis as well. So one should not only imitate Raphael in the parts of painting he had already acquired, but also in those toward which he was working, including excellence in color (*Réflexions,* 98).

The neoclassical viewpoint was extolled from Italy in a treatise by Algarotti, the leading Italian critic of the mid-eighteenth century.[20] In his *Essay on Painting* of 1764 (translated into French in 1769),[21] he combined adulation of the Greeks in Winckelmann's fashion with a broader eclecticism. From our perspective, the most interesting aspect of his treatise is his reconsideration of Roger de Piles's "Balance des Peintres" (*Essay,* 165–71).

Algarotti saw Raphael as the culmination of the revival of painting that had begun with Cimabue. Raphael, "studying the works of the Greeks, without ever losing sight of Nature, brought the art, in a manner, to the highest pitch of perfection. This great man has, if not entirely, at least in a great measure, attained those ends, which a painter should always propose to himself to deceive the eye, satisfy the understanding, and touch the heart" (*Essay,* 158).

In considering de Piles's "Balance" in which Rubens and Raphael were judged equally great, Algarotti criticized de Piles's judgments made with a bias in favor of Rubens. He showed an appreciation for Rubens's virtues as an inventor and a colorist, but argued that his peculiarly "Flemish" manner rendered him inferior to Raphael. Speaking of Poussin:

> He would have equalled Raphael himself, whose st[y]le he imitated, were gracefulness, ease and vivacity to be acquired by study. For, in fact, it was by mere dint of labour and fatigue, that he produced what in a manner, cost Raphael nothing; insomuch, that his figures may be said to mimick the natural actions of that great master. (*Essay,* 171)

Here Algarotti reversed de Piles, just as de Piles had reversed the seventeenth-century Academy. De Piles had raised Rubens over Raphael on the basis of greater naturalism. Algarotti implied that one found mannerism, not naturalism in Rubens's art; Raphael was the more naturalistic and superior painter. In his *Inquiry into the Beauties of Painting* (1760),[22] the English amateur Webb carried Winckelmann's and Mengs's belief in Raphael's inferiority to the ancients to an unequaled extreme. Although he praised a number of Raphael's works, such as his *Saint Cecilia,* and agreed that Raphael came closest to antiquity, he stressed Raphael's inadequacies. Like Fréart de Chambray, Webb revealed more vitriol than reason.[23] Discussing treatment of the nude, Webb suggested that a comparison of Raphael's figures in the *Fire in the Borgo* with the *Laöcoon* or *Gladiator* "would have much the same effect, as that of a Flemish coach-horse with an Arabian

courser" (50). There is no evidence that the French ever shared such an extreme view of the disparity between Raphael and the ancients.

Joshua Reynolds's *Discourses*

At the distribution of annual prizes between 1769 and 1790, Joshua Reynolds delivered fifteen widely acclaimed Discourses in his role as president of the Royal Academy.[24] Neither strikingly original, nor brilliant, their primary virtue was the expression of generally held beliefs with clarity and conviction. As Reynolds stated his aim: "I have pursued a plain and honest method; I have taken up the art simply as I found it exemplified in the practice of the most approved Painters. That approbation which the world has uniformly given, I have endeavoured to justify by such proofs as questions of this kind will admit" (269). In following this method, he emulated Dufresnoy, to whose translation by Mason he had appended notes.[25] One of the most important of Reynolds's "approved Painters" was Raphael.

The *Discourses* were influential far beyond the English Academy. In the 1780s they were translated into German, French, and Italian.[26] The French translation was made by Janson (1787), who had just completed the French translation of Mengs's *Works*. In passing, Mengs had criticized Reynolds's *Discourses* as superficial. Janson disagreed and wrote Reynolds, offering to translate the *Discourses* into French. Reynolds heartily concurred with this idea, and a French edition containing Discourses 1–13 appeared in 1787.[27]

Reynolds's philosophical orientation and major principles have been extensively studied and can be briefly summarized. Essentially a classicist who believed in ideal beauty and the moral and ethical ends of art, he was far from rigid. His *Discourses* reveal a number of departures from strict classical theory: He conceded that art must appeal to the viewer's imagination, going beyond purely rational appeal. He also admitted association as a factor in aesthetic response. Although he embraced the hierarchy of styles that placed the grand (Florentine and Roman) over the ornamental (Venetian), he suggested that art had to be judged by its intention. He even suggested that "perfection in an inferior style may reasonably be preferred to mediocrity in the highest walks of art."[28] Although he wholeheartedly supported the academic system of instruction, he believed in the power of the individual to transcend the rules (Discourse 7, 424f.).

In attempting to establish a system of painting based on classicism, Reynolds referred frequently to Raphael. In fact, he figured prominently in nine out of fifteen Discourses.[29] Using Raphael to exemplify many of his general principles, Reynolds adopted several of the well-established images of the artist. Like the French Academicians, Reynolds, president of the Royal Academy, stressed the image of the "academic Raphael," who had learned from a wide variety of sources how to improve his style. In his sixth Discourse, Reynolds suggested that "we should imitate the conduct of great artists in the course of their studies, as well as in the work they produced" (103). Raphael was the perfect example, since he learned from everyone: "And it is from his having taken so many models that he became himself a model for all succeeding painters; always imitating and always original. If your ambition, therefore, be to equal Raphael, you must do as Raphael

did, take many models, and not even him for your guide alone" (104). Reynolds stressed this idea again in his twelfth Discourse, in which he stated, using Raphael as an example, that the more original an artist was, the more successfully he could borrow from his predecessors (217).

Like all classicists, Reynolds believed in the importance of the ancients' example, but he did not dwell on it so much as others discussed above. He stated: "However it may mortify our vanity, we must be forced to allow them our masters and we may venture to prophecy, that when they shall cease to be studied, arts will no longer flourish, and we shall again relapse to barbarism" (106). The ancients' works were a compendium of ideas from which any artist should feel free to borrow, just as Raphael did.

As an Academician, Reynolds certainly believed in the importance of rules, but he also realized that men of artistic genius, such as Raphael, could transcend them. For instance, the student was taught to use contrast for expression, but, echoing Mengs, Reynolds stated:

> The greatest beauties of character and expression are produced without contrast. . . . St. Paul preaching at Athens in one of the Cartoons, far from any affected academical contrast of limbs, stands equally on both legs and both hands are in the same attitude; add contrast, and the energy and unaffected grace of the figure is destroyed. . . . Indeed you will never find in the works of Raphael any of those schoolboy affected contrasts. Whatever contrast there is, appears without any seeming agency of art, by the natural chance of things. (154–55)

For Reynolds, Raphael was the perfect academic model because he was able to transcend the limits of academicism: a too extreme dependence on the rules or one's predecessors to the point of losing originality.

Perhaps the most interesting and revealing aspect of the *Discourses* is Reynolds's comparison of Michelangelo with Raphael. In their "grand style," Raphael and Michelangelo surpassed the "ornamental" Venetians, who excelled in the "mechanical" aspects of art:

> But compare their capricious composition, violent and affected contrasts of figures and chiaroscuro, richness of stuffs—giving a mean effect, and total inattention to expression; then reflect on the conceptions and learning of Michelangelo or the simplicity of Raphael. Their art appears as a struggle without effect, "a tale told by an idiot, full of sound and fury, signifying nothing." (64)

In Discourse 11, Reynolds somewhat amended this harsh judgment, stating that Raphael was the first of painters, but his works would certainly not have been less excellent if he had expressed his ideas with the facility and elegance of Titian (198).

Reynolds was not so clear in his relative ranking of Michelangelo and Raphael, although much of his fifth Discourse was devoted to comparing them. He admitted that Raphael was generally considered the greatest modern artist because of his excellence in the highest parts of art. Michelangelo did not possess so many perfections as Raphael, but his were of a higher sort: correctness of form and energy of character. Reynolds was sensitive to the decline of Michelangelo's reputation and sought to revive it. Like Vasari, he also stressed Raphael's dependence on Michelangelo for his artistic development: "It is to Michelangelo

that we owe even the existence of Raphael; it is to him Raphael owes the grandeur of his style. He was taught by him to elevate his thoughts, and to conceive his subjects with dignity" (83). Reynolds found the flame metaphor expressive:

> Raphael's genius, however formed to blaze and shine, might, like fire in combustible matter, forever have lain dormant if it had not caught a spark by its contact with Michelangelo, and though it never burst out with his extraordinary heat and vehemence, Yet it must be acknowledged to be a more pure, regular and chaste flame. (83)

And he grudgingly admitted:

> Though our judgement must upon the whole decide in favour of Raphael, yet he never takes such a firm hold and entire possession of the mind as to make us desire nothing else and to feel nothing wanting. The effect of the capital works of Michelangelo perfectly corresponds to what Bouchardon said he felt when reading Homer; his whole frame appeared to himself to be enlarged, and all nature which surrounded him reduced to atoms. (84)

This statement of the sublime seems more in accord with the spirit of Romanticism than neoclassicism. According to Reynolds, Raphael had taste; Michelangelo had genius and imagination. Raphael had beauty; Michelangelo had energy. Michelangelo had a more poetic imagination and sense of the sublime; Raphael's imagination was not so elevated: "his figures are not so much disjoined from our own diminutive race of beings, though his ideas are chaste, noble and of great conformity to their subjects" (83). By reviving Vasari's distinction between the sublime genius Michelangelo and the decorous Raphael (see Chapter 1), Reynolds exalted Raphael while attacking his supremacy. Like Winckelmann and Mengs, but for different reasons, Reynolds made Raphael exemplary without viewing his work as the highest level of artistic achievement. Not surprisingly, given his attitude, Reynolds's greatest adulation and final words of instruction in the Academy were reserved for Michelangelo, not Raphael (Discourse 15, 282).

It is apparent from the number of references, translations into French, and quotations from these foreign neoclassical treatises that they were widely read. Winckelmann and Mengs were perhaps the best known. There is little evidence, however, that the French adopted the view promulgated by Winckelmann and Mengs of the exclusive perfection of Greek art. Alexander Potts, who has made the most complete study to date of Winckelmann's European reception, suggests that Winckelmann was widely quoted before he was really understood ("Winckelmann's Construction of History," 394–95). The French, by and large, regarded his work as a speculative history that, although well worth looking at, had serious flaws. Eméric-David, who wrote an alternative history of ancient sculpture in 1805, regarded Winckelmann's work as misguided and useless.[30] Foreign neoclassicists' effect may have been greater on French theory than on practice. The neoclassical style the French adopted was as much based on Raphael and Poussin as on the ancients' works. Eclecticism continued to be the rule in France.

Raphael and Neoclassicism in France (1774–1793)

Having traced Raphael's place in the ideas of Winckelmann, Mengs, Reynolds, and other foreign, neoclassical theorists, we can return to a consideration of the French artistic climate in the second half of the century. The general changes that occurred in the art of this period have been traced by Locquin, Hautecoeur, Waterhouse, and others.[1] Locquin, in particular, traced the move fostered by the *surintendants,* beginning in 1747, away from what was viewed as the frivolity and licentiousness of the *petite manière* toward history painting of serious, exalted subjects taken from antiquity or French history. More than anyone else the count d'Angiviller, who became *surintendant* in 1774, fostered this movement by tightening control of academic teaching and patronage and generally imposing his severe tastes on French art.

Recently, this view of developments in French painting in the second half of the eighteenth century has been challenged by Fried and Bryson, and augmented and modified by Crow.[2] Fried attempted to see these developments primarily in what he termed the "ontological" concerns of painting—the shift from a conception of painting based on the concept of "absorption" to a conception based on a

"theatrical" approach. Although Fried does point to significant aspects of the works he discusses, his structuralist approach is too rigid and dichotomous, and tends to remove the works from their historical contexts. Bryson attempts to replace the traditional stylistic approach to these developments with a semiotic reading. His approach represents an important contribution in providing an additional perspective for understanding developments that were not simply a matter of aesthetic taste. By completely abnegating the significance of style, however, he denies what we have seen throughout this study: that style itself carried a symbolic weight. Thomas Crow has augmented rather than refuted Locquin's thesis by stressing the public and political dimensions of this reform movement. These *surintendants,* who represented the ascendent bourgeoisie under Pompadour, attempted to harness the Academy and the artistic establishment to support their own bid for power.[3]

The marquis de Marigny, *surintendant* from 1751 to 1773, was hampered in his revival of history painting by the Rococo tastes of Louis XV. At any rate, he seems to have lacked enthusiasm for elevated history painting himself. D'Angiviller, who came to power under Louis XVI with his full support, had no such handicap. The first official Salon under Louis XVI in 1775 set a new tone. Very precise instructions to the jury from d'Angiviller, Pierre, and the king barred licentious subjects and indecent nudity and recommended respect for propriety. Historical events, as a result, replaced the mythologies that had been popular since the early part of the century. Yet, as Bryson has argued, the *surintendant*'s call for reform did not specify a specifically classical style. In fact, the call for convincingly rendered scenes from French history mitigated against the influence of classical subjects.[4] In this severe atmosphere Vien supplanted Boucher as the leader of the French school.[5]

Although Vien was seen as the father of the return to antiquity in France, the philosophical and practical background had been laid by Encyclopedists, such as Diderot and antiquarians, such as Caylus.[6] Vien's art was one logical outgrowth of neoclassical tendencies already evident in the Academy *conférences* after 1747. Knowledge of antiquity was greatly increased by publications of archaeologists and antiquarians and by pilgrimages to Rome, which came to be viewed as an essential part of the artist's training.[7] D'Angiviller revived the importance of the Roman Academy by abolishing the Ecole des élèves protégées in 1775, which had provided an alternative to study in Rome (Courajod, *L'Ecole,* 130). Vien, the "restaurateur" of good taste in French painting was sent to Rome to direct the Academy, taking David, Peyron, and Bonvoisin with him.

Vien was a key figure for his teaching as much as for his artistic example. As director of the Academy in Rome (1775–87), he reinstituted, under d'Angiviller, a vigorous program of studying past masters, antiquity, and life drawing. Each year in Rome the student had to send five *Académies* to Paris for scrutiny. He also had to make one Old Master copy during his four years.[8] Vien, who had copied Raphael as a student in Rome, made certain that his students followed suit.[9] As Caylus had stated in a 1750 *conférence:* "Raphael's art, delicate synthesis of antique beauty and living nature, provides an incomparable lesson" (Locquin, 98). Almost thirty years later, Menageot wrote to d'Angiviller: "that the only base, the most certain route for not going astray and for achieving the sublime in painting is the study of Raphael and Domenichino, because this is to study nature, and nature in its most beautiful choices" (Locquin, 100).

Although these statements reveal continuity, there is a shift of emphasis. The first sees

Raphael's art as a synthesis of antiquity and nature, in the sense of the *vrai parfait* ideal of Roger de Piles. The second stresses the classicist's view of Raphael's art as a guide to *la belle nature*. Between these statements, in 1775, David went to Rome, under the tutelage of Vien as winner of the Grand Prix.[10] As the ultimate leader and most influential member of the "école française," David is central to any study of neoclassicism, and his views on Raphael are crucial.

Since David began as a pupil of his cousin Boucher, who had once advised a pupil not to take Raphael too seriously,[11] he provides an interesting case for studying Raphael's importance in French art. With the guidance of Vien and the young antiquarian, Quatremère de Quincy, who had been strongly influenced by Winckelmann, David discovered the beauties of the antique and Raphael in Italy. He described his feelings after his trip to Naples in August 1779[12] with Quatremère de Quincy:

> It seems to me as if I have just had an operation for cataracts. I understood that I could not improve my manner, the principle of which was false, and that I had to break with all that I had thought before was beautiful and true. I felt that copying nature without choice, was to follow a vulgar trade with more or less facility, but to proceed as the ancients or Raphael did, this was truly to be an artist.[13]

Writing about his experiences in Rome in a fragmentary autobiography, David described his shift in taste. At first, David admired Pietro da Cortona, making several sketches after him, but he became transfixed by Trajan's Column. After spending six months copying reliefs in his studio:

> Little by little I began to forget the bad French forms which always issued from my hand, and what I made began to take on the character of the antique; for this is what I mainly applied myself to. I intermingled my work, I drew after Domenichino, after Michelangelo, and above all, after Raphael. (Wildenstein and Wildenstein, 157)

He followed this description of his reformed course of study with a paean of praise to Raphael:

> Raphael, divine man! It is you who has gradually lifted me toward the antique! It is you, sublime painter! It is you among the moderns who has most closely approached these inimitable models. It is you yourself that let me see that the antique is even superior to you! It is you, sensitive and beneficent painter, who has placed my chair before the sublime remains of antiquity. It is your learned and graceful paintings which have made me discover the beauties. Also, after an interval of three hundred years, given my enthusiasm for you, O worthy Raphael, recognize me as one of your pupils. (Wildenstein and Wildenstein, 157)

This evaluation of Raphael accords exactly with Winckelmann's. We know that David was familiar with Winckelmann's writing, and it seems likely that he had read the *Gedanken* or the *Geschichte* by this time.[14]

Although David represented this change entirely in aesthetic terms, it may well have

had much to do with his desire to challenge his chief rivals for supremacy among rising French artists, as Crow has argued (*Painters,* 198–211), by more closely conforming to the tastes of d'Angiviller. David reflected further on his altered taste in a letter to Vien on his second visit to Rome in 1784, suggesting that artists such as Cortona, Andrea Sacchi, Luca Giordano, who once pleased him, no longer did. His enthusiasm had shifted to Raphael, the Carracci, Domenichino and above all to antiquity (Wildenstein and Wildenstein, 17).

David's studies seemed to have followed these priorities very closely. Although he copied Raphael, he devoted most of his energy to antiquity.[15] For the most part, he copied what he saw as Raphael's approach, rather than his forms, just as Winckelmann had recommended. Yet David never devotes himself exclusively to the antique as Winckelmann suggests. His works, such as the *Horatii,* the *Brutus,* and others owe as much or more to Poussin and Caravaggio as they do to antiquity (Cummings, "Painting under Louis XVI," 39). There are exceptions, in which David's works seem directly dependent on Raphael: The clarification and simplification of his style in the *Belisarius* is certainly based on the cartoons, as well as the works of Poussin. His *Intervention of the Sabine Women* (Fig. 44) relies on Raimondi's *Massacre of the Innocents* (engraving after Raphael; Fig. 45),[16] but most of his works rely more directly on antique models. These include the *Death of Socrates* (1787), the *Leonidas* (completed 1814), *Hector and Andromache* (1783), and others.[17]

Yet Raphael's work was clearly a standard of excellence for David which he communicated to his pupils. When Mme Vigée-Lebrun asked David for advice on how to paint the queen holding the dauphin, David gave her an engraving after Raphael's *Holy Family.* Vigée-Lebrun had made a very extensive study of Raphael, copying a number of his works.[18] When his beloved pupil Drouais died in 1788, he gave him the highest possible praise as "a man who perhaps was destined to be cited along with Raphael" (Wildenstein and Wildenstein, 25). Commenting to his pupil Jean Broc (one of the infamous Barbus or "the bearded ones," one of several names given to a rebellious group of young artists in David's studio) David noted that Broc's primary strength was colorism. Therefore, he told him, "you should not set yourself up to act as if you are a Raphael." Broc should study the Venetians first and then the Italians. After this, he should forget the masters and copy nature as if he were copying a painting (Wildenstein and Wildenstein, 138). This may seem rather extraordinary advice by the archneoclassicist, yet it was precisely this merging of realism with classicism that gave David's works their power. He told another pupil, Girodet, that his conceptions were too forced and exaggerated, and that he should learn that beauty is always simple, as one sees in the works of Raphael, Leonardo, and even Michelangelo (Wildenstein and Wildenstein, 158).

Of course David was not limited to studying Raphael in Rome. In addition to being able to study the works in Paris (greatly enhanced in number by the Napoleonic conquests), he owned engravings of many of Raphael's major works.[19]

Although the veneration of antiquity and Raphael grew throughout this period, it was not universal. David's views stand in stark contrast to those of the sculptor Falconet, writing in 1772, who produced some of the severest criticism of Raphael written in France.[20] Falconet never saw Italy, but this did not temper his criticisms of Raphael's works in Rome. In discussing the *Disputà,* he criticized what he regarded as the "trivial arrange-

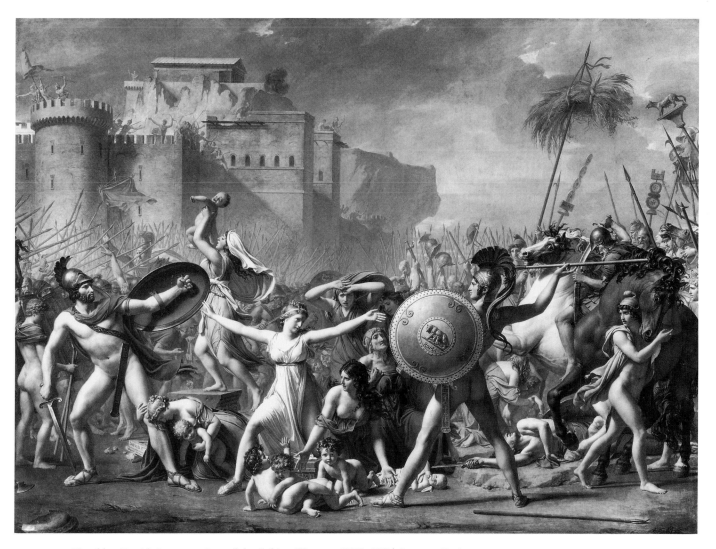

Fig. 44. David, *Invervention of the Sabine Women,* 1799–1804, Louvre, Paris

ment" of the Father, Son, and Holy Spirit, as well as two ridges of clouds, rather "meanly larded with cherubim," making for a ridiculous gothic effect (*Oeuvres complètes,* 1:393).

Discussing chiaroscuro, Falconet found Raphael lacking. He suggested that Raphael's works lacked the overall harmony of tone that represents the "magic of chiaroscuro." Therefore, to master this aspect, one should study the works of Titian, Rubens, Rembrandt, and other artists who were masters of this aspect (*Oeuvers complètes,* 1:378). (Falconet did not universally despise Raphael. Speaking of *Saint Paul Preaching,* he praised its skill, poetry, and the mastery of its composition. He also admired the *School of Athens* [*Oeuvres complètes,* 1:393].)

The sculptor reserved his most severe condemnation for the *Transfiguration,* in which he felt that there was a disjunction between the two parts of the composition, with the less significant episode given the greater prominence. One might even have difficulty discern-

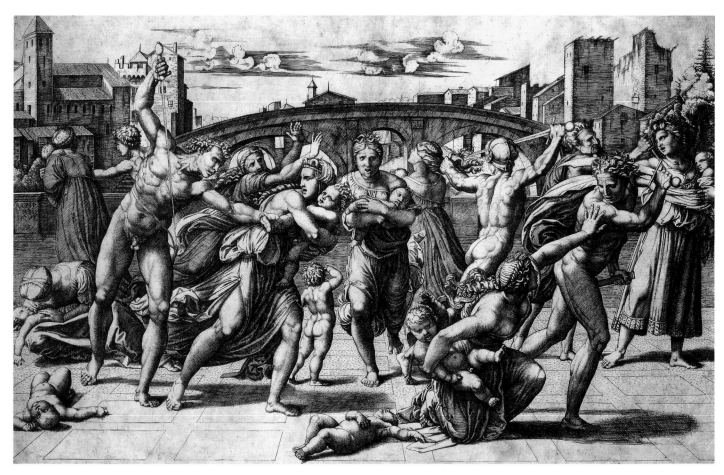

Fig. 45. Marcantonio Raimondi, *Massacre of the Innocents,* engraving after Raphael, c. 1511–12

ing the principal subject (*Oeuvres complètes,* 1:391). He concluded that it was difficult to see why this work would be termed Raphael's masterpiece: "If it is for the skill, it is filled with weakness; if it is for the composition, one can see at what point it is irrational; if it is for the poetry, I defy you to show me a part of the painting which evidences it in such a way that immediately, it would not be counteracted by a contradiction or an absurdity" (*Oeuvres complètes,* 1:392).

Falconet represented a particular extreme, one not shared by most of his contemporaries, rather than the typical view of antiquity and Raphael. His works prove that acceptance of the new neoclassical aesthetic was not universal.

The Rise of Primitivism

In addition to the challenge posed by Winckelmann and others to the French notion of the virtual equality of Raphael and the ancients, the image of Raphael was modified by other

currents. Specifically, the exaltation of primitivism in the works of the Barbus and in the writings of Seroux d'Agincourt, Alexandre Lenoir, head of the Musée des Monuments françaises, and others challenged the accepted notions of Raphael's place in the history of artistic development.

As interest in and acceptance of the Italian primitives grew, more attention was paid to Raphael's art as a culmination of centuries of artistic development. The prestige of Raphael was used to justify interest in his remote predecessors. For Seroux d'Agincourt, Giotto was the first great reformer of modern art.[21] His successors drew art ever closer to the perfection of the Renaissance. Of course, this notion could also be traced back to Vasari.

Seroux d'Agincourt's disciple Artaud de Montor in his tellingly titled study *Considerations sur l'état de la peinture en Italie, dans les quatre siècles qui ont precédé celui de Raphael* (1811) (*Considerations on the state of painting in Italy in the four centuries preceeding that of Raphael*) made an explicit statement of Raphael's dependence on his predecessors. These earlier artists "were responsible for spurring Raphael's emulation, ennobling his soul and elevating his enthusiasm. . . . Thus, let us pay homage to rivals who have been left far behind, but to whom we perhaps owe the masterpieces of the immortal founder of the Roman school" (Levitine, *Dawn,* 103).

Paillot de Montebert, another disciple of Seroux d'Agincourt and a member of David's atelier after 1796, not only exalted primitive art; he condemned art following Raphael. He proclaimed that the Italian primitives, despite their technical shortcomings, possessed the sublime and naive qualities that constitute the character and the dignity of art (Levitine, *Dawn,* 105).

The theoretical justifications for primitivism found their tangible embodiment in the works of the Barbus, Primitifs, or Méditateurs, as they were variously called, that curious, rebellious sect in David's atelier. Deriding David's *Sabines,* in which he had attempted to be "more Greek," as not going far enough, Maurice Quai and his followers called for an archaic purity, which they felt could only be found in ancient literature (i.e., in Homer, the Bible, and Ossian), and in the ancient visual arts (i.e., in the works done in the time of Phidias and before). They viewed everything that came later as tinged with falseness and theatricality, traits with which the greatest Italian masters, presumably even Raphael, were afflicted (Levitine, *Dawn,* 61).

The new exaltation of the primitive reversed the traditional perspective on Raphael. Rather than seeing his work as the rebirth of ancient principles of art and the beginning of great subsequent developments, the Primitifs and such theorists as Seroux d'Agincourt viewed his career as the endpoint of a long progressive process and the beginning of the degradation of art. One effect of this perspectival shift was to place greater emphasis on a purer, more naive Raphael epitomized in the early Madonnas and other early works and to see later works, such as the proto-Baroque *Transfiguration* as heading off in the wrong direction.

The Primitifs certainly did not reject Raphael out of hand. Jean Broc's *School of Apelles* (1800) recalls Raphael's *School of Athens* in countless details of setting, figure-type, pose, and gesture.[22] The resemblance was so obvious that Broc was even accused of plagiarism. In particular, his color was seen as emulating old frescoes or worn cartoons. One critic asserted, "This is the way color was used at the time of the birth of art, and one can find some examples in the paintings of Perugino and in those of early Raphael" (Levitine,

Dawn, 114). Whether offering an accurate appraisal or not, the critic was clearly correct in choosing Raphael as the appropriate reference point. Another obvious example of Raphaelism among the Primitifs is evident in Jean-Pierre Franque's late *Madonna and Child* (1853; Chapel of Quintigny) (Levitine, *Dawn,* pl. 47). Although this group of artists promoted a pure primitivism, Raphael was still considered an acceptable model.

Additional emphasis on the early, pious, naive Raphael was provided by the Catholic revival that took place in France around 1800. The "pious Raphael" was most clearly emphasized in books such as Chateaubriand's *Génie du Christianisme* (1802), and Wackenroeder and Tieck's *Herzensergießungen eines kunstliebenden Klosterbruders* (Heartfelt outpourings of an art-loving monk) (1797). In his "Raphael's Vision," Wackenroeder suggested that Raphael's image of the Madonna was divinely inspired. For Chateaubriand, the development of art between the fifteenth and sixteenth centuries represented the triumph of faith and church support.[23]

Watelet and Levesque's *Dictionnaire*

Watelet and Levesque's encyclopedic *Dictionnaire portatif de peinture, sculpture, et gravure* (1792) provides a rich guide to common artistic ideas in France at the end of the century.[24] As a collaboration produced over many years, the dictionary or encyclopedia reveals changing ideals from Watelet, who shared the eclecticism common at mid-century, to Levesque, who had absorbed the new tenets of reform and neoclassicism. Levesque clearly stated in his introduction that there was a strong divergence of values between him and his earlier collaborator Watelet:

> This esteemed amateur saw antiquity and Italy, but it is apparent that he did not have an esteem that was profoundly enough felt for Rome and antiquity. This is not his fault, but rather the time at which he was born. The impressions received in one's youth are indelible and in Mr. Watelet's youth our school had more than ever the fault of being purely French, a major fault, without a doubt, since the best taste in the arts is that which is most universally approved. (vol. 2, foreward)

It is hard to imagine a stronger statement of the laissez-faire, naturalistic aesthetic's inadequacy and its total rejection.

Levesque stated that he published Watelet's articles as he found them after Watelet's death. He did on occasion add a new article under the same word "to supplement his omissions, or to pose principles more universally accepted; occasionally we have simply established in other articles principles contrary to the prejudices which have for so long had the force of law in the French school" (1:87). Levesque's approach for dealing with Watelet's ideas allow us to contrast the two men's views, representing two different periods in French artistic thinking. One can ask what notions of Watelet Levesque regarded as outmoded.

In his article "Antique," Watelet stated that although the common idea is that everyone should study antiquity, people have different inclinations. Not all are suited to pursue the

most sublime aspects of art; many have a penchant for simple imitation, and they are still capable of producing estimable works (1:87). Watelet even suggested that if one attempted to imitate antiquity without having the proper inclinations, the artist could not only fail to achieve sublime beauty, falling into affectation, but he could lose "the amiable truth which simple nature presents" (1:x).

Contrast this with Levesque's ideas on antiquity:

> One finds in the works of the ancient Greeks the most beautiful, the greatest aspects of art, those which raise it above what can be achieved through the most perfect handbook, the practice of classic and conventional rules of composition, and the prestige of color. It is primarily in these sublime aspects that Raphael and the artists of the Roman school, these illustrious pupils of antiquity, made their principal subject of study, neglecting some of the lesser aspects which have made the glory of many other schools. (1:602)

With this statement Levesque reinstituted the hierarchy that had dominated seventeenth-century classicism before de Piles, placing Raphael and the ancients at the pinnacle. He also adopted a notion from Winckelmann that modern art represented an inevitable decline from the heights of the antique and Renaissance, because current historical conditions made the attainment of such greatness impossible. As Potts has shown, this pessimistic view and nostalgia for the glory of Greece tended to become associated with political conservatism in France as is evident in Levesque, Quatremère de Quincy, and others.[25]

Commenting on the relative merits of design and color, Watelet revealed his eclecticism by arguing that the end of painting was the "imitation of visible nature," imitating objects' form and color. To try to decide which aspect of painting was more essential was like trying to decide whether a person's body or soul was more essential (1:xiii).

Levesque revealed an acceptance of different genres, but instituted a clear hierarchy: Even though expression and purity of design were the most noble aspects of art, one should not reject young artists whose inclinations lay elsewhere (1:431). With this hierarchy, Levesque clearly viewed the Venetians and Flemish as inferior to Raphael: "Raphael, sculptor, would have approached the artists of ancient Greece; Rubens, as sculptor, would perhaps have equalled Puget in one area, the sensation of flesh, and he would have been very much inferior in all the rest" (1:531).

Levesque's article on color strongly revealed his sense of values. He pointed out that the Roman School's color is really "clair-obscur illuminé," that is, that draperies are painted in single color as if they were white. He freely admitted that the Venetians and Flemish were the most celebrated colorists, but he still judged them inferior overall to the Italians (1:535).

Throughout most of the eighteenth century, it was believed that perfect art would result from a combination of the virtues of Raphael and the colorists, de Piles's *vrai parfait*. Levesque challenged that notion in terms that might be drawn from Winckelmann:

> Let us imagine a noble subject, such as Raphael might conceive; let us suppose that the expression of the figures is what he could give them; add here the beauty of

forms for which the most perfect antiquities provide the model; and here is enough to occupy the spirit of the viewer. If you add to all this the color of Titian or Rubens, rather than adding to the impression, you will weaken it because the viewer will no longer be in the proper state of repose in which one should above all be occupied. (4:145)

This is a direct and total reversal of de Piles's criticism of Raphael. As in the seventeenth century, Raphael's lack of immediate sensual appeal was seen as a virtue. Rich color was not only nonessential, but a distraction from higher beauties.

Subordinating color to design, Levesque made a statement that could equally well have come from Félibien: "The purity of design, the beautiful choice of forms, the expression, propriety, these are the great parts of art; these are the ones which assure Raphael the sceptre of painting. All these aspects are found to a high degree in beautiful antique statues" (4:145).

In discussing the value of Raphael's art in relation to that of antiquity, however, Levesque revealed sentiments closer to Winckelmann and Mengs than to the seventeenth-century Academy. In fact, most of his specific judgments on Raphael quote Mengs, stressing Raphael's inferiority to the ancients. Under "Idéal," Levesque quoted Mengs's judgment that Raphael's conception of ideal beauty was not so sublime as that of the ancients (3:86). Levesque took care nonetheless also to quote Mengs's praise of Raphael. Discussing invention, Mengs had stated that Raphael's works were the finest example in this area. His invention and disposition made one perceive the essence of the work at the first glance (3:185). And Levesque summed up the neoclassical view of Raphael by quoting Mengs: "The Greeks hovered in majesty between the heaven and the earth; Raphael walked correctly on the earth" (1:45).

Both the art and image of Raphael played a major role in the rejection of the Rococo and the neoclassical revival in France. When Academicians were urged by the *surintendant* to reinstitute a vigorous program of instruction through their *conférences,* they used the prestige of Raphael to bolster their ideas and to justify the academic approach. To support their continuing eclecticism and reviving classicism, they emphasized images of Raphael as the sublime eclectic and the modern Apelles. These had been used by the seventeenth-century Academy in an earlier period with similar ideals. Once again, in the late eighteenth century, the Academy borrowed the prestige of associating itself with Raphael to justify its singular position of authority in French art. As serious historical and religious subjects began to supplant erotic mythologies, many artists once again modeled their works directly on Raphael's examples.

Foreign neoclassical theorists stressed, much more than the French, the gulf between Raphael and antiquity. They believed that since the perfection of Greek art was a product of that particular culture and society, a modern artist could only equal the ancients in ideal beauty by emulating them directly. Although Raphael had followed antiquity more closely than any other modern, he did not go far enough. His procedure was correct, but his ideal was imperfect, so his art could not replace antique works as a model.

The ideas of Winckelmann, Mengs, and others shaped developing neoclassicism in France, though their ideas were never accepted uncritically. With increased knowledge of

and passion for antiquity, the French adopted the belief of Raphael's inferiority to the ancients, at least in theory. Although they increasingly copied and emulated antique works, they continued to study Raphael as a paradigm and to model their works on him as well. David, in particular, instilled a profound respect for his Renaissance master in all his pupils, particularly Ingres. The rise of primitivism and the religious revival that took place at the beginning of the nineteenth century also affected the French view of Raphael. The full extent of Raphael's direct influence on French neoclassical art has not yet been studied. Some aspects of his influence in the nineteenth century will be considered in Part Four.

Part Four

Nineteenth-Century Perspectives on Raphael
(1793–1830)

Raphael's Fortunes Under the Revolution and Napoleon

Raphael's fortunes, like David's paintings, were at least temporarily affected by Revolutionary ideals. The Roman Academy, so instrumental in preserving Raphael as a model, was suppressed with its parent body in 1793 and only revived in 1801.[1] For a brief period, political concerns outweighed artistic ones, and many of Raphael's works, particularly religious subjects, were deemed unacceptable. Many of these were discontinued as tapestry models for the Gobelins by the Jury des Arts meeting in 1793. In their own words, they would reject "from execution into tapestries all paintings which represent emblems or subjects incompatible with Republican ideas and values."[2] Although they rejected Raphael's works for models, they never disparaged them. Their judgment of a copy of the *Heliodorus* revealed a mixture of artistic and political concerns, describing it as a poor copy of a superb original but with a subject consecrated to mistaken and fanatical ideas. Therefore, the committee rejected the work as a model for a tapestry ("Les modèles," 355).

Raphael's works, which had played an important role in royal decoration since Louis XIV, could no longer meet Revolutionary standards. Of all the works so diligently copied by pensionnaires in

Rome, only his neoclassical subjects, the *Parnassus* and the *School of Athens* were still acceptable, as David replaced Raphael as the prime model for tapestries ("Les modèles," 379).

Copies of Raphael's works were not confined to the Gobelins. The confiscation records of the Commission des Monuments indicated that replicas of his masterpieces were widely disseminated.[3] In the library of the Château d'Orsay, inspectors found 716 engravings after Raphael. The Château d'Ecouen contained a mosaic pavement and windows designed after Raphael's *Psyche* and a portrait of Michelangelo and Raphael attributed to the latter. The agent's comments revealed the official and public attitude toward Raphael, suggesting that the work should certainly be preserved, despite its aristocratic qualities.[4]

Many churches throughout Paris contained Raphael copies. Saint-Germain-des-Prés and Notre Dame both housed copies of the *Transfiguration*. Saint-Geneviève contained eleven tapestries after Raphael. Saint-Lazare contained a copy of Raphael's Borghese *Entombment*. The monasteries and convents were similarly furnished.[5] Even at the height of antireligious, antimonarchical fervor, Raphael originals and copies were preserved and maintained, if not reproduced. In French eyes, even his debased subjects retained their artistic merits.

With the Napoleonic conquests, Raphael's works and those of countless other masters became artistic currency in Napoleon's bid for absolute dominion. The Musée Napoléon, containing as many Raphaels as he could transplant, was to be a symbol of French moral and intellectual, as well as military, superiority.[6] Although assembling so many of Europe's masterpieces in Paris was a great political coup for Napoleon, the plan was opposed by many artists and amateurs, including David and his friend, Quatremère de Quincy, a politically conservative antiquarian who later became secretary of the Fine Arts Section of the Institut. In opposing the plan in a series of published letters, Quatremère de Quincy, later the biographer of Raphael, made clear his devotion to the artist.[7] Showing Winckelmann's influence, he argued that great antique and modern masterpieces brought from Rome should be seen in the milieu that produced them. For artists to receive the maximum benefit, they should be able to study Raphael's works alongside those of his pupils in the climate that formed them. Echoing David's sentiments on the stimulating atmosphere of Rome, Quatremère wrote: "One must always go to Italy, in order to learn how to study, in order to learn how to see (*Lettres,* 45).

Quatremère lamented that so many of Raphael's works were already scattered all over Europe. Recalling Richardson's judgment on the Hampton Court cartoons, he wrote that since these late works were among Raphael's greatest, it would be an extraordinary lesson for artists to compare them with the style of his earlier frescoes (*Lettres,* 49). Focusing on Raphael's eclecticism and his image as the model academic, Quatremère argued that when one understood Raphael's development, one saw how he had become great by "creating a rare combination of all the manners of his time." Even though Quatremère entered these debates from a clearly conservative political orientation, he could use Raphael as a symbol of pure artistic value to claim that he was above petty politics. Commenting on his role in the debate over abolition of the Academy in 1791, he wrote: "In the midst of the debates and divisions of this academic brawl, I am too well-known for people to suppose that I belong to any other party than that of the Antique and Raphael."[8]

Ironically, Raphael's works were the symbolic focus for both the opposition to Napo-

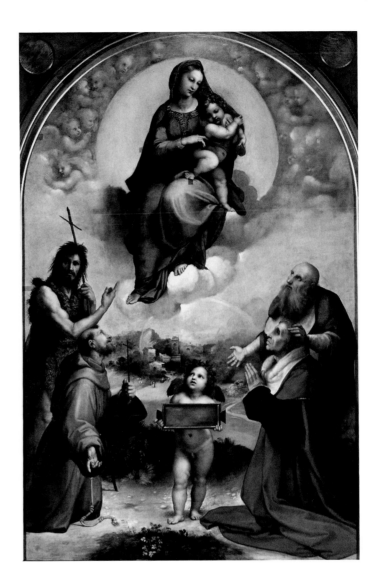

Fig. 46. *Madonna da Foligno,* c. 1512,
Pinocoteca Vaticana, Rome

leon's artistic looting and the justification for the Musée Napoléon. Napoleon's ministers
argued that they should confiscate these works because the French were more willing and
able to preserve these masterpieces than their present owners. Raphael's works were
important pawns in Napoleon's master gameplan. When the *Madonna da Foligno* (Fig.
46) was confiscated as a condition of the Treaty of Tolentino and exhibited in Paris in 1802,
a lengthy published report detailed its restoration, including the technically exacting
transfer from panel to canvas. The concern for the work was described in glowing terms,
as saving the work from imminent ruin. Since a work by Raphael was deemed so impor-
tant, the minister of the interior was asked to have the Institut name a special commission
to monitor the restoration.[9]

Among the seventeen paintings by or attributed to Raphael coming to Paris from all
over Italy (see Appendix III) were the *Saint Cecilia* from Bologna, one of the first paint-

ings mentioned by Napoleon; the *Coronation of the Virgin* from Perugia; and the *Madonna da Foligno*. Perhaps the greatest treasure trove was the Pitti Palace in Florence, which yielded the portraits of *Leo X* and *Julius II*, the *Madonna della Sedia*, the *Madonna dell'Impannata*, the *Vision of Ezekiel*, and the *Madonna del Baldacchino*. Of course, of all Raphael's works, the *Transfiguration* (Fig. 30) was judged the greatest masterpiece and caused the most excitement.[10] The French did not limit themselves to Raphael's paintings. They also confiscated the tapestries of the *Acts of the Apostles* from the Vatican and many drawings, including the cartoon for the *School of Athens* from Milan. Despite the immobility of Raphael's frescoes and the inaccessibility of such works as the *Sistine Madonna* in Dresden and the Hampton Court cartoons, the French still managed to assemble a representative sample of Raphael's oeuvre. The conquest of Spain yielded five more works attributed to Raphael including the *Spasimo di Sicilia* and the *Madonna della Pesca* (Gould, 100). Even before the confiscations arrived, many of Raphael's works from what had been the royal collection, were exhibited in the Musée Français, which opened in 1793 in the Louvre.[11] Most of the newly acquired works joined the Raphaels from the royal collection, such as the *Saint Michael* and the *Belle Jardinière* (Fig. 47), in a series of public exhibitions beginning in 1797.[12] They then became part of the Musée Napoléon formed in 1803 from the richest collection of artistic booty ever assembled.[13]

From the earliest exhibitions, Raphael's works were a center of attention. The crown jewel among twenty Raphael drawings exhibited in the Galerie d'Apollon beginning 16 August 1797 was the cartoon for the *School of Athens* (Fig. 48), which one critic called "this first idea for the most beautiful composition by the greatest painter in the world."[14] Raphael's works were spread all over the Louvre. As the same time the tapestries of the *Acts of the Apostles* (see Figure 49 for an example) were exhibited in the Grand Salon.[15] A display of paintings representing the stages of Raphael's development described by Vasari and accepted by the French was placed prominently in the Grande Galerie next to a similar display of Rubens's works.[16] An engraving by Zix of Napoleon's and Josephine's wedding procession through the Grande Galerie illustrates the arrangement of Raphael's paintings (Fig. 50). The display centered on the *Transfiguration* flanked by the *Saint Cecilia, Madonna da Foligno,* and the *Belle Jardinière* among others. A graphic lesson of what could be achieved by eclecticism and dedication was presented for all artists to see.

The museum provided a great opportunity for critics and popularizers, such as Lavallée, Eméric-David, and C.-P. Landon to point out the highlights of this astonishing collection.[17] Unlike their seventeenth-century predecessors, who had been writing for an academic audience, they directed their ideas at the enlightened public who came to see the treasures of the Musée Napoléon. They also served the political function of extolling Napoleon's "Trophy of Conquest." Much of what they wrote on Raphael's works consisted of hackneyed praise and banal commonplaces, but some of their criticism is of interest. In sharp contrast to many of the earlier French critics of Raphael, they had firsthand knowledge of the works they discussed. Yet, their observations were still strongly shaped by the symbolic images which had become the cornerstones of all Raphael criticism.

Lavallée, secretary of the Academy and author of the catalog of the Musée Napoléon, praised the *Portrait of Julius II* (Uffizi) as one of Raphael's richest paintings coloristically. He asserted that if one were not certain that the work is by Raphael, one might well attribute it to Titian, since its color really approaches the level of that master colorist

Fig. 47. *La Belle Jardinière,* 1507, Louvre, Paris

(1:chap. 11, 4). Discussing the *Madonna della Sedia* (see Fig. 63), Lavallée acknowledged Richardson's earlier critique, but disagreed with some of his judgments. He felt the image of the Madonna revealed grace, nobility, and an amiable quality, but criticized the Christ Child as too muscular and with poor expression, appearing inappropriately disdainful. The expression and conception of Saint John was better (1:chap. 18, 2). Lavallée's criticism, like that of the seventeenth-century Academy, often placed an overriding emphasis on abstract principles, derived from rhetoric, of unity of time or of *convenance* (propriety), while ignoring more painterly concerns. For instance, he criticized the *Saint Cecilia* (Fig. 51) for anachronisms, but still asserted that it had many sublime aspects (1:chap. 33, 2). His praise of various figures' conception and expression showed as little penetration as his criticism of the work in painter's terms.

Outside official publications, other critics such as the sculptor Eméric-David described

Fig. 48. *School of Athens,* cartoon, Biblioteca Ambrosiana, Milan

selected works in periodicals such as the *Moniteur.* He praised the *Saint Michael* (see Fig. 9) in terms that seem derived from Winckelmann, praising the "tranquil superiority" of the angel who has been victorious without effort. He also praised the sublime contrast between the movement of the wings and drapery and the tranquil visage (*Choix,* 14). His comments on the *Vision of Ezekiel* (Fig. 13) revealed a deeper comprehension of painterly values than Lavallée's comments did. He praised the richness of color and the delicacy of execution (*Choix,* 21). He also defended the *Saint Cecilia* from charges of dryness by Richardson. He praised the lively characterization of each figure, the vivid fleshtones, and the sublime composition, despite the alteration of tones with time. Praising an aspect for which Raphael was usually criticized, Eméric-David asserted that in this work, the overall sense of harmony proved Raphael's abilities with color (*Choix,* 28–29).

Although Eméric-David admitted that in color the *Saint Cecilia* was inferior to the *Transfiguration* or the *Madonna da Foligno,* it still proved his mastery of that aspect of painting. Even though Raphael's works hung directly beside Rubens's, Eméric-David could still praise Raphael's colorism because he praised each of their works without directly comparing them.[18]

Another critic who considered the *Saint Cecilia* was J.-B.-P. Lebrun, a dealer and expert for the Musée Central des Arts, and the husband of Elizabeth Vigée-Lebrun, the great portraitist of the ancien régime. His remarks, recalling those made by Abraham Bosse 120 years earlier, prove the effect of long-lasting preconceptions on the way Raphael's works were viewed:

> Because of the great reputation it made for Raphael, this remarkable painting merits the spectator's particular attention. At first glance, nothing attracts; Only when one regards it for some time and with quiet contemplation, one begins to understand its beauties, and one approaches the degree of admiration it cannot fail

Fig. 49. *Miraculous Draught of the Fishes,* tapestry, c. 1515–16, Vatican, Rome

to excite. . . . They will read here the principles of this sublime art which Raphael carried to the highest perfection.[19]

After praising the expression, composition, and design in terms with which the earlier Le Brun would have agreed, he discussed Raphael's colorism in terms used by Roger de Piles. Even if one can criticize Raphael's skin tones and his dry execution, "the *St. Michael* and the *Holy Family* that he did later, prove that he would have had all that was necessary to be the greatest painter in the world, even though he said, before dying, that he was going to concentrate on color" ("Examen," 402). Even if Raphael was criticized for what he achieved, he could still be praised for his suggested potential. No wonder the balance of criticism had little or no effect on Raphael's prestige.

Despite the admiration heaped on the *Madonna da Foligno,* the *Saint Michael,* the

Fig. 50. Benjamin Zix, drawing, *Procession of Napoleon Through the Grande Galerie*, detail, c. 1810, Manufacture Nationale de Sèvres

Vision of Ezekiel and all of Raphael's other works, the *Transfiguration* was clearly the center of attention and adulation. Its eminence was established with the triumphal entry on 27 July 1798 of masterpieces confiscated in Italy.[20] According to an eyewitness account, Napoleon's loot entered Paris on a seemingly endless procession of chariots, as we see them in this engraving by Prieur and Berthault (Fig. 52). Twenty-seven chariots of antique sculpture came first. The twenty-sixth carried the Laöcoon; in the twenty-seventh rode the Apollo Belvedere, the crown jewel of the collection, so rhapsodically praised by Winckelmann as the epitome of ancient sculpture.

In the very next chariot was the *Transfiguration,* dominating the Roman masterpieces, as we see in this drawing by Valois (Fig. 53).[21] Since the *Transfiguration* had originally been commissioned by the French Cardinal Guilo de' Medici for the cathedral of Narbonne, the work had political and artistic significance.[22] The French authorities could justify its confiscation by suggesting that it was being returned to its rightful home. The piece in the *Moniteur* suggests the general tone of comments made:

> Rome could not detach itself from Raphael's last work, and three centuries passed on the French claims, when Bonaparte's victories resulted in the conquest of this work, and its restoration to its original destination to complete the wall in the middle of which it has been placed; one has chosen among the works of this artist, those which allow one to see instantly, this extent of this painter's genius, the astonishing rapidity of his development, and the variety of genres that his talent included.[23]

The excitement of the *Transfiguration* in the Musée Napoléon provoked many accounts describing the painting and extolling its virtues, which ranged from short pieces in the journals to complete treatises such as Pardo de Figueroa's *Analyse de la Transfiguration,* published in French in 1805.[24] In 1818, Pierre Lamontagne even published an ode honoring the work.[25] The critic of the *Journal des Arts* urged young artists to go see it: "The imagination of young artists will be drawn out by contemplating this masterpiece, a precious monument; Here they will learn the secret of uniting the genius which creates with correct design, with purity of form, and the taste and grace which embellishes everything."[26]

The *Transfiguration* was a particularly intriguing work for several reasons: It was Raphael's last work, done mostly by his own hand and considered by many to be his greatest achievement. According to Vasari, it had even been placed at the head of his funeral bier as an appropriate tribute.[27] This scene was immortalized first by Monsiau at the Salon of 1804 (Fig. 54), and then by Bergeret at the Salon of 1806 in his painting *Homage to Raphael after his Death* (Fig. 55), one of the most popular paintings at that Salon.[28] Finally, the complexity of this difficult-to-interpret scene added interest. All of these factors were given much play in contemporary criticism, adding to the work's celebrity. The gushing praise of the writer for the *Journal de Paris* was fairly typical:

> Place yourself here and contemplate this magnificent painting. . . . Everything is admirable. . . . This scene is sublime. There is nothing of the material. . . . How does

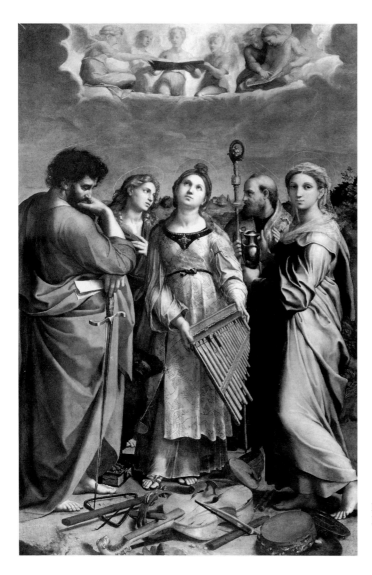

Fig. 51. *Saint Cecilia,* Pinocoteca
Nazionale, Bologna

this figure rise so majestically? . . . by a simple act of will over nature! How difficult
to render all this was! The perfections are visible; but what art produces them?[29]

What art indeed? This was the question Pardo de Figueroa purported to answer in his
detailed analysis of the painting. His treatise offered high praise for Raphael in general and
the *Transfiguration* in particular. In a lavish publication, which included seventeen full-
sized heads engraved after the original, he argued that the beauties and perfections of the
work far outweighed its trivial defects. His acknowledged purpose was "to vindicate the
inimitable genius, by whom the painting was conceived and executed, from those pre-
tended critics who have animadverted upon his faults with more malice than reason" (3,
7). He ardently defended the composition's unity against critics, such as Falconet, who had
claimed that the upper and lower scenes did not relate. Pardo argued that the episode of

Fig. 52. Prieur and Berthault, *Entry of Triumphal Procession of Works of Art Taken from Italy, July 27, 1798,* engraving, c. 1798

the demoniac was a proper and imaginative addition, coexistent and contemporaneous with the main scene. The lower scene was properly subordinated to the upper by the lesser dignity of its subject and characters, yet it augmented the central action (4). He also praised the sublime conception, particularly of the floating Christ, and the variety and poignancy of expressions.

Pardo's discussion of design suggests a criticism of much contemporary neoclassical painting. Raphael's mode of design was original

> and in no respect whatever partakes of that kind of literal imitation or copying of the antique so observable in the works of other celebrated masters. He doubtless admired and studied the Greek and Roman models, but he imitated them without copying them, and adapted their beauties to the great model of nature. From this combination, improved by the ideas of a creative genius, resulted that system of design which adorns everything by its purity, elegance, and harmony. (8)

Fig. 53. Valois, drawing of *Triumphal Procession of Objects Brought from Italy to Paris*, detail of design for a Sèvres ceramic, Manufacture Nationale de Sèvres

Seeing in him the kind of synthesis of ideal and nature proposed by Roger de Piles, Pardo directly attacked Mengs's notion that Raphael had not studied antiquity deeply enough (8). He even suggested that Raphael had surpassed the ancients in expression. Pardo clearly revealed his value system when he described the color in the *Transfiguration* as "[t]ranscendent, and superior to that of most of the great masters; though he has confessedly failed in acquiring that preeminence in this branch of the art of painting which holds in its other and more essential departments" (12).

As Charles Le Brun had found his ideal in the *Saint Michael,* early nineteenth-century critics found theirs in the *Transfiguration.* When viewing this last work, they seemed to feel that they were communing with the very soul of the immortal Raphael. C.-P. Landon, an artist and publisher of the *Annales du Musée,* and a two-volume compilation of 465 engravings of Raphael's oeuvre, called it Raphael's "chef-d'oeuvre et celui de la peinture."[30] He pointed out that artists flocked to the museum every day to admire Raphael's purity of line, pathos of expression, and grand manner. The Musée Napoléon was important to artists and critics because it created a new standard of excellence based on the greatest past masterpieces, against which contemporary production could be measured. Hubert Robert, not surprisingly, in one of his paintings showing a possible plan for refurbishing the Grande Galerie of the Louvre, shows an artist copying Raphael's *Holy Family of Francis I* (Fig. 56). One writer, observing Italian works exhibited in the Musée Central, made the point clearly:

> French painters! Your judges have arrived: The present Salon is a tribunal before which each of you in turn will be forced to appear. Your works will be compared with these kinds of beauty. How many among you will leave victorious from this terrible confrontation! The people who have never had before them so many beautiful things and works of the most famous schools of Italy, will soon begin to see what painting is, and what it ought to be.[31]

Many young artists, both David's pupils and others, obviously received a great new impetus to find something relevent to their own art in Raphael's by a direct confrontation with so many of the master's great works. The effect is most obvious on Ingres, but we also see it on Vigée-Lebrun, Bergeret, Gros, Géricault, and others.

Although critics and theorists were also given a new, direct stimulus to use Raphael's art creatively as a point of reference and a standard of perfection, they did so primarily through established preconceptions about the artist. Seldom, if ever, did they break new, critical ground concerning his oeuvre. Not even the massed impact of the Raphaels in the Musée Napoléon could shake hidebound ideas about the artist.

Chaussard, the anonymous author of an extensive critique of the Salon of 1806, entitled *Le Pausanius français,* used the works of the Musée Napoléon to establish an ideological framework for his remarks on contemporary works.[32] Basically eclectic, he had high praise for the beauties of Titian and Rubens, in addition to more conventional esteem for the Greeks and Raphael, suggesting that the Roman School should be regarded as the most important due to the quality of its compositions and the correctness of its design (26). Chaussard both revived Roger de Piles's view of Raphael and gave unusual criticism of the *Transfiguration:* "The Transfiguration, regarded as his masterpiece, since it is his

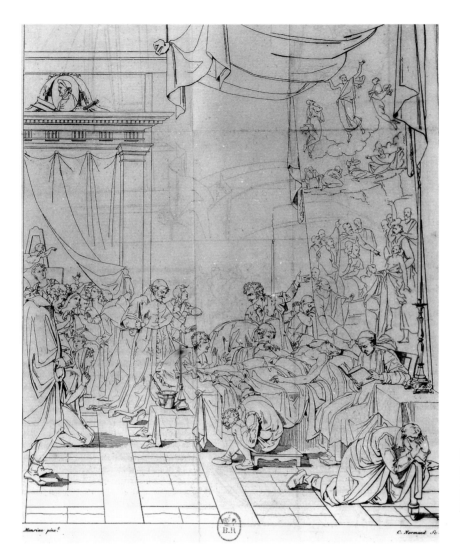

Fig. 54. Monsiau, *Death of Raphael,* Salon of 1804, engraving from Landon, *Annales du Musée* x (1805)

last work, perhaps does not offer the sublimity of his Frescoes. Death stopped him in the middle of his course; he wished to reconcile the principles of diverse schools, and in a word to unite them and to turn all the means of art to the most perfect imitation of nature (26). While Chaussard admired Raphael, he was eclectic at heart. He urged students that they had only to choose one of many great models from the past: If their character were energetic or somber, they should study the sublime terror of Michelangelo's works. However, if they preferred calm and energy without violence, they should ceaselessly focus on the masterpieces of Raphael (28).

Chaussard reacted very enthusiastically to a work at the 1806 Salon that translated Raphael's mythology into painting: Bergeret's *Homage to Raphael after his Death:*

> This tableau is one which best fulfills the intentions of painting. The subject moves and interests. . . . The most sublime genius eclipsed before his midpoint; the hom-

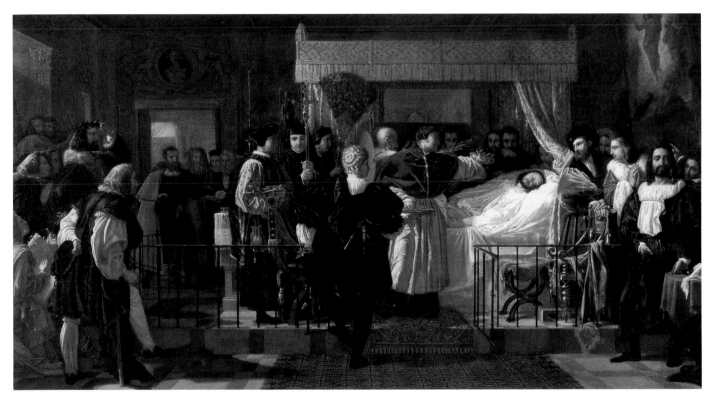

Fig. 55. Pierre-Nolasque Bergeret, *Homage to Raphael After His Death,* 1806, Allen Memorial Art Museum, Oberlin College, R. T. Miller, Jr., Fund, 1982

age rendered to supreme talent by the powerful themselves . . . this last marvel of the brush suspended like a trophy above the funeral bed. (85)

It is not surprising that this work caught the attention of critics and artists. Not only did it honor the most popular artist in the Musée Napoléon, it suggested the essential role of the artist in ensuring the place of great men in history. This issue was certainly relevent during the age of Napoleon, who bought the work for Malmaison. From the artist's point of view the work not only honored the illustrious dead; it held out the possibility of glory to the talented living. Bergeret's painting was one of several dealing with the theme of Raphael's death that appear at this time.[33]

Other critics used Raphael more directly as a critical standard for measuring their contemporaries. One of the most interesting examples of this method was Delpech's comparison in his *Salon of 1814,* of David's *Sabines* with Girodet's *Deluge,* the leading contenders for Napoleon's *Prix décennal* awarded in 1810, for the outstanding painting of the decade.[34] David's former pupil had been awarded the palm over his master, a decision Delpech regarded as unjust. The jury's decision had been defended by M. Boutard, although he agreed that the *Sabines* was distinguished by "the elegance and purity of design, by the simplicity, nobility and delicacy of style which is truly admirable." Drawing a direct analogy, Delpech argued:

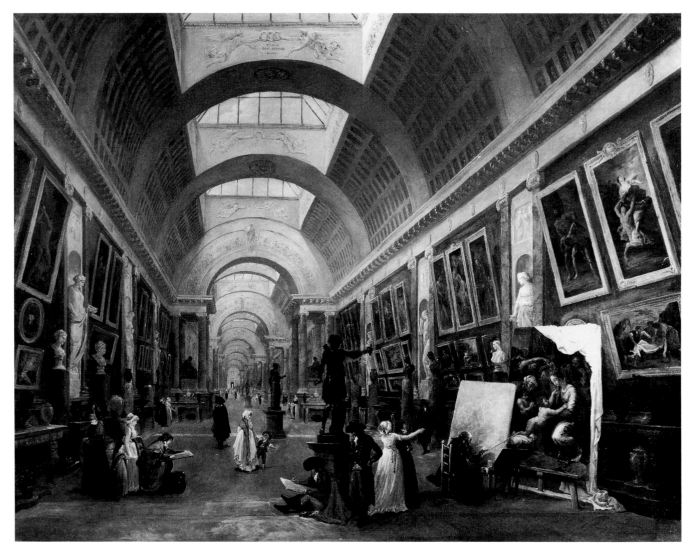

Fig. 56. Hubert Robert, *Grande Galerie du Louvre,* Louvre, Paris

Aren't the qualities which one accords to M.David precisely the most beautiful ones which a painter can possess? If the artist of the *Transfiguration* and the *School of Athens* is placed above all his rivals, if he manages to steal the sceptre of painting from Michelangelo, is it not to these precious qualities that he owes the honor of his triumph? (*Examen,* 137)

Delpech also answered Boutard's charge that David's *Sabines* was a bit cold, with an allusion to Raphael that revealed Winckelmann's influence. M. Boutard had praised David for having chosen to portray the moment when the armies suspended combat. Delpech went on to say: "This type of repose permits the artist to reduce confusion in the composition, and to give his figures more simple, tranquil and elegant poses. . . . The one among

all painters who is most worthy to serve as a model, Raphael himself often sacrificed force of expression in order not to alter the beauty" (*Examen,* 138).

In addition to regular Salon critiques, numerous treatises on the beaux-arts appeared to enlighten amateurs during these years. The authors included Alexandre Lenoir, Gault de Saint-Germain, and Seroux d'Agincourt.[35] Most of these treatises only summarized accepted ideas gleaned from others' works, but a few interesting ideas on Raphael can be found.

Seroux d'Agincourt's *Histoire de l'art par les monumens* (1823) gave a view of Raphael consonant with that expressed by Le Brun in his *conférences*. Raphael, like the great painters of antiquity, employed color "as an instrument subordinate to design, as the material means to attain moral expression."[36] This seventeenth-century classicism with an Enlightenment twist simply ignored the battle between the advocates of color and design and much eighteenth-century painting, as if they had never existed.

If Seroux d'Agincourt revived the view of Raphael in seventeenth-century classicism, Alexandre Lenoir revived eighteenth-century eclecticism, with rich appreciation of Raphael, Rubens, Titian, Correggio, and others. With his *La Vraie Science des artistes* (1823) and *Observations sur le génie et les principales productions des artistes* (1824), Lenoir tried to provide primers for young artists.[37] For our purposes, the two most interesting aspects of these works are his critique of de Piles's argument for the compatibility of great design and color, and his suggestions of alternative examples from Le Brun's for various emotions.

De Piles had attacked the notion that the charms of color must cause one to neglect design. This resulted from the painter's weakness, an inability to assimilate new ideas without losing established abilities. De Piles had used Raphael as an example of an artist who did not have this deficiency (Lenoir, *Vraie Science,* 135). Lenoir was astonished that de Piles had used Raphael as the example, since he was a much greater draftsman than colorist. Ironically, Lenoir defended Raphael's colorism with concepts dating back to Le Brun:

> One does not place Raphael among the great colorists; but, in his painting of the Sleep of the Infant Jesus, in those of the Holy Family and the Transfiguration, isn't the color always what is appropriate for each of these subjects? and isn't it this intimate unity ... which truly constitutes perfection in painting? (*Vraie Science,* 140–41)

This criterion of *convenance* was the basis of Le Brun's defense of Raphael's color in his *conférence* on the *Saint Michael* (see Chapter 1). As late as the nineteenth century, ideas about Raphael first expressed in the times of Le Brun and de Piles recurred. These preconceptions continued to determine what people saw in Raphael's art.

Another enduring conception of Raphael was as a master of expression. Lenoir reinforced this by suggesting many of Raphael's works as better examples of particular emotions than those given by Le Brun in his treatise on the passions. Discussing *coquetterie,* Lenoir suggested the *Madonna della Sedia* as an example. He saw an aspect in it which was exaggerated by Ingres:

> It seems that Mary is particularly involved with pleasing the spectator, by her enticing regard and her curving movements, and thinks little of her son, who ought

to be the major object of her concern. This work, by the greatest painter in the world, proves that, in composing it, its author was animated by a desire to please and to seduce. (*Vraie Science,* 179, 215–16)

Similarly, Lenoir could find no better example of compassion than in Raphael's *Borghese Entombment.*

Raphael in the Romantic Period

The final question I would like to address is how admiration for aphael was affected by some of the shifts in attitudes and values that occur at the beginning of the nineteenth century, shifts that are generally subsumed under the broad rubric of Romanticism. The boundaries of the Romantic period are still very much in dispute. Some scholars have suggested the publications of Victor Hugo or the Salon confrontations of Ingres and Delacroix in 1824 and 1827 as significant milestones. M. H. Abrams has brilliantly characterized the move from the classical viewpoint to the Romantic by the metaphorical shift from viewing art as a mirror to viewing art as a lamp. In the former concept, the artist passively imitates reality; in the latter, the artist illuminates the world through individual personality and imagination:[1] In retrospect, we can also see that much of the impulse behind the neoclassical revival was Romantic, based on a desire to recapture the glory of a lost age.

Although the Romantic period begs precise definition, one can say that by the 1820s there was a group of artists and critics who, at least on the surface, wished to maintain the status quo, preserving the residue of Davidian classicism. Another group, emphasizing original-

ity and individuality, abandoned what they considered an anachronistic ideal to seek one more relevant to their age. Although these positions were never totally antithetical, certain individuals appear to fall naturally into one or the other camp. To contrast the two positions and their views of Raphael, we shall consider Delécluze, the conservative critic, and Ingres, who was viewed as the leading follower of David. The novelist and critic Stendhal, and Delacroix can represent those who placed a much higher value on using their art to illuminate the world with the fire of their imaginations. However, as has long been recognized, when we contrast the artists' works rather than their words, we find Ingres and Delacroix far less antithetical than their historical roles would suggest. In fact, each reached a very personal rapprochement with Raphael.

One can make the distinction between these two positions much more easily in terms of theory than of practice. Even within the immediate orbit of the "Ecole de David," there was an astonishing range of expression, from the archaizing search for the tabula rasa of the Primitifs to the neo-Baroque elements of Gros; from the striking originality of Girodet to the linear complexities of Ingres. The extraordinary range of masterpieces present in the Musée Napoléon certainly contributed to the breakdown of any single artistic authority and to the wide eclecticism of the period. This artistic eclecticism seemed more justified as the realization grew that each past *époque* had been unique and, in a sense, irreproducible. When a seventeenth-century classicist looked to the past for a model, he would turn to antiquity, Raphael, or Poussin. A nineteenth-century neoclassicist, such as Ingres, might turn to Van Eyck, Botticelli, or even a Byzantine ivory as well as to the accepted classical canon. The rise of historicism and the plethora of new subjects that appear at this time contributed to the broadly ranging eclecticism of the period.

Delécluze's tastes and allegiances are what would one would expect from a former pupil of David.[2] As the conservative critic of the *Journal des Débats,* he defended the Davidian neoclassical ideal at a time when some critics had come to see works in this vein as cold, lifeless vestiges of an outmoded ideal. Like his master, he had a particular passion for Raphael's art. He devoted considerable energy to defending his ideal from the onslaught of the Romantics. He praised the art of David, Ingres, and Raphael as Homeric, contrasted with that of Delacroix and Horace Vernet, whom he disparaged as Shakespearean.[3] Delécluze even saw Ingres's *Vow of Louis XIII* at the 1824 Salon as worthy of establishing him as a successor to Raphael.[4] Ingres could desire no higher praise.

In contrast to Delécluze's conservative position, Stendhal believed that France had to rid itself of the albatross of classical tradition.[5] He even accused David of only being capable of painting bodies, not souls.[6] Abandoning the concept of a timeless ideal—which is the basis of classicism—Stendhal believed that ideas of beauty must respond to historical change. Of necessity, the contemporary ideal must differ from the ancient one.[7] This more relativistic view of history corresponded to the rise of historicism in the visual arts, a movement in which Ingres and Delacroix took active parts.

Despite his radically anticlassical views, Stendhal passionately admired Italian art. In 1811, he began a *Histoire de la peinture en Italie,* which was completed in 1817, after his stint in Napoleon's army. His other writings on art included travelogues, Salon criticism, and his major theoretical statement, *Racine et Shakespeare* (1823).[8] Although Stendhal rejected contemporary classicism, he argued in the *Histoire* that the Italian Renaissance artists had painted in a manner appropriate to their time. Carrying Winckelmann's ideas of

cultural influence on art to their logical concluslon, he called for a new art that would reflect the greater psychological complexity of a later stage of civilization. He would have liked to see an artist of the caliber of Raphael arise to create this new art (Wakefield, *Stendhal and the Arts,* 16).

Raphael was often a point of reference for Stendhal. As a man of letters, he valued expression more highly than the means of achieving it: line, color, and perspective. He praised the expressive quality of Masaccio's art by suggesting that his heads had something in common with Raphael's, each with a different expression (Wakefield, *Stendhal and the Arts,* 38). Like Diderot, his great literary predecessor, Stendhal was attracted by painting's immediacy, which could surpass that of prose or poetry: "In order to describe a person like the Virgin in the *Madonna alla Seggiola* words need a long succession of events; painting can place her before our heart in the twinkling of an eye" (Wakefield, *Stendhal and the Arts,* 42).

Paralleling Winckelmann's vision of antiquity, Stendhal had a Romantic vision of the Renaissance as a time of greater simplicity and purity than his age, a conception of Raphael closer to the spirit of Walter Scott than Vasari:

> In the fifteenth century people felt things more keenly. Life was not stifled by etiquette, and the Old Masters were not always on hand to be copied. . . . Violent passions had not yet been extinguished by excessive politeness. . . . Great men always associated the woman they loved with the success of their art. A few people will understand Raphael's happiness, as he painted the sublime St. Cecilia from La Fornarina. (Wakefield, *Stendhal and the Arts,* 44).

Not only were Renaissance masters more direct and expressive than nineteenth-century artists, they were more talented. Discussing a few pencil studies for Madonnas, Stendhal praised Raphael's facility: "Look how great artists almost attain ideal form simply in light pencil sketches. There are barely four strokes to the drawings, and yet each one fills an essential outline. Next to this look at the drawings of the artist craftsmen. They begin with details, and that is why they delight the philistine, who only notices the pretty little things in art" (Wakefield, *Stendhal and the Arts,* 66).

Striking at the core of neoclassicism, particularly as practiced by David's weaker followers, Stendhal criticized artists who believed they could attain greatness by following rule books, such as Mengs's treatise. Mengs had criticized Michelangelo, but Stendhal asserted that comparing the two artists' works would prove Michelangelo superior. He had utter contempt for those who would prefer correctness to sublimity, asking: "How can commonplace souls help admiring commonplace art?" (Wakefield, *Stendhal and the Arts,* 85).

Although Stendhal praised the Renaissance ideal, he would have found it no more applicable to his time than the ancient ideal he rejected. Renaissance masters, such as Raphael and Michelangelo, represented a standard of quality, not an example to imitate. He clearly indicated his attitude in his perceptive critique of Ingres's *Vow of Louis XIII* (Fig. 57) at the Salon of 1824:

> In my opinion at least, it is a very dry piece of work and what is more, a pastiche of the old Italian painters. The Madonna is beautiful enough, but it is a physical kind

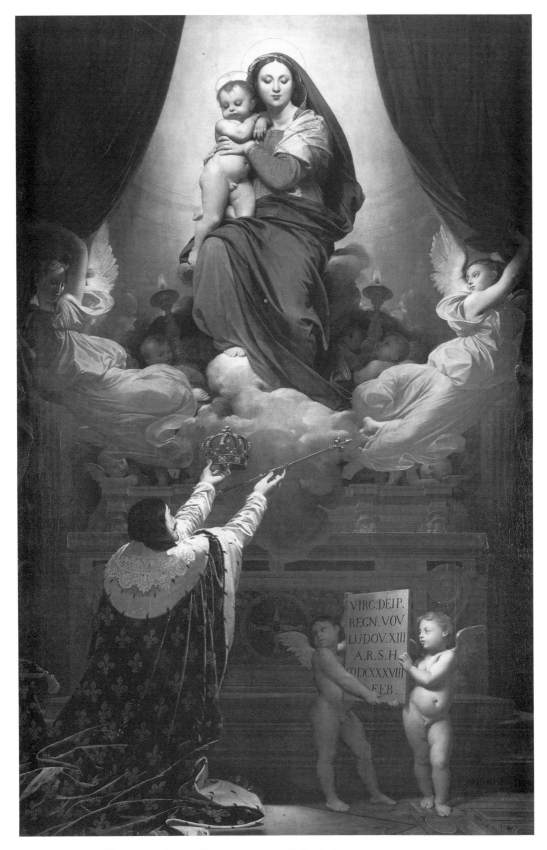

Fig. 57. Ingres, *Vow of Louis XIII,* 1824, Montauban Cathedral

of beauty, incompatible with the idea of divinity. This is a psychological, not a technical defect, and is still more glaringly apparent in the child Jesus, who although very well drawn, could not possibly be less divine. (Wakefield, *Stendhal and the Arts,* 114)

Like Diderot, Stendhal believed that art had to be a personal authentic expression of the artist's experience and imagination, which could not be channeled through another's ideas: "Every artist must see nature in his own way. What is more absurd than to borrow the vision of another man, often of totally different character" (Wakefield, *Stendhal and the Arts,* 43). Delécluze admired Raphael as a timeless ideal worthy of emulation. Stendhal admired Raphael's authenticity for his own time, but felt that ideal was totally outmoded for the complex age in which Stendhal lived.

Stendhal clearly admired Raphael, but one suspects that, like Reynolds, he adored Michelangelo. Both seemed to prefer the sublime to the beautiful.[9] When Stendhal saw the Sistine Chapel, the sight revived the powerful emotions he had felt as a soldier on the retreat from Russia:

> We were suddenly awakened in the middle of the night by a burst of cannon fire which seemed to be coming closer all the time, all our strength appeared to flow into our hearts; we were in the presence of destiny, and, indifferent to matters of vulgar interest, we prepared to measure our lives against fate. The sight of Michelangelo's pictures reawakened in me this almost forgotten sensation (Brookner, *Genius,* 45)

Raphael's paintings could not arouse such awesome emotions.

Ingres and Delacroix

Before considering the specific debts of Ingres and Delacroix to Raphael, we should take a brief overview of Raphael's importance for the "Ecole de David" in general. Although Davidian classicism often drew directly on ancient models, its basic form and emphasis were still compatible with Raphael's art. These classical styles all emphasized clear and forceful, but controlled expression, composition, and design, and an ideal based on *la belle nature,*[10] basically a Raphaelesque form filtered through Poussin. Raphael's forms and expressive vocabulary could be translated into the Davidian idiom.

Davidian classicism, however, was transformed by several new artistic currents at the end of the eighteenth and the beginning of the nineteenth century. The Raphaelesque ideal, based primarily on his *stanze,* cartoons, and other history paintings as it had been for more than a century, was less appropriate than other sources of inspiration for some of the new artistic forms. One of the new currents resulted from the rising interest in "primitive" artistic sources, ranging from Etruscan vases, to Early Christian mosaics, to "pre-Raphaelite" painting, back to Masaccio and Giotto.[11] This interest was evident in many ways, including the obvious influence on contemporary painting of engravings of Hamil-

ton's vases or Flaxman's Homeric illustrations, and treatises such as Artaud de Montor's on painting of the four centuries before Raphael.[12] The pure origins of art were sought by groups as diverse as the Primitifs in David's atelier and the Nazarenes in Germany.[13] As we have seen, the Primitifs modified the traditional focus on Raphael's later works without rejecting him completely. Although the Nazarenes idolized Raphael, it was a different concept of him from the one that served as a model for French classicism. Their ideal, expressed in works such as Overbeck's *Italia and Germania* and Wackenroeder's *Heartfelt Outpouring* was for a naive, pure soul, the young pupil of Perugino, who was uncorrupted by worldly concerns or the power of popes. In any case, the "classical" Raphael was not pure enough for those who sought the tabula rasa. This desire for a "pure" Raphael was picked up in France and fueled by the neo-Catholic revival.[14]

Another current undermined Raphaelesque classicism from the opposite direction, with the search for sublime expression of extreme emotional states. Burke's 1757 treatise was an early manifestation of interest in this aspect of the sublime.[15] The interest in extreme emotional states is evident in the art of Blake and Fuseli in England and in the Sturm und Drang movement in Germany.[16] For the desired extremes of terror or suffering, Michelangelo or Rubens were better models than Raphael, with his sense of classical calm. Examples of this transformation of classicism toward new expressions of emotion include Girodet's Michelangelesque *Deluge* (1806), which posed such a stark contrast to David's *Sabines,* Gros's *Pesthouse at Jaffa* (1804), and Géricault's *Raft of the Medusa* (1818).[17]

This is not to suggest that these new interests caused artists to abandon Raphael completely. Gros, Géricault, Ingres, Delacroix, and countless others still copied Raphael and used aspects of his works in their own. Some artists turned to relatively fresh aspects of Raphael's art, such as his Madonnas or the late battle paintings by his atelier,[18] but many artists either found other models, or drastically transformed what they took from Raphael. The Musée Napoléon not only goaded artistic ambitions; it provided an extraordinary range of models from which to choose. The traditional, classical mode was only one possibility, and many artists felt it had lost its validity. Even for those, such as Ingres, who espoused the pure neoclassical line, practice never strictly adhered to theory. Raphael's art was important to Ingres and Delacroix, and both radically transformed what they took from him.

Unlike so many of their predecessors, Delacroix and Ingres were able to see beyond the artistic clichés attached to Raphael to reach a personal rapprochement with his art. Ingres's often-expressed devotion to Raphael is a commonplace; Delacroix's admiration was less encompassing, but was certainly substantial. In both cases, they esteemed Raphael with their works and their words. Ingres's praise of Raphael was unequivocal, surpassing even that of his master, David. Ingres wrote: "Raphael was not only the greatest of painters; he was beauty, he was good, he was all."[19] By the time he went to Rome in 1806, as a Prix-de-Rome winner, he was already deeply enamored with Raphael's art. He felt that Raphael was inexhaustible. Being overwhelmed by seeing the Vatican frescoes again in 1814, he wrote:

> I would need a book, volumes to expound on the qualities of Raphael and on his incomparable inventions; but I will say that the frescoes in the Vatican are worth

more themselves than all the galleries of paintings together.... When I think that three hundred years earlier I could have become his true disciple. (1:98)

Ingres's well-known subordination of color to design at least in theory was made clear in a comparison of Raphael to Titian: Although Raphael and Titian were certainly in the first rank among painters, Raphael was superior because he sought sublimity in form, rather than simply color (1:100). Statements on color such as the following, established his theoretical position, so apparently antithetical to Delacroix's. He suggested that color could add ornament to painting, but it could only embellish the true perfections of art (1:68).

Ingres had been criticized for caring only for the antique and Raphael, an exclusive taste he justifiably denied, pointing out that he had great admiration for the little Dutch and Flemish masters for their realism (1:38). His admiration, however, did not extend to Rubens, about whom he said: "Rubens is a great painter, but a great painter who has lost everything" (1:103). Supposedly, Ingres even suggested that his pupils avoid Rubens's paintings in the museums the way they would avoid their master's enemies in the street, "For if you approach them, you will surely have bad things to say about my teaching and me" (1:103). If this is a true indication of Ingres's insecurity, his vehemence in opposing Delacroix, the "new Rubens," is not surprising.

Like countless artists before him, Ingres used Raphael's art to justify his own artistic inclinations, particularly his emphasis on design. He felt that expression was strongly dependent on design, so that the painters who excelled in expression excelled in design. Foremost among them was Raphael (1:61).

In the renewed battle of the *anciens* versus the *modernes,* Ingres's stand was unequivocal:

> How can one compare the aspects which glorify the ancients to those for which the moderns are praised? Pompous compositions, pleasing colors, balancing of masses . . . and so many other coquetries of technique which say nothing to the spirit. It is to the spirit to which the ancients wished to speak, it is that that Raphael, Michelangelo and the others alone think worthy of receiving the homages of art. (1:80–81)

Ingres's *Vow of Louis XIII* (Fig. 57), exhibited in the Salon of 1824, was criticized by Stendhal and others as a pastiche of Raphael. Defending himself, Ingres stated what he saw as his true relationship to his great idol:

> It is not a pastiche, it is not a copy.... I have placed my signature here.... Certainly I admire the masters, I bow before them... above all before the greatest of them... but I do not copy them.... I have drunk of their milk, I have nourished myself on it; I have attempted to appropriate their sublime qualities.... I think that from them I have learned to design, since . . . design is the first virtue of painting . . . a thing well-drawn is always well enough painted. (1:178)

In many ways he justly appraised what he owed to Raphael. Ingres was never a mere copyist. Sometimes he directly transposed Raphaelesque motifs into such works as the

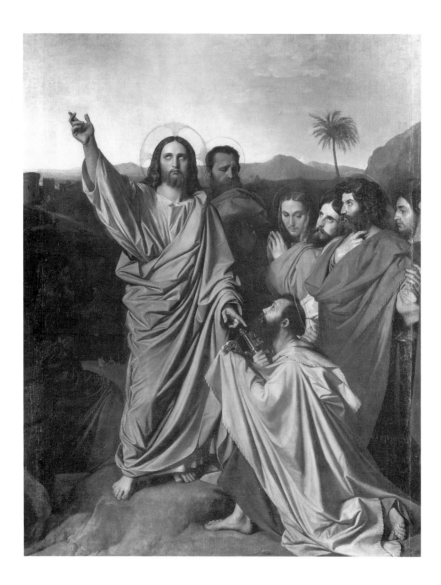

Fig. 58. Ingres, *Christ Giving the Keys to Saint Peter,* 1820, Musée Ingres, Montauban

Vow of Louis XIII and *Christ Giving the Keys to Peter* (Fig. 58). As Michael Driskel has argued, particularly in religious works, Ingres sometimes transforms a source in Raphael by adopting a consciously iconic mode, derived from Egyptian or early Christian sources.[20] His more subtle uses of Raphael include a complex reinterpretation of the balance between contour and surface, line and color, ideal and realistic detail found in works such as the *Madonna della Sedia* (see Fig. 63). In the *Vow of Louis XIII,* Ingres imagined the king's heavenly vision at the Battle of La Rochelle as a combination of the *Sistine Madonna* (see Fig. 41) and the *Madonna da Foligno* (see Fig. 46).[21] We can understand Stendhal's criticism of the work's dryness and lack of religious unction, and take this as an indictment of a whole group of religious works based directly or indirectly on Raphael. Ingres's Madonnas have an air of covert sensuality totally absent in Raphael's, yet their patently hieratic quality came to be seen as the appropriate mode for proper religious images.[22] In other large figural compositions, including the *Apotheosis of Homer,*

the Martyrdom of Saint Symphorian, and others, Ingres transformed the lucidity and idealized, expressive rhetoric of Raphael's *Disputà, Parnassus,* or *School of Athens,* into a much more rigid, iconic mode. Raphael's lucidity was replaced by a dramatic tension in the cramped, airless spaces of Ingres's compositions. The ideal grandeur of Raphael's figures was brought down to earth by what Rosenblum has termed the "incisive" quality of Ingres's draftsmanship and his penchant for realistic detail.[23]

When Poussin models a composition on Raphael, he is following a common ideal. Although Ingres shared that common classical ideal, he painted in a very different artistic and historical milieu. When Ingres emulates Raphael, he is consciously looking back to an earlier historical period and choosing a "style" he deems appropriate to a particular subject. He is separated from Raphael by his materialism, eroticism, and historicism. Recently, Norman Bryson has attempted to explain Ingres's relationship to Raphael's works as a series of tropes that create a "lack set in motion by the displacement of images in a fully self-conscious tradition."[24] But surely, this analogy from literary theory is not rich enough to capture the complex relationship between the works of Ingres and those of Raphael.

In his paintings, Ingres expressed his devotion to Raphael in his choice of subject matter as well as his style, a devotion that seems to have reached the level of personal identification with Raphael. For example, in his *Apotheosis of Homer* (1827; Fig. 59), Ingres paid tribute to one of the central symbolic images of Raphael by showing him as the "modern Apelles" literally being led by Apelles into the pantheon of ancient and modern intellectual and artistic heroes around Homer. In his youth he had planned an entire series illustrating Raphael's life, based on his reading sources from Vasari to Comolli's *Vita inedita* (1790).[25] Of this ambitious undertaking, only *Raphael and the Fornarina* (first version, 1813; drawing, Fig. 60) and *The Betrothal of Raphael* (1813) were completed. That was the year in which Ingres married Madelaine Chapelle. In the *Betrothal,* Raphael's visage is based on the artist's portrait of Bindo Altoviti, believed in Ingres's time to be a self-portrait of Raphael. That same portrait of Altoviti served as the inspiration for the pose of Ingres's *Self-Portrait at the age of Twenty-four* (Musée Condé, Chantilly, 1804).[26] Following the historicizing methods of his time, he tried to re-create, with archaeological exactitude, the scene in which Raphael's attention was divided between his work and his mistress.[27] Ingres's *Fornarina* was based directly on a portrait then attributed to Raphael (Fig. 61), and the *Madonna della Sedia* peeks out at us from the studio's back wall.[28] Ingres's projected series would have continued the common, contemporary practice of commemorating past masters as great historical figures, and stressing the artist's status during periods of past glory.[29]

The theme of *Raphael and the Fornarina,* here seen in the version in the Columbus Museum (Fig. 62) however, which Ingres painted no less than five times, had a more personal significance to the artist. The painting identified Raphael's source of inspiration with Ingres's own: the inexhaustible mysteries of the female form. For Ingres, Raphael's art was less a straitjacket than a rich and abundant garden of artistic delights from which Ingres could choose his own highly personal bouquet. Thus, one can understand his reply to the charge of pastiche leveled against his *Vow of Louis XIII:* "I have done everything I can to make it Raphaelesque and mine" (Rosenblum, *Ingres,* 62).

Perhaps Ingres's greatest debt to Raphael was expressed in his uses of the *Madonna*

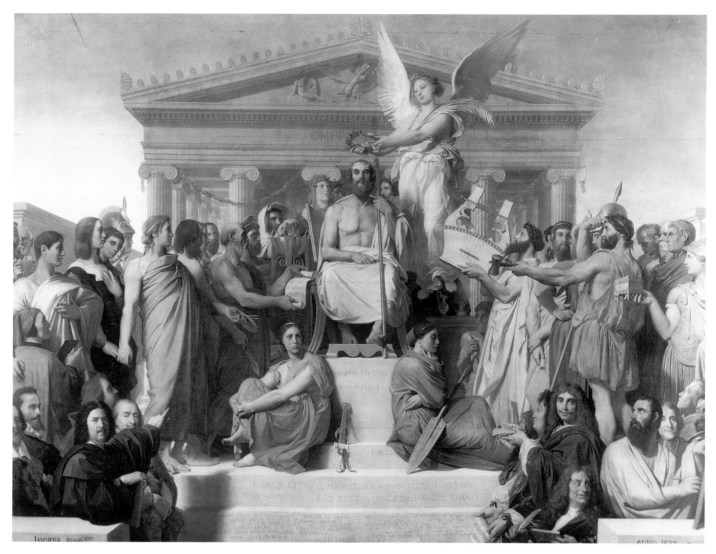

Fig. 59. Ingres, *Apotheosis of Homer,* 1827, Louvre, Paris

della Sedia (Fig. 63), one of the masterpieces of the Musée Napoléon. The work was a talisman for Ingres, inserted unobtrusively in many different guises, into works as different as *Raphael and the Fornarina* and *Napoleon I on the Imperial Throne.* It appears as an engraving dropped casually on the table of *M. Rivière* and as a wall decoration in a painting of *Henry IV.*[30] From the time that the young Ingres became acquainted with it through a copy brought back to Montauban by his teacher, Rocques, no work had a deeper, more profound significance to the artist.[31] For example, the work clearly provided the model for the head of Ingres's *Grande Odalisque* (1814; Fig. 64).

The work was more than a symbol of Ingres's devotion to Raphael. Its tantalizing interplay between contour and surface, line and color, realistic detail and abstract geometry provided endless stimulation to Ingres's imagination. His fascination is expressed in a

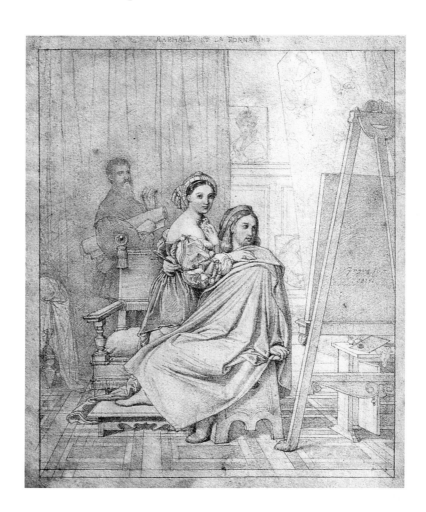

Fig. 60. Ingres, *Raphael and the Fornarina,* drawing, Louvre, Cabinet des Dessins, Paris

beautiful drawing in the Musée Ingres of the Madonna's head with its perfect geometry (Lapauze, *Les dessins de J. D. Ingres,* Inv. 867, 825). Being both more realistic and more abstract than Raphael, he transformed the delicate balance of these elements in Raphael into a creative tension most effectively realized in his portraiture.[32] Here his characteristic, realistic intensity can be balanced by an equally powerful, rhythmic geometry. The portrait of *Madame Rivière* (1805) is a case in point, an elliptical version of Raphael's circular composition.

Ingres's creative adaptations of Raphael's works far surpass his words. Like David, Ingres attempted to instill his devotion for Raphael in his pupils. Particularly during his tenure as director of the French Academy in Rome, he had his students, such as the brothers Balze, copy Raphael's works.[33] In many cases, as Michael Driskel has argued, Ingres's pupils carried the hieratic and iconic approach pioneered by their master even further, particularly after such qualities became identified with the Ultramontane movement of the neo-Catholic revival in France from the 1830s on. Paralleling the rise of Ultramontanism was a critique of the notion that Raphael's late works, such as the *Transfiguration,* represented the summit of religious painting. Instead, a doctrine arose of the "Fall" of Raphael from the pure monastic ideal of his early work to the "decadence" of his

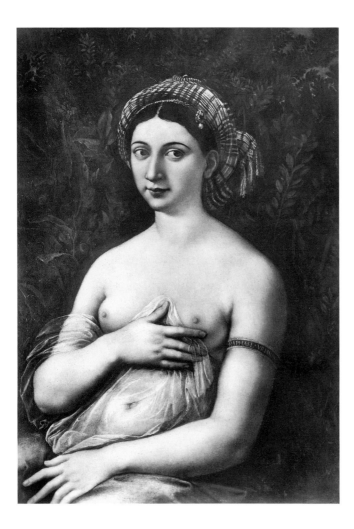

Fig. 61. *Fornarina,* c. 1518–20, Galleria Nazionale d'Arte Antica, Rome

later career. These value shifts made it highly unlikely that Ingres's pupils, such as Flandrin, would try to emulate Raphael directly to the degree that their master had.[34]

Like his art, Delacroix's ideas are intricate, complex, and ambiguous. As Mras has demonstrated, Delacroix, with his wide-ranging intellect, managed to see two sides to every artistic question.[35] Delacroix's most concise statement on Raphael was in his 1830 essay for the *Revue de Paris,* but he also mentioned Raphael frequently in his *Journal,* compiled between 1822 and 1832, and 1847 and 1863, the year of his death.[36] The 1830 article provides Delacroix's sentiments on Raphael in his early career; the later *Journal* entries can suggest how those views changed as his art developed.

Delacroix was strongly opposed to the lifeless quality of much neoclassical painting in his time, but he certainly did not disparage the great classical master, Raphael:

> The name of Raphael calls to mind what is most elevated in painting, and this impression, which starts out as prejudice, is confirmed by the scrutiny of all who have artistic sensibilities. The sublimity of his talent combined with the particular

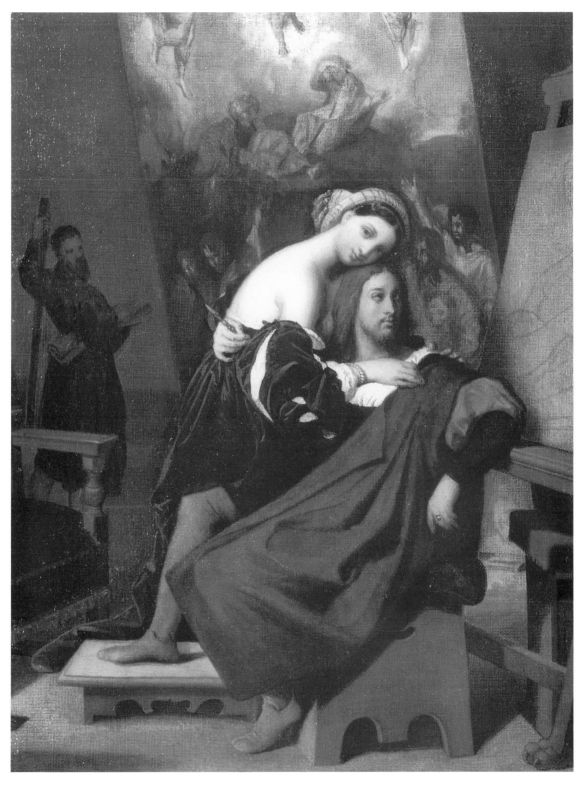

Fig. 62. Ingres, *Raphael and the Fornarina*, 1840, Columbus Museum of Art, Bequest of Frederick W. Schumacher, Columbus, Ohio

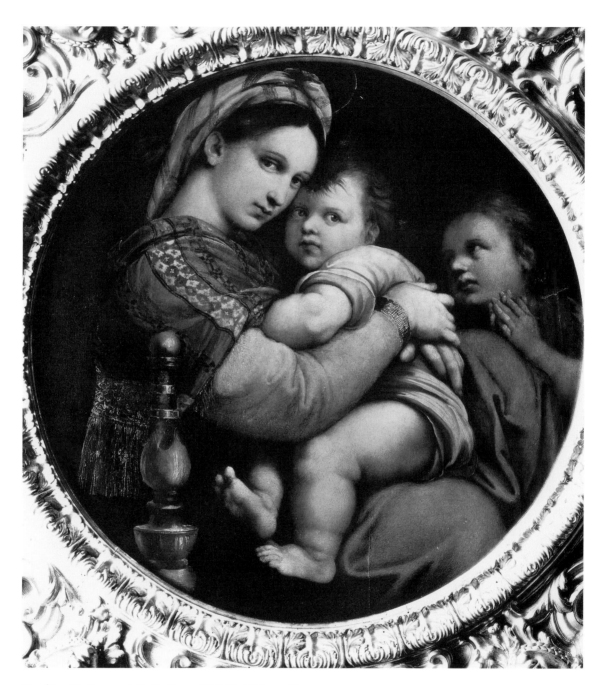

Fig. 63. *Madonna della Sedia,* c. 1514, Pitti Palace, Florence

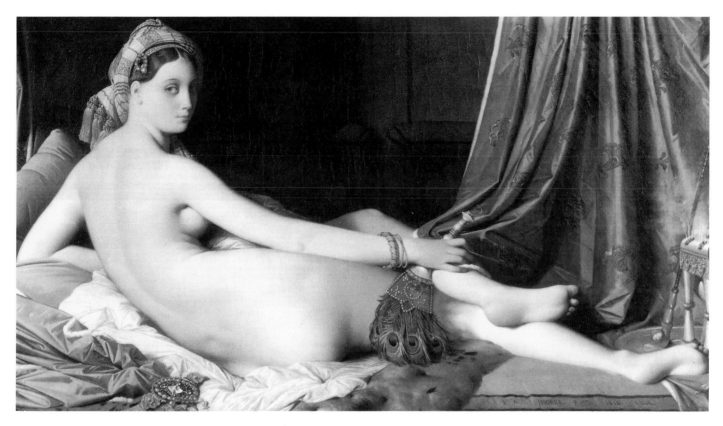

Fig. 64. Ingres, *Grande Odalisque,* 1814, Louvre, Paris

circumstances in which he lived and this nearly unique combination of advantages which nature and fortune gave him have placed him on the throne where no one can supplant him. (*Oeuvres littéraires,* 2:9)

Despite his admiration for the artist, Delacroix attacked the common notion of Raphael's total superiority:

Raphael has no more attained perfection than has anyone else; he has not even, as is the common opinion, alone united the greatest number of possible perfections, but he alone has carried to the highest degree those qualities which are the most captivating and which exert the most influence on men: an irresistible charm in his style, and a truly divine grace, which breathes throughout all his works, and masks the defects and makes us excuse all his excesses. (*Oeuvres littéraires,* 2:9)

This is a curious reversal. The statement that Raphael had virtues that outweighed his faults might well have been made about Rubens in the early eighteenth century.[37] Delacroix certainly did not support the Romantic stereotype of the wholly independent, inspired genius when he praised Raphael's eclecticism, drawing on the works of the ancients as well as those of his contemporaries (*Oeuvres littéraires,* 2:11). Delacroix

concluded that Raphael was always able to breathe new life into his model. For Delacroix, this was the absence of genius. On the question of Michelangelo's influence on Raphael, Delacroix sided with Roger de Piles, in suggesting that the sight of Michelangelo's works had a profound impact on Raphael (*Oeuvres littéraires,* 2:15). In fact, many of his comments on Raphael seem to be taken directly from the seventeenth-century critic's works. De Piles had also maintained that Raphael was moving toward an assimilation of Venetian color. Delacroix agreed that he would have mastered this aspect of painting if not for his premature death (*Oeuvres littéraires,* 2:15). He also denied the academic stereotype of Raphael as an artist who only achieved success through hard work. In fact, Delacroix admired most in Raphael what he perceived as effortless facility and creativity, qualities Delacroix clearly deemed essential for artistic greatness:

> It was obviously jealousy which caused Michelangelo to say that Raphael owed everything to work. On the contrary, everything he did carried the imprint of ease The hand submitted to, as if by instinct, such an abundance of wonderful ideas so important that choice was impossible, but there was never extravagance, triviality or baseness. (*Oeuvres littéraires,* 2:17)

Raphael's dignity was not theatrical like Poussin's, nor was it like the elevated, but somewhat affected dignity of Leonardo:

> It is an elegance which does not come from the model; a modest verve . . . an earthly manifestation of a spirit who converses with the gods. It is not the pomp, the striking ideas, the sometimes indiscreet profusion of the Venetian painters. In his most simple compositions, as well as in his vast, majestic compositions, his spirit answers everywhere with life and movement, the most perfect and enchanting harmony. (*Oeuvres littéraires,* 2:18)

Despite his ample respect for Raphael, Delacroix's hero was clearly Rubens. In the 1847 notebook of his journal he wrote that all the great problems of art had been solved in the seventeenth century: In Raphael, the perfection of drawing, grace, and composition was attained. Correggio, Titian, and Veronese had perfected color and chiaroscuro. "Then came Rubens, who had already forgotten the traditions of grace and simplicity. By sheer genius he created a new ideal. This he drew from the depths of his nature; it consisted of strength, striking effects, and expression carried to its utmost limit."[38]

Two journal entries suggest how Delacroix's views of Raphael changed as his art developed. In 1824, he wrote:

> The first and most important thing in painting is contour. Even if all the rest were neglected, provided the contours were there, the painting would be strong and finished. I have more need than most to be on my guard about this matter; I think constantly about it, and always begin that way. It is to this that Raphael owes his finish, and so, very often, does Géricault. (*Journal,* 28)

At a later stage of his career, in 1851, his concerns had changed. Discussing the necessity for unity in a work, Delacroix criticized Raphael's lack of fusion in his compositions,

resulting, according to Delacroix, from Raphael's practice of conscientiously drawing each figure in the nude before draping it. Criticizing Raphael's studio method, Delacroix suggested a different model:

> I feel convinced that Rembrandt would never have achieved his power of representing character by a significant play of gestures, or those strong effects that make his scenes so truly representative of nature, if he had bound himself down to this studio method. Perhaps they will discover that Rembrandt is a far greater painter than Raphael. (*Journal,* 142–43)

Even as he uttered this blasphemy, calculated as he said, "to make every good academician's hair stand on end." he qualified it by stating that he had not made a firm decision on the matter. Rembrandt might not quite have Raphael's nobility of mind, but might be considered "more of a natural painter than Perugino's studious pupil" (*Journal,* 143). As Delacroix worked toward a poetic and painterly unity in his own work, he came to regard those qualities more highly in others.

Although Delacroix's art increasingly approached that of Rubens in much of his later work, he never lost his appreciation for Raphael's outstanding qualities. Considering in 1852, Poussin's comment that Raphael had been an ass compared with the antique, Delacroix agreed that, in comparing Raphael's drawing and anatomical knowledge with the ancients', Poussin had a good case. As always, however, Delacroix qualified his remarks:

> In a different connection, he might equally well have said that Raphael did not know as much as he, Poussin. . . . But before these paintings, where grace and elegance are so marvellously united, where knowledge and the instinct for composition are carried to a point which no artist has ever reached, Raphael would have appeared to him what in very much truth he is, superior even to the ancients in many aspects of his art, and especially in those qualities which were entirely denied to Poussin. (*Journal,* 165)

Delacroix's direct debt to Raphael is not so obvious or overriding as his debt to Rubens. Like most of his contemporaries, Delacroix copied several of Raphael's works in paintings and drawings, particularly during his early years.[39] His early *Virgin of the Harvest* (see Trapp) echoes the form of the *Belle Jardinière,* which he had copied earlier. Since Delacroix never went to Italy and was quite young during the Musée Napoléon existence, his knowledge of Raphael was based on the works that remained in France after 1814, but primarily on engravings; he owned eighty-four at his death.[40] Lichtenstein has suggested that Delacroix's penchant for copying Raphael's later works as his own career proceeded may reflect the development in both artists from an early lyricism toward a greater power and complexity of style. Particularly in his later career, Delacroix would copy only part of a composition, focusing on and enhancing its action and expression.[41]

Delacroix's process of transformation of Raphael's art is suggested by his *Expulsion of Heliodorus* for Saint-Sulpice (1856–61).[42] As Trapp has suggested, Delacroix's painting shows the same scene as Raphael's and shares many of the same compositional elements. They both focus on the dramatic moment when the heavenly defender overcomes Heliodorus, but they achieve their dramatic effect in totally different ways (297–300). The

energetic, but tightly controlled group of principal figures in Raphael's work bears little resemblance to Delacroix's, with its sprawling energy. In Raphael's work, the drama is created by the eccentric placement of the group in the cavernous space of the temple. In Delacroix's work, a higher energy is created by dramatic lighting, free brushstrokes, and extraordinary contrasts of complementary colors.[43] Trapp is correct in suggesting that the relationship of Delacroix's to Raphael's work is more one of "purposeful analogy" than direct dependence. Delacroix admired Raphael's grace, harmony, and lucidity, but his deepest inclinations were of an entirely different sort. The ways that Delacroix transformed Raphael are more significant than what he owed to him. Raphael merited his respect, but he could not fire Delacroix's blood the way Rubens could.

Transformations of Raphael in France (1660–1830)

In this study I have shown that Raphael's image and his art played a crucial role in defining, preserving, and justifying French artistic theory. By erecting the French academic tradition on the bedrock of Raphael's art and image, the Academy legitimized its position and tastes and lent the Renaissance master a position of unequaled prestige in French artistic life. Since changes in French artistic values and institutions were deeply embedded in broader social and political shifts, Raphael's prestige could have political significance as well. In the narrower world of aesthetic concerns, Raphael's works provided a direct model for countless artists from the classical through the neoclassical period, but what they saw in his works was largely determined by their preconceptions of the artist. These recurring images of Raphael were ultimately derived from Vasari.

In constructing his image of Raphael as an artist of catholic excellence, Vasari described several aspects of the Renaissance master that could be interpreted to justify the tastes and practices of the French Academy. The Academicians justified their idealism and classicism by viewing Raphael, like Poussin, as a "modern Apelles." By following the ancients, they learned to represent *la belle nature.* Raphael's approach, as defined by Vasari, also justified another aspect of academic practice. Vasari stressed that Raphael, the "sublime eclectic," achieved his perfection by constant study of sources ranging from antiquity to Michelangelo. What could better prove that the eclecticism fostered by the Academy was the true road to artistic success? Vasari also dwelled on the renown and patronage achieved by the "prince of painters." This inviting picture of a painter, who could achieve such success by talent, good fortune, but above all, constant diligence stimulated countless ambitious artists. This picture of Raphael's achievement still haunted Delacroix in 1830.[1]

Like Vasari, the Academy focused on Raphael as a model history painter, the master of sublime composition, design, and expression. Although Titian and Correggio were his acknowledged superiors in the use of color and chiaroscuro, Raphael was judged to excel in the most important aspects of painting. In the eyes of seventeenth-century Academicians, Raphael's lack of immediate, sensual appeal was no fault. The more one studied Raphael, the more beautiful and appropriate his conceptions seemed.

Beginning in the 1670s, the partisans of color, led by Roger de Piles, forced a shift in values as they proclaimed color and sensual appeal as essential to painting as design. They introduced a broadened eclecticism embracing a *Rubéniste* alternative to seventeenth-century classicism, based on Raphael and Poussin. Such a change in values had to affect Raphael's prestige, but not nearly so severely as one would expect if the positions of the advocates of color and design were as antithetical as is sometimes suggested. The *Rubénistes* wanted to alter the old system of values to include the virtues of color, not to

destroy the system entirely. In addition, the degree to which the name of Raphael carried a prestige that transcended any single aesthetic approach ensured that his name would not disappear, even at the height of the Rococo.

Roger de Piles, the archprotagonist of colorism and Rubens, never rejected Raphael. The eclecticism he advocated was broad enough to encompass both the Flemish and the Roman masters, although he shifted the focus in painting from didacticism to sensuousness. This value shift fit changing patterns of patronage in the first half of the eighteenth century. De Piles redefined Raphael as an artist who was assimilating naturalism and color at the end of his career. From opposite poles, Rubens and Raphael were moving toward de Piles's idea of perfection in painting: a complete synthesis of nature and ideal, of color and design, yet with nature and color having the upper hand. This was the perfect fusion of the *vrai simple* and the *vrai idéal* that he termed the *vrai parfait*. It is, after all, not surprising that he rated Raphael and Rubens equal, but with complementary virtues, in his "Balance des Peintres." Although there can be no doubt that de Piles thought Rubens superior to Raphael, Raphael was such a cornerstone of the French classical tradition that he could not be rejected entirely. Instead, the prevailing view of him was transformed to support the new aesthetic.

During the first half of the eighteenth century, the broadened eclecticism promoted by de Piles, Antoine Coypel, and others dominated the Academy. The direct impact of Raphael's work on contemporary painting may have lessened, but it never disappeared. Watteau may have had little use for Raphael, but history painters continued to use him as a model. Two other sectors of the French artistic world acted to preserve Raphael's prestige during this period: amateurs, such as Mariette, who never abandoned seventeenth-century classicism; and the French Academy in Rome, which constantly placed Raphael as a model before its students, even as it eventually adopted the eclecticism of the parent Academy. The monumental enterprise of copying ten of the Vatican frescoes for tapestry models kept Raphael before the students from the 1730s to the 1750s. Many of the artists who copied Raphael as students took part in the revival of history painting after 1747.

In the second half of the century, the need for an academic model grew more acute as the emphasis in French painting shifted from delectation to instruction. Like their seventeenth-century predecessors, Academicians around mid-century used images of Raphael that justified their return to a classical ideal and a stricter academic method. Raphael's *stanze* and cartoons also provided an ideal model for serious history painting, as advocated by La Font de Saint-Yenne in 1747 and increasingly promoted by *surintendants* thereafter, as a means of enhancing their own positions.

I have suggested that French views on Raphael from the late seventeenth to the mid-eighteenth century had a self-perpetuating, internal logic. Excepting Diderot, the French almost never questioned their assumptions about the artist, and so were never able to see his works with fresh, unbiased eyes. It may seem paradoxical that with their limited vision of his art, Raphael was so important to the French. Yet it was precisely this stability in the view of Raphael that rendered him such a powerful ideal, a symbol of certain permanent and universal values, the bedrock of French classicism. As we have seen, the discourse concerning Raphael played an important political function in justifying the privileged status and protection of the king that the Academy claimed. Throughout the eighteenth century, Raphael's continuing prestige could be enlisted by those both inside and outside the Academy to further a variety of artistic and political agendas.

For the most part, the only jolts to French complacency were administered by foreigners. Richardson not only discussed many of Raphael's lesser-known works, he challenged the widely accepted French notion that the *stanze* were among Raphael's greatest works by chauvinistically suggesting that they were inferior to the Hampton Court cartoons. The French attacked him as soon as his treatises were translated and were still challenging his views on specific works when they could see them in the Musée Napoléon.

Winckelmann and Mengs were the foreigners most influential on French thought. Their somewhat ambivalent view of Raphael was different from the one widely held in France. Like the French, they saw Raphael as the modern who most closely emulated the ancients, but they also stressed his inferiority to the Greeks.

There can be no doubt that Winckelmann's and Mengs's views were influential in France, even though their ideal of beauty was never totally accepted.[2] David partially adopted the Germans' neoclassical viewpoint, but he never entirely abandoned the moderns, including Raphael, to model his work solely on antique remains. Most of his contemporaries and followers, who were exposed to the diverse riches of the Musée Napoléon, were even less prone to an exclusive taste of antiquity. Moreover, the particular social, historical, and political conditions that gave antique form and content such validity in David's hands passed away with the Revolution. The neoclassical focus on the ancient past was challenged by the rise of other forms of historicism.[3] In this intellectual climate, the death of Raphael was as appropriate a subject as the death of Socrates.

At the beginning of the nineteenth century, as creative artists diverged from Davidian classicism, they sometimes explored less traditional aspects of Raphael's art. Gros found inspiration for his battle scenes in the Sala di Constantino.[4] Ingres was stimulated by the grace and complexity of Raphael's Madonnas, but transformed Raphael's style in the direction of the hieratic and iconic. Delacroix found a starting point for his *Heliodorus* in the corresponding scene by Raphael. As long as creative artists embraced what was conceived of as a grand conception of painting, they could find elements in Raphael to stimulate their imaginations.

As the century progressed, however, Raphael became a less vital model as art diverged from the grand ideal still cherished by Ingres and Delacroix. Their followers tended to turn to different models from past art to create works with very different qualities than the *grand goût* of Raphael. In addition, what passed for the academic ideal was so modified that it was often no longer compatible with Raphael's art. Considering the works of later nineteenth-century artists who, supposedly, perpetuated the classical ideal, we find the sentimentality of Bouguereau, the overt eroticism of Cabanel, and the quasi-photographic realism of Gérome are all equally distant from Raphael.[5] Increasingly, many talented painters abandoned the academic ideal entirely to paint landscapes or scenes from modern life. Although artists continued to copy the Old Masters, Manet was exceptional in needing to confront directly and to transform the great art of the past, as in his *Déjeuner sur l'herbe* (1863).[6] It is indicative of the spirit of the times, however, that although Manet borrowed the *Déjeuner*'s composition from Raphael's *Judgment of Paris,* he radically transformed it into a disconcerting image of modern life. By Manet's time, the seemingly immutable values of ideal beauty, for which Raphael's art had so long served as paradigm, had fallen victim to modernity.

Appendix I: Raphael's Works in the King's Collection*

1. Saint Michael
2. Holy Family for Francis I
3. Saint John the Evangelist
4. Saint John in the Desert
5. The Belle Jardinière
6. Portrait of Joanna of Aragon
7. Portrait of Raphael and Pontormo
8. Saint Margaret
9. Small Holy Family
10. Portrait of Castiglione
11. Saint Michael (small)
12. Saint George and the Dragon
13. Portrait of a Young Man
14. Portrait of Leo X as Cardinal
15. Madonna with the Diadem

*This list is extracted from B. Lépicié, *Catalogue raisonné des tableaux du roy,* Paris, 1752–54. For complete provenance and illustrations, see Dussler, *Raphael.* Many of these works are no longer solely attributed to Raphael. See *Raphael dans les collections françaises.*

Appendix II: Roger de Piles's "Balance des Peintres"

	Composition	Design	Color	Expression	Total
Le Brun	16	16	8	16	56
Carracci	15	17	13	13	58
Domenichino	15	17	9	17	58
Giulio Romano	15	16	4	14	49
Michelangelo	8	17	4	8	37
Veronese	15	10	16	3	44
Poussin	15	17	6	15	53
Raphael	17	18	12	18	65

Titian	12	15	18	6	51
Rubens	18	13	17	17	65
Rembrandt	15	6	17	12	50

SOURCE: From Roger de Piles, *Cours de peinture par principes,* Paris, 1708. Each score is out of a possible 20.

Appendix III: Italian Works Brought to France by Napoleon*

1. Five Saints (Parma) (attributed now to Giulio)
2. Saint Cecilia (Bologna)
3. Coronation of the Virgin (Perugia)
4. The Theological Virtues (Perugia)
5. Annunciation, Adoration, and Presentation (Perugia)
6. Coronation of the Virgin (Perugia) (finished by pupils)
7. Madonna da Foligno (Foligno)
8. Transfiguration (Rome)
9. Madonna di Loretto (Loreto) (considered a copy)
10. Portrait of Leo X (Pitti Palace, Florence)
11. Madonna della Sedia (Pitti Palace, Florence)
12. Madonna dell'Impannata (Pitti Palace, Florence)
13. Vision of Ezekiel (Pitti Palace, Florence)
14. Madonna del Baldacchino (Pitti Palace, Florence)
15. Portrait of Cardinal Bibbiena (Pitti Palace, Florence)
16. Portrait of Tommasso Inghirami (Pitti Palace, Florence)

From Spain

1. Madonna of the Fish
2. Carrying of the Cross (Lo Spasimo)

*M.-L. Blumer, "Catalogue des peintures transportées d'Italie en France de 1796 à 1814," *Bulletin de la Société de l'Histoire de L'Art Français,* 2 fasc., 1936, 244–348. For illustrations of these works, see Dussler, *Raphael.*

NOTES

INTRODUCTION

1. For a detailed exploration of the relationship between aesthetic and philosophical ideas, see Annie Becq, *Genèse de l'esthétique française moderne: De la raison classique à l'imagination créatrice, 1680–1814,* 2 vols., Pisa, 1984.

2. See Norman Bryson, *Word and Image: French Painting of the Ancien Régime,* Cambridge, 1981, esp. chap. 2.

3. Katie Scott, "D'un siècle a l'autre," in Colin Bailey, *The Loves of the Gods: Mythological Painting from Watteau to David,* exh. cat., Grand Palais, Paris, and Kimball Art Museum, Fort Worth, Texas, 1991–92, 33.

4. See Martin Weyl, *Passion for Reason and Reason of Passion: Seventeenth-Century Art and Theory in France, 1648–1683,* New York, 1989, for a detailed discussion of the role of the concept of the "honnête" man in French society, esp. 214ff.

5. Thomas Crow, *Painters and Public Life in Eighteenth-Century France,* New Haven, 1985, chap. 1.

6. Robert Rosenblum, *Transformations in Late Eighteenth-Century Art,* Princeton, N.J., 1967; Detroit Institute of Arts, *French Painting, 1774–1830: The Age of Revolution,* Detroit, 1975; Pierre Rosenberg, *The Age of Louis XV: French Painting, 1710–1774,* exh. cat., Toledo Museum of Art (Ohio), 1975–76.

7. Colin Bailey, *Loves of the Gods: Mythological Painting from Watteau to David,* exh. cat., Grand Palais, Paris, and Kimball Art Museum, Fort Worth, Texas, 1991–92; Donald Rosenthal, *La Grande Manière: Historical and Religious Painting in France, 1700–1800,* exh. cat., Memorial Art Gallery of the University of Rochester, Rochester, N.Y., 1987; Philip Conisbee, *Painting in Eighteenth-Century France,* Oxford and Ithaca, N.Y., 1981.

8. Hugh Honour, *Neo-classicism,* Harmondsworth, 1968; Albert Boime, *Art in the Age of Revolution, 1750–1800,* Chicago, 1987; Crow, *Painters and Public Life.*

9. Bryson, *Word and Image;* Michael Fried, *Absorption and Theatricality: Painting and Beholder in the Age of Diderot,* Berkeley and Los Angeles, 1980; Mary Sheriff, *Fragonard,* Chicago and London, 1990.

10. This point has been stressed in the recent book by Thomas Puttfarken, *Roger de Piles' Theory of Art,* New Haven, 1985. See also R. Lee's classic study of the relationship between literary and artistic theory, *Ut Pictura Poesis: The Humanistic Theory of Painting,* New York, 1967. See also J. Lichtenstein, *The Eloquence of Color: Rhetoric and Painting in the French Classical Age,* trans. E. McVarish, Berkeley and Los Angeles, 1993.

11. See Crow, *Painters and Public Life.*

12. N. Bryson, *Tradition and Desire,* Cambridge, 1984. Bryson's ideas are based on those of the literary critic Harold Bloom; see, for example, Bloom, *The Anxiety of Influence: A Theory of Poetry,* New York, 1975. For a critique of Bryson's concept of "tradition," see L. Eitner, "Foregrounding the Trope," *Times Literary Supplement,* 12 April 1985, 413–14. For a less combative view of the effects of tradition, see E. Gombrich, *Norm and Form: Studies in the Art of the Renaissance,* Oxford, 1966. For a comprehensive examination of the role of tradition in culture, see E. Shils, *Tradition,* Chicago, 1981.

13. The best general discussion of Italian art theory is A. Blunt, *Artistic Theory in Italy,* Oxford, 1940, particularly 83–84, 94, 146–47, 156–58. For a recent useful study of the derivation of French art theory from the Italians, see Moshe Barasch, *Theories of Art from Plato to Winckelmann,* New York, 1985. Also see A. Blunt, "The Legend of Raphael in Italy and France," *Italian Studies* 13, 1958, 2–5. Dolce, in particular, reversed Vasari's subordination of Raphael to Michelangelo. See L. Dolce, *L'Aretino, Dialogo della Pittura,* Venice, 1557.

14. A. Félibien, *Entretiens sur les vies et sur les ouvrages des plus excellens peintres anciens et modernes* (1666–88), Paris (1666); facsimile of the 1725 Trévoux edition, Farnsborough, 1967, 1:292. The French reads: "Si quelques-uns ont excellé en une partie de la peinture, ils n'ont sçu les autres que fort médiocrement et l'on peut dire que Raphael a été admirable en toutes."

15. E. Müntz, *Les Historiens et critiques de Raphael,* Paris, 1883; A. Blunt, "Legend," 2–21; V. Golzio, "Raphael and his Critics," in *The Complete Work of Raphael,* ed. M. Salmi, Novara, 1969, 607–43.

16. A. Fontaine, *Les Doctrines d'art en France, de Poussin à Diderot,* Paris, 1909, considers the general evolution of French art theory from its inception to the 1760s.

17. M. Rosenberg, "Raphael in French Art Theory, Criticism and Practice 1660–1830," diss. University of Pennsylvania, 1979.

18. J.-P. Cuzin et al., *Raphael et l'art français,* exh. cat. Grand Palais, Paris, November 1983–February 1984. For my review of the exhibition, see M. Rosenberg, "Raphael and France," *Art Journal* 44, Spring 1984, 70–74.

19. For a discussion of Napoleon's politicization of Raphael, see M. Rosenberg, "Raphael's Transfiguration and Napoleon's Cultural Politics," *Eighteenth-Century Studies* 19, no. 2, Winter 1985–86, 180–205.

20. See Michael Driskel, "Raphael, Savonarola and the Neo-Catholic Use of 'Decadence' in the 1830s." In *Fortschrittsglaube und Dekadenzbewußtein im Europa des 19. Jahrhunderts,* ed. Wolfgang Drost, Heidelberg, 1986, 259–66. These ideas are expanded in Driskel's recent *Representing Belief, Religion, Art, and Society in Nineteenth-Century France,* University Park, Pa., 1992.

CHAPTER 1

1. On French knowledge of Raphael before the second half of the seventeenth century, see Cuzin et al., *Raphael et l'art français,* especially 11–18, 47–52.

2. Crow, *Painters and Public Life,* 33.

3. Bryson, *Word and Image,* chap. 2.

4. Weyl, *Passion for Reason.*

5. Blunt, "Legend."

6. For a list of works by Raphael in the king's collection, see Appendix I. All of Raphael's major works had been engraved by the late seventeenth century. For an extensive listing of engravings after Raphael, see T. Euboeus (W. Lepel), *Catalogue des estampes gravées d'après Rafael,* Frankfurt am Main, 1819. A list of engravings after Raphael available in 1675 is appended to the translation of Vasari's *Life* by I. de Bombourg, *Recherche curieuse de la vie de Raphael Sansio d'Urbin,* Lyon, 1675.

7. For a discussion of the impact of literary theory on art theory, see Rensselaer Lee, *Ut Pictura Poesis: The Humanistic Theory of Painting,* New York, 1967; T. Puttfarken, *Roger de Piles' Theory of Art,* New Haven, 1985, especially chaps. 1 and 3.

8. For a detailed discussion of works attributed to Raphael in France, see *Raphael dans les collections françaises,* exh. cat., Galeries nationales du Grand Palais, Paris, November 1983–February 1984. On the *Saint Michael,* see 91–92.

9. This was primarily from about 1710 to 1725. See pages 71–72.

10. On the importance of engravings for knowledge of Raphael's works, see M. Vasselin, "La fortune gravée de Raphael en France," in Cuzin et al., *Raphael et l'art français,* 37–46. See also I. H. Shoemaker, *The Engravings of Marcantonio Raimondi,* exh. cat., Spencer Museum of Art, University of Kansas, Lawrence, Kansas, 1981.

11. There were a number of such compendia. One important volume by Dorigny contained many details taken from the cartoons of the *Acts of the Apostles.* See N. Dorigny, *Recueil de XC Têtes d'après les Actes des Apôtres de Raphael,* Paris, 1719.

12. For discussions of Raphael's influence on Poussin, see A. Blunt, *Nicolas Poussin,* 3 vols., New York, 1967; A. Blunt, *The Drawings of Poussin,* New Haven, 1979; Walter Friedlaender, *Nicolas Poussin,* New York, 1966; Konrad Oberhuber, *Poussin: The Early Years in Rome* (exh. cat., Kimball Art Museum, Fort Worth, Texas), New York, 1988; Christopher Wright, *Poussin Paintings—A Catalogue Raisonné,* London, 1984; E. Havercamp-Begemann, *Creative Copies: Interpretative Drawings from Michelangelo to Picasso,* exh. cat., The Drawing Center, New York, 1988, 106–7, 194–95. A. Mérot, *Nicolas Poussin,* London, 1990. For illustrations of the *Sacraments,* see Wright, *Poussin Paintings,* 68–100.

13. On the Seven Sacraments, see Friedlaender, *Nicolas Poussin,* 58–60. Merot, *Poussin,* 138.

14. See also Cuzin et al., *Raphael et l'art français,* 163–68.

15. Although Le Sueur never ventured to Italy, he assiduously studied Raphael's works through engravings and the king's collection. Raphael's influence is particularly evident in Le Sueur's *Muses,* executed for the Hôtel Lambert in 1645–48. See L. Dimier, *Histoire de la peinture française: Du Retour de Vouet à la mort de Le Brun,* Paris, 1927, 2:2. For Le Brun's debt to Raphael, see J. Pope-Hennessey, *Raphael,* New York, 1970, 244–46 In addition, see the sections under each artist in Cuzin et al., *Raphael et l'art français:* Le Brun, 137–39; Le Sueur, 142–46; Mignard, 150–53.

16. G. Vasari, *Le Vite de' Piu Eccelenti Pittori, Scultori e Architettori* (1568); ed. Gaetano Milanesi, 9 vols. (1878); Florence, 1906. All quotes in Italian are from the Milanesi edition. All English translations are from Vasari, *Lives,* trans. G. du C. DeVere, 10 vols., repr. ed., London, 1912–14. French translations of Vasari were published by P. Daret, *Abrégé de la vie de Raphael,* Paris, 1651; and I. de Bombourg, *Recherche curieuse de la Vie de Raphael,* Lyon, 1675. Blunt, "Legend," 2–4 discusses Vasari's role.

17. Vasari, Milanesi ed., 4:316: "Laonde si puo dire sicuramente che sono possessori di tante rare doti, quante si videro in Raffaello da Urbino, sian non uomini semplicamenti, ma, se è cosi lecito dire, Dei mortali."

18. Vasari, DeVere ed., 4:243–44; The Italian is Milanesi ed., 4:375–76: "Ma conoscendo nondimeno che non poteva in questa parte arrivare alla perfezione di Michelangnolo; come uomo di grandissimo guidizio, considerò che la pittura non consiste solamente in fare uomini nudi, ma che ell'ha il campo largo, e che fra i perfetti dipintori si possono anco coloro annoverare

che sanno esprimere bene e con facilità l'invenzioni delle storie et i loro capricci con bel guidizio, e che nel fare i componimenti delle storie chi sa mon confonderle col troppo, et anco farle non povere col poco, ma con belle invenzione et ordine accomodarle, si può chiamare valente e guidizio artefice. A questo, siccome bene andò pensando Raffaello, s'aggiugne lo arrichirle con la varietà e stravaganza delle prospettive, de' casamenti e de' paesi, il leggiadro modo di vestire le figure; il fare che elle si perdino alcuna volta nello scuro, et dalcuna volta venghino innanzi col chiaro; il fare vive e belle le teste delle femmine, de' putti, de' giovani e de' vechi e dar loro, secondo il bisogno, movenza e bravura.... Queste cose, dico, considerando Raffaello, si risolvè, non potendo agguignere Michelagnolo in quella parte, dove egli aveva messo mano, di volerlo in queste altre pareggiare e forse superarlo; e così si diede non ad imitare la maniera di colui, per non perdervi vanamente il tempo, ma a farsi un ottimo universale in queste altre parti che si sono raccontate."

19. DeVere ed., 4:223. The Italian is Milanesi ed., 4:339:

20. The Italian is Milanesi ed., 4:339: "Nella quale opera per le cose vedute di Michelagnolo migliorò et ingrandì fuor di modo la maniera e diedele più maestà."

21. DeVere ed., 4:245: The Italian is Milanesi ed., 4:378: "Dal quale errore ravedutosi, come guidizioso, volle poi lavorare da se solo, e senza aiuto d' altri la tavola di San Pietro a Montorio, della Trasfigurazione di Cristo; nella quale sono quelle parti, che già s'è detto che ricerca e debbe avere una buona pittura." For the role of the *Transfiguration* in Vasari's creation of the myth of Raphael, see Paul Barolsky, *Why Mona Lisa Smiles and Other Tales By Vasari,* University Park, Pa., 1991, 38–39.

22. This is the gist of all Vasari's descriptions of Raphael's works. See DeVere ed., 4:243–44, 83. See also DeVere ed., 4:244–45: The Italian is Milanesi ed., 4:377: "un modo mezzano di fare, così nel disegno come nel colorito; e mescolando col detto modo alcuni altri scelti delle cose migliori d'altri maestri, fece di molte maniera una sola, che fu poi sempre tenuta sua propria, la quale fu e sarà sempre stimata dagli artefici infinitamente."

23. DeVere ed., 4:83: The Italian is Milanesi ed., 4:11–12: Raphael "arrichì l'arte della pittura di quella intera perfezzione, che ebbero anticamente la figure d'Apelle e di Zeusi."

24. Roland Fréart de Chambray (1606–76) was an early advocate of classicism in France. He served under his cousin Sublet de Noyers, who became *surintendant des bâtiments,* and was responsible, with Richelieu, for bringing Poussin to Paris in 1640–42. Fréart's brother Fréart de Chantalou was one of Poussin's major patrons. Fréart de Chambray's publications included a translation of Leonardo's *Trattato* in 1651. His only original work on painting was his *Idée de la Perfection de la Peinture.* For a discussion of

Fréart's ideas and their importance, see Fontaine, *Les Doctrines d'art,* 20–22; J. Thullier, "Polémiques autour de Michel-Ange au XVIIIe siècle," *Dix-septième Siècle,* 13, 1957, 353–69. Thuillier argues that Fréart was responsible for elevating Raphael over Michelangelo in the French artistic hierarchy; See also Blunt, "Legend," 7–12. Blunt concentrates on only those aspects of Fréart's picture that link Raphael to Poussin, giving a limited picture of Fréart's ideas.

25. On Dufresnoy, see L. Demonts, "Deux peintres de la première moitié de XVIIe siècle, Jacques Blanchard et Charles Dufresnoy," *Gazette des Beaux-Arts,* ser. 5, 1, 1925, 161–78. For an outline of the principal ideas of these theorists, see Fontaine, *Les Doctrines d'art,* 18–22, 41–60.

26. See Cuzin et al., *Raphael et l'art français,* 137–39.

27. Ibid., 89, 150–53.

28. On the dispute between Bosse and Fréart, see Carl Goldstein, "Studies in Seventeenth-Century French Art Theory and Ceiling Painting," *Art Bulletin* 47, June 1965, 231–38.

29. Roland de Fréart de Chambray, *Idée de la perfection de la peinture* (Le Mans, 1662), all quotes from facsimile edition, 1968. This passage is from 116–17.

30. Franciscus Junius, *De Pictura veterum, libri tres,* Amsterdam, 1637. In addition to propounding abstract ideas without specific examples, Junius had to deal with fragments of theory and aphorisms that could not easily be shaped into a coherent artistic theory. For an account of Junius's ideas and importance, see L. Lipking, *The Ordering of the Arts in Eighteenth-Century England,* Princeton, N.J., 1970, 23–33.

31. For a useful discussion of Fréart's attack on aspects of Vasari's account of Raphael's works, see Jeremy Wood, "Cannibalized Prints and Early Art History," *Journal of the Warburg and Courtauld Institutes* 51, 1988, 210–20.

32. *Idée,* 28. Later Bosse would show that his remarks on Raphael's use of perspective were erroneous; see Fréart, *Idée,* 123.

33. Preface to *Idée,* n.p. See also Blunt, "Legend," 1, 9–12.

34. Wright, *Poussin Paintings,* 87.

35. A. Bosse, *Le Peintre converti aux précises et universelles règles de son art,* Paris, 1667. This is one of a large number of his treatises on perspective and related topics. For a bibliography for Bosse, see B. Teyssèdre, *Roger de Piles et les débats sur le coloris au siècle de Louis XIV* (1957), Paris, 1965, 574–75. Bosse's importance in the development of French academic theory is discussed by C. Goldstein, "Studies," 231–56. See Bosse, preface.

36. Bosse, 36. The idea that design appealed to the mind, while color appealed to the senses, a notion largely inherited from the Italians, was basic to French classical art theory. Perhaps this dichotomy goes back to the Platonic distinction between idea and matter. Titian, the painter of nature, was seen as appealing to

the senses; Raphael's elevated design and expression appealed to the intellect. The virtues took more effort to perceive, but were more lasting in their effect. With the French dichotomy between design and color, Raphael's colorism was seen only as an inadequate imitation of nature, with little immediate impact in comparison to Titian's. See R. Lee, *Ut Pictura Poesis,* 9–16.

37. A. Félibien, *Entretiens sur les vies et les ouvrages des plus excellens peintres anciens et modernes,* part 1 (I–II), 1666; part 2 (II–IV), 1672; part 3 (V–VI), 1679; part 4 (VII–VIII), 1685; part 5 (IX–X), 1688. The various editions are listed in Teyssèdre, 590–93. All quotes are from the facsimile of the 1725 Trévoux edition, Farnsborough, 1967. For a good recent summary of Félibien's ideas and place in French art theory, see Claire Pace, *Félibien's Life of Poussin,* London, 1981. Pace stresses the impact of Poussin's art and ideas on Félibien's thought.

38. See Goldstein, "Studies," 237–39; See also Becq, *Genèse,* vol. 1, chaps. 1 and 2.

39. See Y. Delaporte, "André Félibien en Italie (1647–49): Ses visites à Poussin et à Claude Lorraine," *Gazette des Beaux-Arts,* ser. 6, 51, April 1958, 192–214.

40. Félibien, vol. 1, part 2, 292. The French reads: "Raphael s'est tellement élevé audessus de tous par la force de son génie, qu'encore que les couleurs ne soient pas traitées dans ses tableaux avec une beauté aussi exquise que dans ceux de Titien, et qu'il n'ait pas eu un pinceau aussi charmant que celui de Corège, toutefois, il y a tant d'autres parties qui rendent ses ouvrages recommendables, que sans avoir égard à tout ce que les autres Peintres ont fait mieux, il faut confesser qu'il n'y a point eû de comparable de lui. Car si quelques uns ont excellé en une partie de la peinture, ils n'ont sçu les autres que fort mediocrement, et l'on peut dire que Raphael a été admirable en toutes."

41. C.-A. Dufresnoy, *De Arte Graphica Liber,* Paris, 1668, published with French translation and notes by Roger de Piles; see Teyssèdre, *Roger de Piles,* 586–87, for the publication history. The work went through dozens of editions. All quotes are from the English translation of the poem and its appendages from Dryden ed., London, 1695.

42. The adaptability of Dufresnoy's ideas is discussed by L. Lipking, "The Shifting Nature of Authority in Versions of *De Arte Graphica,*" *Journal of Aesthetics and Art Criticism* 23, Summer 1965, 487–504. See also Teyssèdre, *Roger de Piles,* 586–87, 639–40.

43. Blunt, *Artistic Theory,* 157. On the issue of the Carraccis's eclecticism, see Goldstein, *Visual Fact,* 1–4, 23–28, 177–91.

44. Teyssèdre, *Roger de Piles,* 587. It seems that de Piles adapted ideas from Dufresnoy's manuscript "Observations sur la Peinture et ceux que l'ont pratiquée" (B.N. supp. Fr. 4030) and added sections on Rubens and Van Dyck, publishing them as Dufresnoy's *Sentimens* with de Piles's French translation of Dufres-

noy's *De Arte Graphica.* In this way he borrowed Dufresnoy's authority for his own ideas.

45. Dufresnoy's *Sentimens* are translated in the Dryden edition of *De Arte Graphica* as "The Judgement of Charles Alphonse du Fresnoy on the works of the Principal and Best Painters of the Last Two Ages." This passage is on 224.

46. Dufresnoy (de Piles trans.), *Sentimens,* 236–37.

CHAPTER 2

1. A good general account of the French Academy's organization and methods is in N. Pevsner, *Academies of Art, Past and Present,* Cambridge, 1940; repr. New York, 1973, 82–100. The seventeenth-century *conférences* of the Academy were published in the following sources: A. Félibien, *Conférences de l'Académie royale de peinture et de sculpture pendant l'année 1667,* Paris, 1668; these and others are included in H. Jouin, *Conférences de l'Académie royale,* Paris, 1883; A. Fontaine, *Conférences inédites de l'Académie de Peinture,* Paris, 1903. In his preface Fontaine gives a clear account of the establishment of regular *conférences* and their importance in the Academy curriculum. Many *conférences* are unpublished or lost. B. Teyssèdre, *Roger de Piles,* 544–68, gives a listing of all *conférences* between 1667 and 1709.

2. These precepts were collected into tables and published by the secretary of the Academy, H. Testelin, *Sentimens des plus habiles peintres du temps, sur la pratique de la Peinture,* Paris, 1699. These are also published in Jouin, *Conférences.*

3. Crow, *Painters,* 33.

4. See Cuzin et al., *Raphael et l'art français,* 89, 150–53.

5. Teyssèdre, *Roger de Piles,* 656ff. The *conférences* focusing on Raphael were C. Le Brun, *Saint Michael Slaying the Dragon,* 7 May 1667; N. Mignard, *Holy Family,* 3 September 1667; Philippe de Champagne, *Madonna and Child with Saint Elizabeth and Saint John,* 2 March 1669; Jean Nocret, *Madonna and Child with Saint John,* 6 April 1669.

6. For Vasari's views on Raphael, see Chapter 1. Dolce's ideas on Raphael are found in his dialogue *L'Aretino,* Venice, 1557. For the text, see M. Roskill, *Dolce's "Aretino" and Venetian Art Theory of the Cinquecento,* New York, 1968. Dolce accepted Vasari's picture of Raphael's catholic excellence in all aspects of painting, but raised him above Michelangelo, who only excelled in drawing; see Roskill, 160–81. For Lomazzo's views, see his *Trattato dell'Arte de la pittura,* Milan, 1584, and the *Idea del tempio della Pittura,* Milan, 1590. The first book of the *Trattato* was published in French in 1649. See Lomazzo, *Idea,* facsimile ed., Hildesheim, 1965, 7, 43, 132, 146–47. For a discussion of Lomazzo's treatises, see G. Ackerman, "Lomazzo's Treatise on Painting," *Art Bulletin* 49, 1967, 317–26.

7. Armenini's treatise could be seen as the forerun-

ner to the Academy's *préceptes positifs*. For a good summary of these developments in Italian art theory, see Barasch, *Theories of Art*, chap. 5.

8. For Bryson's ideas, see his *Word and Image*, chaps. 1 and 2. For Puttfarken's, see his *Roger de Piles' Theory of Art*, New Haven, 1985, chap. 1. For a useful discussion of the creation of the academic system, see Barasch, *Theories of Art*, 330–48.

9. N. Mignard, "La Sainte Famille par Raphael," in Jouin, 28–39. This was the large *Holy Family* executed for Francis I.

10. See Cuzin et al., *Raphael et l'art français*, 153.

11. C. Le Brun, "Les Israelites Recueillant la Manne dans le Desert par Nicolas Poussin," in Jouin, 48–65.

12. Philippe de Champagne, "Un Tableau de Raphael Representant l'Enfant-Jesus, La Vierge, Sainte Elizabeth et Saint Jean," in Fontaine, *Conférences inédites*, 90–96. This is on the smaller *Holy Family* in the king's collection; see Appendix I. See also *Raphael dans les collections françaises*, 104–6.

13. Testelin's discourses dealt with line (16 February 1675), expression (6 July 1675), proportions and composition (2 October and 5 November 1678; and 4 February 1679). See Teyssèdre, *Roger de Piles*, 662–64. The tables of precepts are reproduced in Jouin, 152, 179, 186, 192, 206. This passage is from Testelin, "L'Usage du Trait et du Dessin," in Jouin, 141–47.

14. Quoted in Jouin, 146. Here again the rule of *convenance* is stressed.

15. This was one of the Mays done for Notre-Dame de Paris. See P. M. Auzas, "Les grands Mays de Notre-Dame de Paris," *Gazette des Beaux-Arts*, ser. 6, vol. 36, 1949, 197–200. A catalogue raisonné for Le Sueur has been published by Alain Mérot, *Eustache Le Sueur, 1616–1655*, Paris, 1987. Mérot discusses many instances of the direct influence of Raphael's works on Le Sueur. See Mérot, 237–41, for his discussion of the *Saint Paul*.

16. D. Posner, "Charles Le Brun's *Triumphs of Alexander*," *Art Bulletin* 41, 1959, 237–48, discusses the series.

17. See Cuzin et al., *Raphael et l'art français*, 269–304.

18. Bryson, *Tradition and Desire*, esp. the section on Ingres. On Poussin's use of Raphael, see Pope-Hennessey, 234–38.

19. Richard Shiff, "Representation, Copying, and the Technique of Originality," *New Literary History* 15, no. 2, Winter 1983–84, 333–63.

20. For a general history of the French Academy in Rome, see H. Lapauze, *Histoire de l'Académie de France à Rome*, 2 vols., Paris, 1924; J.-P. Alaux, *L'Académie de France à Rome*, 2 vols. Paris, 1933; and Pevsner, 98–100.

21. The best source for knowledge of the French Academy at Rome's practices is A. Montaiglon, ed., *Correspondance des Directeurs de l'Académie de France à Rome avec les Surintendants des Bâtiments*, 17 vols., Paris, 1887. Hereafter it will be referred to as *Correspondance*. This passage is 1:1.

22. See *Correspondance*, 1:2. See also Cuzin et al., *Raphael et l'art français*, 52–55.

23. The idol of the French Academy, Poussin had spent almost his entire career in Rome studying Raphael and antiquity. Dufresnoy and Mignard had studied the Carracci and Raphael in the 1630s and 1640s. Dufresnoy was in Rome from 1634 to 1653. See "Life of Dufresnoy," in Dufresnoy, *Art of Painting*, Mason ed. London, 1783. Le Brun had visited Rome and copied Raphael in 1645–47. On Le Sueur, see Mérot, 241–43. Charles de la Fosse had visited Rome in 1662, making a copy of the *Mass at Bolsena*.

24. On Louis de Boulogne, see P. Rosenberg, *The Age of Louis XV*, exh. cat., Toledo Museum of Art, 1975, 24–25.

25. P. Monier, *Histoire des Arts qui ont rapport au dessin*, Paris, 1699.

26. A note to Villacerf of 27 September 1691, with a list appended, confirms that the tapestries were complete at that date; *Correspondance*, 1:222–23. The note also discussed obtaining permission to copy the *Coronation of Charlemagne* and the *Oath of Leo III*.

27. The most comprehensive study of the conflict between the advocates of color and design is B. Teyssèdre, *Roger de Piles et les débats sur le coloris au siècle de Louis XIV* (1957), Paris, 1965. Although Teyssèdre utilizes a vast amount of documentation from the period, he errs by interpreting every artistic idea solely in terms of color polemics. For a critique of Teyssèdre's ideas with which I agree, see C. Goldstein's review, "Reviews of B. Teyssèdre, *Roger de Piles et les débats sur le coloris*, and *L'histoire de l'art vue du Grand Siècle*," *Art Bulletin* 49, no. 3, 1967, 264–68. See also Puttfarken, chap. 1.

28. For a discussion of these *conférences*, see Teyssèdre, *Roger de Piles*, 151–74; and A. Fontaine, *Conférences inédites*, 4–6.

29. For an account of some of the further skirmishes between the advocates of colorism and those of design, see Fontaine, *Conférences inédites*, 7–47; Teyssèdre, *Roger de Piles*, 175ff.

30. The text and translation of Bellori's *Idea* is found in E. Panofsky, *Idea: A Concept in Art Theory*, Columbia, S.C., 1968 (a translation of the German edition, Leipzig, 1924), 154–74. All translated passages are from this source. For a summary of Bellori's theory, see Barasch, 315–22.

31. Panofsky, 105–9. For a useful summary of Bellori's ideas, see Barasch, 310–30.

32. Bellori, quoted in Panofsky, 155. The Italian reads: "Il perche li nobili Pittori e Scultori quel primo fabbro imitando si formano anch'essi nella mente un esempio de belleza superiore, e in esso riguadando emendano la natura senza colpa di colore e di lineamento."

33. Quoted in Panofsky, 157. The Italian (156) reads: "Cosi l'Idea constituisce il perfetto della bellezza naturale e unisce il vero al verisimile delle cose sottoposte all'achio, sempre aspirando all'ottimo ed al marauglioso, onde non solo emula, ma

superiore fasse alla natura, palesondoci l'opere sue elegante e complete, quali essa non e solita dimostrarci perfetti in ogni parti."

34. See Barasch, 125ff.

35. Panofsky, 156–59, 161. The Italian (160) reads: "Per dipingere una bella mi bisognerebbe vedire piu belle, ma per essere carestia di belle donne, io mi seruo di una certa Idea, che mi biene in mente."

36. Panofsky, 171.

37. Bellori, G. P., *Le Vite de pittori, scultori, e architetti moderni* (Rome, 1672); ed. G. Einandi, Turin, 1976. For a useful discussion of Bellori's art theory as it related to Baroque artistic practice, see Carl Goldstein, *Visual Fact over Verbal Fiction,* Cambridge, 1988, 30–32.

38. Barasch, 315–30.

39. See K. Donohue, "The Ingenious Bellori—A Bibliographical Study." *Marsyas* 3, 1946, 107–38. On the French connections with and knowledge of Bellori's ideas, see Pace, 18–19, 31ff.; on Roger de Piles's familiarity with Bellori, see the preface to his *Abrégé* of 1699.

40. Bellori, quoted in Panofsky, 175. The Italian (172–74) reads: "All'Hora la Pittura venne in grandissima ammiratione de gli huomini e parue discesa dal Cielo, quando il divino Rafaelle con gli ultimi lineamenti dell'arte acrebbe al sommo la sua bellezza, riponendola nell'antica maesta di tutte quelle gratie e di que' pregi arricchita, che gia un tempo la resero gloriosissima appresso de' Grece e de' Romani."

41. Bellori, *Studies,* quoted in Goldstein, 25.

42. Poussin, *Lettres et propos sur l'art,* Blunt ed., Paris, 1964, 167–74, gives Poussin's aphorisms on art. All quotes from Bellori's *Life of Poussin* are from the French translation by P. Caillier, *Vie de Nicolas Poussin,* Geneva, 1947. For the Italian, see the Einanadi edition of Bellori's *Vite,* 421–81 (in the original, 407–62).

43. Bellori, quoted in Poussin, *Lettres et Propos,* Blunt ed., 180.

44. Cited in Poussin, *Lettres,* Blunt ed., 181. The Italian is from Bellori, *Vite,* 323 (309).

45. See Poussin, *Lettres,* Blunt ed., 167–74.

46. Poussin, *Lettres,* Blunt ed.; see sections entitled "De l'exemple des bons maîtres," and "De la Nouveauté."

47. Poussin, *Lettres,* Blunt ed., 169. "La peinture n'est rien autre que l'imitation des actions humaines.... L'art n'est pas chose diverse de la nature, ni ne peut passer outré les confins de celle-ci."

48. Poussin, *Lettres,* Blunt ed., 170. "Des limites du dessin et de la Couleur."

49. G. P. Bellori, *Descrizione delle imagini dipinte da Rafaelle d'Urbino* (Rome, 1695), facsimile ed., Gregg International Publishing, Farnsborough, 1968.

50. The correspondence between Bellori, his heirs, and the Abbot Claude Nicaise is published in the *Archives de l'Art Français,* 1:24–38.

51. Bellori, *Descrizioni,* 86–100.

52. Roger de Piles, *Abrégé de la vie des peintres,* Paris, 1699, 172–73.

CHAPTER 3

1. The most important studies of Roger de Piles's role in French art theory and practice are Leon Mirot, *Roger de Piles: Peintre, amateur, critique, membre de l'Académie de Peinture, 1635–1709,* Paris, 1924; and Bernard Teyssèdre, *Roger de Piles et les débats sur le coloris au siècle de Louis XIV,* Paris, 1965. At the time of my original study ("Raphael in French Art Theory," 1979), Teyssèdre's study was the most in-depth to date covering most of de Piles's major ideas. Specific debts and points of disagreement are given below. Roger de Piles's bibliography is given in Teyssèdre, *Roger de Piles,* 638–50. Recently, T. Puttfarken, *Roger de Piles' Theory of Art,* New Haven, 1985, has provided some interesting insights into the unique perspective of de Piles. In particular, Puttfarken has stressed de Piles's desire to supplant the aesthetic of the Academy, which was based on literary theory, with a more purely visual aesthetic. I feel that he draws this dichotomy too absolutely and removes the development of de Piles's theory from its historical context. For a critique of Puttfarken's approach, see Sheriff, 47–50. J. Lichtenstein also stresses de Piles's originality.

2. For a list of works attributed to Raphael in the king's collection, see Appendix I. For comprehensive information on works attributed to Raphael in France, see *Raphael dans les collections françaises,* Grand Palais, Paris, November 1983–February 1984.

3. The theoretical shifts that occurred during this period are discussed by A. Fontaine, *Les doctrines d'art en France, de Poussin à Diderot,* Paris, 1909. The best general study of this transitional period is P. Marcel, *Le Peinture française au début de XVIIIe siècle, 1690–1721,* Paris, 1906.

4. Teyssèdre, *Roger de Piles,* has argued the polemical nature of all de Piles's actions and ideas. J. Steegman, "The 'Balance des Peintres' of Roger de Piles," *Art Quarterly* 17, no. 3, 1954, 255–61, treats Roger de Piles's ideas as simply characteristic of his time. For a more balanced view of Roger de Piles's mixture of tradition and innovation, see J. H. Rubin, "Roger de Piles and Antiquity," *Journal of Aesthetics and Art Criticism* 34, no. 2, Winter 1975, 157–163. See also C. Goldstein's review of Teyssèdre in *Art Bulletin* 49, no. 3, 1967, 264–68. Puttfarken sees de Piles's role as fundamentally altering the terms of discourse relating to painting to deal with its essential visual nature. I feel that Puttfarken characterizes the art theory of the seventeenth-century Academy too narrowly as entirely literary. He thus exaggerates de Piles's break with that theory.

5. From its inception the French Academy made provision for contributions by amateurs, many of whom even delivered lectures to the assembled body. When Roger de Piles was made an *associé libre* in 1699, he joined a list of influential amateurs that would include Mariette, Abbé Dubos, and the marquis d'Argens. On the role of the amateur in France see R. Saisselin, "Amateurs, Connoisseurs and Painters," *Art Quarterly* 27, no. 4, 1964, 429–37.

6. See Thomas Crow, "La critique des Lumières dans l'art du dix-huitième siècle," *Revue de l'art* 73, May 1986, 9–16.

7. The most complete study of the conflict is found in Teyssèdre, *Roger de Piles,* particularly 151–74; See also A. Fontaine, *Conférences inédites,* 4–6. In a *conférence* of 9 January 1672, Le Brun attempted to close the issue by declaring that color was not so essential to painting as design (quoted in Teyssèdre, *Roger de Piles,* 178). This idea is clearly articulated in Roger de Piles, *Dialogue sur le coloris,* Paris, 1673; the edition used here is 1699, 22–26. His other treatises included *Conversations sur la connaissance de la peinture,* Paris, 1677; *Dissertation sur les ouvrages des plus fameux peintres,* Paris, 1681. *Abrégé de la vie des peintres,* Paris, 1699: and *Cours de peinture par principes,* Paris, 1708.

8. Until de Piles, none of the major seventeenth-century French theorists including Fréart de Chambray, Bosse, or Félibien mention Rubens as exemplary; nor is Rubens's work the subject of any of the *conférences* in the Academy. Before 1671 and the battle of the partisans of color and design, relatively little attention was paid to the Medici cycle, Rubens's most important work in France. For the rise of Rubenism in France see *Rubenism,* exh. cat., Brown University and Rhode Island School of Design, Providence, R.I., 1975. Félibien summed up Rubens's faults in his *Entretiens,* part 4, VII, 426ff.

9. The "Balance des Peintres" was appended to Roger de Piles's *Cours* (1708). Although it has received quite a bit of attention in the scholarly literature, no one has attempted to explain it in terms of de Piles's art theory or to use it as a key to his particular brand of eclecticism. Anthony Blunt, "Legend," 14, makes no effort to explain de Piles's rating of Raphael, seeing his respect for Raphael as formal or ambiguous. Steegman (257), simply dismisses de Piles's admiration of Raphael as characteristic of his time, ignoring the ideological conflict in which de Piles played a major role. Jakob Rosenberg, *On Quality in Art,* Princeton, N.J., 1967, discusses the "Balance" at length but never comes to grips with the equal valuation of Raphael and Rubens. B. Teyssèdre, *L'Histoire de l'art vue du Grand Siècle,* Paris, 1964, analyzes the "Balance" at length but never relates de Piles's valuation of the art of Raphael to the theorist's artistic ideal. Surprisingly, although Puttfarken devotes an entire book to de Piles's theory, he never discusses the "Balance," except to dismiss it as "notorious" (47). Bryson, *Word and Image,* 59–60, sees the "Balance" as an attempt to raise the importance of color in the academic hierarchy, by effectively downgrading the importance of expression. For a more positive view of the *Balance,* see Andrew McClellan, *Inventing the Louvre: Art, Politics, and the Origins of the Modern Museum in 18th Century Paris,* Cambridge, 1994, 33–35.

10. This is the central argument of Puttfarken's book. See especially chaps. 1 and 2. Bryson has seen de Piles's advocacy of Rubens as a mere stratagem in the main theoretical struggle he sees as involving the "recomposition of the sign, redefinition of the relation of the image to the world and the text" (*Word and Image,* 61–63). Bryson's assertions remove de Piles from his historical role as connoisseur and critic and passionate advocate on behalf of the art of Rubens, turning him into a pure theoretician. J. Lichtenstein draws connections between de Piles's view of painting and Ciceronian oratory. See J. Lichtenstein, chap. 6.

11. The *Dialogue* focuses on proving that color is as essential as design to painting. The *Cours* attempts to give a coherent approach to painting that embodies that view. Throughout these works, Rubens is seen as exemplary, but not perfect.

12. See De Piles, *Dissertation,* 33–56. He even went so far as to claim that it was excusable that Rubens had not directly emulated antiquity, since he had drawn his perfections from nature just as they had in antiquity. Teyssèdre, *Roger de Piles,* 219ff., notes the more stridently *Rubéniste* tone of the *Dissertation* but sees it as part of de Piles's unified strategy to promote color and Rubens. I feel the desire to promote Rubens at all costs causes de Piles to distort his theory and to disparage Raphael as he does in no other treatise.

13. Roger de Piles, *Abrégé,* 38. The French reads: "On ne séroit donc attaché jusques-là qu'à ce qui depend de l'invention et du Dessein. Et quoy que Raphael ait inventé très ingénieusement, ou il ait dessiné d'une Correction et d'une Elégance achevée, qu'il ait exprimé les passions de l'ame avec une force et une grace infinie, qu'il ait traité ses sujets avec toute la convenance et toute la noblesse possible, et qu'aucun Peintre ne luy ait disputé l'avantage de la primauté dans les grands nombres des parties qu'il a possédées; il est constant neanmoins qu'il n'a pas pénétré dans le Coloris assez avant pour rendre les objets bien vrais et bien sensibles, ni pour donner l'Idée d'une parfaite imitation."

14. On the importance of colorism to the total effect, see Puttfarken, II and IV.

15. On Raphael's grace, see de Piles, *Abrégé,* 180–81. The quote is from *Conversations,* 40–42. On de Piles's view of antiquity, see J. H. Rubin, "Roger de Piles and Antiquity."

16. *Abrégé,* 24. The statement may well be apocryphal. De Piles gives no source for the remark, and may simply be using it to attack Poussin for a too-slavish attachment to antiquity.

17. Teyssèdre, *Roger de Piles,* 195, quotes this passage but sees it primarily as an attack on Poussin. I feel this reinterpretation of Raphael formed one of the bases of de Piles's broadened eclecticism.

18. In 1672, the duc de Richelieu had lost his painting collection, including fifteen Poussins and Carraccis, to the king in a wager. Since these works were virtually irreplaceable, he bought Rubens's works instead. Roger de Piles advised him on the choice of pictures and wrote the catalog, which appeared in 1676. The opening of this collection to the interested public was an important step in the popularization of Rubens in France. See Goldstein, review of Teyssèdre, 265. For de Piles's advocacy of

Rubens to the duke, see Teyssèdre, *Roger de Piles,* 320–21 n. 5.

19. De Piles, *Conversations* (second), 252–53, 257–58. The French reads: "qu'avec une hardie, but sage et sçavante exagération de ce caractere il a rendu la Peinture plus vivante et plus naturelle, pour ainsi dire, que le Naturel mesme."

20. For the French view of Michelangelo at the end of the seventeenth century, see J. Thuillier, "Polémiques autour de Michelange au XVIIIe siècle," *Dix-septième siècle* 13, nos. 36–37, 1957, 353–69. Fréart de Chambray had strongly criticized Michelangelo's exaggerations in his *Idée de la perfection de la peinture,* 65–66. For criticism of Titian and the Venetians, see Chapter 1 for Bosse's opinion.

21. *Dissertation,* 50–51. De Piles's category of "esprit du contour" refers to the energetic quality of Rubens's design which de Piles clearly values more highly than strict adherence to the antique ideal.

22. *Dissertation,* 33. De Piles's sense of the primacy of color would certainly have been enhanced by his trip to Venice in 1682. See Teyssèdre, *Roger de Piles,* 342f.

23. One sees de Piles's influence particularly on Antoine Coypel, *premier peintre* under Louis XV, *recteur* of the Academy, and one of the most influential artists in France in the first half of the eighteenth century. His *Epistre à mon fils* (Paris, 1708), echoes de Piles's eclectic approach very closely although he does not mention Rubens. A more eclectic approach can also be seen in the program of study of the French Academy at Rome in the first half of the eighteenth century. This eclectic approach is particularly evident under N. Wleughels, director from 1725 to 1737, who had students copy the art of Raphael, Titian, Veronese, the Carracci, and others. For Wleughels's practices, see A. Montaiglon, *Correspondance des Directeurs de l'Académie,* vols. 7, 8, and 9.

24. De Piles's liberal eclecticism is most strongly stated in his *Cours;* he declares, "I love Raphael, I love Titian, and I love Rubens" (27). For his praise of Rembrandt, see *Cours,* 10–11.

25. This was from de Piles's lecture on *invention* published in the *Cours,* 75ff. Teyssèdre, *Roger de Piles,* has pointed out that de Piles's description of the *School of Athens* is taken from Bellori (229 n. 1).

26. *Cours,* 32. See Teyssèdre, *Roger de Piles,* 521–23. Puttfarken (48–51) sees this entire discussion of the *vrai parfait* as an attempt to dispose of the classical ideal. If this were correct, why would de Piles include the *vrai idéal* as an essential component of the *vrai parfait?* Once again, I feel Puttfarken exaggerates the degree to which de Piles entirely abandoned the French classical ideal.

27. There has been no in-depth study of the extent or form of the survival of the classical ideal in the first half of the eighteenth century. The best general study of the period is Pierre Marcel, *Le Peinture française au début de XVIIIe siècle, 1690–1721.* The seminal study by J. Locquin, *Le Peinture d'histoire en France de 1747 à 1785,* Paris, 1912, begins with the year traditionally associated with the revival of classicism in France. As Pierre Rosenberg has pointed out in his exhibition catalog *The Age of Louis XV: French Painting, 1710–74* (Toledo Museum of Art, Ohio, 1975), 3–16, scholars are only beginning to appreciate the diversity of this period, which was not totally dominated by Rococo ideals as is sometimes assumed. On this topic see P. Conisbee, *Painting in Eighteenth-Century France,* Ithaca, N.Y., 1981; and D. Rosenthal, *La Grande Manière: Historical and Religious Painting in France, 1700–1800,* exh. cat., Memorial Art Gallery of the University of Rochester, Rochester, N.Y., 1987. On the survival of the Raphaelesque ideal in early eighteenth-century France, (in which de Piles was pivotal), see Chapters 4 and 5. On de Piles's impact on eighteenth-century French art theory, see Puttfarken, VI. Puttfarken underestimates de Piles's lasting impact in France.

28. Bryson argues that de Piles's central role lay in redefining the value of painting from an emphasis on the discursive to a new emphasis on the figural. This prepared the way for Watteau and the Rococo (*Word and Image,* 63). Yet, a transformed classical ideal survived de Piles's dramatic impact on the conception of painting in France.

PART TWO

1. For discussions of the changing artistic climate in France at the end of the seventeenth century, see A. Blunt, *Art and Architecture in France 1500–1700* (1953), 2d ed., Harmondsworth, 1970, 234–43; Schnapper, *Tableaux,* 15ff., Fontaine, *Les Doctrines d'art,* 143–54. Recently, Bryson has interpreted the primary shift as from a discursive to a figural conception of painting (*Word and Image,* chaps. 1 and 2).

2. Blunt, *Art and Architecture,* 218–22, sketches the historical conditions. The effect of prevailing economic conditions on the Academy is discussed by Pevsner, 104; Alaux, 53–66.

3. See Katie Scott, "D'un Siècle à l'Autre," in Colin Bailey, *Loves of the Gods,* 32–59.

4. Although the Medici Cycle had been available to artists for many years, it was largely ignored until ideas about Rubens changed, under the aegis of de Piles and others. Public access to the duc de Riche-lieu's Rubens collection with the catalog written by de Piles certainly helped to increase the artist's popularity. For discussions of Rubenism, see A. Blunt, *Art and Architecture,* 221, 234–35; and the exhibition catalog *Rubenism,* Brown University and Rhode Island School of Design, Providence, R.I., 1975.

5. The style of these artists is discussed in L. Dimier, *Peintres français du XVIIIe siècle,* vol. 1, Paris, 1928; see also P. Rosenberg, *The Age of Louis XV;* and C. Goldstein, "Observations on the Role of Rome in the Formation of the French Rococo," *Art Quarterly* 33, Autumn 1970, 227–45. For Jouvenet, see Schnapper, *Jean Jouvenet,* Paris, 1974.

CHAPTER 4

1. A similar blend of classicism and eclecticism was expounded in treatises by painter Pierre Monier, *Histoire des Arts qui ont raport au dessin,* Paris, 1699; and the amateur B. Dupuy du Grez, *Traité sur la peinture pour en apprendre la théorie et se perfectionner dans la pratique,* Toulouse, 1699, 109ff. Antoine Coypel's importance is discussed by L. Dimier, *Les Peintres français du XVIIIe siècle,* Paris, 1928, 1:93–155. The first modern monograph on the artist has recently been published by Nicole Garnier, *Antoine Coypel (1661–1722),* Paris, 1989.

2. A. Coypel, *Epistre à mon fils, sur la Peinture,* was read to the Academy on 1 January 1708 and published that same year. The verses must have been completed by 1697, since he showed them to de Piles on Roger's return from prison; see Teyssèdre, *Roger de Piles,* 583. The *Epistre* is reproduced in Jouin, 230–33. Coypel began to read the commentary on his *Epistre* on 7 May 1712. On 7 December 1720, after all parts had been read at Academy *conférences* the text was published as *Discours,* Paris, 1721. For a summary of these *conférences,* see A. Montaiglon, ed., *Procès-Verbaux de l'Académie de Peinture et Sculpture 1648–1797,* 10 vols., Paris, 1875, esp. 4:146–307. For a useful discussion of Antoine Coypel as an art theorist, see Garnier, 65ff.

3. Garnier's study of Coypel supports my view of Coypel as an eclectic, who helped to preserve the classical aesthetic of the late seventeenth century by adapting it to new tendencies; see Garnier, 87f. For another example of Coypel's eclecticism, see the discussion of his *Bacchus and Ariadne* (1693; Philadelphia Museum of Art) in Bailey, *Loves of the Gods,* 144–49. The other *conférences* were devoted to the history of the Academy and its members and to rereading of earlier lectures. See Montaiglon, ed., *Procès-Verbaux,* vol. 4 (1705–25) and vol. 5 (1726–44). For a discussion of the importance of the Crozat circle, see T. Crow, *Painters and Public Life,* 39–44. As *recteur* of the Academy and *premier peintre* to the king, Antoine Coypel was in a position of prominence similar to Reynolds. Like Reynolds, he stated generally accepted truths in a clear, forceful way. Reynolds is discussed in Chapter 9.

4. A. Coypel, *Epistre* in Jouin, 232, lines 87–100. The French reads: "Découvre à la fois les plus rares trésors; Justesse de contours, proportions des corps, Le dessin élégant de l'antique sculpture, Joint aux effets naïfs qui fournit la nature; Un choix pur et savant, de simples agrémens; Un grand goût de draper, . . . Un génie à la fois sublime et profond. . . . Sage sans être froid, et simple sans bassesse, Grand sans paroitre outré, toujours pleins de noblesse, Profond sans être obscur, agréable sans fard, La raison y paroit souveraine de l'art."

5. On Coypel's *Moses,* see A. Schnapper, "The *Moses* of Antoine Coypel," *Bulletin of the Allen*

Memorial Art Museum (Oberlin College), 37, no. 2, 1979–80, 58–70.

6. Coypel's *Discours* is reproduced in Jouin, 234ff. This passage is 243.

7. The French reads: "Il semble qu'il ait voulu donner l'âme à ces admirables statues des anciens Grecs qui sont et seront toujours les règles de la plus parfaite beauté."

8. See W. Kalnein and M. Levey, *Art and Architecture of the Eighteenth Century in France,* Harmondsworth, 1972, 29. He suggests that many painters active in the 1720s were "overshadowed by the example of the past and unable to form a fresh style." This claim was strongly disputed by Schnapper, *Tableaux,* 15ff., and P. Rosenberg, *The Age of Louis XV.* See also P. Conisbee, *Painting in Eighteenth-Century France,* Ithaca, N.Y., 1981. For discussions of some of the myriad influences on Coypel's works, see the catalog entries in Garnier, 89ff.

9. P. Rosenberg, *The Age of Louis XV,* 29–30;

10. On this stylistic shift, see A. Schnapper, *Au temps du Roi Soleil: Les Peintres de Louis XIV (1660–1715),* exh. cat., Lille 1968; A. Blunt, *Art and Architecture.*

11. The only period from 1670 to 1750 when Raphael was not being copied by students in Rome was under the directorate of Poerson, at the nadir of the Roman Academy. See discussion in this chapter.

12. On Roman painting in the eighteenth century, see Art Institute of Chicago, *Painting in Italy in the Eighteenth Century: Rococo to Revolution,* 1970, and other publications by Anthony M. Clark on individual Roman painters, including "Imperiali," *Burlington Magazine* 106, May 1964, 226–33; On the aesthetic of the Accademia di San Luca, see Barasch, 315–30.

13. *Correspondance,* 1:223. See also the letter from Mignard to Villacerf in *Correspondance,* 1:vi, 223–26.

14. Alaux, 61ff., details the decline of the Roman Academy.

15. *Correspondance,* 3: letter 1201. For the correspondance of Poerson, see vols. 3 and 4.

16. *Correspondance,* 7:67. See also Alaux, 80ff.

17. The best study of Wleughels's paintings is by B. Hercenberg, *Nicholas Vleughels: Peintre et Directeur d'Académie de France à Rome,* 1688–1737, Paris, 1975, parts 4–10.

18. For a discussion of De Troy's directorate, see Alaux, 120ff.

19. Levey, 3–34. See also Brown University and Rhode Island School of Design, *Rubenism.* Boucher had supposedly once told a fellow painter that "despite Raphael's reputation, he was a pretty mediocre painter" (quoted in A. Dresdner *Die Kunstkritik: Ihre Geschichte und Theorie,* Munich, 1915, 145f.

20. See Bailey, *Loves of the Gods,* 297, figs. 1 and 5.

21. See P. Rosenberg, *The Age of Louis XV,* 4–16 and Conisbee, *Painting,* for a broader view. There is no modern, comprehensive study of history painting in the first half of the eighteenth century. Conisbee and Rosenthal have made important recent contributions to this topic. In many cases, the most up-to-date

scholarship on these artists is L. Dimier's 1928 study, *Les Peintres français,* vol. 1. For bibliography, see P. Rosenberg, 87–94. For Restout, see P. Rosenberg and A. Schnapper, *Jean Restout (1692–1768),* Rouen, 1970.

22. Bailey, 284–91. The Coypel is catalog entry 30.

23. See Cuzin et al., 141.

24. On Bouchardon, see Levey, 55–63.

25. See Cuzin et al., 80. Fifty-five of Bouchardon's drawings after Raphael are preserved in the Louvre's Cabinet des Dessins.

26. For good summaries of history and religious painting in the period, see Conisbee, chaps. 2 and 3. Also see Rosenthal, *La Grande Manière.*

27. Conisbee, 45–46.

28. Rosenberg and Schnapper, *Restout,* fig. 81, p. 176. Similar comments could be made about Restout's *Christ Healing the Paralytic* (1725; Museé d'Arras).

29. See Rosenberg, *The Age of Louis XV,* 52–53, fig. 18. On Le Clerc, see A. Schnapper, "A la recherche de Sébastien II Leclerc, 1676–1763," *Revue du Louvre et des Musées de France* 23, 1973, 241–48.

30. P. Rosenberg, *Age of Louis XV,* 38–39.

31. For instance, the Academy library contained a drawing book by Mme Chéron-le-Hay, *Livre de principes à dessiner,* Paris, 1706, which was illustrated by details from Raphael's works. See E. Müntz, *La Bibliothèque de l'Ecole des Beaux-Arts avant la Révolution,* Nogent-le-Rotron, 1897, 12. As mentioned above, Nicolas Dorigny had published a volume containing ninety details from the cartoons in 1719.

CHAPTER 5

1. Like de Piles, Richardson wished to establish new standards of taste for his contemporaries. His importance in English art theory and criticism is considered by Lipking, *Ordering,* 109–26. For a recent study of his importance, see Carol Gibson-Wood, "Jonathan Richardson and the Rationalization of Sight," *Art History* 7, March 1984, 38–56.

2. All quotations from The *Theory of Painting and Essay on the Art of Criticism* are from J. Richardson, *The Works of Jonathan Richardson* (1773), London, 1792. All quotes from *An Account* (1722) are taken from the French edition: J. Richardson, père et fils, *Traité de la peinture et de la sculpture,* 3 vols., Amsterdam, 1728.

3. Lipking, *Ordering,* 113 n. 15. Richardson gave a list of some of his sources, particularly *Lives,* in *Works,* 207.

4. *Traité,* 196. Many of Richardson's criticisms of Raphael's *Galatea* were echoed by Winckelmann later in the century. See Chapter 7.

5. *Traité,* 324–440. His statement of the superiority of the cartoons is on 440.

6. This concept is very close to Winckelmann's

idea of *edle Einfalt und stille Grosse* (noble simplicity and tranquil grandeur). See Chapter 8.

7. See Francis Haskell, *The Painful Birth of the Art Book,* London, 1987, 17ff.

8. Crow, *Painters,* 39–41. On the contents of the collection, see M. Stuffmann, "Les tableaux de la collection de Pierre Crozat," *Gazette des Beaux-Arts* 72, 1968, 1–144. For the works attributed to Raphael, see Stuffmann, 62–64.

9. Haskell, 17–55, esp. 26ff., on the importance of the engravings after Raphael.

10. See Barbara Scott, "Pierre Crozat: A Maecenas of the Régence," *Apollo* 97, January 1973, 11–19.

11. For the collection of the Palais Royale, see Dubois de Saint-Gelais, *Description des tableaux du Palais-Royale avec la vie des peintres,* Paris, 1727.

12. Abbé Dubos, *Réflexions critiques sur la poésie et sur la peinture,* 3 vols., Paris, 1719. For a summary of his ideas, see Fontaine, 199ff. See also Becq, *Genèse,* 1:243–69 for a more detailed examination of Dubos's role in the development of eighteenth-century French aesthetics.

13. E. Müntz, *La Bibliothèque de l'école des Beaux-Arts,* 14.

14. See Puttfarken, chap. 6, 124ff.

15. Abbé Dubos, *Réflexions,* 1:419.

16. Diderot is discussed in Chapter 6. The concept of *ut pictura poesis* is studied by R. Lee, "Ut Pictura Poesis: The Humanistic Theory of Painting," *Art Bulletin* 22, 1940, 197–269. As Puttfarken has recently pointed out, Dubos reversed some of de Piles's most cherished values. See Puttfarken, 125–31.

17. See D. Wildenstein, ed., *Notes Manuscrits de P. J. Mariette,* (facsimile of MS. in Bibliothèque Nationale), 2 vols., Paris, n.d., introduction ix–xix.

18. See R. G. Saisselin, "Amateurs, Connoisseurs and Painters," *Art Quarterly* 27, no. 4, 1964, 433.

19. P. J. Mariette, *Abécédario, et autres notes inédites de cet amateur sur les arts et les artistes* (1740–70) 6 vols., Paris, 1857–58, especially 4:259–338 on Raphael. For a discussion of his taste, see R. Bacou, *Dessins français du XVIIIe siècle: Amis et contemporains de P. J. Mariette,* exh. cat., Cabinet des dessins, Musée du Louvre, 1967; and *Le Cabinet d'un Grand Amateur, 1694–1774,* Musée du Louvre, Paris, 1967. In December 1750, Mariette was made an *associé libre* of the Academy.

20. P. J. Mariette, *Abécédario,* 4:262. His collection included several Raphael drawings. See "Comments on the Sale of the Collection of P. J. Mariette," *Nouvelles Archives de l'Art Français,* 1872, 365, and *Le Cabinet,* 92ff.

21. Mariette, *Abécédario,* 4:265ff. Engravings after virtually all of Raphael's major works were included. For a discussion of the collection, see Stuffmann, 1–44,

22. See Wildenstein, ed., *Notes manuscrits,* 1:71–98 for examples.

23. Marquis d'Argens, *Réflexions critiques sur les différentes écoles de peinture,* Paris, 1752. For a

summary of the marquis's aesthetic, see Becq, *Genése,* 1:295–98.

24. A.-J. Dézallier d'Argenville, *Abrégé de la vie des plus fameux peintres,* 2 vols. (1745); 2d ed., 4 vols., Paris, 1762. See Fontaine, *Les doctrines d'art,* 191–95.

25. Fontaine, *Les doctrines d'art,* 194.

PART THREE

1. J. Locquin, *La Peinture d'histoire en France de 1747 à 1785,* Paris, 1912; repr. 1978.

2. L. Courajod, *L'Ecole Royale des Elèves protégées, précédé d'une étude sur le caractère de l'enseignement de l'art français aux différentes époques de son histoire,* Paris, 1874, discusses the school and its importance in French artistic training.

3. On the Lenormand clan's use of the Academy for political purposes, see Crow, *Painters,* 110ff. See Bryson, *Word and Image,* chaps. 5–8; see also Fried's *Absorption and Theatricality.*

CHAPTER 6

1. Unlike most seventeenth-century *conférences,* those after 1747 have by and large not been published. Their content was briefly considered by Fontaine, *Conferences inédites,* 235–51. Most of them are listed in E. Müntz, *Catalogue des manuscrits de la Bibliothèque de l'École des Beaux-Arts,* Paris, 1895, 15–18. All quotes are taken from *Conférences Académiques* (MS. 1018, Bibliothèque d'Art et d'Archéologie, Université de Paris; a copy of MS. 203, Bibliothèque de l'École des Beaux-Arts [Müntz 183 bis I]).

2. Son of Antoine, and *premier peintre du Roi* after 1747. See P. Rosenberg, *The Age of Louis XV,* 30. The text of the discourse is in *Conférences académiques* (MS. 1018), vol. 1.

3. Claude-François Desportes, son of the nature painter, François Desportes. See Locquin, 13–14,94.

4. J. B. Massé was an engraver and custodian of the king's painting collection; Locquin, 30–31, 94 n. 3. His ideas are briefly summarized by Fontaine, *Les doctrines d'art,* 241ff.

5. *Conférences académiques,* 1:163. During the first half of the eighteenth century, Bouchardon was considered the artist who most closely emulated Raphael and antiquity in his correctness and simplicity of design; Locquin, 74. Cochin's statement on Bouchardon is in C. N. Cochin, *Memoires inédites sur le Comte de Caylus, Bouchardon, Slodtz, etc.,* ed. C. Henry, Paris, 1880, 85. Caylus designated Raphael's works as the sculptor's model in his *Life* of the artist read 4 September 1762. See Caylus, *Vies,* 81.

6. *Conférences académiques,* 1:201. The *conférence* on 8 November 1749 was entitled "Réflexions sur les Arts de peinture et de sculpture, et particulièrement sur la Nécessité de bien connoitre l'Antique et l'Anatomie."

7. The history painter, Louis Galloche, pupil of Louis de Boullonge, gave four lectures at the Academy between 1750 and 1753. See P. Rosenberg, *The Age of Louis XV,* 40–41. Their content is summarized in Jouin, 404–7. This *conférence,* "Sur le Dessin," was on 6 June 1750.

8. For the *Coriolanus,* see Locquin, pl. 3. See also Bailey, *Loves of the Gods,* 172–75 for a discussion of Galloche's painting and teaching.

9. Comte de Caylus was certainly the most influential amateur of his time. Since the founding of the Academy, such men had been invited to lend their time, energy, and funds and to express their ideas in the Academy. See S. Rocheblave, *Essai sur le Comte de Caylus,* Paris, 1889; Cochin, *Mémoires d'artistes du XVIIIe siècle: Discours sur la peinture et la sculpture: Salons 1751 & 1753),* ed. A. Fontaine, Paris, 1910.

10. Locquin discusses the comte de Caylus's role in the Academy, 8, 80, 92–95. For Hulst's statement, see Comte de Caylus, *Vies,* introduction by Fontaine, xxxi. For a recent examination of Caylus's importance, see Francis Haskell, *History and Its Images: Art and the Interpretation of the Past,* New Haven and London, 1993, 180–86.

11. The discourses are published in Comte de Caylus, *Vies,* 119–94.

12. See Crow, *Painters,* 126ff. on the ascension of Cochin. C. N. Cochin was Marigny's close assistant, having accompanied him to Italy in 1749. He was also *graveur du Roi* and secretary of the Academy. He published his comments on his Grand Tour in his *Voyage d'Italie,* Paris, 1758. His importance is also discussed in Locquin, 20–40. On Cochin's role in the ancien regime, see Richard Wrigley, *The Origins of French Art Criticism from the Ancien Regime to the Restoration,* Oxford, 1993, esp. 150–52.

13. Crow, *Painters,* 127, stresses Cochin's role in opposing the authority of Raphael and Poussin, in effect, undercutting the entire effort of academic reform.

14. See Chapter 4, note 31.

15. L. Hautecoeur, *Rome et la renaissance de l'antiquité à la fin du XVIIIe siècle,* Paris, 1912, 22. I have been unable to find a copy of this work by the pensionnaires.

16. This was an enlarged second edition of his *Nouvelle méthode pour apprendre à dessiner sans maître,* Paris, 1740. It contained thirteen plates after Raphael, primarily details consisting of hands, with some hands and feet.

17. Locquin, 100. François-Guillaume Ménageot was director of the French Academy in Rome from 1787 to 1793. For copying of Domenichino, see Caylus, *Correspondance,* 11:380; 15:131, 141.

18. See Locquin. Recently, Thomas Crow has questioned the effectiveness of these measures in reviving history painting (*Painters,* chaps. 4–6).

19. Collin de Vermont (1693–1761) was one of the last pupils of Jouvenet. See Locquin, 175–76.

20. See Chapter 4, note 19.

21. Carle Van Loo (1705–65) was considered the "chef de l'école française" in the middle of the eighteenth century. Locquin also noted the Raphaelesque character of this work (180–83); see also P. Rosenberg, *The Age of Louis XV,* 76–77. Van Loo became director of the Ecole Royale des élèves protégés in 1749, and *premier peintre du Roi* in 1762. Fried has singled out Van Loo to support his thesis of the primacy of absorption in mid-eighteenth-century aesthetics. However, one could argue that this is simply one aspect of Van Loo's acknowledged gift for expression; see Fried, 17–27.

22. Jean Restout (1692–1768), nephew of Jouvenet, had a very long and successful career, primarily as a religious painter. The major study of his work is the 1970 exhibition catalog by Rosenberg and Schapper, *Jean Restout;* also Rosenberg, *Age of Louis XV,* 65–66.

23. For the Dumont le Romain, see Locquin, pl. 66.

24. The Amand is in Locquin, pl. 93. The best overall study of the survival of history painting in the eighteenth century is D. Rosenthal, *La Grande Manière: Historical and Religious Painting in France, 1700–1800,* exh. cat., Memorial Art Gallery of the University of Rochester, Rochester, N.Y., 1987.

25. On the opening of the Luxembourg gallery, see Andrew McClellan, "The Politics and Aesthetics of Display: Museums in Paris, 1750–1800," *Art History* 7, no. 4, December 1984, 438–64. See also McClellan, *Inventing the Louvre,* chap. 1.

26. The beginnings of Salon criticism are discussed in Fontaine, *Les doctrines d'art,* 252–90. The early critics are listed by H. Zmijewska, "La Critique des Salons en France avant Diderot," *Gazette des Beaux-Arts,* ser. 6, 76, July–December, 1970, 1–143. For bibliography, also see A. de Montaiglon, *L'Essai de bibliographie des livrets et des critiques de Salons,* Paris, (n.d.); Much of the eighteenth-century Salon criticism is preserved in the *Collection Deloynes,* Cabinet des Estampes, Bibliothèque Nationale, Paris. This has been updated by Neil MacWilliam, *A Bibliography of Salon Criticism in Paris from the Ancien Regime to the Restoration, 1699–1827,* 2 vols., Cambridge, 1991. For a recent comprehensive study of French art criticism, see Richard Wrigley, *The Origins of French Art Criticism from the Ancien Regime to the Restoration,* Oxford, 1993.

27. Fontaine, *Les doctrines d'art,* 263ff. suggests that until Diderot, the primary merit of critics was to make the public used to free expression of judgments about art. Most of these "critics" looked at art in purely literary terms. More space was devoted to polemics and personal attacks than to art criticism. Few of these critics have been studied in any detail. In his recent book, Thomas Crow has attempted to recapture the public and political voice of these anonymous critics, seeing their ideas as a strong opposition to the doctrine of the Academy (*Painters,* chaps. 5–6).

28. La Font de Saint-Yenne, *Réflexions sur quelques causes de l'état présent de la peinture en France,* Paris, 1747, instituted regular Salon criticism. For numerous entries on La Font, see Wrigley, *Origins of French Art Criticism.*

29. The literature on Diderot as art critic is vast. The bibliography is collected by G. Paschoud and Ph. Junod, *Diderot, critique d'Art: Etude bibliographique,* Etudes de Lettres, Université de Lausanne, 1975, ser. 3, vol. 8. I have found the following works analyzing Diderot most useful: D. Funt, *Diderot and the Aesthetics of the Enlightenment,* Diderot Studies 10, ed. O. Fellows and D. Guiragossian, Geneva, 1968; M. Cartwright, *Diderot: Critique d'art et le problème de l'expression,* (Diderot Studies 13, ed. O. Fellows, Geneva, 1969; Diderot, *Salons,* ed. J. Seznec and J. Adhémar, 4 vols., Oxford, 1957–67; G. May, *Diderot et Baudelaire, Critiques d'Art,* Paris, 1957; G. Boas, "The Arts in the Encyclopédie," *Journal of Aesthetics and Art Criticism* 23, Fall 1964, 97ff.; Y. Belaval, *Esthétique de Diderot,* Paris, 1950; B. L. Tollemache, ed., *Diderot's Thoughts on Art and Style* (1893), repr. New York, 1971. See also *Diderot et l'Art de Boucher à David, Ses Salons 1759–1781,* exh. cat., Hôtel de la Monnaie, Paris, October 1984–January 1985; E. Bukdahl, *Diderot, Critique d'Art,* trans. J. Pilosz, 2 vols., Copenhagen, 1981–82. An important study that examines Diderot's ideas on the relationship between the work and the spectator is M. Fried, *Absorption and Theatricality.* See also Bryson, *Word and Image,* chaps. 6 and 7.

30. Diderot, *Salons,* ed. Seznec and Adhémar, reproduces critiques by contemporaries of Diderot under their entries in the *livrets.* See *Salons,* 1:7, for a list of some of these critics. Their remarks were generally highly subjective and arbitrary. For a descripton of Diderot's critical procedure, see Diderot, *Oeuvres esthétiques,* ed. P. Verniere ed., Paris, 1959, 790. For Diderot's critical procedure, see also Bukdahl, *Diderot, Critique,* vol. 1, chap. 2. For the relationship of Diderot's ideas to those of his contemporaries, see Bukdahl, *Diderot, Critique,* vol. 2. For a discussion of many aspects of Diderot's criticism, see Wrigley, *Origins of French Art Criticism.*

31. A list of Diderot's artist friends is found in May, 40. Diderot also read a great deal of art theory by Lomazzo, de Piles, Dubos, La Font de Saint-Yenne, Webb, Hagedorn, Winckelmann, Mengs, etc.

32. May traces the great influence Diderot had on Baudelaire, seeing Delacroix as an intermediary; see chap. 2. Of course, the *Correspondance littéraire* was written for a foreign audience. See Cartwright, *Diderot,* 100–103.

33. May, 61–90 discussed Diderot's philosophical and moral orientation.

34. *Salons,* 1:18–19; May, 46–50.

35. Diderot, *Essais sur le Peinture,* in *Oeuvres esthétiques,* 672ff.

36. Diderot, "Recherches Philosophique sur l'Origine et la Nature du Beau," in *Oeuvres esthétiques,* 418–20. See also Fried, chap. 2, esp. 76–92.

37. Diderot's emphasis on the organic quality of nature and art is discussed by Funt, 109–36. He also treats Diderot's notion of aesthetic judgment as an

active engagement with the total unity represented by the work of art. For an example of Diderot's "repainting" of a scene, see his criticisms of Doyen's *Le Miracle des Ardens* (1767), in *Salons*, 3:180ff. Bryson has discussed the relationship between word and image in Diderot's Salons at length (*Word and Image,* chap. 7).

38. For his discussion of Vien, see *Salons*, 3:74–89; for Doyen, see *Salons*, 3:178–91. Also see Fried, 115–18. In general, Diderot praised Vien for his simplicity and harmony and criticized him for his lack of poetry. Doyen was criticized for his lack of control. For Diderot's discussion of these paintings and others that he compared to Raphael's works, see Bukdahl, *Diderot, Critique,* vol. 1. For a different view by a contemporary critic, L.-P. Bachaumont, see his *Mémoires secrets,* 13:8–9, which contains letters on the Salon of 1767. Bachaumont much preferred Doyen's work to Vien's, which he found totally lacking in action.

CHAPTER 7

1. The standard work on Winckelmann is still C. Justi, *Winckelmann und seine Zeitgenossen* (2d ed., 1898), 3 vols., Leipzig, 1956. A more recent biography is W. Leppmann, *Winckelmann,* New York, 1970. Other useful works are H. Hatfield, *Winckelmann and His German Critics,* New York, 1943; L. D. Ettlinger, "Winckelmann," in *The Age of Neoclassicism,* exh. cat., Arts Council of Great Britain, 1972, xxx–xxxiv, René Wellek, *A History of Modern Criticism, 1750–1950,* 4 vols., New Haven, 1955–65 (see 1:149ff.); D. Irwin, *Winckelmann: Writings on Art,* London, 1972. Winckelmann's views on Raphael are considered by M. Ebhardt, *Die Deutung der Werke Raffaels in der deutschen Kunstliteratur von Klassizismus und Romantik,* Baden-Baden, 1972, 11–25. For an important recent study of Winckelmann's ideas in relation to the art of the late eighteenth century, see Régis Michel, *Le Beau Idéal,* exh. cat., Louvre, Cabinet des Dessins, Paris, 1989. On Winckelmann's place among eighteenth-century antiquarians, see Haskell, *History,* 218–24.

2. Hatfield provides a brief summary of Winckelmann's major ideas. For Goethe's tribute, see Ettlinger, xxxiv.

3. Hatfield, 7. J. Winckelmann, *Gedanken über die Nachahmung der Griechischen Werke in der Malerei und Bildhauerkunst,* Dresden, 1755. A long account of it was published in the *Journal étranger,* January 1756; *Geschichte der Kunst des Altertums,* Dresden, 1764. The first French translation, which was severely criticized by Winckelmann, was 1766; the second, by Huber, was 1781. See Locquin, 290–91.

4. Winckelmann, *Reflections on the Imitation of the Painting and Sculpture of the Greeks,* trans. H. Fuseli, London, 1765, 12. All translated quotes are from this edition.

5. Winckelmann's famous discussion of "edle Einfalt und stille Grosse" is in Winckelmann, *History of Ancient Art,* (1850), trans. G. H. Lodge, London, repr. 1968, vol. 2, book 5, chap. 3, 245ff.

6. Winckelmann, *History,* vol. 2, book 5, chap. 3, 256.

7. For bibliography, see Ettlinger and Justi.

8. Most of the major references to Raphael in the *Geschichte* have been considered above. Although Winckelmann considered Raphael inferior to the ancients, he still considered him exemplary, indeed praising Mengs as the "German Raphael"; Winckelmann, *History,* vol. 2, book 6, 297. See also, Michel, 47, 54–56.

9. See Chapter 8. Locquin discusses Winckelmann's impact on French art, 103–6, 146–55. See also Hautecoeur, *Rome et la renaissance,* 33–35. According to Hautecoeur Winckelmann's works were very important in France, but his ideal of beauty was not entirely accepted. His writings reinforced the developing neoclassicism; see 157–58. The most in-depth study of Winckelmann's reception in France is A. Potts, "Winckelmann's Interpretation of the History of Ancient Art in Its Eighteenth-Century Context," diss., Warburg Institute, London University, 1978. Some of Potts's key ideas are summarized in his "Winckelmann's Construction of History," *Art History* 5, no. 4, December 1982, 377–407.

10. See note 8 above. Winckelmann described Mengs as arising "like a phoenix new-born out of the ashes of the first Raphael to teach the world what beauty is contained in art."

11. Locquin, 103–6; Hautecoeur, *Rome et la renaissance,* 148ff. Works on Mengs include D. Honisch, *Anton Raphael Mengs und die Bildform des Frühklassizismus,* Recklinghausen, 1965; T. Pelzel, *Anton Raphael Mengs and Neoclassicism,* diss., Princeton University, 1968; New York, 1979. The *Parnassus* is a pastiche of Raphael's *Parnassus* and the *Apollo Belvedere,* with figures taken from the first volume of *Le Antichite de Ercolano.* See Waterhouse, "British Contributions to the Neoclassical Style," *Proceedings of the British Academy,* 15, 1954, 57–74. For a recent study of Mengs, see Steffi Roettgen, *Anton Raphael Mengs 1728–1779 and His British Patrons,* London, 1993.

12. A. R. Mengs, "Reflections in Beauty and Taste in Painting" in *The Works of Anton Raphael Mengs,* J. N. d'Azara ed., London, 1796, intro. (First edition in German, 1762; first French translation, H. Jansen, 1781).

13. On the copy of the *School of Athens,* see Leppmann, 151. See also Roettgen, *Anton Raphael Mengs,* 11–12. For other Raphaelesque works by Mengs, see Roettgen, Catalog nos. 19, 24, 25, 27, and 32.

14. Locquin, 293. Mengs's *Gedanken* (1762) were not published in France until 1781, unlike Winckelmann's works, which were almost immediately translated.

15. Mengs, "Reflections of Anton Raphael Mengs upon the Three Great Painters, Raphael, Corregio and Titian and upon the Ancients," in *Works,* 136.

16. Golzio, "Raphael," 617–18, considers some of the major aspects of Mengs's opinion of Raphael; see also Ebhardt, 25–30. This aspect is discussed in Mengs, *Works,* 146.

17. Fontaine, *Les doctrines d'art,* 294. I know of no major study of Hagedorn. His views on Raphael are summarized by Ebhardt, 32–34.

18. For a list of some of his sources see Hagedorn, *Réflexions sur la peinture,* trans. M. Huber, Leipzig, 1775, book 2, chap. 57, 302. This was the French translation of *Betrachtungen über die Mahlerey,* Leipzig, 1762. All quotes are from the French edition. Huber states that he has changed some of the author's ideas to make the treatise more suitable for a French audience.

19. *Réfléxions,* 346ff. Hagedorn stated that the perfect artist's guides were antiquity, Raphael, and *la belle nature.* He was much more of an eclectic than Winckelmann or Mengs.

20. Algarotti was a very strong partisan of the ancients, sharply denying the marquis d'Argens's assertion that study in Rome was not necessary to become a great artist.

21. Algarotti, *Saggio sulla Pittura,* Leghorn, 1755; translated into French in 1769; Locquin, 291. All quotes are from the English translation of 1764, *An Essay on Painting.*

22. D. Webb, *An Inquiry into the Beauties of Painting,* London, 1760. The treatise was translated into French in 1765; Locquin, 293.

23. An example is his discussion of the color in the *Galatea.* Webb, 86: "Had we never seen better coloring than that of the *Galatea* of Raphael, a description of the *Venus* of Titian would appear extravagant. Why might not the Greek school have been as far superior to the Venetians as this is to the Roman?"

24. All quotes are from Sir Joshua Reynolds, *Discourses on Art,* ed. Robert Wark, San Marino, Calif., 1959; New Haven, 1975. Lipking, *Ordering,* 164–207, discusses their influence. Recently, the Discourses have been interpreted in political terms as relating to the ideals of civic humanism by John Barrell, *The Political Theory of Painting from Reynolds to Hazlitt,* New Haven, 1986.

25. See Lipking, "The Shifting Nature of Authority in Versions of *De Arte Graphica,*" 499–501.

26. The publication history of the *Discourses* is in F. W. Hilles, *The Literary Career of Sir Joshua Reynolds,* Cambridge, 1936, 279–300.

27. The correspondence between Reynolds and Jansen is in Hilles, 61–66.

28. These nontraditional attitudes are summarized by Wark in Reynolds, xxv–xxix. The quote is Discourse 7, 424f.

29. Raphael is considered in Discourses 1, 2, 4–6, 8, 9, 12, and 15.

30. T. B. Eméric-David, "Discours historique sur la sculpture ancienne," *Musée Français,* 1805. See Potts, "Winckelmann's *History,*" 404–14. On Eméric-David, see M. Shedd, "T.-B. Eméric–David and the Criticism of Ancient Sculpture in France, 1790–1839," diss., University of California, Berkeley, 1980.

CHAPTER 8

1. J. Locquin, *La Peinture d'histoire;* L. Hautecoeur, *Rome et la renaissance,* traces the importance of Rome as the center of neoclassical revival; E. Waterhouse, "British Contributions to the Neoclassical Style," *Proceedings of the British Academy* 15, 1954, 57–75, disputes Locquin's assertion that British neoclassical artists, such as Garvin Hamilton were simply the "Ecole de Mengs." R. Rosenblum, *Transformations in Late Eighteenth-Century Art,* Princeton, N.J., 1967, contributes greatly to understanding the complexities of the period. Two exhibition catalogs are of particular importance: *The Age of Neoclassicism,* Arts Council of Great Britain, 1972, and *French Painting, 1774–1830: The Age of Revolution,* Detroit Institute of Arts, Detroit, 1975.

2. See Michael Fried, *Absorption and Theatricality;* Bryson, *Word and Image;* and Crow, *Painters.*

3. D'Angiviller's actions as *surintendant* are detailed in Locquin, 41–69. On d'Angiviller's role in this reform movement, see Crow, *Painters,* 190–208.

4. F. Cummings, "Painting under Louis XVI, 1774–89, *French Painting 1774–1830,* 35. See also Bryson, *Word and Image,* 204–18. On d'Angiviller's patronage, see Frances Dowley, "D'Angiviller's *Grands hommes* and the Significant Moment," *Art Bulletin,* 39, 1957, 259–77; and Andrew McClellan, "D'Angiviller's 'Great Men' of France and the Politics of the Parlements," *Art History* 13, no. 2, June 1990, 175–91.

5. Vien was seen as the founder of the neoclassical school in France, with the encouragement of the comte de Caylus; Locquin, 190–98. See also F. Aubert, "Mémoires de Vien," *Gazette des Beaux-Arts,* 1867, series 1, vols. 22–23. The importance of Vien was stressed by Chaussard, in his anonymous treatise and critique of the Salon of 1806, *Le Pausanius Français,* 1806. It can also be found in *Collection Deloynes,* 39:38ff. Chaussard states that with Vien, "Dès ce moment, l'Ecole Français marcha d'un pas rapide vers sa régénération."

6. The importance of antiquity to the philosophes is traced by P. Gay, *The Enlightenment: The Rise of Modern Paganism,* New York, 1966. Caylus's major work was his *Recueil d'antiquités égyptiennes, étrusques, grecques et romaines,* Paris, 7 vols., 1752–67. For other antiquarian publications, see Hautecoeur, *Rome et la renaissance,* 76ff.

7. For the importance of the Grand Tour for artists and amateurs, see Hautecoeur, *Rome et la renaissance,* and P. F. Kirby, *The Grand Tour in Italy, 1700–1800,* New York, 1952.

8. The new rules under d'Angiviller are in A. de Montaiglon, *Correspondance des Directeurs de l'Académie de France à Rome avec les Surintendents des Bâtiments,* Paris, 1887, 15:182ff.

9. Vien's stress on Raphael in his teaching is recounted in *Le Pausanius français,* 63–64. Vien was in Rome between 1744 and 1750, and took part in the great copying enterprise of the Vatican frescoes under Orry and his successors.

10. David studied in Vien's atelier from 1765 to 1775, when he finally won the Prix de Rome on his fourth attempt.

11. See Chapter 4, note 19.

12. In July 1779, David went to Naples with Vivant-Denon and Quatremère de Quincy, an antiquarian much influenced by Winckelmann. He returned with a greater understanding of antiquity; see L. Hautecoeur, *Louis David,* Paris, 1954, 48.

13. Documents concerning David are collected by D. Wildenstein and G. Wildenstein, *Documents complémentaires au catalogue de l'oeuvre de Louis David,* Paris, 1973, 9.

14. Wildenstein and Wildenstein, Documents 743 and 1287 mention Winckelmann. The French translation of Winckelmann's *Geschichte* was in the library of the French Academy in Rome by 1782 and could have been there when David was in Rome. See Montaiglon, ed., *Correspondance,* 15:20. The source for David's figure of Leonidas was Winckelmann's 1767 *Monumenti Antichi inediti,* pl. 142. For this source and the influence of Winckelmann on David, see M. Kemp, "J. L. David and the Prelude to a Moral Victory for Sparta," *Art Bulletin* 51, 1969, 178–83.

15. Hautecoeur, *Louis David,* 39f. David filled more than a dozen sketch books with studies of antique monuments. The influence of antiquity on his style, particularly in the *Funeral of Patroclus,* is discussed by J. de Caso, "J. L. David and the Style 'All-Antica.'" *Burlington Magazine* 114, 1972, 686–90. For a recent, sweeping reexamination of David's oeuvre, see Dorothy Johnson, *Jacques-Louis David: Art in Metamorphosis,* Princeton, N.J., 1993. Johnson questions the usual classification of David's art as neoclassical, stressing instead his constant metamorphosis and his modernity. See esp. 44.

16. This point was made by Steven Levine in a talk on the *Sabines* at Temple University's March 1978 symposium, "From Sketch to Finished Work: The Genesis of Art in the Nineteenth Century."

17. *French Painting, 1774–1830,* 367–68, discusses the *Socrates;* for the *Leonidas,* see Kemp, 178–83. *Hector and Andromeche* is discussed in *French Painting, 1774–1830,* 366–67. For antique sources of the *Patroclus,* see note 15 above. For recent studies of David, see A. Brookner, *Jacques Louis David,* New York, 1980; A. Schnapper, *David, temoin de son temps,* Paris, 1981; Crow, *Painters,* chap. 7; and Bryson, *Tradition and Desire,* Cambridge, 1984.

18. Wildenstein and Wildenstein, 24. See also, Joseph Baillio, "Marie-Antoinette et ses enfants par Mme Vigée-Lebrun" (part 1) *L'Oeil,* January 1981, 306–11.

19. Wildenstein and Wildenstein, Document 2041. David owned a number of engravings after Raphael, including one of the *Madonna della Sedia,* one of the *Transfiguration* by Girodet, and one of the *Saint Michael* by Tardieu.

20. E. Falconet, *Oeuvres complètes* (1772), 3 vols., 3d ed., Paris, 1808. He had read Webb and approved of his criticism of Raphael, 3:231.

21. G. Levitine, *The Dawn of Bohemianism,* University Park, Pa., 1978, 92.

22. G. Levitine, "*L'Ecole d'Apelle* de Jean Broc, un Primitif au Salon de l'an VIII," *Gazette des Beaux-Arts* ser. 6, 58, November 1972, 85–94.

23. On the Catholic revival in France, see Michael Driskel, "Raphael, Savonarola and the Neo-Catholic Use of Decadence in the 1830's," in *Fortschrittsglaube und Dekadenzbewußtsein im Europa des 19. Jahrhunderts,* ed. W. Drost, Heidelberg, 1986, 259–66. See also Driskel, *Representing Belief,* 59ff.

24. C. H. Watelet and Levesque, *Dictionnaire portatif de peinture, sculpture, et gravure,* 5 vols., Paris, 1792, was begun by Watelet and finished by Levesque after Watelet's death. Watelet, a painter and *associé libre* of the Academy had already expressed his ideas on painting in his *L'Art de peindre: Poème,* which contained his "Réflexions sur les différentes parties de la peinture," Paris, 1760. Although he praised Raphael (Watelet, 43), he revealed the eclecticism still common at the time. On Watelet, see M. Henriet, "Un amateur d'art au XVIIIe siècle: L'Académicien Watelet," *Gazette des Beaux-Arts,* ser. 5, 6, September–October, 1922, 173–94. The importance of the *Dictionnaire* as a guide to common artistic ideas has been suggested by R. Saisselin, "Some Remarks on French Eighteenth-Century Writings on the Arts," *Journal of Aesthetics and Art Criticism* 25, 1966–67, 187–95. Saisselin has discussed some of the major concepts in the *Dictionaire* in *The Rule of Reason and the Ruses of the Heart: A Philosophical Dictionary of Classical French Criticism,* Cleveland, 1970.

25. A. D. Potts, "Political Attitudes and the Rise of Historicism in Art Theory," *Art History* 1, no. 2, June 1978, 191–213.

CHAPTER 9

1. For the effects of the Revolution on the French Academy in Rome, see Alaux, 1:214–16, 2:40–48.

2. "Les modèles des Gobelins devant le Jury des Arts en Septembre, 1794," *Nouvelles Archives de l'Art Français (N.A.A.F.),* 13, 1897, 351.

3. The *procès-verbaux* of the commission are published in *N.A.A.F.,* 17–18, 1901–2.

4. *N.A.A.F.,* 17, 1901, 309–10; 18, 1902, 189, for the inventory of the Château d'Orsay.

5. *N.A.A.F.,* 17, 1901, 59, 119, 196; H. Stein, "Etat des objets d'art placés dans les monuments religieux

et civils de Paris au début de la Révolution française," *N.A.A.F.,* 6, 1890, 1–131.

6. A good study of the Musée Napoléon is C. Gould, *Trophy of Conquest: The Musée Napoléon and the Creation of the Louvre,* London, 1965. See also P. Wescher, *Kunstraub unter Napoleon,* Berlin, 1976. On Napoleon's use of Raphael for political purposes, see M. Rosenberg, "Raphael's Transfiguration and Napoleon's Cultural Politics," *Eighteenth-Century Studies* 19, no. 2, Winter 1985–6, 180–205. See also McClellan, *Inventing the Louvre,* chaps. 3, 4.

7. A Quatremère de Quincy, *Lettres sur le projet d'enlever les monuments de l'Italie,* Paris, 1796. The most thorough study of his importance is R. Schneider, *Quatremère et son intervention dans les arts, 1788–1830,* Paris, 1910. As a disciple of Winckelmann, he was very influential in promoting the classical ideal in France. His popular biography of Raphael was published in 1824. Potts, "Political Attitudes," 199–202, places Quatremère's ideas in the context of his conservative political attitudes.

8. Quatremère, *Suite aux considérations...* (1791), quoted in Potts, "Political Attitudes," 201.

9. "Notice de plusieurs précieux tableaux recueillis à Venise, Florence, Turin et Foligno, 9 March, 1802," in *Collection Deloynes,* 27:1036. (Cabinet des Estampes, Bibliothèque Nationale, Paris.)

10. Complete information on the confiscation, exhibition, and restitution of Raphael's works taken from Italy is given by M. L. Blumer, "Catalogue des peintures transportées d'Italie en France de 1796 à 1814," *Bulletin de la Société de l'Histoire de L'Art Français,* 2 fasc., 1936, 305–8. The history of the tapestries is in E. Müntz, *Les Tapisseries de Raphael au Vatican,* Paris, 1897. For the cartoon for the *School of Athens* see Gould, 72.

11. The *Catalogue des objets contenus dans la Galerie du Muséum Français,* Paris, 1793, lists nine works attributed to Raphael, including the *Portrait of Castiglione,* the *Saint Michael,* and the *Belle Jardinière.*

12. See Blumer, 305–8, for Raphael's works in each exhibition. To take one example, the *Transfiguration* was exhibited in 1798, 1800, 1801, and then became part of the Musée Napoléon.

13. *Notice des Tableaux exposés dans la Galerie Napoléon,* Paris, 1811, lists twenty-eight Raphaels. The total collection included several thousand works; see Gould, 72ff.

14. "Notice des dessins originaux du Musée Central des Arts, 15 July 1802," in *Coll. Deloynes,* 28:61.

15. C. Aulanier, *Histoire du Palais et du Musée du Louvre,* Paris, 1947–, 1:41.

16. Six Raphaels were hung with three Peruginos. The three stages of his career were represented by the *Belle Jardinière,* the *Madonna da Foligno,* and the *Transfiguration.* See McClellan, *Inventing the Louvre,* 131–48.

17. Publications on the works in the Musée Napoléon included J. Lavallee, *Galerie du Musée Napoléon,*

11 vols., Paris, 1804–28; T. B. Eméric-David, *Choix de notices sur les tableaux du Musée Napoléon,* Paris, 1812; C. P. Landon, *Annales du Musée,* 17 vols., Paris, 1801–9. There were also dozens of articles in the journals.

18. Eméric-David, 36–38. He has high praise for Rubens's *Descent from the Cross.*

19. J.-B.-P. Lebrun, "Examen historique et critique des tableaux exposés provisoirement," *Coll. Deloynes,* 19, 401. For a study of the painter and dealer, Lebrun, see F. Haskell, *Rediscoveries in Art,* Ithaca, N.Y., 1976.

20. Articles on the *Transfiguration* appeared in many periodicals. See *Coll. Deloynes,* 50, nos. 1380–84. The eyewitness account is "Entrée triomphale des objets des sciences et d'arts recueillis en Italie," *Coll. Deloynes,* 50:987ff. For a comprehensive study of Napoleon's political uses of Raphael focusing on the *Transfiguration,* see my article, "Raphael's *Transfiguration.*"

21. *Coll. Deloynes,* 50:996.

22. L. Dussler, *Raphael,* London, 1971, 52.

23. "Notice relative à l'exposition du tableau de la *Transfiguration," Journal du Moniteur* (n.d.), in *Coll. Deloynes,* 50:1036.

24. B. Pardo de Figueroa, *Examen analytique du tableau de la Transfiguration du Raphael,* Paris, 1805.

25. P. Lamontagne, *La Transfiguration par Raphael: Un Ode,* Paris, 1818.

26. "Tableau de la Transfiguration," *Journal des Arts* (n.d.), *Coll. Deloynes,* 50:1043.

27. See Salmi, ed., *Raffaelo,* 193.

28. On Bergeret's painting, see M. Rosenberg, "Bergeret's *Honors Rendered to Raphael on his Deathbed," Allen Memorial Art Museum Bulletin* (Oberlin College), 42, no. 1, 1984–85, 3–15. The most complete study of Bergeret is L. El-Abd, "Pierre-Nolesque Bergeret (1782–1863)" diss., Columbia University, 1976.

29. "Tableau de la Transfiguration par Raphael," *Journal de Paris,* no. 215, 1805, in *Coll. Deloynes,* 50:1061–62.

30. Landon, *Annales,* 2:145. Landon published engravings of Raphael's oeuvre in *Vies et Ouvrages des Peintres: Ecole Romaine-Raphael,* 2 vols., Paris, 1805.

31. M. Duval, "Quelques observations sur les tableaux recueillés en Lombardie, et actuellement exposés dans le grand Salon du Musée central des Arts" (n.d.), *Coll. Deloynes,* 19:466.

32. [P. Chaussard], *Le Pausanius français,* Paris, 1806.

33. M. Rosenberg, "Bergeret," 5–6. On the general topic of artists' lives as subjects for painting, see F. Haskell, "The Old Masters in Nineteenth-Century Painting," *Art Quarterly* 24, Spring 1971, 55–85.

34. M. S. Delpech, *Examen raisonné des ouvrages de peintures, sculptures, et gravures exposés au Salon de Louvre en 1814,* Paris, 1814, 136ff. For a discussion of one aspect of his criticism, see J. J. Whitely, "The Origin and the Concept of 'Classique' in French Art

Criticism," *Journal of the Warburg and Courtauld Institutes,* 39, 1976, 268–74.

35. Gault de St. Germain wrote guidebooks, Salon criticism, and a treatise on the passions. A. Lenoir, himself a painter, wrote several treatises for amateurs, including *La Vraie Science des artistes* (1823). In Seroux d'Agincourt's *Histoire,* he attempted to become the French Winckelmann. Other treatises on the Beaux-Arts were written by Artaud de Montor, Miel, and Droz (see Select Bibliography).

36. Seroux d'Agincourt, *Histoire de l'art par les monuments,* 2 vols., Paris, 1823, 2:171ff. On Seroux d'Agincourt, see Haskell, *History,* 193–98.

37. A. Lenoir, *La Vraie Science des artistes,* Paris, 1823; *Observations sur la génie et les principales productions des artistes . . . ,* 2d ed., Paris, 1824. For a discussion of Alexandre Lenoir and the Musée des Monuments française, see Haskell, *History,* 236–52.

CHAPTER 10

1. Abrams, *The Mirror and the Lamp,* deals primarily with poetry, but much of it is applicable to painting. Rosenblum in his publications *Ingres* and *Transformations in Late Eighteenth-Century Art* has shown that no hard-and-fast lines can be drawn between neoclassicism and Romanticism. Other major studies aimed at defining Romanticism include A. Lovejoy, "Meaning of Romanticism," *Journal of the History of Ideas* 2, June 1941, 257–78. M. Praz, *The Romantic Agony,* London, 1933, deals with the more pathological aspects of Romanticism. R. Wellek, *A History of Modern Criticism,* esp. vols. 1–2 on the later eighteenth century and the Romantic Age provide a good discussion of issues relevant to art and literature. For more recent attempts to encompass aspects of this complex phenomenon, see Hugh Honour, *Romanticism,* New York, 1979; Jean Clay, *Romanticism,* Secaucus, N.J., 1980; and C. Rosen and H. Zerner, *Romanticism and Realism: The Mythology of Nineteenth-Century Art,* New York, 1984.

2. Delécluze was a student with Ingres in David's atelier. His book *Louis David: Son école et son temps: Souvenirs,* Paris, 1855, is an important source for our knowledge of David's career and his students. His writings on art included a series of travelogues, a journal, and a treatise on the Beaux-Arts. For a study of Delécluze, see R. Baschet, *Delécluze, temoin de son temps,* Paris, 1942. For several aspects of Delécluze's art criticism, see Wrigley, *Origins of French Art Criticism.*

3. D. Wakefield, "Stendhal and Delécluze at the Salon of 1824," in *The Artist and the Writer in France: Essays in Honor of Jean Seznec,* ed. F. Haskell et al., London, 1974, 81ff. Wakefield discusses the spirited battle of words between Delécluze and Stendhal over Romanticism.

4. Wakefield, "Stendhal and Delécluze," 83. Actually, Delécluze was only one of a large number of conservative critics of the Salon of 1824. For a summary of the critical views, see P. Grate, "La critique d'art et la bataille romantique," *Gazette des Beaux Arts,* ser. 6, 54, September 1959, 129–48.

5. The literature on Stendhal (Marie-Henri Beyle) is vast. For his position on the classical ideal, see Wakefield, "Stendhal and Delacroix," 78. A. Brookner, *The Genius of the Future,* London, 1971, is an extremely perceptive study that places his art criticism in the context of his literature novels and personality. Two other useful studies are D. Wakefield, *Stendhal and the Arts,* London, 1973; and "Art Historians and Art Critics XI: Stendhal," *Burlington Magazine* 117, December 1975, 803–9.

6. Wakefield, "Stendhal and Delécluze," 79. This was part of a pointed attack on David's *Sabines,* which he felt was pedantic and unnatural.

7. Wakefield, "Stendhal and Delécluze," 80–81. Stendhal explored these themes in his *Histoire de la Peinture en Italie* (1817) and *Racine et Shakespeare* (1823).

8. Brookner, *Genius,* 33–55. For the bibliography of Stendhal's writings on art, see Wakefield, *Stendhal and the Arts,* chap. 1.

9. Stendhal devoted whole chapters of the *Histoire* to Michelangelo, particularly chap. 144. See Wakefield, *Stendhal and the Arts,* 79ff. See also Brookner, *Genius,* 44–46.

10. For an attempt to define this ideal, see C. Goldstein, "Towards a Definition of Academic Art," *Art Bulletin* 57, March, 1975, 102–9. The crux of this view of art is that the basic problems have been solved for all time.

11. On the rise in interest in "primitive" sources, see R. Rosenblum, *The International Style of 1800: A Study in Linear Abstraction,* New York, 1976. On Flaxman's influence, see S. Symmons, "French Copies after Flaxman's Outlines," *Burlington Magazine* 115, September 1973, 591–99. For a study of Ingres's interest in pre-Renaissance sources, see K. Berger, "Ingrisme et Pre-Raphaelitisme," in *Relations artistiques entre la France et les autres pays* (Actes du XIXe congrès international d'histoire de l'art, Paris, 1958), Paris, 1959.

12. A.-F. Artaud de Montor, *Considerations.* The purpose of this treatise was to show that Raphael did not fall "tout-à-coup du ciel; son talent est l'addition de tous les talens qui avaient existé précédemment" (10).

13. On the "Primitifs," see G. Levitine, *Dawn.* The Nazarenes have been studied by K. Andrews, *The Nazarenes,* Oxford, 1964.

14. Wackenroeder's *Heartfelt Outpourings of an Art-Loving Monk* (1797) created a new image of Raphael as the simple, pure painter whose art was a divine revelation. This was the image of Raphael adopted by the Nazarenes. See Andrews, *Nazarenes,* 15ff. As early as 1802, Friedrich von Schlegel had challenged the notion that Raphael's last manner represented the height of Western art. See Driskel, *Representing Belief,* 74ff.

15. E. Burke, *A Philosophical Enquiry into the*

Origin of our Ideas of the Sublime and the Beautiful, London, 1757.

16. On Blake and the sublime, see A. Blunt, *The Art of William Blake,* New York, 1959, 13–22. Fuseli was strongly influenced by Burke's concept of the "sublime of terror"; see P. Tomory, *The Life and Art of Henry Fuseli,* New York and London, 1972, 75–76. A discussion of the *Sturm and Drang* movement is in Wellek, 2: chap. 9.

17. Chaussard in *Le Pausanius français* (69) praised Girodet's *Déluge* for the "verve du dessin" of Michelangelo. Rosenblum has aptly characterized this trend as the "neoclassic horrific" in *Transformations,* chap. 1.

18. Both Ingres and Delacroix were inspired by Raphael's Madonnas as I shall discuss below. Gros used elements from Raphael's battle paintings for his own; see S. Lichtenstein, "The Baron Gros and Raphael," *Art Bulletin* 60, March 1978, 126–38. Géricault and Girodet also used elements from Raphael. See Lichtenstein, "Baron Gros," 127 n. 5.

19. J. A. D. Ingres, *Ingres raconté par lui-même et par ses amis,* ed. P. Cailler, 2 vols., Geneva, 1947–48, 97. Subsequent quotes are from this edition. For complete bibliography on Ingres, see N. Schlenoff, *Ingres: Ses sources littéraires,* Paris, 1956.

20. Michael Driskel, "Icon and Narrative in the Art of Ingres," *Arts* 56, no. 4, December 1981, 100–107.

21. Delaborde records a statement that shows that the reflections of Raphael were intentional: "All that I will tell you is that I spare nothing in order to make the thing Raphaelesque and mine"; quoted in A. Mongan, *Ingres: Centennial Exhibition, 1867–1967,* Fogg Art Museum, Cambridge, Mass., 1967, no. 54. For a recent discussion of Ingres's working methods focusing on several Raphaelesque works, see P. Condon et al., *In Pursuit of Perfection: The Art of J. A. D. Ingres,* exh. cat., J. B. Speed Museum, Louisville, Ky., 1983–84. The iconography of the *Vow* is discussed by P.-M Auzas, "Observations iconographiques sur le 'Voeu de Louis XIII,'" in *Actes du Colloque Ingres,* Montauban, 1969, 1–11. For a more specifically political interpretation, see C. Duncan, "Art and Politics in Ingres' *Vow of Louis XIII,*" in *Art and Architecture in the Service of Politics,* ed. H. Millon and L. Nochlin, Cambridge, Mass., 1978.

22. This is not only evident in the *Vow of Louis XIII.* See also the *Virgin with the Host* in Rosenblum, *Ingres,* 29, 126, and fig. 26. On the neo-Catholic response to the *Virgin of the Host,* see Driskel, "Icon and Narrative," 104–6.

23. Rosenblum, *Ingres,* 29. For other works copied after or related to Raphael, see G. Wildenstein, *Ingres,* London, 1954, figs. 17–18, 29–31, 46–48, 66–68, 143–45, 178–80.

24. N. Bryson, *Tradition and Desire,* chaps. 4–5. Although many of Bryson's observations provide insight into individual works, one can question his explanations in terms of the literary concept of the trope.

25. His sources are described in N. Schlenoff,

Ingres: Cahiers littéraires, inédits, Paris, 1956, 195. Cahier 7 was devoted to Raphael. For a detailed discussion of Ingres's personal identification with Raphael, see E. van Liere, "Ingres' 'Raphael and the Fornarina': Reverence and Testimony," *Arts* 56, December 1981, 108–15.

26. D. A. Brown, *Raphael and America,* exh. cat., National Gallery of Art, Washington, D.C., 1983.

27. The term "historicism" is used in the sense suggested by Rosenblum in *Transformations,* 34ff. For a consideration of the political dimensions of this term, see A. Potts, "Political Attitudes."

28. See Rosenblum, *Ingres,* fig. 92. Now the portrait in the Galleria Borghese is attributed to Giulio Romano. Richard Shiff sees the Fornarina as a statement about the nature of representation from the idealizing, "academic" perspective of Ingres; see Shiff, "Representation," 332–44; See also Shiff, "Phototropism (Figuring the Proper)," in *Retaining the Original: Multiple Originals, Copies, and Representations,* Studies in the History of Art 20, National Gallery of Art, Washington, D.C., 1989, 161–70.

29. By this time artists had become popular subjects. See F. Haskell, "The Old Masters." For other examples of Raphael as subject, see Rosenblum, *Ingres,* 98–99. Of course Bergeret had already won acclaim for his painting of Raphael's obsequies at the Salon of 1806; see M. Rosenberg, "Bergeret's *Honors,*" 5–8.

30. In the *Napoleon,* it appears as Virgo of the zodiac in the carpet on which the throne rests.

31. Schlenoff, *Ingres: Ses sources littéraires,* 40 n. 3.

32. Examples might include *Mlle. Rivière* (1805), *Madame Devauçay* (1807), *Madame Panckouke* (1811). One of the most successful examples of this interplay is the *Grande Odalisque* (all are illustrated in Rosenblum, *Ingres.*)

33. See D. Ternois and J. Lacambre, *Ingres et son temps,* exh. cat., Musée Ingres, Montaubon, 1967; see fig. 9. This copy of the *Madonna della Sedia* by Paul Balze, his pupil, hung in his salon.

34. See Driskel, *Representing Belief,* chap. 3, esp. 76ff. for this shift in the view of Raphael. An example of this aesthetic shift would be Flandrin's *The Mission of the Apostles* (1861), which accentuates the iconic quality of Ingres's *Christ Giving the Keys to Peter.* For Flandrin's work, see Philadelphia Museum of Art, *The Second Empire 1852–1870: Art in France under Napoleon III,* 1978, catalog entry VI-53. Ingres's followers are discussed by R. Rosenblum, "Ingres, Inc.," in *The Academy, Art News Annual,* 33 (n.d.), 67–79.

35. G. Mras, *Eugene Delacroix's Theory of Art,* Princeton, N.J., 1966.

36. The 1830 essay is in E. Delacroix, *Oeuvres littériares,* ed. E. Faure, vol. 2 4th ed., Paris, 1923. All journal quotes are from E. Delacroix, *The Journal of Eugène Delacroix,* ed. H. Wellington, New York, 1959.

37. In fact, de Piles, whose writings Delacroix knew well, used such arguments to promote Rubens. See Chapter 3.

38. Delacroix, *Journal,* 85. For a discussion of Delacroix's debt to Rubens, see F. Trapp, *The Attainment of Delacroix,* Baltimore, 1971.

39. For Delacroix's copies see S. Lichtenstein, "Delacroix's Copies after Raphael," *Burlington Magazine* 113, part 1, September 1971, 525–34; part 2, October 1971, 593–603. Five painted copies and about twenty-five drawings are known. The number of copies after Rubens is much greater: thirty-two paintings and about ninety-seven drawings. See B. E. White, "Delacroix's Painted Copies after Rubens," *Art Bulletin* 49, January 1967, 37–51.

40. Lichtenstein, "Delacroix's Copies," 525–29.

41. Lichtenstein, "Delacroix's Copies," 533. See also part 2, 593–603.

42. The most thorough study of the murals is by J. Spector, *The Murals of Eugène Delacroix at St. Sulpice,* New York, 1967.

43. Trapp, 299. For illustrations of Delacroix's, see Trapp.

CONCLUSION

1. Delacroix, *Oeuvres Littéraires,* 2:9–10. Perhaps when he wrote this, Delacroix was feeling a bit envious of Raphael, since he had not yet achieved the official patronage that he did later in his career.

2. The most comprehensive study of the influence of Winckelmann and Mengs in France is A. Potts, "Winckelmann's Interpretation."

3. These include the gothic revival and all such related forms of historicism. For a discussion of some of these, see Rosenblum, *Transformations.*

4. See Lichtenstein, "Baron Gros." Her work needs to be continued and expanded to reach a comprehensive picture of Raphael's influence on David and his followers.

5. Bouguereau's *Birth of Venus* (1879), although loosely based on Raphael's *Galatea,* brings the scene down to a prosaic level that severs all connection with its prototype. For an illustration, see Rosenblum, *Ingres,* fig. 131. A typical Gérome is *Woman's Bath at Brusa* (1885); see same volume, fig. 142. For other works see Philadelphia Museum of Art, *Second Empire,* 306–9.

6. Artists certainly continued to copy in the Louvre, but they seldom copied Raphael. See T. Reff, "Copyists in the Louvre, 1850–1870," *Art Bulletin* 46, 1964, 552–59. One exception was the great modern figure painter, Degas. He copied Raphael, but much more often he copied Ingres. See T. Reff, *Degas: The Artist's Mind,* New York, 1976. Much study has focused on Manet's use of the Old Masters; see N. Sandblad, *Manet: Three Studies in Artistic Conception,* London, 1954. A. C. Hanson, *Manet and the Modern Tradition,* New Haven, 1977, contains an extensive bibliography. Renoir still later sought stimulation from Raphael in Italy.

SELECT BIBLIOGRAPHY

Abrams, M. H. *The Mirror and the Lamp*. New York, 1953.

Académie de France à Rome. *David et Rome*. Rome, 1981.

Ackerman, G. "Lomazzo's Treatise on Painting." *Art Bulletin* 49, 1967, 317–26.

The Age of Neo-Classicism. Exh. cat., Arts Council of Great Britain. London, 1972.

Alaux, J.-P. *L'Académie de France à Rome: Ses Directeurs, ses pensionnaires,* 2 vols. Paris, 1933.

Alazard, J. "Ce que J. D. Ingres doit aux primitifs italiens." *Gazette des Beaux-Arts* 16, November 1936, 167–75.

Algarotti, F. *Essai sur la peinture et sur l'Académie de France etablée à Rome.* Trans. Pingeron. Paris, 1769.

———. *An Essay on Painting* (1764). English translation of *Saggio sulla Pitura*.

———. *Saggio sulla Pittura*. Leghorn, 1755.

Anderson, H., and J. Shea, eds. *Studies in Criticism and Aesthetics: Essays in Honor of Samuel Holt Monk*. Minneapolis, 1967.

Andersen, W. "Manet and the Judgement of Paris." *Art News* 72, February 1973, 64ff.

Andrews, K. "Dürer's Posthumous Fame." In *Essays on Dürer* (Colloquium at Manchester, 1971), 1973, 82–103.

———. *The Nazarenes*. Oxford, 1964.

Angelica Kauffmann und ihre Zeitgenossen. Exh. cat. Bregenz and Vienna, 1968.

Antal, F. *Classicism and Romanticism*. London, 1966.

Archives de l'Art Français, XI, Catalogue des ouvrages relatives aux Beaux-Arts du Cabinet des Estampes de la Bibliothèque Nationale. Paris, 1921.

Archives de l'art français. Ed. Ph. de Chennevières and A. de Montaiglon. 14 vols. Paris, 1851–62.

Argens, Marquis d'. *Réflexions critiques sur les différentes écoles de peinture*. Paris, 1752.

Armenini, G. B. *De' veri precetti della pittura*. Ravenna, 1587. Trans. J. Olsszewski. New York, 1977.

Arnaud, J. *L'Académie de Saint-Luc à Rome*. Rome, 1886.

Art Institute of Chicago. *Painting in Italy in the Eighteenth Century: Rococo to Revolution*. Chicago, 1970.

Artaud de Montor, A.-F. *Considérations sur l'état de la peinture en Italie, dans les quatre siècles qui ont précédé celui de Raphael*. Paris, 1811.

Aschenbrenner, K. *The Concepts of Criticism*. Dordrecht, 1975.

Aubert, F. "Mémoires de Vien." *Gazette des Beaux-Arts,* ser. 1, 22, 1867, 180–90, 282–94, 493–507; 23, 1867, 175–87, 297–310, 470–82.

Aulanier, C. *Histoire du Palais et du Musée du Louvre*. 9 vols. Paris 1947–.

Auzas, P.-M. "Les grands Mays de Notre-Dame de Paris." *Gazette des Beaux-Arts,* ser. 6, 36, 1949, 197–200.

———. "Observations iconographiques sur le 'Voeu de Louis XIII.'" in *Actes du Colloque Ingres*. Montauban, 1969, 1–11.

Bachaumont, L-P. de. *Mémoires secrets*. 13 vols. 1784.

Bacou, R. *Dessins français du XVIIIe siècle: Amis et contemporains de P. J. Mariette*. Exh. cat., Cabinet des dessins, Musée du Louvre, Paris, 1967.

Bagnani, G. "Winckelmann and the Second Renaissance, 1755–1955." *American Journal of Archaeology* 59, April 1955, 107–18.

Bailey, C. *The Loves of the Gods: Mythological Painting from Watteau to David*. Exh. cat., Kimbell Art Museum, Fort Worth, Texas, 1992.

Baillio, J. *Elisabeth Louise Vigée-Lebrun*. Exh. cat., Kimbell Art Museum, Fort Worth, Texas, 1982.

———. "Marie-Antoinette et ses enfants par Mme Vigée-Lebrun" (part 1). *L'Oeil*. no. 310, January 1981, 306–11.

———. "Marie-Antoinette et ses enfants par Mme Vigée-Lebrun" (part 2). *L'Oeil*. no. 306, May 1981, 52–60, 91–92.

Bailly, N., ed. *Inventaires des collections de la couronne: Inventaires des tableaux du Roy, redigé en 1709 et 1719*. Paris, 1889.

Barasch, M. *Theories of Art from Plato to Winckelmann*. New York, 1985.

Barolsky, P. *Why Mona Lisa Smiles and Other Tales by Vasari*. University Park, Pa., 1991.

Barrell, J. *The Political Theory of Painting from Reynolds to Hazlitt*. New Haven, 1986.

Baschet, R. *Delécluze, temoin de son temps*. Paris, 1942.

Batteux, Abbé C. *Les Beaux-Arts réduits à un même principe.* Paris, 1746.

Bauer, H., et al. *Kuntsgeschichte und Kunsttheorie im 19. Jahrhundert.* Berlin, 1963.

Beaume, G. *L'Académie de France à Rome.* Paris, 1923.

Becq, A. "Expositions, peintres, et critiques, vers l'image moderne de l'artiste." *Dix-huitième siècle,* no. 14, 1982, 131–50.

———. *Genèse de l'esthétique française moderne: De la raison classique à l'imagination créatrice, 1680–1814.* 2 vols. Pisa, 1984.

Belaval, Y. *Esthétique de Diderot.* Paris, 1950.

Belloc, P. C. *La Vierge au Poisson de Raphael.* Lyon, 1833.

Bellori, G. P. *Descrizione delle imagini dipinte da Rafaelle d'Urbino* (Rome, 1695). Facsimile. Gregg International Publishing, Farnsborough, 1968.

———. *Vie de Nicolas Poussin.* Ed. P. Cailler. Geneva, 1947.

———. *Le Vite de pittori, scultori, et architetti moderni.* Rome, 1672. Ed. G. Einandi. Turin, 1976.

Benezit, E. *Dictionnaire Critique et documentaire des Peintures . . .* 8 vols. Paris, 1948–55.

Benisovich, N. "Monsieur Ingres as an Art Expert." *Gazette des Beaux-Arts,* ser. 6, 34, July 1948, 78–80.

Benoit, F. *L'Art français sous la Révolution et l'Empire.* Paris, 1897.

Benot, Yves, ed. *Diderot et Falconet: Le Pour et le Contre.* Paris, 1958.

Benton Museum. *The Academy of Europe: Rome in the Eighteenth Century.* Exh. cat., Storrs, Conn., 1973.

Berger, K. "Ingrisme et Pre-Raphaelitisme." In *Relations artistiques entre la France et les autres pays.* (Actes du XIXe congrès international d'histoire de l'art, Paris, 1958). Paris, 1959. 479–85.

Bergeret de Grancourt, P. *Voyage d'Italie, 1773–74.* Ed. J. Wilhelm. Paris, 1948.

Bernetz, D.-A. *Dictionnaire portatif de peinture, sculpture, et gravure . . .* Paris, 1756.

Bertoletti, L. "Ouvrages d'art envoyés de Rome en France." *Nouvelles Archives de l'Art Français,* ser. 2, 2, 1880–81, 79ff.

Blake, W. *Descriptive Catalogue.* London, 1809.

Bloom, Harold. *The Anxiety of Influence: A Theory of Poetry.* New York, 1975.

Blum, A. *Abraham Bosse et la société française au XVIIe siècle.* Paris, 1924.

Blum, I. "Ingres, Classicist and Antiquarian." *Art in America* 24, January 1936, 3–11.

Blumer, M.-L. "Catalogue des peintures transportées d'Italie en France de 1796 à 1814." *Bulletin de la Société de l'Histoire de l'Art Français,* 2 fasc., 1936, 244–348.

Blunt, A. *Art and Architecture in France, 1500–1700.* 2d ed. Harmondsworth, 1970. (Originally published 1953.)

———. *The Art of William Blake.* New York, 1959.

———. *Artistic Theory in Italy.* Oxford, 1940.

———. "Des origines de la critique et de l'histoire de l'art en Angleterre." *Revue de l'Art,* 1975, 5–16.

———. *The Drawings of Poussin.* New Haven, 1979.

———. "The Legend of Raphael in Italy and France." *Italian Studies* 13, 1958, 2–21.

———. *Nicolas Poussin.* 3 vols. New York, 1967.

———. "Poussin's Notes on Painting." *Journal of the Warburg and Courtauld Institutes* 1, 1937–38, 344–51.

Boas, G. "The Arts in the Encyclopédie." *Journal of Aesthetics and Art Criticism* 23, Fall 1964, 97–108.

———. "The Mona Lisa in the History of Taste." *Journal of the History of Ideas,* 1, 1940, 207–24.

Boime, A. *The Academy and French Painting in the Nineteenth Century.* London, 1971.

———. *Art in the Age of Revolution, 1750–1800.* Chicago, 1987.

———. "Le Musée des Copies." *Gazette des Beaux-Arts* 60, 1964, 237–47.

Boinet, A. *Les églises Parisiennes.* 3 vols. Paris, 1958.

Bombourg, I. de. *Recherche curieuse de la vie de Raphael Sanzio d'Urbin . . .* (translation of Vasari's *Vite*). Lyon, 1675.

Bonnaffe, E. *Dictionnaire des amateurs au XVIIe siècle.* Paris, 1884.

Bonnaire, M. *Procès-Verbaux de l'Académie des Beaux-Arts: an IV* (1810). Paris, 1937–43.

Bonno, G. "Liste chronologique des périodiques de langue française du dix-huitième siècle." *Modern Language Quarterly* 5, March 1944, 3–55.

Borenius, T. "The Rediscovery of the Primitives." *Quarterly Review* 239, April 1923, 258–70.

Bosse, A. *Le Peintre converti aux précises et universelles règles de son art.* Paris, 1667.

Boutard, M. *Dictionnaire des arts du dessin . . .* Paris, 1826.

Boyer d'Agen, A. *Ingres.* Paris, 1909.

———. "La legende dorée de Raphael Sanzio." *Art et les Artistes,* September 1920, 259–64.

Braunschvig, M. *L'Abbé Dubos: Renovateur de la critique au XVIIIe siècle.* Toulouse, 1902.

Bray, R. *La Formation de la doctrine classique en France.* Paris, 1927.

Brookner, A. *Genius of the Future: Studies in French Art Criticism: Diderot, Stendhal, Baudelaire, Zola, the Brothers Goncourt, Huysmans.* London, 1971.

———. "J. L. David. A Sentimental Classicist." *Akten des 21. Internationalen Kongress für Kunstgeschichte.* Bonn, 1964; Berlin, 1967, 184–90.

———. *Jacques Louis David.* New York, 1980.

Brosses, Charles de. *Lettres historiques et critiques sur l'Italie . . .* Paris, 1798.

Brown, D. A. *Raphael and America.* Exh. cat., National Gallery of Art, Washington, D.C., 1983.

Brown University and the Rhode Island School of

Design. *Rubenism*. Exh. cat., Providence, R.I., 1975.

Brunot, F. "Naissance et développement de la langue de la critique d'art en France." *Revue de l'Art*, supp. 1, April 1931, 145–62.

Bryson, N. *Tradition and Desire*. Cambridge, 1984.

———. *Word and Image: French Painting of the Ancien Régime*. Cambridge, 1981.

Bukdahl, E. *Diderot, Critique d'Art*. Trans. J. Pilosz. 2 vols. Copenhagen, 1981–82.

———. "Diderot, son indépendance par rapport aux salonniers de son temps." *Gazette des Beaux-Arts*, ser. 6, 102, July 1983, 11–20.

Burke, E. *A Philosophical Enquiry into the Origin of our Ideas of the Sublime and the Beautiful*. London, 1757.

Burke, J. *Hogarth and Reynolds, A Contrast in English Art Theory*. London, 1943.

Burtin, F.-X. de. *Traité théorique et pratique des connaissances qui sont nécessaires à tout amateur de tableau . . .* Brussels, 1808.

Le Cabinet d'un Grand Amateur, 1694–1774. Musée du Louvre, Paris, 1967.

[Caillou, A.]. *Dictionnaire de l'Académie des Beaux-Arts*. 2 vols. Paris, 1858–68.

Calliéres, F. de. *L'Histoire poétique de la guèrre nouvellement déclarée entre les anciens et les modernes*. Paris, 1688.

Carlson, V. "View of the 1761 Salon by Gabriel de St.-Aubin." *Gazette des Beaux-Arts*, ser. 6, 61, January 1963, 5–8.

Cartwright, M. *Diderot: Critique d'art et le problème de l'expression*. Diderot Studies 13. Ed. O. Fellows, Geneva, 1969.

———. "Gabriel de St.-Aubin, An Illustrator and Interpreter of Diderot's Art Criticism." *Gazette des Beaux-Arts*, ser. 6, 73, April 1969, 207–24.

Caso, J. de. "J. L. David and the Style 'All-Antica.'" *Burlington Magazine* 114, 1972, 686–90.

Castel de Courval, H. de. *Les Tableaux de la Sainte Bible ou Loges de Raphael*. Paris, 1825.

Catalogue des estampes qui ont été gravées d'après les originaux de Raphael d'Urbin. Leipzig, 1769.

Catalogue des tableaux du Cabinet du Roy au Luxembourg. Paris, 1766.

Caylus, A.-C.-P., Comte de. *Correspondance inédite du Comte de Caylus avec le P. Paciaudi, . . .* Ed. C. Nisard. 2 vols. Paris, 1877.

———. *Mémoires et réflexions du Comte de Caylus*. Paris, 1874.

———. *Recueil d'antiquités égyptiennes, étrusques, grecques et romaines*. 7 vols. Paris, 1752–67.

———. *Vies d'artistes de XVIIIe siècle; Discours sur la Peinture; Salons de 1751 et 1753; Lettre à Lagranée*. Ed. A. Fontaine. Paris, 1910.

Chambers, F. P. *The History of Taste: An Account of the Revolutions of Art Criticism and Theory in Europe*. New York, 1932.

Charles, M. L. *The Growth of Diderot's Fame in France from 1784 to 1875*. Bryn Mawr, Pa., 1942.

Chatelain, J. *Dominique Vivant Denon et le Louvre de Napoléon*. Paris, 1973.

[Chaussard, P.]. *Le Pausanius français, ou Description du Salon de 1806: Etat des arts du dessin en France, à l'ouverture du XIXe siècle . . .* Paris, 1806.

Chennevieres, Ph. de. *Recherches sur la vie et les ouvrages de quelques peintres provinciaux*. 4 vols. Paris, 1847–82.

Chéron-le-Hay, Mme. *Livre de principes à dessiner*. Paris, 1706.

Chouillet, J. *La Formation des idées esthétiques de Diderot*. Paris, 1973.

Clark, Anthony. "Development of Collections and Museums of 18th Century Rome." *Art Journal* 26, no. 2, Winter 1966–67, 136–43.

———. "Imperiali." *Burlington Magazine* 106, May 1964, 226–33.

Clay, Jean. *Romanticism*. Secaucus, N.J., 1980.

Cochin, C. N. *Mémoires d'artistes du XVIIIe siècle: Discours sur la peinture et la sculpture: Salons 1751 & 1753*. Ed. A. Fontaine. Paris, 1910.

———. *Mémoires inédites sur la vie de Caylus, Bouchardon, Slodtz, etc*. Ed. C. Henry. Paris, 1880.

———. *Voyage d'Italie*. Paris, 1758.

Cohm, M. B., and S. Siegfried. *Works by J. A. D. Ingres in the Collection of the Fogg Art Museum*. Cambridge, Mass., 1980.

Coindet, Jean. *L'Histoire de la peinture en Italie*. Paris, 1849.

"Comments on the Sale of the Collective of P. J. Mariette." *Nouvelles Archives de l'Art Français* 1, 1872, 365.

Comolli, Angelo. *Vita inedita di Raffaello da Urbino*. Rome, 1790.

Condon, P., et al. *In Pursuit of Perfection: The Art of J. A. D. Ingres*. Exh. cat., J. B. Speed Museum, Louisville, Kentucky, 1983–84.

Conférences académiques. MSS. 1018. Bibliothèque d'Art et d'Archéologie, Université de Paris.

Conisbee, P. *Painting in Eighteenth-Century France*. Oxford and Ithaca, N.Y., 1981.

Connolly, J. "Ingres Studies: Antiochus and Stratonice; The Bather and Odalisque Themes." Diss., University of Pennsylvania, 1974.

Courajod, L. "Documents sur la vente du cabinet du Mariette." *Nouvelles Archives de l'Art Français*, 1872, 347–70.

———. *L'Ecole Royale des Elèves protégés, précédé d'une étude sur le caractère de l'enseignement de l'art français aux différentes époques de son histoire*. Paris, 1874.

Coypel, A. *Discours prononcé dans les conférences de l'Académie Royale de Peinture et Sculpture*. Paris, 1721.

Coypel, C.-A. *Discours sur la Peinture*. Paris, 1732.

———. *Epistre à mon fils*. Paris, 1708.

Crousaz, P. *Traité du Beau*. Amsterdam, 1715.

Crow, T. "La Critique des Lumières dans l'art du dix-

huitième siècle." *Revue de l'Art* 73, May 1986, 9–16.

———. *Painters and Public Life in Eighteenth-Century Paris.* New Haven, 1985.

Croze Magnan, S. C. *Le Musée Français: Recueil complet des tableaux, statues et bas-reliefs qui composent la collection national, etc.* Paris, 1803.

Cumberland, G. *An Essay on the Utility of Collecting the Best Works of the Ancient Engravers of the Italian School.* London, 1827.

Cummings, F. "Painting under Louis XVI, 1774–89." In *French Painting, 1774–1830: The Age of Revolution.* Exh. cat., Detroit Institute of Arts, 1975.

———. "The Problem of Artistic Style as It Relates to the Beginnings of Romanticism." In *Studies in Eighteenth-Century Culture* 2. Ed. H. Pagliaro. Cleveland, 1972, 143–65.

Cundall, J., ed. *The Great Works of Raphael Sanzio of Urbino.* London, 1869.

Cuzin, J.-P., et al. *Raphael et l'art français.* Exh. cat., Grand Palais, Paris, November 1983–February 1984.

Dacier, C. *Dessins de maîtres français.* Paris, 1930.

Dacier, E. *Catalogues de ventes et livret de Salons illustrés par Gabriel de St.-Aubin.* 7 vols. Paris, 1909–19.

Dandre-Bardon, M. F. *Traité de Peinture.* Paris, 1765.

Daret, P. *Abrégé de la vie de Raphael* (trans. of Vasari, *Vite*). Paris, 1651.

David, J. *Le Peintre Louis David, 1748–1825: Souvenirs et documents inédits.* Paris, 1880; Plates, 1882.

Dayot, A. *Les Vernet.* Paris, 1898.

Defer, P.-F. *Catalogue Général des Ventes Publiques de Tableaux et Estampes depuis 1737 jusqu'à nos jours.* 5 vols. Paris, 1863–86.

Delaborde, H. *L'Académie des Beaux-Arts depuis la fondation de l'Institut de France.* Paris, 1891.

———. "De quelques traditions de l'art français à propos du tableau de M. Ingres' Jésus au milieu des docteurs." *Gazette des Beaux-Arts* 13, 1862, 385–400.

Delacroix, E. *The Journal of Eugène Delacroix.* Ed. H. Wellington. New York, 1959.

———. "Raphael." In *Revue de Paris,* 1830. Also in *Oeuvres Littéraires,* ed. E. Faure, vol. 2. 4th ed. Paris, 1923.

Delaporte, Y. "André Félibien en Italie (1647–49): Ses visites à Poussin et à Claude Lorraine." *Gazette des Beaux-Arts,* ser. 6, 58, April 1958, 192–214.

Delécluze, E. *Carnet de Route d'Italie, 1823–4: Impressions Romaines.* Ed. R. Baschet. Paris, 1942.

———. *Journal de Delécluze.* Ed. R. Baschet. Paris, 1948.

———. *Louis David: Son école et son temps: Souvenirs.* Paris, 1855.

———. *Précis d'un traité de peinture.* Paris, 1828.

Deloynes Collection. Cabinet des Estampes, Bibliothèque nationale, Paris.

Delpech, F. S. "Beaux-Arts." *Mercure de France* 53, 1812, 225.

———. *Examen raisonné des ouvrages de peintures, sculptures, et gravures exposés au Salon du Louvre en 1814.* Paris, 1814.

Demonts, L. "Deux peintres de la première moitié de XVIIe siècle, Jacques Blanchard et Charles Dufresnoy." *Gazette des Beaux-Arts,* ser. 5, 1, 1925, 161–78.

Dézallier d'Argenville, A.-J. *Abrégé de la vie des plus fameux peintres* (1745) 2 vols.; 2d ed., 4 vols., Paris, 1762.

Diderot, D. *Oeuvres esthétiques.* ed. P. Verniere. Paris, 1959.

———. *Salons.* ed. J. Seznec and J. Adhémar. 4 vols. Oxford, 1957–67.

Diderot et l'Art de Boucher à David: Ses Salons 1759–1781. Exh. cat., Hôtel de la Monnaie, Paris, October 1984–January 1985.

Dieckmann, H. *Esthetic Theory and Criticism in the Enlightenment: Introduction to Modernity.* Austin, Tex., 1965.

Dimier, L. *Histoire de la peinture française: Du retour de Vouet à la mort de Le Brun.* 2 vols. Paris, 1927.

———. *Les Peintres français du XVIIIe siècle.* Paris: vol. 1, 1928; vol. 2, 1930.

Dobai, J. *Die Kunstliteratur des Klassizismus und der Romantik in England.* Vol. 1, *1700–50;* Vol. 2, *1750–90.* Bern, 1974.

Dolce, L. *L'Aretino, Dialogo della Pittura.* Venice, 1557.

Donohue, K. "The Ingenious Bellori—A Bibliographical Study." *Marsyas* 3, 1946, 107–38.

Dorigny, N. *Recueil de XC Têtes d'après les Actes des Apôtres de Raphael.* Paris, 1719.

Dowd, D. L. *Pageant Master of the Republic: Jacques-Louis David and the French Revolution.* Lincoln, Neb., 1948.

Dowley, F. "D'Angiviller's *Grands hommes* and the Significant Moment." *Art Bulletin* 39, 1957, 259–77.

Dresdner, A. *Die Kunstkritik: Ihre Geschichte und Theorie.* Munich, 1915.

Driskel, M. P. "Icon and Narrative in the Art of Ingres." *Arts Magazine* 56, no. 4, December 1981, 100–107.

———. "Raphael, Savonarola and the Neo-Catholic Use of 'Decadence' in the 1830's." In *Fortschrittsglaube und Dekadenzbewußtsein im Europa des 19. Jahrhunderts.* Ed. W. Drost. Heidelberg, 1986, 259–66.

———. *Representing Belief, Religion, Art, and Society in Nineteenth-Century France.* University Park, Pa., 1992.

Droz, Joseph. *Etude sur le beau dans les arts.* Paris, 1815.

Dubois de Saint-Gelais. *Description des tableaux du*

Palais-Royale avec la vie des peintres. Paris, 1727.

Dubos, Abbé J. B. *Réflexions critiques sur la poésie et la peinture.* 3 vols. Paris, 1719.

Dufresnoy, C.-A. *The Art of Painting.* Ed. J. Dryden. London, 1695.

———. *The Art of Painting.* Ed. W. Mason. London, 1783.

———. *De Arte Graphica Liber.* Paris, 1668.

———. "Sentimens sur le plus fameux peintres." In *L'art de peintrure,* trans. Roger de Piles. Paris, (1668) 1673.

[Dulaure, J. A.]. *Critique des quinze critiques du Salon . . .* Paris, 1787.

Dumesnil, J. *Histoire des plus célèbres amateurs français,* Paris, 1856.

———. *Voyageurs français en Italie.* Paris, 1865.

Duncan, C. "Art and Politics in Ingres' *Vow of Louis XIII.*" In *Art and Architecture in the Service of Politics,* ed. H. Millon and L. Nochlin. Cambridge, Mass., 1978, 80–91.

———. "Happy Mothers and Other New Ideas in French Art." *Art Bulletin* 55, December 1973, 570–600.

Dupaty, C. M. *Lettres sur l'Italie,* Paris, 1789.

Duplessis, G. *Catalogue de la collection de pièces sur les Beaux-Arts imprimées et manuscrites recueillé par Pierre-Jean Mariette, Charles N. Cochin et M. Deloynes.* Paris, 1881.

———. *Essai d'une bibliographie générale des beaux-arts.* Paris, 1866.

Dupuy du Grez, B. *Traité sur la peinture pour en apprendre la théorie et se perfectionner dans la pratique.* Toulouse, 1699.

Durkin, T. "Three Notes to Diderot's Aesthetic." *Journal of Aesthetics and Art Criticism* 15, March 1957, 331–39.

Dussieux, Louis. *Mémoires inédits sur la vie et les ouvrages des membres de l'Academie . . .* Paris, 1854.

Dussler, L. *Raffael: Kritisches Verzeichnis der Gemälde, Wandbilder, und Bildteppiche.* Munich, 1966. English translation, London, 1971.

Duval, M. "Quelques observations sur les tableaux recueillés en Lombardie, et actuellement exposés dans le grand Salon du Musée . . ." (n. d.). *Coll. Deloynes* 19:466.

Duverger, Erik. "Réflexions sur le commerce d'art au XVIIIe siècle." *Stil und Überlieferung* 3, Berlin, 1967, 67–88.

Duvivier, A. "Sujets des morceaux de réception des membres de l'ancienne académie de peinture, sculpture, et gravure, 1648 à 1793 . . ." *Archives de l'Art française, Documents* 2 1852–53, 353–91.

Ebhardt, M. *Die Deutung der Werke Raffaels in der deutschen Kunstliteratur von Klassizismus und Romantik.* Baden-Baden, 1972.

Ehrard, J. *Montesquieu: Critique d'art.* Paris, 1965.

Eitner, L. "Foregrounding the Trope." *Times Literary Supplement,* 12 April 1985, 413–14.

———. *Neoclassicism and Romanticism: Sources and Documents in the History of Art.* 2 vols. Englewood Cliffs, N.J., 1970.

El-Abd, L. "Pierre-Nolesque Bergeret (1782–1863)." Diss., Columbia University, 1976.

Eméric-David, T. B. *Catalogues des livres anciens et modernes composant la bibliothèque de feu M. Emeric-David.* Paris, 1862.

———. *Choix de notices sur les tableaux du Musée Napoléon.* Paris, 1812.

———. *Discours historique sur la peinture moderne.* Paris, 1812.

———. "Discours historique sur la sculpture ancienne." *Musée Français,* 1805.

———. *Suite d'études calqués et dessinées d'après cinq tableaux de Raphael . . .* Paris, 1818.

———. *Vies des artistes anciens et modernes.* Ed. P. Lacroix. Paris, 1853.

———. "La Visitation par Raphael." *Moniteur Universel,* December 1818.

Engerand, F. *Inventaire des tableaux commandés et achetés par la Directeur des Bâtiments du Roi (1709–92).* Paris, 1900.

Engerand, L. *Catalogue générale des MSS des bibliothèques publiques de France.* Paris, 1908.

Eriksen, S. "Marigny et le gout grec." *Burlington Magazine* 104, March 1962, 96–101.

Ettlinger, L. D. "Winckelmann." In *The Age of Neoclassicism,* exh. cat., Arts Council of Great Britain, 1972, xxx–xxxiv.

Euboeus, T. *Catalogue des éstampes gravées d'après Rafael.* Frankfurt-am Main, 1819.

Falconet, E. *Oeuvres complètes.* 3 vols. 3d ed. Paris, 1808. (Originally published 1772).

———. *Oeuvres d'Etienne Falconet: Statuaire.* 6 vols. Lausanne, 1781.

Farwell, B. "Manet's 'Espada' and Marcantonio." *Metropolitan Museum of Art Bulletin* 2, 1969, 199f.

Félibien, A. *Conférences de l'Académie royale de peinture et de sculpture pendant l'année 1667.* Paris, 1668.

———. *Entretiens sur les vies et sur les ouvrages des plus excellens peintres anciens et modernes* (1666–88). 6 vols. Trévoux, 1725; Farnsborough, 1967.

———. *L'Idée du peintre parfait . . .* London, 1707. (Originally published 1667)

Fisher, J. *Drawings and Studies by Raffaelle Sanzio in the University Galleries.* Oxford, 1879.

Flocon, F., and M. Aycard. *Salon de 1824.* Paris, 1824.

Folkierski, W. *Entre le classicisme et la romantisme.* Paris, 1925.

Fontaine, A. *Les Collections de l'Académie Royale de Peinture et de Sculpture.* Paris, 1910.

———. *Conférences inédites de l'Académie de Peinture.* Paris, 1903.

———. *Les Doctrines d'art en France, de Poussin à Diderot.* Paris, 1909.

———. *Essai sur le principe et les lois de la critique d'art.* Diss., Paris, 1903.

Fréart de Chambray, R. *Idée de la perfection de la peinture.* (Le Mans, 1662), facsimile edition, 1968.

French Painting, 1774–1830: The Age of Revolution. Exh. cat., Detroit Institute of Arts, Detroit, 1975.

Fried, M. *Absorption and Theatricality: Painting and the Beholder in the Age of Diderot.* Berkeley and Los Angeles, 1980.

Friedlaender, W. *Nicolas Poussin.* New York, 1966.

Funt, D. *Diderot and the Aesthetics of the Enlightenment.* Diderot Studies 10, ed. O. Fellows and D. Guiragossian, Geneva, 1968.

Furcy-Raynaud, M., ed. *Correspondance des directeurs généraux des Bâtiments du Roi (Tournebam, Marigny, Terray, d'Angiviller) avec Ch. Coypel, Lépicié, Cochin, Pièrre, et Vien.* Paris, 1903–6.

Fuseli, H. *Über das Leben und die Werke Raphael Sanzios.* Zurich, 1815.

Gaentgens, T. "Diderot und Vien: Ein Beitrag zu Diderots klassizistischer Ästhetik." *Zeitschrift für Kunstgeschichte* 36, 1973, 51–82.

Garnier, N. *Antoine Coypel (1661–1722).* Paris, 1989.

Gault de Saint-Germain, P.-M. *Choix des productions les plus remarquables exposées dans le Salon de 1817.* Paris, 1817.

———. *Des Passions et de leur expression générale . . .* Paris, 1804.

———. *Ecole Italienne: Guide des amateurs . . .* Paris 1835.

Gay, P. *The Enlightenment: The Rise of Modern Paganism.* New York, 1966.

Gerard, A. *An Essay on Taste: With Ideas on the Subject by Voltaire, d'Alembert, Montesquieu.* London, 1759.

Gibson-Wood, C. "Jonathan Richardson and the Rationalization of Sight." *Art History* 7, March 1984, 38–56.

Goethe, J. W. von. *Italian Journey.* Harmondsworth, 1970.

Goldstein, C. "Observations on the Role of Rome in the Formation of the French Rococo." *Art Quarterly* 33, Autumn 1970, 227–45.

———. "Reviews of B. Teyssèdre, *Roger de Piles et les débats sur le coloris,* and *L'histoire de l'art vue du Grand Siècle.*" *Art Bulletin* 49, no. 3, 1967, 264–68.

———. "Studies in Seventeenth-Century French Art Theory and Ceiling Painting." *Art Bulletin* 47, June 1965, 231–56.

———. "Towards a Definition of Academic Art." *Art Bulletin* 57, March 1975, 102–9.

———. *Visual Fact Over Verbal Fiction: A Study of the Carracci and the Criticism, Theory, and Practice of Art in Renaissance and Baroque Italy.* Cambridge, 1988.

Golzio, V. *Rafaello nei documenti nelle testimianze dei contemporanei e nella letteratura de suo secolo* (1936). Facsimile. Farnsborough, 1971.

———. "Raphael and His Critics." In *The Complete Work of Raphael,* ed. M. Salmi. Novara, 1969, 607–43.

Gombrich, E. *Norm and Form: Studies in the Art of the Renaissance.* Oxford, 1966.

Gougenot, L. *Critiques sur la peinture, la gravure, et l'architecture.* Paris, 1750.

Gould, C. *Trophy of Conquest: The Musée Napoléon and the Creation of the Louvre.* London, 1965.

Grand Palais. *Les Artistes du Salon de 1737.* Exh. cat., Paris, 1930.

———. *Le Neo-classicisme français: Dessins des musées de provence, 1770–1815.* Paris, 1974–75.

Grate, Pontus. "La Critique d'art et la bataille romantique." *Gazette des Beaux-Arts,* ser. 6, 54, September 1959, 129–48.

———. *Deux critiques d'art de l'époque romantique.* Stockholm, 1959.

Greathead, B. *An Englishman in Paris—1803.* Ed. J. Bury and J. Bury. London, 1953.

Greenhalgh, M. *The Classical Tradition in Art from the Fall of the Roman Empire to the Time of Ingres.* New York, 1978.

Grinten, E. van der. *Enquiries into the History of Art—Historical Writing.* The Hague, 1953.

Gueffier, P. F. *Entretien sur les ouvrages de peinture, sculptures, et gravures exposés au Musée Napoléon en 1810.* Paris, 1811.

Guiffrey, J. "L'Académie de France à Rome, 1793–1803." *Journal des Savants,* January 1909.

———, ed. *Collection des livrets des anciennes expositions.* Paris, 1869–72.

———, and P. Marcel, eds. *Inventaire général des dessins du Musée du Louvre . . . Ecole Française.* 10 vols. Paris, 1907–27.

Guizot, E. "De l'état des Beaux-Arts en France et du Salon de 1810." In *Etudes sur les Beaux-Arts en général.* Paris, 1852, 3–100.

Hagedorn, De. *Réflexions sur la peinture.* Trans. Huber. Leipzig, 1775. (Translation of *Betrachtungen über die Mahlerey* [Leipzig, 1762])

Hancarville, P. F. d'. *Dissertation on the Helicon of Raphael.* Trans. Parr. Lausanne, 1824.

Hanson, A. C. *Manet and the Modern Tradition.* New Haven, 1977.

Haskell, Francis. *History and Its Images: Art and the Interpretation of the Past.* New Haven and London, 1993.

———. "The Old Masters in Nineteenth-Century French Painting." *Art Quarterly* 24, Spring 1971, 55–85.

———. *The Painful Birth of the Art Book.* London, 1987.

———. *Rediscoveries in Art.* Wrightsman Lectures, Ithaca, New York, 1976.

———, and N. Penney. *Taste and the Antique.* New Haven, 1981.

Hatfield, Henry. *Winckelmann and His German Critics.* New York, 1943.

Hatin, E. *Bibliographie de la presse périodique française*. Paris, 1866.

Hautecoeur, L. *Louis David*. Paris, 1954.

———. *Rome et la renaissance de l'antiquité à la fin du XVIIIe siècle*. Bibliothèque des Écoles Françaises d'Athènes et de Rome (fasc. 105), Paris, 1912.

Haverkamp-Begemann, E. *Creative Copies: Interpretive Drawings from Michelangelo to Picasso*. Exh. cat., The Drawing Center, New York, 1988.

Hawley, H. *Neoclassicism Style and Motif*. Cleveland, 1964.

Henriet, M. "Un amateur d'art au XVIIIe siècle: L'Académicien Watelet." *Gazette des Beaux-Arts*, ser. 5, 6, September–October 1972, 173–94.

Hercenberg, B. *Nicolas Vleughels: Peintre et Directeur de l'Académie de France à Rome, 1668–1737*. Paris, 1975.

Hess, T., and J. Ashbury. *The Academy. Art News Annual* 33. New York, 1967.

Hilles, F. W. *The Literary Career of Sir Joshua Reynolds*. Cambridge, 1936.

Hofstadter, A., and R. Kuhns, eds. *Philosophies of Art and Beauty: Selected Readings in Aesthetics from Plato to Heidegger*. New York, 1964.

Hogarth, W. *Analysis of Beauty*. London, 1753. (French trans. 1805).

Honisch, D. *Anton Raphael Mengs und die Bildform des Frühklassizismus*. Recklinghausen, 1965.

Honour, H. *Neo-classicism*. Harmondsworth, 1968.

———. *Romanticism*. New York, 1979.

———. "Y eut-il une peinture 'neoclassique' en France?" *Revue de l'Art*, no. 34, 1976, 81–91.

Ingrams, R. "Bachaumont: A Parisian Connoisseur of the Eighteenth Century." *Gazette des Beaux-Arts*, ser. 6, 75, January 1970, 11–28.

Ingres, J. A. D. *Ingres raconté par lui-même et par ses amis*. Ed. P. Cailler. Geneva, 1947–48.

Institut de France, Classe des Beaux-Arts, Rapport historique sur les progrès des arts depuis 1789. Report made to Napoleon on 5 March 1808.

Inventaire général des oeuvres d'art appartenans à la Ville de Paris, dresse par le service des Beaux-Arts. 6 vols. ed. A. Chaix, Paris, 1878–89.

Irwin, D. *English Neoclassical Art*. Greenwich, Conn., 1966.

———. *Winckelmann: Writings on Art*. London, 1972.

Jal, A. *Esquisses, Croquis, Pochades*. Paris, 1828.

———. *L'Ombre de Diderot*. Paris, 1819.

Jay, L.-J., trans. *Recueil de Lettres sur la Peinture* . . . Paris, 1817.

Johnson, D. *Jacques-Louis David: Art in Metamorphosis*. Princeton, N.J., 1993.

Jombert, C.-A. *Méthode pour apprendre le dessin* . . . 2d ed. Paris, 1755.

Jouanny, C. *Correspondance de Nicolas Poussin, Archives de l'Art Français*, vol. 5, 1968.

Jouin, H. *Conférences de l'Académie Royale*. Paris, 1883.

Junius. F. *De Pictura veterum, libri tres*. Amsterdam, 1637.

Justi, C. *Winckelmann und seine Zeitgenossen*. 3 vols. 2d ed. Leipzig, 1898; repr. 1956.

Kalnein, W., and M. Levey. *Art and Architecture of the Eighteenth Century in France*. Harmondsworth, 1972.

Kate, L. H. ten. *Ideal Beauty in Painting and Sculpture Illustrated by Remarks on the Antique and the Works of Raphael* (trans. from French). London, 1766.

Kemp, M. "J. L. David and the Prelude to a Moral Victory for Sparta." *Art Bulletin* 51, 1969, 178–83.

Kennedy, R. W. "Degas and Raphael." *Smith College Museum Bulletin*, nos. 33–34, 1953, 5–12.

Keratry. A.-H. "Notice biographique sur Raphael d'Urbino." In *Ephémérides nouvelles*. Paris, 1829.

Kirby, P. F. *The Grand Tour in Italy, 1700–1800*. New York, 1952.

Klenze, C. "The Growth of Interest in the Early Italian Masters." *Modern Philosophy* 4, October 1906, 207–68.

———. *The Interpretation of Italy during the Last Two Centuries*. Chicago, 1907.

La Font de Saint-Yenne. *Réflexions sur quelques causes de l'état présent de la peinture en France*. Paris, 1747.

La Lande, J. J. de. *Voyage en Italie*. Paris, 1765–66.

Lacombe, J. *Dictionnaire portatif des Beaux-Arts*. Paris, 1753.

———. *Le spectacle des Beaux-Arts* . . . Paris, 1763.

Lairesse, G. *The Art of Painting*. London, 1738.

Lamontagne, P. *La Transfiguration par Raphael: Un Ode*. Paris, 1818.

Lamy, M. "Seroux d'Agincourt (1730–1814) et son influence sur les collectioneurs, critiques, et artistes français." *La Revue de l'Art Ancien et Modern* 39, 1929, 169–91; 40, 1921, 182–90.

Landon, C.-P. *Annales du Musée et de l'école moderne des Beaux-Arts*. 17 vols. Paris, 1801–9; 2d ed., 44 vols., Paris, 1823–35.

———. *Oeuvre complet de Raphael Sanzio réduit et gravé au trait* . . . Paris, 1814.

———. *Vies et oeuvres des peintres les plus célèbres de toutes des écoles* . . . Paris, 1811.

———. *Vies et Ouvrages des Peintres: Ecole Romaine-Raphael*. 2 vols. Paris, 1805.

Langer, I. K., ed. *Reflections on Arts: A Source Book of Writings by Artists, Critics, and Philosophers*. Baltimore, 1958.

Lanzi, Abbé L. *Histoire de la peinture en Italie depuis la Renaissance* . . . *Jusques vers la fin du XVIII siècle*. Trans. A. Dieude-Defly. Paris, 1824.

Lapauze, H. *Les dessins de J. D. Ingres du Musée de Montauban*. Paris, 1901.

———. *Histoire de l'Académie de France à Rome, 1666–1910*. 2 vols. Paris, 1924.

Lavallee. J. *Galerie du Musée Napoléon*. 11 vols. Paris, 1804–28.

Lebel, G. "Bibliographie des revues et périodiques d'art parus en France de 1746 à 1914." *Gazette des Beaux-Arts,* ser. 6, 38, January 1951, 5–64.

Lebrun, J. B. P. "Examen historique et critique des tableaux exposés provisoirement." *Coll. Deloynes* 19, n.d., 401.

Lecoy de la Marche. *L'Académie de France à Rome.* Paris, 1874.

Lee, R. "Ut Pictura Poesis: The Humanistic Theory of Painting." *Art Bulletin* 22, 1940, 197–269.

———. *Ut Pictura Poesis: The Humanistic Theory of Painting.* New York, 1967.

Lempereur, J.-B.-D. *Dictionnaire général des artistes anciens et modernes.* 3 vols. Paris, 1795.

Lenoir, A. *La Vraie Science des artistes.* Paris, 1823.

———. *Observations sur la génie et les principales productions des artistes...* 2d ed. Paris, 1824.

Lépicié, B. *Catalogue raisonné des tableaux du Roy.* Paris, 1752–54.

———. *Vies des premiers peintres du roi depuis M. LeBrun jusqu'à present.* Paris, 1752.

Leppmann, W. *Winckelmann.* New York, 1970.

Lethève, J. *Daily Life of French Artists in the Nineteenth Century.* New York, 1968.

"Lettres sur l'Académie royale de sculpture et de peinture et sur le salon de 1777. Deuxième lettre. Suite coup d'oeil sur l'école française," *Revue Universelle des Arts* 22, 1865–66, 213–33.

Levey, M. *Rococo to Revolution.* London, 1966.

Levitine, G. *The Dawn of Bohemianism.* University Park, Pa., 1978.

———. "L'Ecole d'Apelle de Jean Broc, un Primitif au Salon de l'an VIII." *Gazette des Beaux-Arts,* ser. 6, 58, November 1972, 85–94.

Leyde, A. *Observations sur les arts et sur quelques morceaux de peinture et de sculpture exposés au Louvre en 1748.* Paris, 1748.

Lichtenstein, J. *The Eloquence of Color: Rhetoric and Painting in the French Classical Age.* Trans. E. McVarish. Berkeley and Los Angeles, 1993.

Lichtenstein, S. "The Baron Gros and Raphael." *Art Bulletin* 60, March 1978, 126–38.

———. "Delacroix's Copies after Raphael." Part 1, *Burlington Magazine* 113, September 1971, 525–34; Part 2, October 1971, 593–603.

Liere, E. van. "Ingres' 'Raphael and the Fornarina': Reverence and Testimony." *Arts* 56, December 1981, 108–15.

Lieude de Sepmanville. *Réflexions nouvelles d'un amateur des beaux-arts...* Paris, 1747.

Liotard, J. E. *Traité des principes et des règles de la peinture.* Geneva, 1781.

Lipking, L. *The Ordering of the Arts in Eighteenth-Century England.* Princeton, N.J., 1970.

———. "The Shifting Nature of Authority in Versions of *De Arte Graphica.*" *Journal of Aesthetics and Art Criticism* 23, Summer 1965, 487–504.

Lochhead, I. "The Image of the Artist in Diderot's Salons." In *World Art. Themes of Unity in Diversity, Acts of the XXVIth International Congress of the History of Art,* ed. Irving Lavin. 3 vols. University Park, Pa., 1989, 2:471–75.

Locquin, J. *La Peinture d'histoire en France de 1747 à 1785.* Paris, 1912. Repr. 1978.

Lomazzo, P. *Idea de tempio della Pittura.* Milan, 1590. Facsimile. Hlldesheim, 1965.

———. *Trattato dell'Arte de la Pittura.* Milan, 1584. Facsimile. Hlldesheim, 1968.

Lovejoy, A. O. *Essay in the History of Ideas.* Baltimore, 1948.

———. "Meaning of Romanticism." *Journal of History of Ideas* 2 June 1941, 257–78.

Lugt, F. *Repertoire des catalogues de Ventes Publiques, 1600–1800.* Paris, 1938–53.

Lutgens, H. *Rafaels Transfiguration in der Kunstliteratur der Letzten Vier Jahrhundertes.* Diss, University of Göttingen, 1929.

Lynch, J. B. "History of Raphael's *St. George* in the Louvre." *Gazette des Beaux-Arts,* ser. 6, 59, April 1962, 203–12.

MacWilliam, N. *A Bibliography of Salon Criticism in Paris from the Ancien Regime to the Restoration, 1699–1827.* 2 vols. Cambridge, 1991.

Mahon, D. "Poussiniana." *Gazette des Beaux-Arts,* ser. 6, 60, July–August 1962, 96ff.

Mander K. van. *View des peintres anciens,* 1603; *Vies des peintres modernes,* 1604. Trans. Hepmans.

Marcel, P. *Charles Le Brun.* Paris, n.d..

———. *La Peinture française au début du XVIIIe siècle, 1690–1721.* Paris, 1906.

Mariette, P. J. *Abécédario de, et autres notes inédites de cet amateur sur les arts et les artistes (1740–70).* 6 vols. Paris, 1857–58.

———. *Catalogues d'estampes des plus grands maîtres italiens...* Paris, 1775.

Marionneau, M. C. *Montesquieu considéré comme critique d'art.* Paris, 1882.

Marquet de Vasselot, A. J. J. *Repertoire des Catalogues du Musée du Louvre, 1793–1917.* Paris, 1917.

Mauner, G. *Manet: Peintre-Philosophe.* University Park, Pa., 1975.

May, G. *Diderot et Baudelaire, Critiques d'Art.* Paris, 1957.

McClellan, A. "D'Angiviller's 'Great Men' of France and the Politics of the Parlements." *Art History* 13, no. 2, June 1990, 175–91.

———. *Inventing the Louvre: Art, Politics, and the Origins of the Modern Museum in Eighteenth-Century Paris.* Cambridge, 1994.

———. "The Politics and Aesthetics of Display: Museums in Paris, 1750–1800." *Art History* 7, no. 4, December 1984, 438–64.

———. "The Responsible Republic: Art, Conservation and the Museum during the French Revolution." *Apollo,* n.s. 130, no. 329, July 1989, 5–8.

Mengs, A. R. *The Works of Anton Raphael Mengs* (translated from the Italian). Ed. J. N. d'Azara. London, 1796.

Mery de la Canorgue, J. *La Théologie des Peintres...* Paris, 1765.

Merot, A. *Eustache Le Sueur, 1616–1655.* Paris, 1987.
———. *Nicolas Poussin.* London, 1990.
Messelet, J. "Jean Restout (1692–1768)." *Nouvelle Archives de l'Art Français* 19, 1938, 99–188.
Metz, C. M. *Imitations of Ancient and Modern Drawings*... London, 1798.
Michel, R. *Le Beau Idéal.* Exh. cat., Louvre, Cabinet des Dessins, Paris, 1989.
Miel, E.-F. *Essai sur les Beaux-Arts et particulièrement sur le Salon de 1817*... Paris, 1817.
Millin, A.-L. *Dictionnaire des Beaux-Arts.* Paris, 1806.
Mireur, H. *Dictionnaire des Ventes d'art faites*... 7 vols. Paris, 1901–2.
Mirot, L. *Roger de Piles: Peintre, amateur, critique, membre de l'Académie de Peinture, 1635–1709.* Paris, 1924.
Misserini, M. *De la bienheureuse Vierge Marie avec l'enfant Jesus.* Paris, 1838.
"Les modèles des Gobelins devant le Jury des Arts en Septembre, 1794." *Nouvelles Archives de l'Art Français* 13, 1897, 351.
Mommeja, J. *La Collection Ingres au Musée de Montauban*... Vol. 7. Paris, 1905.
Mongan, A. *Ingres: Centennial Exhibition, 1867–1967.* Fogg Art Museum, Cambridge, Mass., 1967.
Monier, P. *Histoire des Arts qui ont rapport au dessin.* Paris, 1699.
Montagu, J. "Charles le Brun's Use of a Figure from Raphael." *Gazette des Beaux-Arts,* ser. 6, 51, February 1958, 91–96.
Montaiglon, A. de, ed. *Correspondance des Directeurs de l'Académie de France à Rome avec les Surintendants des Bâtiments.* 17 vols. Paris, 1887.
———. *L'Essai de bibliographie des livrets et des critiques de Salons.* Paris, n.d.
———. *Procès-Verbaux de l'Académie de Peinture et Sculpture, 1648–1797.* 10 vols. Paris, 1875.
Montesquieu, A. *Voyages de Montesquieu.* Paris, 1896.
Moore, R. E. *Changing Taste in Eighteenth-Century Art and Literature.* Los Angeles, Calif., 1972.
Morgenstern, K. *Über Rafael Sanzio's Verklärung.* Dorpat-Leipzig, 1822.
Mortier, R. *Diderot and the "Grand Goût."* Oxford, 1982.
Mras, G. *Eugène Delacroix's Theory of Art.* Princeton, N.J., 1966.
Müntz, E. *Les Archives des Arts.* Paris, 1889.
———. *La Bibliothèque de l'Ecole des Beaux-Arts avant la Révolution.* Nogent-le-Rotron, 1897.
———. *Catalogue des manuscrits de la Bibliothèque de l'école des Beaux-Arts.* Paris, 1895.
———. *Les Historiens et critiques de Raphael.* Paris, 1883.
———. *Les Tapisseries de Raphael au Vatican.* Paris, 1897.
Musée des Arts Décoratifs. *Les artistes français en Italie de Poussin à Renoir.* Paris, 1934.

Musée Napoléon. *Explications des ouvrages de peinture*... Paris, 1808.
———. *Explications des ouvrages de peinture, sculpture*... Paris, 1812.
———. *Notice des Tableaux exposés dans la Galerie Napoléon.* Paris, 1811.
Mustoxide, T. *Histoire de l'esthétique française, 1700–1900.* Paris, 1920.
Naef, H. *Ingres in Rome: A Loan Exhibition from the Musée Ingres, Montauban and American Collections.* Washington International Exhibition Foundation, 1971.
Nicolle, M. "Une anthologie de la critique d'art en France." *Gazette des Beaux-Arts,* ser. 6, 5, January 1931, 45–63, supp. 3.4.
Novotny, F. *Painting and Sculpture in Europe, 1780–1880.* Pelican History of Art. Harmondsworth, 1960; 2d ed., 1970.
Oberhuber, K. *Poussin: The Early Years in Rome.* Exh. cat., Kimball Art Museum, Fort Worth, Texas, New York, 1988.
Pace, C. *Félibien's Life of Poussin.* London, 1981.
Pader, H. *La Peintre parlante.* Toulouse, 1653.
Paillot de Montabert, J. N. *Traité complet de la peinture.* 9 vols. Paris, 1829–51.
Panofsky, E. *Idea: A Concept in Art Theory.* Trans. J. Peake. Columbia, S.C., 1968. (Originally published in German, Leipzig, 1924)
Pardo de Figueroa, B. *Examen analytique du tableau de la Transfiguration de Raphael.* Paris, 1805.
Paschard, G., and Ph. Junot. *Diderot, critique d'art: Etude bibliographique.* Etudes de Lettres, Université de Lausanne, ser. 3, 8, 1975.
Passavant, J. *Rafael von Urbino und Sein Vater Giovanni Santi.* Leipzig, 1839.
Peloux, C. du. *Repertoire biographique des artistes du XVIIIe siècle français.* Vol. 2, Paris, 1930; vols. 2, Paris, 1941.
Pelzel, T. *Anton Raphael Mengs and Neoclassicism.* Diss., Princeton University 1968; New York, 1979.
———. "Winckelmann, Mengs, and Casanova: A Reappraisal of a Famous Eighteenth-Century Forgery." *Art Bulletin* 54, August 1972, 301–15.
Perrault, C. *Parallèles des anciens et des modernes.* Paris, 1688–97.
———. *La Peinture.* Paris, 1668.
———. *Le Siècle de Louis le Grand.* Paris, 1687.
Pevsner, N. *Academies of Art, Past and Present.* Cambridge, 1940; repr. New York, 1973.
Philadelphia Museum of Art. *The Second Empire 1852–70: Art in France under Napoleon III.* Philadelphia, 1978.
Piles, R. de. *Abrégé de la vie des peintres.* Paris, 1699.
———. *Conversations sur la connaissance de la peinture.* Paris, 1677.
———. *Cours de peinture par principes.* Paris, 1708.
———. *Dialogue sur le coloris.* Paris, 1673.
———. *Dissertation sur les ouvrages des plus fameux peintres.* Paris, 1681.

————. (trans.) *L'Art de peinture* (translation of Dufresnoy's *De Arte Graphica*). Paris, 1668, containing De Piles's *Remarques* and Dufresnoy's *Sentimens*.

Ponce, N. "Dissertation sur le beau idéal." In *Mélanges sur les Beaux-Arts*. Paris, 1826.

Pope-Hennessy, J. *Raphael*. New York, 1970.

Popham, A. E. *Selected Drawings from Windsor Castle, Raphael and Michelangelo*. London, 1954.

Posner, D. "Charles Le Brun's Triumphs of Alexander." *Art Bulletin* 41, 1959, 237–48.

Potts, A. D. "Political Attitudes and the Rise of Historicism in Art Theory." *Art History* 1, no. 2, June 1978, 191–213.

————. "Winckelmann's Interpretation of the History of Ancient Art in Its Eighteenth-Century Context." Diss., Warburg Institute, London University, 1978.

————. "Winckelmann's Construction of History." *Art History* 5 no. 4, December 1982, 377–407.

Poussin, N. *Lettres et propos sur l'art*. Ed. A. Blunt. Paris, 1964.

Praz, M. *The Romantic Agony*. London, 1933.

Puttfarken, T. *Roger de Piles' Theory of Art*. New Haven, 1985.

Quatremère de Quincy, A. *Considérations sur les arts du dessin en France: Suivies d'un plan d'Academie...* Paris, 1971.

————. *Historie de la vie et des ouvrages de Raphael*. Paris, 1824.

————. *Lettres sur le projet d'enlever les monuments de l'Italie*. Paris, 1796.

Raphael dans les collections françaises. Exh. cat. Galeries nationales du Grand Palais, November 1983–February 1984, Paris.

Raphael de Sanctis, Urbines, prima elementa picturae, id est modus facilis delineandi omnes humani corpus partes, Rome, 1747.

Rapport sur la restauration du tableau de Raphael, connu sous le nom de la Vierge de Foligno... Paris, 1803.

Reff, T. "Copyists in the Louvre, 1850–1870." *Art Bulletin* 46, 1964, 522–59.

————. *Degas: The Artist's Mind*. New York, 1976.

Rehlberg, F. *Rafael Sanzio aus Urbino*. Munich, 1824.

Reitlinger, G. *The Economics of Taste: The Rise and Fall of Picture Prices, 1760–1960*. London, 1961.

Remy, P. *Catalogue raisonné des tableaux, estampes, coquilles et autres curiosités: Après de décès de feu M. Dezallier d'Argenville*. Paris, 1766.

Renou, A. *Dialogues sur la peinture* (1773). Facsimile. Geneva, 1973.

Renouvier, J. *Histoire de l'art pendant la Révolution considéré principalement dans les estampes*. Paris, 1863.

Restout, J. *Discours prononcé dans l'Académie royale de peinture et de sculpture...* (19 December 1789). Paris, 1790.

Reynolds, J. *Discourses on Art*. Ed. R. Wark. San Marino, Calif., 1959; New Haven, 1975.

Richard, L'Abbé J., *Description historique et critique d'Italie*. Dijon, 1766; Paris, 1768–69.

Richardson, J., père et fils. *Traité de la peinture et de la sculpture*. 3 vols. Amsterdam, 1728.

————. *The Works of Jonathan Richardson* (1773). London, 1792.

Riepenhausen, F., and J. Riepenhausen. *Vita di Raffaelle da Urbino*. Rome, 1833.

Roberts, K. "Drawings by Raphael and Pupils in the British Museum." *Burlington Magazine* 104, December 1962, 558.

Robertson, K. "Art Criticism in France." *Studio* 189, March 1975, 140–41.

Rocheblave, S. *Essai sur le Comte de Caylus*. Paris, 1889.

Roettgen, S. *Anton Raphael Mengs 1728–1779 and His British Patrons*. London, 1993.

Rosen, C. and H. Zerner. *Romanticism and Realism: The Mythology of Nineteenth-Century Art*. New York, 1984.

Rosenberg, J. *On Quality in Art*. Princeton, N.J., 1967.

Rosenberg, M. "Bergeret's *Honors Rendered to Raphael on His Deathbed*." *Allen Memorial Art Museum Bulletin* (Oberlin College), 42, no. 1, 1984–85, 3–15.

————. "Raphael and France." *Art Journal* 44, Spring 1984, 70–74.

————. "Raphael in French Art Theory, Criticism and Practice, 1660–1830." Diss., University of Pennsylvania, 1979.

————. "Raphael's Transfiguration and Napoleon's Cultural Politics." *Eighteenth-Century Studies* 19, no. 2, Winter 1985–86, 180–205.

Rosenberg, P. *The Age of Louis XV: French Painting, 1710–1774*. Exh. cat., Toledo Museum of Art, 1974–76.

————, J. Mejanes, and J. Vilain. *P. C. Trémolières* (Cholet, 1703–Paris, 1739). Exh. cat., Paris, 1974–75.

————, N. Reynaud, and I. Compin. *Musée du Louvre, Catalogue illustré des Peintures: Ecole française XVIIe et XVIIIe siècles*. Paris, 1974.

————, and A. Schnapper. *Jean Restout (1692–1768)*. Exh. cat., Rouen, 1970.

Rosenblum, R. *Ingres*. New York, 1876.

————. "Ingres, Inc." *The Academy: Art News Annual* 33 (n.d.), 67–79.

————. *The International Style of 1800: A Study in Linear Abstraction*. New York, 1976.

————. *Transformations in Late Eighteenth-Century Art*. Princeton, N.J., 1967.

Rosenthal, D. *La Grande Manière: Historical and Religious Painting in France, 1700–1800*. Exh. cat., Memorial Art Gallery of the University of Rochester, Rochester, N.Y., 1987.

Roskill, M. *Dolce's "Aretino" and Venetian Art Theory of the Cinquecento*. New York, 1968.

Royal Academy of Arts. *France in the Eighteenth Century.* Exh. cat., London, 1968.

Rubin, J. H. "New Documents on the *Méditateurs.*" *Burlington Magazine* 117, December 1975, 785–90.

———. "Roger de Piles and Antiquity." *Journal of Aesthetics and Art Criticism* 34, no. 2, Winter 1975, 157–63.

Sahut, M. C. *Le Peintre Louis Galloche (1670–1761).* Mémoire de maîtrise. Paris, 1972.

Saisselin, R. "Amateurs, Connoisseurs, and Painters." *Art Quarterly* 27, no. 4, 1964, 429–43.

———. *The Rule of Reason and the Ruses of the Heart: A Philosophical Dictionary of Classical French Criticism,* Cleveland, 1970.

———. "Some Remarks on French Eighteenth-Century Writings on the Arts." *Journal of Aesthetics and Art Criticism* 25, 1966–67, 187–95.

———. *Taste in Eighteenth-Century France.* Syracuse, N.Y., 1965.

Salmi, M., ed. *Raffaelo: L'Opera, le fonti, la fortuna.* Novara, 1968.

Salon 1748. *Observations sur les arts, et sur quelques morceaux de peinture et de sculpture exposés au Louvre en 1748.* Paris, 1748.

Sandblad, N. *Manet: Three Studies in Artistic Conception.* London, 1954.

Saunier, C. *Les Conquêtes artistiques de la Révolution et de l'Empire.* Laurens, 1902.

Schlenoff, N. *Ingres: Cahiers littéraires, inédits.* Paris, 1956.

———. *Ingres: Ses sources littéraires.* Paris, 1956.

Schlosser, J. *La Letteratura Artistica.* Rev. O. Kurz. Florence, 1960.

Schnapper, A. "A la recherche de Sébastien II Leclerc, 1676–1763." *Revue du Louvre et des Musées de France* 23, 1973, 241–48.

———. *Au temps du Roi Soleil: Les Peintres de Louis XIV (1660–1715).* Exh. cat., Lille, 1968.

———. *David: Temoin de son temps.* Paris, 1981.

———. *Jean Jouvenet.* Paris, 1974.

———. "The *Moses* of Antoine Coypel." *Bulletin of the Allen Memorial Art Museum* (Oberlin College), 37, no. 2, 1979–80, 58–70.

———. *Tableaux pour le Trianon de Marbre, 1688–1714.* Paris, 1967.

Schneider, R. *Quatremère et son intervention dans les arts, 1788–1830.* Paris, 1910.

Schubert, M. *W. H. Wackenroeder's Confessions and Fantasies.* University Park, Pa., 1971.

Schudt, L. *Italienreisen im 17. und 18. Jahrhundert.* Römische Forschungen der Biblioteca Hertziana 15, Munich, 1959.

Scott, B. "Pierre Crozat: A Maecenas of the Régence." *Apollo* 97, January 1973, 11–19.

Seran de la Tour, Abbé. *L'Art de sentir et de juger en matières de goût.* Strasbourg, 1790.

Seroux d'Agincourt, J. B. L. *L'Histoire de l'art par les monuments.* 2 vols. Paris, 1823.

Serulluz, M., and A. Serulluz. *Dessins Français des 1750–1825: Le Neo-classicisme.* Exh. cat., Louvre, Cabinet des Dessins, Paris, 1972.

Seznec, J. *Denis Diderot sur l'art et les artistes.* Paris, 1967.

Shedd, M. "T.-B. Émeric-David and the Criticism of Ancient Sculpture in France, 1790–1839." Diss., University of California, Berkeley, 1980.

Sheriff, M. *Fragonard, Art, and Eroticism.* Chicago and London, 1990.

Shiff, R. "Phototropism (Figuring the Proper)." In *Retaining the Original: Multiple Originals, Copies, and Reproductions.* Studies in the History of Art 20, National Gallery of Art, Washington, D.C., 1989, 161–79.

———. "Representation, Copying, and the Technique of Originality." *New Literary History* 15, no. 2 Winter 1983–84, 333–63.

Shils, E. *Tradition.* Chicago, 1981.

Shoemaker, I. H. *The Engravings of Marcantonio Raimondi.* Exh. cat., Spencer Museum of Art, University of Kansas, Lawrence, Kansas, 1981.

Simches, S. *Le Romantisme et le goût esthétique du XVIIIe siècle.* Paris, 1964.

Soubeyran, F., and J. Vilain. "Gabriel Bouquier, Critique du Salon de 1775." *Revue du Louvre* 25, 1975, 85–104.

Spector, J. *The Murals of Eugène Delacroix at St. Sulpice.* New York, 1967.

Sprague, A. *Tides in English Taste, 1619–1800.* New York, 1958.

Steegman, J. "The 'Balance des Peintres' of Roger de Piles." *Art Quarterly* 17, no. 3, 1954, 255–61.

Stein, H. "Etat des Objets d'Art placés dans les monuments religieux et civils de Paris au début de la Révolution Française." *Nouvelles Archives de l'Art Français* 6, 1890, 1–131.

Steinmann, E. "Rafael im Musée Napoléon." *Monatshefte für Kunstwissenschaft,* 10, Leipzig, 1917, 8–25.

Stendhal [Marie-Henri Beyle]. *Histoire de la peinture en Italie.* Paris, 1811–17.

———. *Mélanges d'art.* Paris, 1932.

———. *Racine et Shakespeare* (1823). Ed. P. Martino. Paris, 1926.

Studdert-Kennedy, W., and M. Davenport. "Balance of Roger de Piles: A Statistical Analysis." *Journal of Aesthetics and Art Criticism* 32, Summer 1974, 493–502.

Stuffmann, M. "Les tableaux de la collection de Pierre Crozat." *Gazette des Beaux-Arts,* 72, 1968, 1–144.

Symmons, S. "French Copies after Flaxmann's Outlines." *Burlington Magazine* 115, September 1973, 591–99.

Taillasson, J. *Observations sur quelques grands peintres . . .* Paris, 1807.

Tate Gallery. *Turner, 1775–1851.* Exh. cat., London, 1974–75.

Ternois, D. *Les Dessins d'Ingres au Musée de Montaubon. Les portraits . . .* Paris, 1959.

———. *Montaubon, Musée Ingres. Peintures. Ingres et son temps . . .* Paris, 1965.

———, and J. Lacambre. *Ingres.* Exh. cat., Petit Palais, 1967–68.

———. *Ingres et son Temps.* Exh. cat., Musée Ingres, Montaubon, 1967.

Testelin, H. *Sentimens des plus habiles peintres du temps, sur la pratique de la Peinture.* Paris, 1699.

———. *Table des préceptes.* Paris, 1680.

Teyssèdre, B. *L'Histoire de l'art vue du Grand Siècle . . .* Paris, 1964.

———. *Roger de Piles et les débats sur le coloris au siècle de Louis XIV* (1957). Paris, 1965.

Thiers, A. *Salon de 1822.* Paris, 1822.

———. *Salon de 1824.* Paris, 1824.

Thuillier, J. "Les Débuts de l'histoire de l'art en France et Vasari." In *Il Vasari storiografo e artista: Atti del Congresso internazionale nel IV centenario della morte.* Arezzo-Florence, 1974, 667–89.

———. "Polémiques autour de Michelange au XVIIe siècle." *Dix-septième siècle* 13, nos. 36–37, 1957, 353–69.

———. "Pour un Corpus Poussinianum." In *Nicolas Poussin.* Paris, 1960, 2:49–238.

———, and A. Chatelet. *French Painting: From Le Nain to Fragonard.* Geneva, 1964.

———. "Raphael et la France: Présence d'un Peintre." In J. P. Cuzin, *Raphael et l'art français.* Exh. cat., Grand Palais, Paris, 1983, 11–35.

Tild, J. "Théophile Gautier: Peintre et critique d'art préfèrait Ingres à Delacroix." *Arts,* 1946.

Tollemache, B. L., ed. *Diderot's Thoughts on Art and Style.* New York, 1971. (Originally published 1893)

Tomory, P. *The Life and Art of Henry Fuseli.* New York and London, 1972.

Tourneux, M. *Salons et Expositions d'art à Paris (1801–70): Essai bibliographique.* Paris, 1919.

———. *Table générale des documents contenus dans les Archives de l'Art Français et leur annexes (1851–96).* Paris, 1897.

Trapp, F. *The Attainment of Delacroix.* Baltimore, 1971.

Tuetey, L., ed. *Documents inédits sur l'histoire de France: Procès-verbaux de la Commission Temporaire des Arts.* Paris, 1917.

Valery, A. C. P. *Voyages historiques et littéraires en Italie pendant les années 1826–27–28.* Paris, 1831–35.

Vasari, G. *Lives.* Trans. G. du C. DeVere. 10 vols. Repr., London, 1912–14.

———. *Le Vite de' Piu Eccelenti Pittori, Scultori e Architettori* (1568). Ed. G. Milanesi (1878). 9 vols. Florence, 1906.

Venturi, L. "Doctrines d'art au début du XIXe siècle." In *Renaissance,* 1943, 1:559–72.

———. *History of Art Criticism.* New York, 1936.

Verdi, R. "Poussin's *Eudamidas:* Eighteenth-Century Criticism and Copies." *Burlington Magazine* 113, September 1971, 513–24.

Vivant Denon, D. *Monuments des arts du dessin.* Paris, 1829.

Wakefield, D. "Art Historians and Art Critics XI: Stendhal." *Burlington Magazine* 117, December 1975, 803–9.

———. "Stendhal and Delécluze at the Salon of 1824." In *The Artist and the Writer in France: Essays in Honor of Jean Seznec,* ed. F. Haskell et al. London, 1974, 81ff.

———. *Stendhal and the Arts.* London, 1973.

Wasserman, E. R., ed. *Aspects of the Eighteenth Century.* Baltimore, 1965.

Watelet, C. H. *L'Art de peindre: Poème.* Paris, 1760.

———, and P. C. Levesque. *Dictionnaire portatif de peinture, sculpture, et gravure.* 5 vols. Paris, 1792.

Waterhouse, E. "British Contribution to the Neoclassical Style." *Proceedings of the British Academy* 15, 1954, 57–75.

Webb, D. *An Inquiry into the Beauties of Painting.* London, 1760.

Weber, G. "Diderot, First of the Art Critics." *Connoisseur* 159, August 1965, 235–39.

Weiss, R. *The Renaissance Discovery of Classical Antiquity.* Oxford, 1969.

Wellek, R. *A History of Modern Criticism, 1750–1950.* 4 vols. New Haven, 1955–65.

Weyl, M. *Passion for Reason and Reason of Passion: Seventeenth-Century Art and Theory in France, 1648–1683.* New York, 1989.

White, B. E. "Delacroix's Painted Copies After Rubens." *Art Bulletin* 49, January 1967, 37–51.

Whitely, J. J. L. "The Origin and Concept of 'Classique' in French Art Criticism." *Journal of the Warburg and Courtauld Institutes* 39, 1976, 268–74.

———. *Ingres.* London, 1977.

Wildenstein, D., ed. *Notes Manuscrits de P. J. Mariette* (facsimile of MS in Bibliothèque National). 2 vols. Paris, n.d.

Wildenstein, D., and G. Wildenstein. *Documents complémentaires au catalogue de l'oeuvre de Louis David.* Paris, 1973.

Wildenstein, G. "Le Goût pour la peinture dans le cercle de la bourgeoisie parisienne autour de 1700." *Gazette des Beaux-Arts,* ser. 6, 58, September 1956, 133ff.

———. *Ingres.* London, 1954.

———. *Le Salon de 1725 (compte rendu par le Mercure de France).* Paris, 1924.

Winckelmann, J. *Gedanken über die Nachahmung der Griechischen Werke in der Malerei und Bildhauerkunst.* Dresden, 1755.

———. *Geschichte der Kunst des Altertums.* Dresden, 1764. (First French trans., 1766)

———. *History of Ancient Art.* Trans. G. H. Lodge. London, 1850; repr. 1868.

———. *Reflections on the Imitation of the Painting*

and Sculpture of the Greeks. Trans. H. Fuseli. London, 1765.

———. "Réflexions sur les ouvrages de l'art." *Journal Etranger,* April 1760. (Extract from *Gedanken*)

Wittkower, R., and M. Wittkower. *Born Under Saturn.* New York, 1963.

Wood, J. "Cannibilized Prints and Early Art History." *Journal of the Warburg and Courtauld Institutes* 51, 1988, 210–20.

Woodfield, R. "Freedom of Shaftsbury's Classicism." *British Journal of Aesthetics* 15, Summer 1875, 254–66.

———. "Winckelmann and the Abbé DuBos." *British Journal of Aesthetics* 13, Summer 1970, 271–75.

Wright, C. *The French Painters of the Seventeenth Century.* New York, 1985.

———. *Poussin Paintings: A Catalogue Raisonné.* London, 1984.

Wrigley, R. *The Origins of French Art Criticism from the Ancien Regime to the Restoration.* Oxford, 1993.

Zeitler, R. *Klassizismus und Utopia . . .* Stockholm, 1954.

Zmijewska, H. "La Critique des Salons en France avant Diderot." *Gazette des Beaux-Arts,* ser. 6, 76, July–December 1970, 1–143.

Zuccaro, F. *L'Idea de pittori, scultori, et architetti.* Turin, 1607.

Zupnick, I. L. "The Significance of the Stanza dell'Incendio for Leo X and François I." *Gazette des Beaux-Arts,* ser. 6, 80, October 1972, 195–204.

INDEX